'An evocative and crowded chronicle... ê
Guardian

'Wonderfully fluent and revealing... Ov
art and culture to show how perceptions of the British countryside have changed
over the centuries and how artists and writers have been at the vanguard
of these shifts... She uses her impressively wide frame of reference effortlessly –
and always revealingly – to zoom from panorama to close-up' *Literary Review*

'If you think you know the British landscape, think again... This informative,
elegant book wears its learning lightly, moving sympathetically through space
and centuries and inviting us to become mental travellers, coming with
open minds and eyes to the wonders of the British landscape'
Fiona Stafford, author of *The Long, Long Life of Trees* and *The Brief Life of Flowers*

'[A] lovely, lyrical study... gorgeously illustrated and rich in voices...
fascinating and personal' *Tatler*

'Enchanting... Owens has a poet's skill for finding the right word
or metaphor, lyrical yet spearingly precise' *World of Interiors*

'Timely and comprehensive' *RA Magazine*

'Enlightening' *New Statesman*

'Owens marries cultural history and nature writing, exploring the
interpretations of a wealth of distinctive voices, from William Shakespeare
and Jane Austen to John Constable and Barbara Hepworth' *The Arts Society*

'A gorgeously illustrated scholarly tome that can be enjoyed and referred
to again and again... [Owens'] erudite alacrity reveals her skill as art
historian and curator... This is a book about how landscape is
interpreted not shaped, and in that it is second to none' *Countryfile*

'Deftly written and beautifully illustrated... a delight' *Standpoint*

'A panoramic view of the landscape, as seen through the eyes of writers
and artists from Bede and the Gawain-poet to Gainsborough, Austen,
Turner and Constable; from Paul Nash, WG Sebald and Barbara
Hepworth to Robert Macfarlane' *The Deskbound Traveller*

'Evocative' *Choice*

'A perfect book for a year when striking out from home has been curtailed'
Arts Society Review

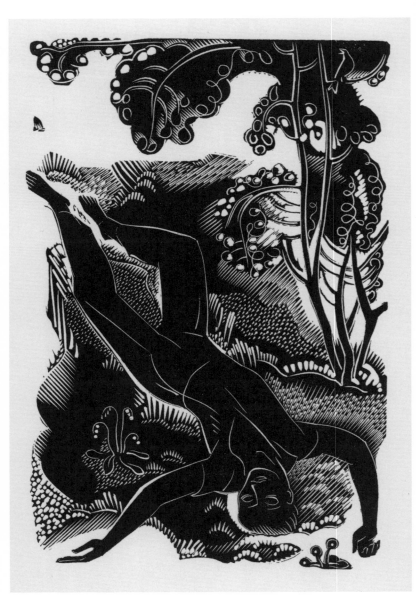

Susan Owens

Spirit of Place

ARTISTS, WRITERS & THE BRITISH LANDSCAPE

DR SUSAN OWENS is an art historian and curator who has
worked at the Royal Collection and the Victoria and Albert
Museum. Her previous books include *The Ghost: A Cultural
History* (2017) and *Christina Rossetti: Poetry in Art* (2018).

ON THE COVER
Isaac Oliver, *Edward Herbert, 1st Lord Herbert of Cherbury* (detail),
c. 1613–14. Watercolour on vellum mounted on panel, 18.1 x 22.9 cm.
Powis Castle and Garden, Powys. National Trust Images/Todd-White
Art Photography/Bridgeman Images

FRONTISPIECE
Gertrude Hermes, wood-engraved frontispiece to
Richard Jefferies, *The Story of my Heart*, 1938

First published in the United Kingdom in 2020 by
Thames & Hudson Ltd, 181A High Holborn, London WC1V 7QX

First published in the United States of America in 2020 by
Thames & Hudson Inc., 500 Fifth Avenue, New York, New York 10110

This compact paperback edition published in 2021
Reprinted 2022

Spirit of Place: Artists, Writers and the British Landscape © 2020
Thames & Hudson Ltd, London
Text © 2020 Susan Owens

Typeset by Mark Bracey

British Library Cataloguing-in-Publication Data
A catalogue record for this book is available from the British Library

Library of Congress Control Number 2020932462

ISBN 978-0-500-29635-6

Printed and bound in China by Shanghai Offset Printing Products Ltd

Be the first to know about our new releases,
exclusive content and author events by visiting
thamesandhudson.com
thamesandhudsonusa.com
thamesandhudson.com.au

MIX
Paper from
responsible sources
FSC® C109093

CONTENTS

INTRODUCTION

One late December day in 1828, the young artist Samuel Palmer sat down in Lullingstone Park, Kent, in front of one of the largest, oldest oak trees he could find, and attempted to draw it. But, as he later admitted to a friend, the oak he chose did not begin to measure up to the image he had in his mind, which had been planted there by a single phrase of John Milton's: 'Pine and *monumental* oak'. There it grew to immense proportions; 'the poet's tree', complained Palmer, 'is huger than any in the park'.[1] In a couple of words, it seemed, Milton had outstripped nature itself.

What Palmer noticed that day affects many of us as we go about our daily lives. Artists and writers do not just describe our landscape; they make it, too. The pictures we see and the stories we read seep deeply into our minds, forever changing the way we perceive the world around us. Palmer himself has had a profound and lasting effect on flowering horse chestnuts for me – his watercolours, with their hyper-vivid colours, subtly exaggerate the trees' joyful essence like clever caricatures. He has made them more real to me than they were before. In the same way, I am

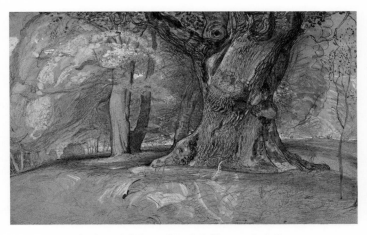

Samuel Palmer, *Oak Tree and Beech, Lullingstone Park, Kent*, 1828.

incapable of looking at the South Downs without thinking of William Nicholson's oil paintings; and every time I drive down the A12 from my home in Suffolk to London, a sweeping view opens up of Dedham Vale and I am struck by the absurd degree to which it looks like a painting by Constable. I can't help it. These are the filters through which the landscape appears to me – I am sure you have your own.

Men and women have experienced the landscape in different ways at different times. Great physical changes have of course been made to the land over the centuries, as methods of farming have developed, patterns of land ownership have altered the shapes and sizes of fields and urban sprawl has covered much of what was once countryside. But cultural shifts in the aesthetic appreciation of landscape have played at least as important a role. There have been times when the countryside has been a place to lift the heart, and others when it has been regarded as better suited for melancholy reflection; times when it could offer spiritual enlightenment and times when people shut the door against it with a shudder of relief. Perhaps the most dramatic illustration of changing perceptions is our attitude to mountains. Before the late eighteenth century, mountains were considered ugly and offensive. No one went near them if they could possibly avoid it – touring southern Scotland in the 1720s, Daniel Defoe was distressed by country of 'the wildest and most hideous aspect' surrounding Drumlanrig.[2] Scant decades later, tourists and artists alike could hardly tear themselves away: 'the Mountains are extatic [*sic*], & ought to be visited in pilgrimage once a year', enthused Thomas Gray in 1739, after his first sight of the Highlands.[3]

Landscape is a vast subject, and I am fascinated by the way successive cultural, social and intellectual changes have shaped our attitudes to it over centuries. The scope of this book is intended to offer a view of the big picture as it unfolds. But just as interesting to me are the voices of individuals who experience the landscape: I wanted to know what a woman living at the time of Queen Anne saw as she rode through the Peak District; what an Elizabethan thought while gazing across a heath; how a tenth-century man felt about woodland. In this book I have set out to put these writers, artists and chroniclers centre stage; to notice the details they notice, and to write about why they frame this subject in the ways they do.

Spirit of Place probably first took root in my childhood, spent in rural Derbyshire at the tip of the Pennines' toes. It has certainly grown from my work as a museum curator. Much of my research has taken place in collections of fine and decorative arts, particularly those of the Victoria and Albert Museum. Not only does the V&A house Britain's national collection of watercolours, one of the greatest resources for landscape art, it also has a long history of collecting the curious and difficult things that do not easily fit into other museums. London's National Gallery, for example, collects oil paintings but not works on paper. With equal fastidiousness, the British Museum collects works on paper but not oil paintings. The V&A has few such qualms. So when, in the past, half a painted room needed a home – or the wooden viewing-box that Gainsborough constructed to view his glass paintings by candlelight – or Philip de Loutherbourg's paper models of Peak Cavern, designed for a long-forgotten play called *The Wonders of Derbyshire* – off to the V&A they went. My time as a curator of the oil paintings, watercolours, drawings and associated oddments in the V&A's collections taught me that art history is messy and complicated, and all that awkward, delicate, difficult-to-store, three-dimensional stuff cannot be made to sit up straight and behave itself. In any case, working in a huge museum with such a large component of decorative arts is an education in itself: walking daily through the galleries on my way to my eyrie of an office, I could not help but think about the ways in which tapestries and embroideries, for instance, might relate to so-called fine art.

My years at the V&A were ones in which I thought a lot about landscape, and planned galleries and exhibitions on the subject. But sometimes it takes an unexpected spark to ignite an idea. It happened one September weekend; I was at a literary festival listening to a talk when I heard an old cliché: that British landscape painting was invented in the eighteenth century. 'But it's more complicated than that!', I scrawled in my notebook. Most art historians, in fact, date its appearance to the seventeenth century, when landscape paintings – paintings, that is, in oil on canvas or panel – began to arrive in Britain from the Netherlands and Italy, where artists had specialized in the distinct genre of landscape since the early sixteenth century. Indeed, what is thought to be the earliest surviving response to imported paintings by a native artist is a small

rocky landscape of the 1620s by the gentleman–artist Nathaniel Bacon, now in the Ashmolean Museum in Oxford – sadly, it is no masterpiece.[4] But that particular moment in which landscape began to be regarded as a fitting subject for oil paintings, important as it is, is only part of a larger story that encompasses decorative, applied and literary arts as well as fine art. An idea began to take shape in my mind. Of course people looked at the British landscape long before the seventeenth century. They drew it, pondered it and told tales about it, wove it into tapestries and lived with images of it on their walls. Could I tell a story about imaginative responses to our landscape that took both art and literature into account? Where would it begin?

I knew that to make sense of it I had to take the long view, to explore the panorama of landscape as it has been represented in art and literature. When I began to search for early accounts by those who lived among Britain's hills, woods and rivers, I soon found a story that can first be made out in what used to be called the Dark Ages – and that continues in an unbroken path (though one with many twists, turns and dramatic changes of scene) that leads right up to the present day. It became clear that men and women have written about the land, and drawn and painted it, for as long as they have had pen and paper (or parchment). For centuries artists and writers have climbed Britain's mountains, boated down its rivers, studied its skies and got down on their hands and knees for a closer look. Others have preferred to retreat indoors and look inwards, letting memories of the outside world filter through their minds. Most have tried to express the emotions the landscape arouses as well as the facts of its appearance.

Landscape is at the heart of British culture. We have a history of inventing and reinventing the ways in which we look at and think about it that stretches back more than a thousand years. Today, with storms, floods and droughts dramatically reshaping our world, discussions of what we should do with the landscape, and do *about* it, become ever more urgent and conflicted. As contemporary novelists, poets, artists and nature writers find ways of reimagining it to fit these uncertain times, now is also the moment to look back and understand its long and extraordinary cultural history.

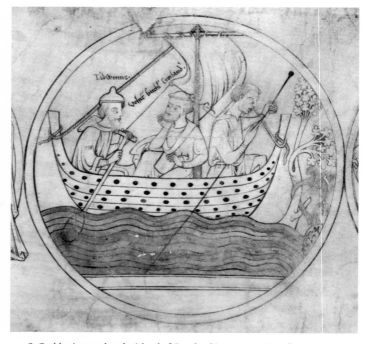

St Guthlac is rowed to the island of Crowland in a manuscript of *c.* 1175–1215.

I

MYSTERY

...in contrayez straunge
Fer floten [moving further] fro his frendes
Anon., *Sir Gawain and the Green* Knight

NOT LOOKING AT THE LANDSCAPE

Around the year 676, Cuthbert retreated from Lindisfarne Priory to the small rocky island of Inner Farne off the coast of Northumberland. In his biography of the saint, Bede tells us that the hermitage he built there was almost round, some seventy or eighty feet across, with an outside wall that was taller than a man. But on the inside Cuthbert made it higher still; sliver by painful sliver he burrowed down into the floor of his windowless cell, 'cutting away the living rock, so that the pious inhabitant could see nothing except the sky from his dwelling, thus restraining both the lust of the eyes and of the thoughts and lifting the whole bent of his mind to higher things.'[1] From the heaven-viewing funnel he had created, the wild, ever-changing drama of land and sea could no longer distract him from his prayers.

Cuthbert took unusually direct action to avoid looking at the land-scape, but it was common for holy men to choose to live in wild places – or to have that choice thrust upon them. In his *Gesta regum Anglorum* (History of the English kings), William of Malmesbury notes that in the early eighth century, Ine, King of Wessex from 688 to 726, ordered the Abbey at Glastonbury to be built 'in a sequestered marsh, intending that the more confined the monks' view on earth, the more eagerly they would hold to heavenly things.'[2] And in accordance with the Cistercian

tradition of living and worshipping in sequestered areas, Fountains Abbey in Yorkshire (est. 1132) was, in the words of a monk writing in the early thirteenth century, deliberately sited in 'a place uninhabited for all the centuries back, thick set with thorns, lying between the slopes of mountains and among rocks jutting out both sides'. It was, he added slightly plaintively, rather more suited to be 'the lair of wild beasts than the home of human beings'.[3] In a world in which every human settlement was hard-won against the wilderness, electing to live in a remote wasteland was – like Cuthbert's digging – a powerful statement of Christian faith.

Was the ordinary landscape so dangerously captivating? It was according to its earliest British chronicler, a writer called Gildas.[4] If you could travel back to the early sixth century, you would find – according to him – that Britain was a paradise. It had lovely hills and wide plains with fertile soil for growing crops. It had mountains on which livestock could happily graze, adorned with flowers of many colours. It had natural fountains whose flowing waters washed the pebbles as white as snow, abundant lakes and brilliant rivers whose gentle murmuring invited you to lie down on their banks and be lulled into a pleasant slumber.[5] Gildas placed this vision at the beginning of the book to which he gave the sensational title *De excidio et conquestu Britanniae* (On the Ruin and Conquest of Britain). Contemporary readers' reactions are unknown, but it seems unlikely that they would have recognized this idyll as their native land, a great deal of which, beyond the fields and pasture serving settlements, was rough, uncultivated country. Roman troops had left around a century before Gildas was writing. Homes and villages were vulnerable to attack, and wolves and wild boar were common. Under the circumstances, lying down on a riverbank and allowing yourself to be lulled to sleep by the water's sweet sounds would have been unwise.

Gildas, of course, knew this all too well. His outrageously fanciful picture of Britain had a purpose: to highlight the contrast between the rich potential of the land and the dismal failings of those in charge. 'Britain has kings, but they are tyrants', he declares; 'she has judges, but they are wicked.' Things were no better when it came to the clergy. Priests were fools, ministers were shameless, clerics were treacherous

and grasping.[6] But even so, Gildas's gilded vision of the British landscape cast a long shadow. When, in the early eighth century, Bede sat down in his monastery at Jarrow in Northumbria to write his *Historia ecclesiastica gentis Anglorum* (Ecclesiastical History of the English People), Gildas's *De excidio* was among the accounts upon which he drew. Like his predecessor, Bede begins with agriculture. 'The island', he says, 'is rich in crops and in trees, and has good pasturage for cattle and beasts of burden. It also produces vines in certain districts, and has plenty of both land- and waterfowl of various kinds. It is remarkable too for its rivers, which abound in fish...and for copious springs.' But unlike Gildas, who gestures grandly towards a wide, distant landscape, Bede quickly turns his description into an encyclopedic exercise, counting off the land's assets one by one. He writes of salmon and eels, seals and dolphins, whales and mussels; he describes 'pearls of every colour, red and purple, violet and green' and even draws our attention to whelks, 'from which a scarlet-coloured dye is made'. He writes of the metals found underground: copper, iron, lead and silver; and he describes the 'excellent jet, which is glossy black and burns when put into the fire, and, when kindled...drives away serpents'.[7] His is a scientific inventory of the landscape, in which each feature of, or sustained by, the land, the rivers and the sea is enumerated and held up for our admiration – look at this beautiful colour! See how this one shines! As on the page of an illuminated manuscript, each object is carefully delineated and limned with its proper colour.

These are entirely different vantage points. Gildas gives us the broad view, but is not a reliable narrator; he is a propagandist, inventing an impossible dream-image only to give himself away when he remarks that the flower-covered mountains he describes resemble 'a delightful picture'.[8] Bede, on the other hand, is absorbed by detail. He sees the landscape as a precious place, blessed and enriched by God with the abundant component parts he enumerates – an idea of England's special preciousness that would eventually find form in the medieval period with the idea that it was 'Mary's Dowry'.[9] Yet despite their different starting points, Gildas and Bede both shared a vision of landscape in which it soared above its muddy everyday lived realities of boundaries, ditches,

fords and footpaths. For them, as for many others in the future, it could be transfigured by states of mind and spirit.

THE MISTIGE MORAS

An early English warrior was facing an existential crisis. He had lost his lord and comrades, and alone, in exile, he was turning his sad predicament over and over in his mind. One day he began to describe his experiences in brief lines of poetry, his compound words kept under such tight control they seemed ready to burst with sheer force of emotion: 'earmcearig', 'wintercearig', 'drēorigne oft' – wretched and troubled, desolate as winter, often sorrowful.[10] Since the death of his lord, this Wanderer explains, he has travelled far from the 'foldan blæd' – the glories of the earth – and, drifting through the waterways, has been forced to stir the ice-cold sea with his hands.[11] But if those lost glories were natural ones in the shape of hills, rivers and valleys, he has nothing further to say about them. It is not his former surroundings but people – his dead lord and fellow warriors – that appear to the Wanderer's mind's eye with hallucinatory clarity. Occasionally his reverie is interrupted when a nearby seabird stretches its wings, or when he is caught in a storm, and 'hreosan hrím ond snaw, hagle gemenged' – rime and snow fall, mingled with hail – but these natural phenomena are quickly folded back into his thoughts, where they serve only to reflect his anguish.[12]

Looking for descriptions of landscape in Old English literature is like gazing through a window into dense fog. The distant view is obscured. Things near at hand are made vividly present, but evocations of the wider scene are vanishingly rare. We might expect the protagonists of the two great Old English poems about exile, *The Wanderer* and *The Seafarer*, occasionally to look up and scan the horizon, but they do not: they are bent too intently on the bleak inner landscapes of their souls. The only distances they survey are those that lead back into the past.

The Wanderer and *The Seafarer* reach us in an anthology of poetry, the Exeter Book, written down in the tenth century by a single scribe. These two solemn works of profound psychological insight share the

book's pages with, among other texts, ninety-six Old English riddles. And while the two long poems tell us much about early English ideals of endurance and hard-won wisdom, it is the riddles, with their earthiness, ingenuity and zest, that bring us closer to the concerns of everyday life. These texts weave their puzzles around onions, dough and mead, keys and bellows, creatures and natural phenomena ranging from a book-worm to an iceberg. What they do not give us, however, is much sense of the landscape. We come nearest to a view in the very first riddle, in which a storm speaks to us:

> Hlin bið on eorþan,
> wælcwealm wera, þonne ic wudu hrere,
> bearwas bledhwate, beamas fylle

> *There is a roar on earth,*
> *men meet violent deaths when I shake the woods,*
> *bring down branches from each flourishing grove*

Here we catch a fleeting glimpse of the windblown treetops, but we are going too fast for any more than the most impressionistic of views before the storm veers off on another tack. In another riddle of the outdoors, a plough describes itself: 'My nose is turned downward; I go deep and dig into the ground'. This mechanical beast of burden, made to 'tear' the earth with its 'teeth', is not permitted to lift its eyes to the horizon. With the riddles, we are either too high or too low; like *The Wanderer* and *The Seafarer*, they shift their attention from the particular to the conceptual without settling on the view in between.

But there is a moment in early English literature when the fog clears and a landscape comes into sharp focus. *Beowulf* is the longest extant Old English epic poem and a foundation-stone of English literature. Preserved through the chance survival of a single manuscript of the early eleventh century, the story itself was composed earlier, perhaps as far back as 700.[13] It relates the exploits of Beowulf, a Scandinavian prince still further back in time, and his heroic battles with the man-eating monster Grendel, Grendel's equally monstrous mother and, if that were

not enough, a dragon that fatally wounds him. It is a tale driven by contrasts: hero and ogre, brightness and murk, mead hall and wasteland. At the beginning of the poem we see Heorot, the magnificent 'hart's hall' where men gather together to eat and drink, to tell and to hear stories, built in the early sixth century by the legendary Danish king Hrothgar. The poem recounts a day of loud rejoicing in the hall, at which a minstrel sings to the accompaniment of a harp. His song tells how God created the earth, how he hung up the sun and the moon to give light and decorated the world with branches and leaves. Lit by the great celestial lanterns of 'sunnan ond monan', the poet's vision of a hospitable landscape is reminiscent of the abundantly fecund rural scenes the Romantic artist Samuel Palmer was to imagine some thousand years later, in which man and nature exist in perfect concord.[14] But even as those in Heorot listen to this music about the beauties of the land, the monster Grendel is lurking outside, infuriated by the laughter and harmonious singing.

The lair of Grendel and his mother is the first fully realized landscape in English poetry:

Hie dygel lond
warigeað, wulfhleoþu, windige næssas,
frecne fengelad, ðær fyrgenstream
under næssa genipu niþer gewiteð,
flod under foldan. Nis þæt feor heonon
milgemearces, þæt se mere standeð;
ofer þæm hongiað hrinde bearwas,
wudu wyrtum fæst wæter oferhelmað.

They inhabit a hidden land of wolf-haunted slopes, windy headlands, dangerous swamps, where the mountain stream passes down under misty headlands, water under the earth. It is not far from here in miles that the mere stands; over it hang frosty groves; trees held fast by their roots overshadow the water.[15]

A fearsome, inhospitable site evidently seemed a natural habitat for a creature such as Grendel; it would be many centuries before anyone

thought of contemplating high, lonely places with admiring awe. Now the tables have turned, and these places have to be protected from us – but the earliest listeners to *Beowulf* would have been uncomfortably aware of the precariousness of human settlement and of the wide wilderness beyond.

This secret, mysterious place is not only dangerous, a place where one might be attacked by wild animals while negotiating the rocks and swamps; it is also uncanny. Water behaves strangely – a mountain stream runs into a subterranean lake where each night one can see the strange phenomenon of 'fyr on flode', in which the surface of the dark pool appears to burn as marsh gas rises to the surface and ignites in the air.[16] In this landscape, haunted by more than wolves, nature is distorted and inverted. Other animals will not go near it:

> Ðeah þe hædstapa hundum geswenced,
> heorot hornum trum holtwudu sece,
> feorran geflymed, ær he feorh seleð,
> aldor on ofre, ær he in wille,
> hafelan hydan.

> *Although the strong-horned stag, hard-pressed by hounds, seeks the forest when he is put to flight, he would sooner give up his life on the riverbank than hide his head there.*

'Nis þæt heoru stow!' exclaims the poet finally, in a laconic understatement: it is not a pleasant place.[17]

Grendel's watery home is fitting: he is a creature of the damp. When we are first introduced to him we are told that 'se þe moras heold, / fen ond fæsten' – he holds the marshes, his fastness is the fens – and later that he rules the 'mistige moras', the misty marshes.[18] Even when Grendel leaves his lair and approaches Heorot, he comes swathed and cloaked in his own element, striding down 'under misthleoþum', misty slopes.[19] 'Mor' was one of a number of Old English words denoting a kind of marsh – at around the time the *Beowulf* manuscript was written, marshland was a far more significant feature of the landscape than it is now, and large tracts of the British Isles were covered by fen and wetland. To the

inhabitants of such areas in present-day Lincolnshire, Cambridgeshire, or the Somerset Levels, these marshes offered an ambiguous space: not exactly wasteland, because their resources were often exploited. Drier areas on the edges of the Fens, for example, were farmed, and in the eighth and ninth centuries earthworks were built to keep the sea from flooding marshland.[20] Marshes provided places for fishing, catching eels and growing water-loving osiers, which when coppiced produced shoots used for wattle panels and baskets. Despite localized efforts by the area's monasteries, it was not until the seventeenth century that the Fens were systematically drained, and for all their usefulness it is easy to imagine how treacherous and uncanny these ancient in-between places – neither land nor water – must have seemed in previous centuries. Fenland was eerie. Sight was obscured by tall reeds, and sound deadened by water and restricted to the repetitive brushing of stems and the calls of birds. It was a place where both distance and the passage of time were hard to judge – a place where the supernatural could all too easily be imagined.

Grendel was not the only malevolent, supernatural creature to haunt fenny areas. Around the year 700, the Lincolnshire Saint Guthlac of Crowland elected to leave his former life as a warrior for one devoted to religion. Having received the tonsure at Repton Abbey in Derbyshire, he was rowed to Crowland, an island in the Fens, where he wished to begin his contemplative, solitary existence – a drawing of the late twelfth or early thirteenth century shows him lost in thought, manuscript in hand, as he reaches the island on which grows a leafy tree (see p. 12). It was there, amidst marshes, bogs and 'black waters overhung by fog', that he was accosted by – and eventually vanquished – a group of demons 'ferocious in appearance' and 'terrible in shape'.[21]

An early biography of Saint Guthlac by an East Anglian monk, Felix, explains that he chose Crowland because it was the site of a barrow: 'a mound built of clods of earth'.[22] These pre-historic burial sites were regarded as uncanny and were associated with the supernatural, which is precisely why Guthlac elected to go there; he was looking for a grim, haunted place.[23] No wonder he found demons. A similarly dark landscape is at the heart of *The Wife's Lament*, an Old English poem that shares the Exeter Book with *The Wanderer*, *The Seafarer* and two versions of

the life of Guthlac, written in the voice of a woman estranged from her husband, who is in exile overseas. Forced to live alone in a wood, she describes her plight:

Heht mec mon wunian on wuda bearwe,
under actreo in pam eorðscræfe.
Eald is pes eorðsele, eal ic eom oflongad;
sindon dena dimme, duna uphea,
bitre burgtunas brerum beweaxne,
wic wynna leas.[24]

I was commanded to dwell in a grove,
Under an oak-tree, in this earth-cave.
This barrow is ancient, I am seized with longing;
The valleys are gloomy, with high hills above,
There is a grim hedge overgrown with briars,
It is a joyless place.

It is as though the woman is being repeatedly swallowed by the earth; she is in a cave in the shadow of a spreading tree, which itself is in a place darkened by surrounding hills, hedges and briars. Like the Wanderer's icy seas, this is as much a landscape of the mind as a physical one: images of enclosure and confinement, each one heaped on top of the one before, reflect the woman's bewilderment and grief. The only effect of the hills – which might otherwise offer a wider view and some perspective on her position – is to cast her dwelling place into deeper shadow. It begins to feel more like an overgrown grave than a place we can imagine any living person inhabiting. Her movements appear restricted, and she is driven by a terrible, unassuageable longing: two qualities that are traditionally ascribed to ghosts.[25] Could she be an unquiet spirit? However we interpret this enigmatic poem, it gives us a rare insight into the profound symbolism Old English literature confers on landscape – and sets the scene for centuries of strange phenomena to come.

CHAPTER I

MARVELS AND WONDERS

During a tour of Wales in 1188, Baldwin, Archbishop of Canterbury, sat down to rest on the trunk of an uprooted oak tree at the end of a particularly arduous trek along the steep sides of a valley near Bangor. For some five weeks he and his entourage had been working their way from church to church in South Wales, and now, in the north, they were beginning the final leg of their journey. It had not been an easy one. Thinking to make conversation during the pause, one of the company remarked that nightingales were never seen in that area. 'If it never comes to Wales the nightingale is a very sensible bird', replied the Archbishop ruefully. 'We are not quite so wise, for not only have we come here but we have traversed the whole country.'[26] The serious purpose for all this toiling up and down steep, stony paths, and giving a great many sermons in-between times, was to drum up support for a Third Crusade; it was said that three thousand men of military age were 'signed with the Cross' – in other words, recruited to join the expedition.

The Archbishop took the writer and cleric Gerald of Wales, or Giraldus Cambrensis, as his principal companion. A former courtier to Henry II, Gerald was a mercurial companion for the rather ponderous Archbishop: sensitive, clever, sharp-eyed. A visit to Ireland he had made in the mid-1180s, in the company of Henry's son John, had resulted in his first work of ethnography, the *Topographia Hibernica* (1186–87). His capacity for observation was extraordinary at a time when, to settle a subject as apparently simple as what the landscape looked like, most writers preferred to open another book than look out of the window. Reverberations from Gildas's sixth-century account of the British landscape continued to rumble around the echo chamber of medieval writing, detectable not only in Bede's *Historia* but in accounts written centuries later. It took someone of unusual independence of mind to put these authorities aside and write with a refreshing directness about the raw material of landscape. Perhaps Gerald's mixed parentage – part-Welsh, part-Norman – caused him to look more keenly than his contemporaries at the wilder aspects of his natural surroundings as he sought to explore his heritage. He certainly had literary ambitions, and not only saw but made detailed

notes about the scenes that unfolded daily before his eyes. He later wrote these notes up as the *Itinerarium Cambriae*, or Journey through Wales (*c.* 1191), and mined them for the further reflections enshrined in the more sober *Descriptio Cambriae*, Description of Wales (*c.* 1194).

Gerald was a raconteur with an eye for detail and an instinct for what would make a curious anecdote. Reading his *Journey*, one can imagine sitting down with him in the evening, listening as he regales the company with accounts of the day's travels. He gives us not only details of the terrain and the road, but more sweeping views too. 'From Llanddew', he tells us, 'we made our way along the rugged pass of Coed Grwyne or Grwyne Wood, by a narrow track way overgrown with trees. On our left we passed by the noble monastery of Llanthony in its great circle of mountains.'[27] His first-hand accounts give us compelling glimpses of the scenes that opened out for him as he rode past. These are not simple reportage, however, but threads in a complex tapestry made up of history, anecdote, observations about the behaviour of birds and animals – and local myth. Accounts of spectacular scenery are frequently embellished by stories of the curious and the uncanny: 'I must not fail to tell you about the mountains which are called Eryri by the Welsh and by the English Snowdon, that is the Snow Mountains', he begins one chapter. 'They rise gradually from the land of the sons of Cynan and extend northwards near Degannwy. When looked at from Anglesey, they seem to rear their lofty summits right up to the clouds.' There are two lakes at the top of the mountains, he tells us, 'each of them remarkable in its own way':

One has a floating island, which moves about and is often driven to the opposite side by the force of the winds. Shepherds are amazed to see the flocks which are feeding there carried off to distant parts of the lake. It is possible that a section of the bank was broken off in times long past and that, bound together in a natural way by the roots of the willows and other shrubs which grow there, it has since become larger by alluvial deposits. It is continually driven from one bank to another by the violent winds, which in so elevated a position never cease to blow, and it can never anchor itself firmly to the shore again.[28]

The other lake, he tells us, abounds in one-eyed eels, trout and perch, the left eye missing in each fish – a snippet laid out for us to wonder at: 'If the careful reader asks me the cause of such a remarkable phenomenon, I can only answer that I do not know', he admits.[29] In his description of Anglesey – disparaged as 'an arid stony land, rough and unattractive' – he singles out as 'worthy of [our] attention [...] a stone almost in the shape of a human thighbone which has this extraordinary property, so often proved true by the local inhabitants, that, however far away it is carried, it returns of its own accord the following night'. There is also a 'stony hill, not very big and not very high', where if you stand on one side and shout, no one on the other side can hear you. 'It is called ironically the Listener's Rock', he adds.[30] For Gerald, the views he had seen with his own eyes and the fantastic stories he had been told were all phenomena worth recording, of equal interest and value.

It was hardly surprising that the landscape should behave in strange ways; it was, after all, known to be alive with powerful supernatural forces. Caverns and fissures in rocks might be gateways to another world; woods and groves could harbour spiritual forces; springs and old or unusually large trees were often sacred.[31] Before the coming of Christianity, people openly celebrated these places. 'I shall not name the mountains and hills and rivers,' hints Gildas darkly, 'once so pernicious, now useful for human needs, on which, in those days, a blind people heaped divine honours.'[32] But things did not change as much as he might have wished to believe; in 1018, King Cnut felt it necessary to enact laws against the worship of the sun and moon, of springs, stones and forest trees.[33] Centuries later, many pre-Christian beliefs may have been quashed or absorbed into Christian ritual, but convictions that the land was animated by supernatural powers had deep roots. In 1480, William Caxton, the man who introduced printing to England, published his *Description of Britain*, a bestselling work based on a small part of an ambitious world history called the *Polychronicon* (literally, 'many stories') written in the early fourteenth century by the monk Ranulf Higden. The *Description* aimed to cover every aspect of Britain, combining history, geography and social history, and Caxton

evidently did not think it strange to include chapters on the 'marvels and wonders' native to England, Wales and Ireland. These passages reveal a particular fascination with what lies underground. He writes of a site in the Derbyshire Peak District 'where such a strong wind blows out of the fissures of the earth that it flings back pieces of cloth which people throw into it', and of a similar phenomenon near Winchester. In the 'great underground cavern' at Cheddar, he remarks, people have often walked and 'seen rivers and streams, but they cannot find an end to them anywhere'.[34]

The land may have a tendency to behave capriciously, but to the medieval mind, it was all part of God's creation and, when in the presence of Christian saints, it often responded with expressions of devotion. When St Edmund landed on the coast of East Anglia before he was captured and martyred, he knelt to pray. A painting illustrating an account of his life by the poet John Lydgate shows this scene: the saint kneels with his hands together in prayer, while his companions look amazed and point at the miracle taking place. Five springs burst energetically from the ground in front of them, spinning like whirlpools at their source and snaking down the hillside. The sky, too, has split open, and in the centre of its heavenly buttonhole God appears with a blessing for Edmund. It was not unusual

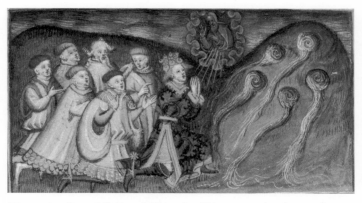

Water springs from a hillside as St Edmund and his entourage kneel to pray, from an illustration to John Lydgate's *Lives of Saints Edmund and Fremund*, c. 1434–39.

for saints to leave a permanent mark on the landscape: wells suddenly appeared where the decapitated heads of virgins fell; footprints in the rock marked the moment when a saint trod there; when stuck in the ground, the staffs of the holy, whether that of Joseph of Arimathea at Glastonbury or the seventh-century St Etheldreda on her journey to Ely, took root and flowered.

These responses are earthily sexual: aroused by some act of piety or violence, or by mere proximity to saints, the holy or the pure, the land suddenly gushes with liquid, opens up to reveal its wet interior, becomes soft to accommodate part of a saint's body or stimulates dead wood to burst into fecund life. This symbolism is pungently expressive of fertility and new growth, qualities more readily associated with pagan deities than ascetic Christian saints. Saints give the impression of being only partly human, with one foot in this world and the other in heaven; it is as though, to make a connection with them and express spiritual love, the landscape meets them halfway by developing some remarkably animalistic qualities of its own.

If place names are to be believed, the Devil has had an even more active role than saints in shaping the land's contours. The Devil's Shovelful in Shobdon, Herefordshire, is an ancient barrow formed, it was said, when he dropped a spadeful of earth with which he had originally intended to bury the village church, having been tricked into abandoning his plan. The Devil's Chair is a huge rock crowning a tor on Stiperstones Ridge in Shropshire – the rocks scattered around it are said to have fallen from his leather apron when the strings broke. A hill in Warwickshire called the Devil's Nutting Bag was formed when the Devil – who, it is said, goes out to gather nuts on Sundays – was walking along a road when he encountered the Virgin Mary and dropped his sack in fright. A deep cavern in the Peak District has long been known as the Devil's Arse (or, more graphically, the Devil's Arsehole) because of sounds like monstrous farts that emanate from its flooded interior.[35] And Devil's Dyke in Sussex, just inland from Brighton, is a great v-shaped cleft in the South Downs that, according to legend, was dug out by Satan. He was so incensed at the number of churches that were being built in Sussex villages that one night he attempted to dig a channel through the Downs so that the sea

would flood in and drown them, but was prevented from completing his task when he was tricked by an old woman, who spotted what he was up to and held up a candle behind a sieve to diffuse the light, making him believe the dawn was breaking. In one version of the story the Devil, realizing he had been thwarted, flew off in a rage and landed heavily in Surrey, thus forming the steep-sided, horseshoe-shaped valley known as the Devil's Punch Bowl.[36]

It was possible, though, that the Devil's Punch Bowl was a misnomer. Could a giant have been responsible instead? It seemed entirely plausible. In around 1138 the historian Geoffrey of Monmouth completed his book *Historia regum Britanniae* (History of the Kings of Britain), which was to become enormously popular; copies of it were soon to be found in libraries up and down the land. Its authority was only increased by Geoffrey's claim that it was translated from 'a very old book in the British tongue'.[37] In it he declares that giants were Britain's original inhabitants, telling of how Brutus of Troy – the first king of Britain, according to legend – arrived on British shores and banished these natives to far-flung places. One day Brutus's follower Corineus, who enjoyed fighting with these enormous opponents, took part in a wrestling match with the ferocious Goemagot in Cornwall. Corineus got the upper hand, put the giant over his shoulder and managed to fling him over the cliff, where he died on the rocks below. So appealing was the legend that even the great Elizabethan antiquary William Camden, who in the preface to his *Britannia* sternly notes that in the course of his research he has paid no regard to fable, relents in his description of Devon so far as to 'take the liberty just to mention the fabulous combat', and quotes from a twelfth-century poem on the subject:

> These savage monsters, train'd to war and blood,
> Dash'd Corinaeus to the stygian flood,
> Aloft in air tall Gogmagog he bore,
> And flung the Giant from his rocky shore,
> While Ocean feasted on his wasted gore.
> His corpse twelve cubits length the waves o'erspread,
> And his soul flitted to the infernal dead.[38]

It was certainly an old legend; the place, traditionally associated with Plymouth Hoe, was called Goemagot's Leap in the twelfth century, at the time Geoffrey was writing his account. Goemagot himself made no direct mark on the landscape in the course of this epic struggle, although he was commemorated by the people of Plymouth, who cut his portrait into the turf on the slopes of the Hoe, exposing the white limestone beneath. Fifteenth- and sixteenth-century account books from the town record occasional payments for scouring 'the Gogmagog', although sadly the figure was destroyed in the 1660s when Charles II built the Royal Citadel.[39]

According to local folklore, an alternative explanation for the peculiar topography of the Devil's Punch Bowl in Surrey is that once, when two giants met for an earth-throwing fight, one kept scooping great handfuls from the ground at his feet. The Wrekin in Shropshire – a hill that was, naturally, built by a pair of giants – has a deep cleft known as the Needle's Eye, which was created when one lost his temper and swung at the other with his spade, missed and hit the hillside instead. Giants were not only behind the construction of Stonehenge – an alternative to the more literary tradition that cited Merlin's conjuring tricks – but were frequently suspected of littering the landscape with boulders and other standing stones. At Melcombe Horsey in Dorset are two large boulders, still standing on the spots where they were thrown in a contest by two rival giants, while the stones of Zennor Quoit in Cornwall – actually the collapsed components of a Neolithic or Bronze Age burial chamber – were at one time explained as pieces used by giants in their favourite throwing game, left lying untidily where they had fallen.

The interlocking basalt columns of the Giant's Causeway in County Antrim on the north coast of Northern Ireland, are, it is said, the result of the most spectacular giant intervention of them all. The story begins with the Scottish giant Benandonner challenging the Irish Fionn mac Cumhaill (Finn MacCool) to a fight. Fionn accepted, and built a causeway across the North Channel to link Ireland to Scotland so they could meet – but when he saw the impressive figure cut by Benandonner, he hid in fear. His wife Oonagh devised a cunning strategy, disguising her husband as a baby and squeezing him into a gigantic cradle. The tables were turned when Benandonner saw this fearsome infant. Speculating

wildly about the father's size, he fled back to Scotland, destroying the causeway behind him. If anyone suspected this story of being a fanciful invention, they only had to be directed to the existence of a further group of identical basalt columns – actually the result of the same ancient lava flow – that appear on the other side of the Channel, in Fingal's Cave on the Hebridean isle of Staffa.

Stories about the legendary warrior King Arthur are woven into the landscape. He left his mark in almost as many places as the devil: there are Arthur's Stones in Herefordshire and Glamorgan, Arthur's Seats in Edinburgh and the Brecon Beacons, Moel Arthur (Arthur's Hill) in Flintshire, King Arthur's Hall on Bodmin Moor and Arthur's Oven on Dartmoor. His knights are sleeping in caves near Snowdon and Caerleon, and his treasure is hidden near Marchlyn Mawr in Snowdonia.[40] The ninth-century *Historia Brittonum*, attributed to the scholar Nennius, includes a section on the *mirabilia*, or wonders, of Britain, among which are a rock at the top of a mountain near Builth, Brecknockshire, that was impressed with a pawprint of Arthur's dog, Cabal, as they passed in pursuit of a wild boar; Arthur later constructed a cairn on the spot and called it Carn Cabal. But Arthur's relationship with Britain has another dimension beyond this extraordinarily widespread impact on the named, visible features of the countryside. Gerald of Wales records the discovery in the 1180s of a hollowed-out oak tree trunk, buried five metres deep, at Glastonbury Abbey – inside were two skeletons, and above was a leaden cross with an inscription identifying King Arthur.[41] The story has long been thought to have been concocted by the Abbey as a fundraising publicity stunt; but the legend persisted that as *Rex quondam Rex que futurus* – the once and future king, words that according to Thomas Malory's *Le Morte d'Arthur* (*c.* 1469) were written upon this tomb – he is sleeping under the earth and will one day return.[42] It implies an altogether more pervasive and long-term enchantment. He has not merely shaped the land – he *is* the land.

Sometimes a moral dimension was added to the stories and legends that shaped the medieval landscape: certain features could broadcast a dire warning about the consequences of immoral behaviour. Standing stones, for instance, were often thought to be the petrified figures of the wicked. One such group, the stone circles known as the Hurlers at

Linkinhorne on Bodmin Moor, were said to be the stark remains of men who unwisely risked playing a ball game on a Sunday afternoon. Other features were explained by a combination of history and myth: there are, for instance, numerous Iron Age hill forts that have been given the name 'Caesar's Camp'. In the absence of much real understanding of British history and the significance of material remains, it was a logical connection to make. Whatever the particular mix of ingredients in any given area, for the local population and travellers alike it would have been hard not to be reminded that the land had been shaped by forces both supernatural and historical – and that it continued to simmer away with this volatile power.

WYLDE WAYES IN THE WORLDE

Three youths in Chaucer's *Pardoner's Tale* stagger out of a tavern, drunkenly determined to find and kill 'a privee theef men clepeth Deeth' who, they hear, has killed one of their friends as well as countless others. They meet an Old Man who tells them that the tree where they will meet Death stands in a grove up a 'croked wey', and points to the place – 'Se ye that ook?', he asks, 'Right there ye shal hym fynde.' Chaucer's images flash vividly through our imagination like stills from an old black and white horror film. His oak is not an individual tree but a symbol; it puts us in mind of folly, disaster and sacrifice, the Tree of Knowledge as well as Christ's cross. It is hard to imagine the twisted path he describes in anything other than deep twilight, the oak to which it leads looming as a forbidding silhouette. The stage-set quality of Chaucer's bleak scene does not detract from its power; this is landscape as experienced in a nightmare, landscape as trap.

But literature was changing. Two long poems, both composed towards the end of the fourteenth century and inscribed in a single, plain-looking manuscript book, offered a fresh way of looking at the world. Towards the end of one of these, *Sir Gawain and the Green Knight*, the narrator describes a hunt on New Year's Eve. He thinks about the early morning sun lighting up the frosty land, and then he thinks about the sky, and he exclaims:

Ferly fayre was the folde, for the forst clenged,
In rede rudede upon rak rises the sunne,
And ful clere casts the clowdes of the welkyn.[43]

The earth was very beautiful, for the frost clung to the ground,
The sun rose fiery red on a rack of clouds,
And with its radiance drove the clouds from the heavens.

Up to this point, the few landscapes to be found in poetry have been adapted from a literary pattern-book of symbolic sites, or are more psychologically charged stage set than natural place. But the Gawain poet's description has a different quality: the feel of lived experience. We recognize the uplifting sensation – the strange beauty of early morning light that still causes us to exclaim aloud to each other. We are entering a world of observation.

Which is not to say that the landscapes described in *Gawain* are not also symbolic, and that psychology and narrative are not written into every bright green leaf and old gnarled tree. The story begins indoors, at Camelot: King Arthur and his court are celebrating the New Year when their festivities are interrupted by a vast figure, 'overal enker grene [dark green]', who rides boldly into the hall carrying a holly bough and an axe and challenges one of the knights to strike him – the bargain being that he will return the stroke in a year and a day.[44] The King's young nephew Sir Gawain duly decapitates the Green Knight, who picks up his head and charges Gawain to keep his appointment at the Green Chapel. It is as though the landscape itself has come indoors: with his holly bough, the Green Knight is a close cousin of the green man whose face stares out from countless medieval ceiling bosses, corbels and misericords. He is, among other things, a personification of nature and a reminder of its capacity for regeneration, of the powerful life force that seethes with energy, even in the depths of winter.

Gawain is a poem embedded in the landscape, and it moves with the seasons. The year that must pass before Gawain sets out for the Green Chapel is described in terms of the changes that come to fields, woods and hedges. Spring, when 'Schyre schedes [brightly falls] the rayn in

schowres ful warme, / Falles upon fayre flat [meadow]', gives way to 'the sesoun of somer' and eventually autumn, when leaves fall 'And al grayes the gres that grene was ere'.[45] Winter is coming, and it is time for Gawain to set out on his journey.

The poet is, at first, surprisingly specific about the locations through which Gawain passes, pinning his route to a number of named places in the north-west. It takes him into North Wales, where he sees 'Alle the iles of Anglesay' on his left, before he crosses a ford and enters the Wirral peninsula – the 'wyldrenesse of Wyrale'.[46] But at that, familiar landscapes disappear and Gawain enters the unknown: he clambers over cliffs in 'contrayeȝ straunge / Fer floten fro his frendes'.[47] His search for the Green Chapel takes him through a 'wylde' forest:

Hiȝe hilles on uche a halve, and holtwodes under
Of hore okes ful hoge a hundreth togeder.
Þe hasel and þe haȝþorne were harled al samen,
With roȝe raged mosse rayled aywhere[48]

High hills on each side, and woods below
Of huge ancient oaks, a hundred together.
The hazel and the hawthorne were all tangled up,
Everywhere arrayed with rough shaggy moss

It is a landscape every bit as overshadowed and tangled as the setting of *The Wife's Lament*, and as marshy as Grendel's lair – Gawain and his horse Gryngolet ride 'Thurgh mony misy and myre', through many a bog and mire, with a new set of obstacles in the form of 'rokkes' and 'hard ysse-ikkles' thrown in for good measure.[49] But unlike Grendel and the lamenting wife, Gawain is not defined by his setting but pitted against it. As a knight on a quest, he must confront and overcome the bogs and the tangles, not to mention the creatures of the wood, both natural and supernatural, that he encounters on his way – dragons, wolves and the part-human, part-forest wodwos, 'bulles and beres and bores'.[50] It is a fantastic landscape of varied terrain – but for Gawain, the wood is one of a series of tests he must undergo before reaching his destination.

As Gawain nears the Green Chapel, the landscape he moves through is of a different kind. If the wood was tangled and marshy, seeming to repel man's presence, this landscape seems instead to be half human. The weather has turned damp and oppressive – 'Mist muged [drizzled] on the mor,' we are told, 'malt [melted] on the mountes' – and in response the hills have put on their hats and cloaks: 'Uch hille hade a hatte, a myst hakel [mist-mantle] huge.'[51] These giant-like hills, huddled under their winter clothes, set the scene for Gawain's imminent meeting with the Green Knight, who is himself a combination of the natural world and the world of men.

Gawain reaches a grassy mound or barrow, but he is not sure at first that he has come to the right place, and walks around it debating with himself:

Hit hade a hole on the ende and on ayther syde,
And overgrowen with gresse in glodes [*patches*] aywhere;
And al was holw [*hollow*] inwith, nobot an olde cave,
Or a crevisse of an olde cragge...[52]

'We! Lorde', Gawain exclaims – this must be it. It looks so sinister that 'Here myght aboute mydnyght / The dele [devil] his matynnes telle!'[53] An illustration added to the manuscript some time after it was written depicts this episode: the landscape takes up all the space on the page, leaving no room for the sky; it seems to be on the point of swallowing Gawain and Gryngolet whole (Plate 2).

Did the poet have a particular place in mind with this 'olde cave'? Various natural features of the landscape around Staffordshire have been suggested as the inspiration for the Green Chapel: one contender is Lud's Church, a deep, narrow chasm in a wood known as Back Forest near Gradbach; another is Thor's Cave, a cavern in the Manifold Valley of the White Peak. Whether he did or not, it is apt that, as their names reveal, places like these have gathered associations with powerful figures. Gawain's quest ends at a place where the natural and the supernatural are fused: a fitting habitat for the Green Knight.

On his journey in search of the Green Chapel, Gawain only sleeps out-doors when he has no other choice: he 'sleped in his yrnes [armour] / Mo nyghtes then innoghe in naked rokkes'.[54] If dreams disturb his sleep, they are evidently not deemed worthy of relating. But we have already seen that the country was sometimes a place of contemplation, somewhere one might lie down and, lulled by the sounds of nature, fall asleep. This idea is there in Gildas, and it occurs again in Geoffrey of Monmouth's *History of the Kings of Britain*, when he expounds lyrically on the subject of Britain's 'green meadows pleasantly situated beneath lofty mountains, where clear streams flow in silver rivulets and softly murmur, offering the assurance of gentle sleep to those who lie by their banks'.[55] Medieval literature is full of sleepers who enter other worlds through their dreams, and these narratives often begin out in the landscape. At the opening of William Langland's *Piers Plowman*, another poem of the late fourteenth century, the narrator Will explains that one morning in spring he was out walking when he lay down and fell asleep:

Ac on a May morwenynge on Malverne Hilles
Me bifel a ferly, of fairye me thogte.
 [*A wonder befel me, an enchantment I thought*]
I was wery [of] wandred and wente me to reste
Under a brood bank by a bournes [*stream*] syde;
And as I lay and lenede and loked on the watres,
I slombred into a slepyng, it sweyed [*flowed*] so murye.[56]

Will is swept into an epic dream-vision, part social satire, part theological allegory – more than he bargained for, one assumes, when he lay down to rest on the riverbank. Another dream vision is described in the theo-logical debate we now know as *Pearl*, a poem in the same manuscript book as *Gawain* and possibly written by the same poet. But if *Gawain* is an unspooling tapestry, *Pearl* is an exquisite embroidery. As in *Gawain*, the landscapes described in *Pearl* are central to the story – but they could hardly be more different. The poem begins in a pleasant 'erber grene', an arbour or garden, where the grieving narrator's young daughter, his 'precious perle wythouten spot', is buried.[57] He lies down on the turf

among the gillyflowers and falls asleep (Plate 1). Dreaming, it seems to him that he has been transported from the garden to a dazzling land, which he describes in wonder: over there are splendid rocks, gleaming with unbelievable radiance; here are cliffs of crystal, while set around them are trees with trunks as blue as indigo and leaves of burnished silver quivering on each branch. 'Wyth schymeryng schene ful schrylle thay schynde', he declares, using words that themselves flash with light – 'they shone dazzlingly with a shimmering brightness'. The very gravel underfoot was made from 'precious perles of oryente'; the riverbanks were like fine gold thread and emeralds and sapphires shone from the riverbed like stars on a winter's night.[58]

If this landscape sounds more like a work of art than nature – well, it surpassed even that: 'For wern never webbes [fabrics] that wyyes [men] weven', the narrator exclaims, 'Of half so dere adubbement [glorious adornment]'.[59] Unlike the earthly garden where he fell asleep, in this dazzling supernatural landscape even the least significant features are constructed from precious metals and stones: everything is permanent and nothing can decay. Paternal and divine love re-fashion the landscape in *Pearl*, transfiguring it into precious materials until it becomes a suitably rich setting for the dreamer's beloved lost daughter. She, too, has sloughed off her human form and become his radiant pearl – perfect, if, as her tart debating style later reveals, a little unyielding. This landscape is a jeweller's fantasy – or a highly cultivated Land of Cockaigne, the fabled place of luxury and ease so seductive to the medieval imagination.

A Welsh poet of the fourteenth century, Dafydd ap Gwilym, also looked at the landscape through the prism of love, but in his case it was of a more earthy kind. More often than not, nature provided him with a setting for his amorous encounters – usually illicit – with women of flesh and blood. 'There is no hill and no deep dale / On either side of Nant-y-glo, / That I don't know...', wrote Dafydd in 'Taith i Garu', or 'Journeys for Love', a poem that offers us a lover's topography: in this personal map, streams, slopes and valleys are all overlaid with memories of past trysts and hopes of new meetings. He has even made a physical impression on the land itself: he passes a place where he and his adored Morfudd had lain down to make love, noting 'The shape [there] of our

arbour beneath the pleasant boughs, / A place of broken leaves...'. [60]

Dafydd's voice – funny, rueful, charismatic – rings out clearly through the elaborate metre and intricate word-weavings of his medieval Welsh verse. Reading him half convinces us that if we were walking the paths of northern Cardiganshire we might just catch sight of the shade of this tall man with his blond hair tied with silver clasps, striding purposefully through a meadow or by the side of a wood. And if Dafydd seems part of the landscape, someone at home in woods and meadows, that is because he conducts an active conversation with nature. He elicits the help of birds and even the weather, asking a woodcock to spy on his lover in one poem and the wind to carry a message to her in another. [61] His imagination makes him a powerful spirit of place.

Dafydd was writing for a sophisticated audience. He performed his poetry, perhaps accompanying himself on a harp, in gentry households around Wales, and his tales of amorous escapades and thwarted attempts to meet his lovers were tailored to entertain. In these stories the local landscape emerges as an unpredictable, mischievous character, an active participant in his trysts for good or ill – as ready to wrong-foot him as to provide a soft, leafy bed.

When nature is in an accommodating mood, it shapes itself into an inviting nest for lovers. Dafydd's poem 'Y Deildy' (The House of Leaves) describes a pleasant bower in a wood of hazels and birches, furnished by his imagination with domestic comforts that his lover might appreciate. If his 'darling, / Comes to this leaf-house of God's making' she will be rewarded by trees that are 'Proper furnishings of this wild citadel' and by its fresh colours – this leafy house is 'unspoilt by soot'. 'It won't be worse to lie beneath the roof', argues Dafydd – because how can God's construction be inferior to a man's? And in any case, 'A room is better if it grows!'[62]

In another temper, nature finds unpleasant ways of confounding him. The poet is rapturously making his way to a tryst promised him the previous day, anticipating a 'session in sweet branches with a maid / Beneath the greenwood', when the landscape suddenly vanishes:

When there came, in truth, on that long moor
A mist most like the night;

Big parchment-roll that was a lid for rain
[Came in] grey sheets to stop me;

The colours of the landscape are masked by a 'grey cowl' that clothes the valleys and covers the meadows with its hood. 'It's easier', he grumbles, 'to walk abroad at night-time / On moorland than in mist in daytime'. Made 'a dark captive' in his house, he is sadly thwarted.[63] On another occasion he is on his way to a clandestine meeting with a woman when, to disguise his course, he leaves the main path and 'made tracks elsewhere'. He is walking 'amongst [the] little oaks' and along a 'fair bypath between a church and hill', searching for 'the shadow of the thick, dark wood' when a briar ('That accursed gut of hedgerow') wraps itself around his legs, entangling both his feet and throwing him painfully to the ground.[64]

For most people, though, the leisure to enjoy the countryside like Dafydd ap Gwilym, let alone to embark on an adventure through 'contraye3 straunge' like Sir Gawain, was a remote possibility, about as likely as a tree sprouting silver leaves. The country was not landscape, it was land: land to be sown with crops, land used to graze sheep, goats and cows, land divided into plots marked out by boundaries separating one's strip from one's neighbour's. The human relationship to this land was shaped by the unchanging agricultural rhythms of ploughing, lambing, seed-sowing and harvest. People were concerned, above all, about particular patches of earth and how they were exploited; what lay beyond was largely irrelevant.

An English calendar of the eleventh century illustrates the month of May with shepherds tending their sheep; one man, with a curly beard and short tunic, sits down on a hummock to watch his sturdy flock graze on tussocky ground, while two others wearing long robes are engaged in such an earnest discussion that they seem to have forgotten the sheep – although it is also possible that these two represent the clergy, and are there to remind us that shepherding had a spiritual dimension.[65] In July six men gather to mow, using scythes and a pitchfork. While they are each given distinct characteristics – two have tucked their tunics up into their belts so they do not get in the way, while a bald man pauses to scratch his head – the crop is represented by two looping contours indicating a

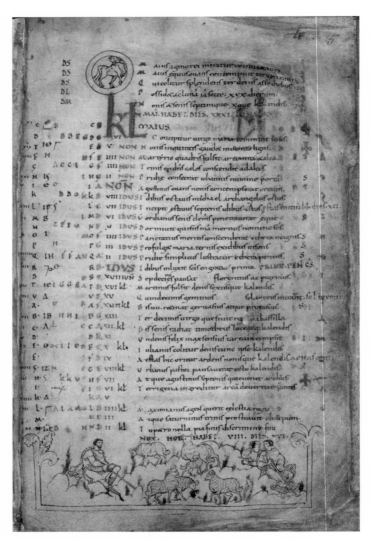

Shepherds watch their flocks in an 11th-century calendar.

background and a foreground. It is the most minimal scenery possible. This bounding line is the artist's default manner of representing 'land', and it is used in similar ways for such disparate activities as ploughing in January, boar hunting in woodland in September and threshing and winnowing grain in December. It is true that linear drawings of this kind, made up of lively loops, incisive strokes and nervous calligraphic flutters, were greatly prized in eleventh-century English manuscript illumination – but there is more to this than artistic style. To a contemporary reader, detail was unnecessary; pasture did not have to be distinguished visually from plough. There was no need to spell it out: the nature of the land was tacitly understood by the kind of labour represented.

The labours of the months settled into a familiar pattern over the following centuries, work associated with each season sitting side-by-side with the fasts, feasts and festivals of the Christian year. The familiar round of pruning, digging, planting, harvesting, ploughing, sowing and slaughtering came to decorate countless calendars and books of hours made for secular owners, the cycle of the year making its own comfortingly inevitable progression, over and over again with only minor variations. These images even came to be used to decorate houses. Among a group of fifteenth-century stained glass roundels now in the Victoria and Albert Museum is one representing the month of June, showing a man tackling dismayingly vigorous weeds with a long-handled hook. His leggings are torn at the knee, while behind the field in which he works stands a large turreted house on a hill. It looms aggressively over him and the surrounding landscape, exuding an air of feudal surveillance. In the unlikely event that any such peasant ever got to see this roundel, he would have found the scene distinctly discomfiting. The subdued colour scheme may have been the height of sophistication, but anyone unfamiliar with the latest fashions in stained glass would be forgiven for thinking that the landscape had taken on an uncanny, nightmarish cast: the field and hills a twilight grey, against which the weeds glow an unnatural yellow. In a roundel from a different set of 'labours', a more cheerful figure clad in jazzy leggings and a warm cowl broadcasts seed from a wicker basket. It is October, and time to sow the winter wheat. There is a landscape of sorts behind him: a copse of trees to one side,

and a steep hillside to the other. But our eye keeps returning to the figure, endlessly acting out his seasonal labour like a medieval Vitruvian man – the human figure at the centre of it all. Land, in this period, was something to be owned, to be tamed, to be populated by an agricultural workforce or by the fortunate few with the leisure to hunt, hawk and court. A medieval landscape without a human figure is a rare thing indeed.

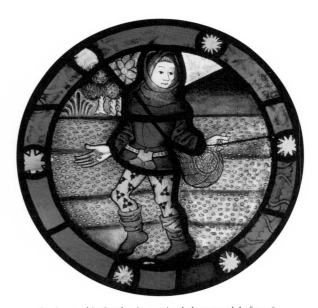

Sowing seed in October in a stained-glass roundel of *c.* 1480.

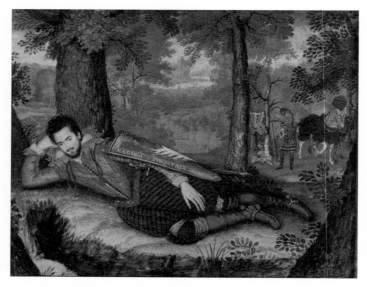

Isaac Oliver, portrait of Edward, Lord Herbert of Cherbury, *c.* 1613–14.

II

REFLECTION

tongues in trees, books in the running brooks,
Sermons in stones, and good in everything
Duke Senior in William Shakespeare, *As You Like It*

ALL THOSE PARTES OF THYS YOUR OPULENT
AND AMPLE REALME

In 1545 the poet and antiquary John Leland sat down to write to Henry
VIII. Leland was a man fascinated by the topography of his country – by
its hills and valleys, its cities and coasts – and, as a scholar, he had studied
with great interest what the 'hystoryanes and chronyclers of Englande'
had to say on the subject. He had also done a fair amount of travelling
himself, having previously been employed by the crown to compile lists
of manuscripts in far-flung monasteries. But even this huge undertak-
ing was not enough: he became determined to conduct a more thorough
survey. 'I was', Leland explained to the king, 'totallye enflamed wyth a
love, to se thoroughlye all those partes of thys your opulent and ample
realme'. Obsessed with his idea, he had got on his horse and explored
Henry's 'domynions', sparing neither cost nor effort. At the end of six
years there was, he was able to boast,

> almost neyther cape nor baye, haven, creke or pere, ryver or confluence
> of ryvers, breches, washes, lakes, meres, fenny waters, mountaynes,
> valleys, mores, hethes, forestes, woodes, cyties, burges, castels, pryn-
> cypall manor places, monasteryes and colleges, but I have seane them,
> and noted in so doynge a whole worlde of thynges verye memorable.[1]

In travelling to see all these places with his own eyes and writing his own descriptions rather than relying on the old authorities, Leland was part of a flourishing age of discovery. But while sea explorers were making voyages in search of far-flung countries, he was setting out to discover his own. The majority of people in the early sixteenth century knew little of geography and had scant if any sense of what the landscape looked like outside their own neighbourhood; it was, in part, an entrenched localism that had made a journey like Sir Gawain's so extraordinary and fearsome. When they were not thinking about practical issues dictated by the lie of the land, or the familiar rhythms of the agricultural year, people thought in terms of signs and symbols. Ideas about Britain's geography and history shaped by myth and layers of pagan and Christian beliefs were often lodged deeply; people were, understandably, attached to the old stories, repeated and embellished from one generation to the next, that gave not only romance but also global status to Britain. Who wanted to be told that Joseph of Arimathea had not set foot anywhere near Glastonbury, and the wooden staff he thrust into the ground had not taken root and grown into a thorn tree that miraculously flowered every Christmas? Or that Britain had not been settled by the Trojan prince Brutus, and that it was a ludicrous fairytale that he saw off the native giants? But change was in the air. For centuries natural scientists both on the Continent and in Britain had been relying ever more heavily on first-hand observation and experimentation to uncover the secrets of the physical world, and in the early sixteenth century there was a keen appetite for empirical fact. Leland's passion for field trips was a symptom of these new currents of thought, a sign of a fundamental change in the way people thought about their wider surroundings. It was time for the landscape to be disenchanted.

The new science of topography – the detailed description of particular places – demanded a good hard look at the land, uncoloured by myth and legend, and the eye that Leland cast over the countryside was a severely practical one. In his desire to avoid giving credence to traditional tales he could, in fact, be accused of having gone too far in the opposite direction. Richard Gough, a late eighteenth-century editor of William Camden's *Britannia*, rolled his eyes over the fact that Leland

had somehow failed even to mention Stonehenge and, 'travelling among towns and along rivers' as he had done, 'did not go out of his way to examine monstrous stones and barrows on wild and widespread downs'.[2] In fact, many of Leland's descriptions resemble the pictorial itineraries created by Matthew Paris, the thirteenth-century monk of St Albans, who depicted his journeys – such as one through London, Rochester, Canterbury and Dover *en route* to the Continent – by drawing short, straight lines connecting ideograms of castellated walls and towers to represent the towns and cities he visited. There is no landscape. The road might as well be a tunnel, an efficient device for posting the traveller from one overnight stop to the next. And when Leland did look about him on his travels it was not, on the whole, with an eye for beauty. On the evidence of his notes he had little feeling for views of rural scenery, and apart from a few approving asides about 'pleasant wooded hills', confines his brisk remarks to its actual or potential agricultural value. At Dunham Massey he notes with approval that 'Good husbandry has turned the neighbourhood here, which used to be fern-infested common land, into excellent corn ground'. Between Sutton and York he 'crossed a large area of flat common land, which was used both for grazing cattle and for digging turves', and just outside York he passed through 'remarkably good arable land'.

This preoccupation with town over country also surfaces in Leland's poem *Cygnea cantio* (Swan Song). The swan that narrates the poem finds himself, like his creator, 'enflamed' with desire to travel beyond his home, the river Isis (the name of the Thames as it flows through Oxford), intending to 'survey' the banks of the river all the way down to the sea. But he also shares his creator's selective vision: although he catalogues the towns and palaces he passes, the landscapes through which he glides on his stately progress go unremarked.

Leland was sadly unable to assemble the copious notes he made while travelling into coherent form, and eventually died in 1552 after a period of insanity, leaving his friend and first editor John Bale wondering if the ambitious task he had set himself, along with his naturally eccentric turn of mind, had overwhelmed him. 'I muche do feare it', Bale wrote, 'that he was vaynegloryouse, and that he had a poetycall

wytt, whyche I lament, for I judge it one of the chefest thynges that caused hym to fall besydes hys ryghte dyscernynges.'³ Poor Leland's notes were not organized and published until 1710 – but long before then his manuscripts were mined by writers of younger generations, including William Harrison and William Camden, each of whom set out to create their own portraits of Britain.

William Harrison, a historically minded rector of a rural Essex parish, was no Leland. Far from being enflamed with the desire to get on his horse and explore every corner of the British Isles in the name of research, his travels were largely conducted in his imagination – 'I sayled about my country', he explains, 'within the compasse of my study.'⁴ The self-confessed armchair topographer sought out the testimony of numerous recent and contemporary eyewitnesses, including Leland, whose notes he borrowed. Harrison admitted, however, that they gave him difficulty: not only were they incomplete, but also 'utterly mangled, defaced with wet, and weather', a sad wreckage of earlier hopeful journeys from which it is hard not to draw parallels with the author's final loss of reason. His other sources of information were 'letters and pamphlets, from sundry places and shires of England', and 'conference with divers [people], either at the table or secretly alone'.⁵ The thousands of snippets and accounts Harrison gathered contained information about everything: food and diet, provision for the poor, universities, punishments for malefactors, building materials, decoration, fairs and markets, antiquities, armour, venomous beasts and precious stones. He brought it all together in his *Description of England*, first published in 1577 at the beginning of Raphael Holinshed's *Chronicles*, a vast narrative of British history. Harrison's *Description* ranges loquaciously from theme to theme, the author never missing the chance to air an opinion about lack of discipline in the church, Sunday trading, or to grumble about the feebleness of 'tenderlings' always complaining of colds despite the increasing adoption of chimneys to channel smoke out of their homes. Whatever he thought he was writing, his interest in the way men and women of his time lived led him to produce a social history; his landscape does not serve to create a portrait of the land so much as to reflect back human concerns:

We have many woods, forests, and parks, which cherish trees abun-
dantly, although in the woodland countries there is almost no hedge
that hath not some store of the greatest sort, beside infinite numbers
of hedgerows, groves, and springs that are maintained of purpose for
the building and provision of such owners as do possess the same.[6]

When he decides to write about the land, what springs immediately to
Harrison's mind are managed landscapes – parks and rabbit warrens,
gardens and orchards; and, when he does look further afield, his
landscapes invariably involve a man riding through them, checking
the state of the woods and worrying that not enough trees are being
planted for timber.

While Harrison was trawling through letters in his study and scrib-
bling notes at the dinner table, the antiquary William Camden was
planning a more ambitious project of writing about the land – one that
would set a new standard in thoroughness and erudition. His enterprise
was so novel that it even required a newly minted word to describe it:
'chorography' (*chorographica*, in the Latin of the first edition of 1586).
A more capacious concept than geography or topography, chorography
was the study of a particular region that took history and culture into
account. Gone were the sections on 'wonders' that were an inevitable part
of the old medieval histories – 'To fable I have not paid the least regard',
Camden noted in his preface with fastidious disdain (if not complete
honesty) – and in their place were sober accounts of the Roman occupa-
tion of Britain, of Celts, Picts and Scots, Saxons, Danes and Normans,
followed by county-by-county descriptions. Camden's *Britannia* unfolded
an unprecedented amount of information about the land – here was
crisply observed reality and meticulously researched history sweeping
away the curious old cobwebs of folklore and hearsay. There was really
no longer any excuse for clinging to ignorant old habits of mind. 'If
there are any', wrote Camden sternly in his preface, 'who wish to remain
strangers in their own country and city, and children in knowledge, let
them enjoy their dream.'[7] *Britannia* offered – to those who cared to
take it – nothing less than intellectual ownership of Britain. Its bracing
tone caught the spirit of the times and made his book hugely popular:

from one squat volume published in 1586, it morphed and expanded through six further Latin editions with various authorial and pictorial additions, before being translated into English in 1610. It continued to be re-translated and edited throughout the eighteenth and into the early nineteenth century. Later editions, which include lists of the nobility, valuations of ecclesiastical preferments and rare plants native to each county, suggest that *Britannia* had begun to be regarded, if not quite as an encyclopaedia, then certainly as an intellectually respectable member of the 'enquire-within-upon-everything' genre.

Camden wove a new way of looking at the landscape into the text of *Britannia*. Part of this was attitude: for him, the land was to be interpreted not only in terms of agricultural usefulness, but as a shaping factor in local culture, as a repository of history – as an intrinsic part of British identity. In the course of his research he travelled widely, gathering information about topography and antiquities and reading the physical landscape for what it could tell him about Britain's past. But another striking way in which *Britannia* differs from previous books is the soaring ambition of the author's viewpoint. Camden, like Leland, would have experienced the view on foot or from horseback, but rather than describe it from this vantage point, as other writers had done, he takes to the air in his imagination, giving us a bird's-eye view as he ranges from county to county, setting each river and town in the context of its physical situation. We hover by his side, noticing Langley in Shropshire below us, 'lying low in a woody park', we take in the 'barren mountains and wilds' of the Derbyshire Peak District in a single glance, and enjoy an aerial view of the mouth of the Plim in Devon; 'where the south coast of this county begins,' writes Camden, 'the land opens with a spacious and broad front as far as the *Stert point*'.[8] By the time we accept his invitation to accompany him on a journey down the Thames, we have begun to picture the land as something laid out beneath us – its hills, woods, rivers and valleys no longer need to be negotiated as they would by the weary rider, merely noted as we fly overhead. Camden's elevated viewpoint eventually found pictorial form. In the 1607 edition of *Britannia* onwards, maps by one of Britain's earliest cartographers, Christopher Saxton, set the scene for each county description.

Camden's elevated view partly results from his authoritative command of his material; and yet is hard to imagine without the culture of mapping and surveying that had developed in the sixteenth century. The first manuals published in England were John Fitzherbert's *Boke of Surveyeng* (1523) and *The Maner of Measurynge* (1537) by an Augustinian canon, Richard Benese. Benese's contents page promised to divulge how to divide woodland, how to work out its value, how to measure timber and stone. What Benese offered – a 'perfecte knowledge bothe of true measurynge of lande, & also of true comptynge and summynge' – came in useful during the Dissolution of the Monasteries, when the vast transfer of landed religious property to the crown created an unprecedented demand for surveyors' skills.[9] Benese, who had been placed in charge of the King's works, was personally responsible for dismantling Merton priory in 1538, the stones of which were used to build the foundations of Nonsuch, Henry VIII's new palace in Surrey. How, in his conscience, he squared his new professional role with loyalty to his former community is not recorded.

For the first time since the Domesday survey in the late eleventh century the land was subject to rigorous scrutiny. But however descriptive measurements and valuations were in their own way, to those untrained in the art of surveying, they did not conjure up much of an image. A way of picturing these parcels of land had to be found. If one could not actually hover overhead, one could at least visualize what it would look like, combining mathematical fact with pictorial imagination. Bird's-eye views began regularly to be used as ways of describing tracts of land, adapted from existing images of town- and cityscapes imagined from an aerial perspective – a famous example was the monumental six-sheet woodcut of Venice created in 1500 by Jacopo de' Barbari, eloquent testimony to the Venetian Republic's prowess as both a maritime and artistic power.[10] This was another aspect of the new science of chorography, which, as the cartographer William Cuningham explained in his 1559 book *The Cosmographical Glasse*, homed in on particular regions – it 'sheweth the partes of th'earth, divided in themselves', he explains, 'And severally describeth, the portes, rivers, havens, fluddes, hilles, mountaynes, cities, vaillages, buildings, fortresses, walles, yea and every particular thing....'[11]

One of the earliest British bird's-eye views represents fields near Newnham, Hampshire. The land, divided by hedges and edged with bare winter trees, is laid out so that we can judge its shape and its relation to the road. All is painstakingly drawn and inscribed: the packhorses and cart travelling along 'The hie Wey leydyng from london to Baysyngstoke' – a role now played by the M3 – the house built of brick and timber, the gates leading from road to field, the hedges and meandering paths. It is an evocative – and, to our eyes, charming – view of winter farmland. We can imagine walking up that path in the shadow of the tall trees whose branches are shaded with grey wash, feel what it was like to push open that gate that leads into the further field. But this landscape was not created to delight the eye – it was made so that land involved in a legal dispute could accurately be described and fought over.[12]

A similarly pragmatic purpose lay behind a group of coastal views created in the 1530s. With the threat of war, coastlines – particularly those looking across the channel towards France – took on a new strategic significance. One of the first to draw this coastal landscape was Vincenzo Volpe, an artist from Naples who came to England to work for Henry VIII. In 1532 he created a detailed bird's-eye view of Dover, commissioned by the burgesses to be presented to the king and his Privy Council to win approval for remodelling this important harbour. Volpe's view showed

A bird's-eye view of fields near Newnham, Hampshire, c. 1536–51.

Vincenzo Volpe's proposed design for a new harbour at Dover, 1532.

improved jetties, sluice-gates and several new defensive towers, the latter complete with firing canons. Where he might have submitted a schematic plan, Volpe has instead, more persuasively, shown the town and the projected harbour within a convincing landscape, taking care to depict the lie of the land and create the illusion of cliffs, hilly terrain and a valley with watercolour washes shading from dark to pale. In order to achieve this he must surely have stood on the hillside and looked over the town and surrounding country, perhaps even making sketches from a variety of vantage points.

A more systematic approach to recording the land came in 1539, when Henry VIII's chief minister Thomas Cromwell ordered a survey.[13] The king had finally been excommunicated from the Catholic Church in December 1538, and a month later the Treaty of Toledo allied Francis I of France and the Holy Roman Emperor Charles V against Protestant England; the threat of war with France loomed. Had this survey happened only a little later, it would have been done with scale maps, but as it was, picture-maps were drawn, creating – for the first time – panoramic views of the English coast: Brighton, Scarborough, Hull, Harwich, the stretch from Faversham to Margate, the south coasts of Dorset, Devon and Cornwall. These bird's-eye views were intended to reveal as clearly as possible the intricate ins and outs of the coastline,

A bird's-eye view of the Dorset coast, 1539–40.

depicting flaming beacons (each with its own ladder) and tall coastal crosses, causeways and harbours, villages and churches, castles, towers and even clumps of trees with wildly oversized grazing deer. They give us a remarkable insight into how the landscape appeared to the mid-sixteenth-century eye.

The thorough, increasingly rigorous methods of picturing the country made full use of the surveyor's skills. When land could be measured accurately, for the first time British maps could be drawn to a consistent scale. Because of this, the viewpoint shifted; a raking, bird's-eye view, which scaled up some elements for emphasis, no longer satisfied the ambitions of cartographers, and instead the more precise overhead view so familiar to us today was adopted. Christopher Saxton was the most distinguished British cartographer of the sixteenth century, and the first to create a national atlas, published in 1579. His vision of the land from above, which married an aerial view drawn to scale with pictograms of hills and trees, depicted as though seen side-on, influenced how it was viewed for centuries. But before a consensus was reached that fixed these conventions, cartographers brought their imagination to bear on the new overhead views. When John Darby, a surveyor from Suffolk, created an estate map of Smallburgh in Norfolk in 1582, he had the idea of subtly colour-coding the carefully marked-out fields: he used rich green watercolour for pasture, yellow-ochre for arable, light

green for heath and meadowland and dark green for marshland. His river is not the blue conventional in later maps, but the dirty white of a sheep's fleece – the colour you might expect to find under Norfolk skies. Look closely, and the landscape comes to life. The surface of the water is flecked with the paint brush to show little waves. A hunting dog has just crashed into the water after some ducks – they flap away and open their beaks to call out in alarm while its owner, holding his gun, gestures and shouts. A heron regards the commotion disapprovingly, while further on a swan drifts calmly away. Nearby, pencilled-in dogs course after a hare, while further afield women carry milk pails and feed pigs. Dotted in fields across the estate animals graze: there are horses, different varieties of cow, sheep and goats. At the bottom margin of the map, represented as a much larger figure as though occupying a different dimension, stands a muscular surveyor with a scale bar and compasses. Looking at this drawing, the impression we get is not so much of a static map: it is more as though Darby has whisked us up by magic to hover above this busy and prosperous estate, where we watch small human and animal dramas unfold before our eyes. They remind us that there was another dimension to the landscape that no

John Darby, map of the Smallburgh estate in Norfolk, 1582.

amount of measuring and surveying could dispel, and that was its role as a place where people wandered and thought, sighed, loved, got lost and perhaps even found themselves again.

MELANCHOLY

A portrait miniature by Isaac Oliver, painted in the early 1590s, shows a young man in a wide-brimmed hat, arms crossed and one discarded glove laid by his side (Plate 3). Eyebrows raised, he glances up towards us: we are intruding on his solitude. His eyes are soft, his cheeks pale and his expression withdrawn. This young man is, without doubt, suffering from the Elizabethan malady: melancholy. Behind him are the neatly clipped parterres of a formal garden in which a distant couple walk, and a great house. But he is separated from this cultivation by a little wall, and he sits on a natural grassy bank among the wild flowers, leaning back against the trunk of a tree, which shields him from view. He has slipped away from polite society and climbed over the wall; the spot he has chosen for his contemplation is the natural landscape, not the garden.

This young man might have been solitary, but he was not alone. From the Elizabethan *fin-de-siècle* to the beginnings of the seventeenth century, melancholy was something of an epidemic among gentlemen of a thoughtful, scholarly bent. Intellectual effort and philosophical speculation were thought to upset the natural balance of the body's four humours – blood, yellow bile, black bile and phlegm. When black bile came to dominate the others, it affected the temperament, throwing it into a state of melancholy. No wonder these men sought after solitude on the banks of streams and in shady groves. Melancholy was not only caused by a lack of inner equilibrium, but by a more general apprehension that the world itself had become unbalanced and 'runne quite out of square', as Edmund Spenser put it in *The Faerie Queene*.[14] In such circumstances, to be sufficiently thoughtful and sensitive to be affected by melancholy was a badge of honour among certain young intellectuals. Henry Percy, 9th Earl of Northumberland and known as the 'Wizard Earl' because of his interest in alchemy, mysticism and the occult, was depicted by Nicholas

Hilliard in a miniature now in the Fitzwilliam Museum, Cambridge, reclining on flowery turf in a wooded grove, having laid aside his book to reflect on its contents. And when the handsome young soldier, diplomat and philosopher Lord Herbert of Cherbury was to be painted by Isaac Oliver in the early years of the seventeenth century, he rode into the woods, got off his horse and stretched out full-length on the grass under shady trees and next to a little stream, resting his head on his hand and adopting an expression that suggested he was lost in thought (see p. 42). His attendant stayed in the background, tending the horses. This time, there is no garden to contrast with the wildness of nature – instead, as far as the eye can see is a landscape of tree-tops, a great river and dramatically tall cliffs, all hazed with the blue of distance. Lord Herbert has left the formal, indoor world far behind and sought a high, remote place. This is my refuge, he seems to say: away from the chatter of society, where my thoughts can grow into strange and pleasing shapes, aided by the sound of the wind in the trees and the running of the brook.

A few years later, Robert Burton, a scholar of Christ Church, Oxford, described this state of mind in an image so seductively captivating that people have used it ever since. 'Most pleasant it is at first, to such as are Melancholy given', he wrote in his *Anatomy of Melancholy*, first published in 1621, '...to walke alone in some solitary grove, betwixt wood and water, by a brooke side, to meditate upon some delightsome and pleasant subject.... A most incomparable delight, it is so to melancholize, to build castles in the ayre...'.[15] But in case we are seduced by these delights, Burton quickly urges his readers to be cautious. Too much time alone devoted to 'fantastical meditations', whether shut up indoors or wandering in solitary spots, can, he warns, turn a formerly sociable person into a beast or an unhappy monster. In his view, the balm offered by solitary groves, riverbanks and suchlike could be a dangerous drug in too great a quantity. It should be taken in strict moderation.

For Elizabethan and Jacobean melancholics, the relationship was complicated. If the country was where one could lose oneself (even if only in thought), was there not another side of the coin? Could it not also be where one could find oneself?[16] This paradox sits at the heart of Shakespeare's *As You Like It*, probably written at the end of 1598. It is set

in the Forest of Arden, which could be the Forest of Ardennes in Belgium and Luxembourg, but might equally refer to the Warwickshire Forest of Arden, the source of Shakespeare's mother's maiden name. Wherever it was, the forest where the exiled Duke Senior has established an alternative court is a kind of Arcadia. 'They say he is already in the Forest of Arden', explains Charles the wrestler, 'and a many merry men with him, and there they live like the old Robin Hood of England'.[17] The Duke and his Lords feast on the venison they catch – humanely regretting its necessary slaughter – and appear to live a contented life exhilaratingly free from the snakes-and-ladders games of court hierarchy. The entire play can be seen as a reaction against urban life. 'Now, my co-mates and brothers in exile,' Duke Senior remarks with cheerful egalitarianism, 'Hath not old custom made this life more sweet / Than that of painted pomp?'

But the forest in which they find such freedom is not exactly wild; rather, for those who care to hear it, it is alive with wisdom and culture. '[T]his our life,' Duke Senior exclaims,

> exempt from public haunt,
> Finds tongues in trees, books in the running brooks,
> Sermons in stones, and good in everything.

People are largely absent, and instead a deep susurration of insight and healing seem to well up from the land itself. Orlando nailing his love-struck verses to the tree trunks is an echo – part-comic – of this serious image of speaking trees. You only have to be in tune with the forest, the Duke seems to suggest, and it will reciprocate, speaking words of wisdom. Is this what the Earl of Northumberland and Lord Herbert of Cherbury were listening for as they stretched out along the grass and placed their ears so close to the ground?

Yet not everyone shared this idea of a happy, harmonious relationship between men, women and woodland. The hectic romance, role-playing and clowning that make the Forest of Arden fizz with high spirits are tempered by the presence of the melancholy Jaques. We hear of Jaques before we meet him, lying on the ground – in classically melancholy pose – under an oak tree by the side of a brook, musing on the suffering of

an injured stag. Although by this standard he appears to be cut from the same cloth as the courtiers depicted in Hilliard's and Oliver's miniatures, by his own reckoning he lacks what he calls 'the scholar's melancholy'; he does not conform to that stock Elizabethan role. His is, he claims, 'a melancholy of mine own, compounded of many samples'.[18]

While Duke Senior exclaims with delight because, as he sees it, the trees, streams and rocks philosophize wisely, the only time Jaques reacts with spontaneous merriment is when he meets the singularly urban figure of Touchstone, who has accompanied Rosalind and Celia from the court. 'A fool, a fool!' Jaques cries, 'I met a fool i' th' forest, / A motley fool – a miserable world! / As I do live by food, I met a fool.'[19] Touchstone's job is to be disruptive and contrary, and he is comically out of place in the forest and out of sorts with nature. When Jaques announces his own desire for a coat of motley ('O that I were a fool!'), he is declaring his own disinclination to be transformed by the wisdom offered by nature. For the other characters in Arden, a journey into the heart of the forest is a journey into the deepest corners of their own and each others' souls before their triumphant return to court – but not so for Jaques. Charles's mention of Robin Hood in connection with Duke Senior and his retinue reminds us that the forest – the dark heart of the landscape – is also a place for rebels.

If the forest holds such rich potential for self-discovery, can the opposite sort of wild landscape do us harm? When King Lear loses his wits it is on a bare heath that offers no shelter from the storm. 'For many miles about / There's scarce a bush', worries Gloucester.[20] The three witches in *Macbeth* gather on a 'blasted heath' to speak their equivocal prophecies to Banquo and Macbeth: here there is little that is living to contrast with their unnatural nature.[21] When Burton, in his preface to the *Anatomy*, sets out plans for his ideal land – his 'new *Atlantis*, a poeticall commonwealth of mine owne' – he declares that he 'will not have a barren acre in all [his] Territories'; he will countenance 'no boggs, fennes, marishes, vast woods, deserts, heaths, commons, but all inclosed'. Even the mountain tops will not be allowed to be wild – 'where nature failes,' he writes, 'it shall be supplied by art'.[22] Melancholy was brought on by uncultivated places, so they must be kept at bay.

As much as they were places that affected the mind, sixteenth-century landscapes were also still places *of* the mind. Poor lamenting Colin Clout addresses the land at the beginning of Spenser's *Shepheardes Calendar* (1579):

Thou barrein ground, whome winters wrath hath wasted,
Art made a myrrhour, to behold my plight:[23]

The land simply reflects his own misery back at him. His mind remains frost-bound even when the seasons transform the country: a dialogue in 'June' between Colin and the shepherd Hobbinol is a clear case of two people looking at the same landscape and seeing very different things. While Hobbinol takes Colin to see the 'pleasaunt syte' in which he takes such delight, pointing out the 'grassye ground with daintye daysies dight', showing him the bramble bush and asking him to listen to the birdsong with which it is alive, Colin's unhappiness prevents him from seeing it. Feeling himself to be pursued by angry gods and with nowhere to hide, all he can think of is shelter; he can take no delight in the open landscape of his friend's 'Paradise'.[24] We think of Hamlet admitting that he can no longer regard the earth as a 'goodly frame' because it has begun to seem to him nothing more than a 'sterile promontory', a barren headland projecting into nothingness.[25] In an age of new doubts, here is landscape as a chilling metaphor of existential angst.

MASQUES AND MUSES

In the Ditchley portrait, now in London's National Portrait Gallery, Queen Elizabeth I poses as though performing in a spectacularly grand masque. At one side of this regal *tableau-vivant*, inky clouds are broken by lightning; at the other – the side to which she inclines her face – sunshine bursts through. The ground makes a yet more emphatic point by turning itself into a map: the queen bestrides a globe, one utterly dominated by the British Isles. Insofar as the natural world is permitted to appear at all, it is put into harness and made to tell the artist's story – but mostly

it speaks a language of coded power. In a world of Elizabethan magnificence, symbolism was all.

This was the cultural climate in which Edmund Spenser wrote *The Faerie Queene* (1590), a poem whose scenes are like court masques: it is as though a new set of gorgeously painted boards, decorated with significant emblems, is wheeled in to frame every episode. Right at the beginning of the poem, which meanders through a richly forested landscape, we are led into the trees. The rain pours down and we look for shelter, making for the haven of a 'shadie grove'. On closer inspection, the protective trees seem to be woodcuts in an emblem book, their names all but hovering in the air above them: here are 'the sayling Pine' (used for ships' masts), the 'Poplar never dry' (used to make barrels), the 'builder Oake' and the 'Cypresse funerall'.[26] Also in this crowded grove is a laurel to crown conquerors and poets, a willow for forsaken lovers to weep beneath and a birch for the manufacture of arrow shafts. Redcrosse and his lady Una, who seek shelter here, walk through a series of heraldic devices representing human life and enterprise.

Spenser's *omnium gatherum* of arboreal symbols provides a highly concentrated form of information. It may be of little use if you wished to know about the trees that would have grown together in an English forest of the late sixteenth century – for that you would have to wait for the publication of John Evelyn's *Sylva* – but anyone wanting to know about its social and industrial worlds could do worse than to start here.

Move on to Book II of *The Faerie Queene*, on the other hand, and in Spenser's 'Bower of Bliss' we find a scene attended by flower-strewing allegorical figures such as Botticelli might have painted:

A large and spacious plaine, on every side
Strowed with pleasauns, whose faire grassy ground
Mantled with greene, and goodly beautifide
With all the ornaments of *Floraes* pride;
Wherewith her mother Art, as halfe in scorne
Of niggard Nature, like a pompous bride
Did decke her, and too lavishly adorne,
When forth from virgin bowre she comes in th'early morne.[27]

'Niggard Nature' indeed: the landscapes of this dazzling procession of a poem are manipulated and embellished by every trick that Art can devise.

Shakespeare's Forest of Arden is, of course, nothing like a real green-wood either. Whether it is supposedly situated in Warwickshire or on the Continent, when Orlando encounters a lioness lurking in the shade of a bush, we are by no means as surprised as he is. The woodland mix, if not quite as comprehensive as Spenser's, is more fantastic. Here are English oaks and osiers – but over there are olive trees that provide fencing for a sheepcote, while Rosalind finds one of Orlando's poems attached to a palm tree.[28] Shakespeare's woodland was not a surveyor's woodland, and its trees only thrive because they are rooted in the rich soil of symbolism. Olives stand, of course, for peace, while the palm, a hermaphrodite, is a fitting bearer of a poem addressed to Rosalind / Ganymede. The enchanted land-scape of *As You Like It* has grown to mirror the shape of its improbable plot.

The architect and designer Inigo Jones made landscape central to his works from the very beginning:

> First, for the *Scene*, was drawne a *Landtschape*, consisting of small woods, and here and there a void place fill'd with huntings; which falling, an artificiall sea was seene to shoote forth, as if it flowed to the land...[29]

So the playwright Ben Jonson described Jones's set for his short play *The Masque of Blackness*, first performed in 1605. Jonson's piece was Jones's first outing as a theatre designer at court. As tradition dictated, the masque was performed at Whitehall on twelfth night, the queen herself, Anne of Denmark, taking part in a dance with her ladies, while her sons, the princes Henry and Charles, also appeared. It sounds as though the scenery for *The Masque of Blackness* was, at least in part, based on the kind of hunting scene conventionally represented in sixteenth-century Flemish tapestries. But even so, Jones was asking the audience to look at stage sets in a new way: as art – something to look at, and discuss, and about which to have opinions – rather than as an attractive system of domestic draught exclusion.[30] It would have been a novelty to an English court used to representations of landscape in the context either of topography or decor.

Jones had travelled to Italy in around 1600, where he remained for long enough to become fluent in the language. He would have known about the extravagant theatrical productions held to entertain the Medici court at least through written accounts and contemporary engravings – it is possible that he even attended one. His imagination was certainly fired by the art, architecture and theatre he had witnessed in Italy, and over subsequent decades he invented lavish and daring costumes, devised astonishing lighting effects and introduced to England what would become the standard elements of theatre design: a proscenium arch, wings and a changeable panel at the back. A master of stage mechanics, he made courtiers appear to drift gently down to earth on clouds (and not, as one observer noted, to descend like a bucket into a well), or presented them, like Botticelli's famous Venus, within the mother-of-pearl interior of a giant shell.[31]

In the face of this ever-growing extravagance, the verses themselves, even those by a writer of Ben Jonson's stature, have been described as little more than 'the stick of the rocket after the firework has flamed and faded'.[32] It is a bold claim, and yet as these confections of costume, dance, painted sets and the ingenious workings of stage machinery came together in extravagant theatrical entertainments, they must have held audiences at the Palace of Whitehall rapt with delight and astonishment. It was perhaps inevitable that Jonson and Jones should eventually argue over the relative importance of verse and design. The former, in an exasperated poem he called An Expostulation with Inigo Jones, questioned the 'Mighty Showes' about whether there was any real need for him to write anything at all: 'What need of prose / Or Verse, or Sense t'express Immortall you?' With Jones squarely in his sights, he concluded bitterly: 'Painting & Carpentry are ye Soule of Masque'.[33] Perhaps they were.

Yet more of the spent firework sticks lying in the grass are the little drawings Jones made to work out his designs, which he would hand over to his assistants to be scaled up and realized in paint. A great many of these hasty pen and ink sketches represent landscapes, tall trees usually framing the scene to left and right, or gentle hills, or rocky outcrops, shown in a perspective that worked perfectly from the eye-line of the centrally placed king's and queen's chairs. Jones made his stage designs pictorial, imagining them as fully realized paintings rather than theatre

props. He would often base his designs on prints by or after landscape painters – the Flemish Paul Bril and the Italian Antonio Tempesta were particular favourites – bringing a continental sophistication to English court masques. Perhaps the most beautiful and freely executed of all Jones's designs is that for a late masque of 1638, *Luminalia: the Queen's Festival of Light*, celebrating the power and virtue of the monarchy with a vision of the queen consort, Henrietta Maria, as 'queen of brightness' – dawn defeating the night.[34] The design was described, probably by Jones himself, as:

> a scene all of darkness, the nearer part woody, and farther off more open, with a calm river, that took the shadows of the trees by the light of the moon, that appeared shining in the river, there being no more light to lighten the whole scene than served to distinguish the several grounds that seemed to run in from the eye.[35]

By that time, however, the end of the day was coming for the court masque. The gunpowder of the English civil war would soon obscure Jones's stage fireworks, spectacular as they were, and the masque, with

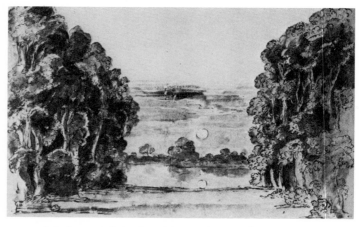

Inigo Jones, set design for a night scene in *Luminalia*, a masque by
Sir William Davenant performed in February 1638.

its elaborate courtly rituals and affirmations of monarchical glory, would become obsolete. Apart from his drawings, the most substantial material legacy of Inigo Jones's genius is the Banqueting House that he designed for Whitehall Palace, where many of the great masques were staged. It was also to be the site of Charles I's execution in 1649.

In 1612 Michael Drayton published the first part of a rambling, eccentric poem that he called *Poly-Olbion*, a title that can be interpreted either as 'many blessings', or 'the variety of Britain'. His poem, a second part of which appeared in 1622, is a celebration of the kingdom's topographical features, historical fragments and legends, and is every bit as theatrical as a masque. 'Of *Albions* glorious Ile the Wonders whilst I write', he begins, and asks the '*Genius* of the place' to give him a guided tour:

> Goe thou before me still thy circling shores about,
> And in this wandring Maze helpe to conduct me out:
> Direct my course so right, as with thy hand to showe
> Which way thy Forrests range, which way thy Rivers flowe;
> Wise *Genius*, by thy helpe that so I may descry
> How thy faire Mountaines stand, and how thy Vallyes lie[36]

This is no mere pleasure trip. For his subtitle Drayton borrows the recently minted word for a new, descriptive approach to Britain's landscape and antiquities; his poem's full title is *Poly-Olbion: A Chorographicall Description of Tracts, Rivers, Mountaines, Forests, and other Parts of this renowned Isle of Great Britaine, With intermixture of the Most Remarquable Stories, Antiquities, Wonders, Rarityes, Pleasures, and Commodities of the same: Digested in a Poem*. But what makes *Poly-Olbion* such an extraordinary concoction of geography and poetry are the maps that introduce each of the muse's tours, created by William Hole, who had engraved nine-teen of the county maps for the second edition of Camden's *Britannia*. Rather than providing sober cartographical accounts of natural landscape features with the position of towns and villages, however, Hole's maps for *Poly-Olbion* feature nymphs rising up out of each river, shepherds perching on the summits of improbably steep hills and elegant ladies at

the site of each town, their hats embellished with houses and churches. In Drayton's verse and Hole's designs alike, this is a noisy, busy place with no uninhabited natural features – all is animated. And despite the fact that Drayton's Muse seems to have taken a course in surveying – she 'measures out this Plaine', he tells us, 'and then survayes those groves' – his outrageously fanciful vision subverts all the diligent mapping and measuring that had changed the way people thought about the land over the previous decades.[37] Indeed, in *Poly-Olbion* Drayton gently but deliberately puts back all the nonsense that had been knocked out of people's ideas about the landscape.

The preface promises that readers will be inspired by 'the Rarities & Historie of their owne Country delivered by a true native Muse' – and where other writers on Britain allow us to sit at home, Drayton takes us gently by the arm and leads us out into the country. But this is not the sort of walk for which one would need to lace up sturdy boots. He promises 'Feelds of the Muses where through most delightfull Groves the

William Hole, map of Somerset and Wiltshire engraved for
Michael Drayton's *Poly-Olbion*, 1612.

Angellique harmony of Birds shall steale thee to the top of an easie hill', from which point we would be conveyed down 'a soule-pleasing Descent through delicate embrodered Meadowes, often veined with gentle gliding Brooks'.[38] We are in for a pleasant time.

If Camden imagined hovering above Britain with his reader, soberly indicating this river-mouth or that plain, Drayton's Muse is, by contrast, an airborne pleasure-seeker. Here is his account of her progress through Dorset, Hampshire and Wiltshire:

> The Muse from Marshwood way commands,
> Along the shore through Chesills sands:
> Where, overtoyld, her heate to coole,
> Shee bathes her in the pleasant Poole:
> Thence, over-land againe doth scowre,
> To fetch in Froome, and bring downe Stowre;
> Falls with New-forrest, as she sings
> The wanton Wood-Nymphes revellings.[39]

But Drayton's landscape is not a wholly harmonious place; below his Muse, the rivers, woods and plains of Britain vociferously debate and argue with each other. Two rivers court stately Salisbury Plain (the 'first of Plaines'), vying with each other to be 'most gracious in her eye' until the Plain 'Fore-warn'd them to desist, and off their purpose brake'. Then, on behalf of plains generally, she launches an attack on forests: 'Away yee barb'rous Woods', she commands, asking rhetorically:

> what pleasure can be found
> In darke and sleepie shades? where mists and rotten fogs
> Hang in the gloomie thicks, and make unstedfast bogs,
> By dropping from the boughs, the o're-growen trees among,
> With Caterpillars kells, and duskie cobwebs hong.

Plains are greatly superior parts of the landscape, she adds, being bathed in light early in the morning – when even at noon the sun hardly pierces dense woodland. Some of the sunny hills around the plain heartily

agree and applaud her speech, while the forests crossly 'sweare the prating Plaine / Growne old began to doate'. The woods of Pewsham and Blackmore in Wiltshire

> Do wish that from the Seas some soultrie Southerne winde,
> The foule infectious damps, and poisoned aires would sweepe,
> And poure them on the *Plaine*, to rot her and her Sheepe.[40]

Elsewhere, matters are no better. The wonders of the land have been catalogued, but Wookey Hole ('Ochyes dreadfull Hole', as Drayton puts it) has not been listed among them and consequently 'held her selfe disgrac't'. It would not have been so bad, had it not been for some of the sites actually chosen:

> But that which vext her most, was, that the Peakish Cave
> Before her darkesome selfe such dignitie should have.

A marginal note tells us that the 'Peakish Cave' to which she refers is, in fact, the Devil's Arse in Derbyshire. No wonder Wookey was upset. Other elements of the landscape took her side '(for all held Ochy deare)' and reacted badly: '...*Froome* for her disgrace / Since scarcely ever washt the Colesleck from her face', while Cheddar 'Gusht forth so forcefull streames, that he was like to breake / The greater bankes of Ax....'[41]

The post-Reformation country may have stopped reacting spontaneously to the presence of saints, but a century of surveying, mapping and researching had, it seems, not managed to empty the landscape completely of its resident spirits – however they were imagined.

INTERIOR LANDSCAPES

Imagine it is a day towards the beginning of the seventeenth century, and you are standing in a village street at the door of an ordinary cottage. You lift the latch, step through the simple plank door and find yourself in a low room. There is scant light from outside; at the windows there are

horn panes or even just waxed or oiled cloth instead of glass, but the fire burning in the hearth gives a cheerful glow which will be the principal source of light when the shutters are fastened later in the evening. For furniture there is an oak trestle table, two chairs, a low bench and a few stools, a plain cupboard and a couple of candle sticks or rush-light holders. But look at the walls. Here are floor-to-ceiling fabric hangings painted with all sorts of designs: Bible stories and verses; fanciful animals; fields, hills and trees. If you were to have visited any but the meanest households from the medieval period until well into the seventeenth century, you would have found many people living their lives surrounded by images of the natural world.

The survival rate of domestic furnishings is in inverse proportion to their contemporary rarity. Many of the woollen tapestries that shielded the wealthy from draughts still exist, *in situ* in some cases, the hunt forever cantering through the deep shade of the forest, the horn poised at the huntsman's lips. When we think of ordinary houses we tend to picture them with little decoration beyond necessary items of furniture – but inventories tell a different story. An astonishing fifty-six per cent of those that list the contents of Nottinghamshire houses in the late sixteenth century mention stained cloths or hangings – a figure we can assume is broadly representative of the country as a whole in all but the poorest counties. In his *Description of England*, William Harrison describes how interior walls 'be either hanged with tapestry, arras work, or painted cloths, wherein either divers histories, or herbs, beasts, knots, and suchlike are stained', while in 1558 a French visitor remarked on the use the English made of 'tapestries of painted cloths [*tapisseries de toiles pinctes*] which are very well executed', remarking on how 'few houses you could enter without finding these tapestries'.[42] We know that Robert Arden, Shakespeare's grandfather, owned eleven sets of stained cloths.[43] The stained cloth was, in essence, the poor man's tapestry; Harrison's description tells us that the subject matter included 'herbs' – plants and flowers – as well as religious and classical subjects, while the few surviving stained cloths, such as those at Owlpen Manor in Gloucestershire, suggest that, as in tapestry, 'verdure' was popular – the depiction of an invented landscape consisting of hills,

plains and rivers, dotted with plants and trees and often populated by picturesque beasts.

These textiles not only provided decoration for rooms but also some protection from chilly gusts from ill-fitting windows and even through walls – many an unwelcome chink of light appeared as the gradually drying oak studs and wattle and daub infill of timber-framed buildings shrank away from each other. The cloths were called 'stained' rather than 'painted' because the visibility of the weave after the dye had been applied mattered: the more they resembled tapestry, the smarter they were.[44] Compared with tapestry, however, they were inherently fragile; when they wore out most were probably sold as rags, which were commonly recycled to make paper (many of these sheets must have ended up in the hands of artists – some even used for landscape drawings). Fashions changed, too: after the seventeenth century stained cloths became old-fashioned and people wanted elegant panelling or plain plaster instead. As a result these pictorial hangings, which had formed backdrops to countless lives lived over ten generations, fell almost completely out of view.

Almost as rare now are paintings made directly on to walls and panels. In 1617, the owner of Woodford Hall in Essex commissioned paintings of rural life to decorate the ballroom. The artist created twelve paintings, each one in a compartment, representing hay-making, sheep-shearing, reaping a wheat-field and making sheaves, apple-gathering in an orchard and tree-felling in winter – georgic idylls for the dancers to enjoy during a pause.[45] It was not only substantial country houses that were decorated in this way – according to the subtitle of Henry Vaughan's 1646 poem 'A Rhapsodie', even a room at the Globe Tavern in Fleet Street had a chamber 'painted over head with a cloudy sky and some few dispersed stars and on the sides with land-scapes, hills, shepherds, and sheep.' It was where he met his friends, and what inspired him to write the poem. Indeed, Vaughan speculates that under the influence of such a painted setting, 'we shall all, / After full cups, have dreams poetical'.[46]

Sometimes a decorative landscape could have a distinctly political dimension. In the late sixteenth century an English landowner called Ralph Sheldon commissioned a series of 'map tapestries' to hang on the four walls of the principal chamber of his house at Weston in Warwickshire,

each of which was to depict areas of the country where he owned land: Gloucestershire, Warwickshire, Worcestershire and Oxfordshire.[47] They were woven with the royal arms and the Sheldon arms – a particularly pointed gesture for this Catholic family, keen to demonstrate its loyalty to Queen Elizabeth – and included a panel containing an appropriate excerpt from Camden's *Britannia*, newly published at the time. The tapestries are loosely based on the maps created by Christopher Saxton in the 1570s, but with many additions that could only have come from further research and local knowledge. Apart from some improbably high peaks in the Chilterns, the landscapes they represent are pleasingly accurate – trees cluster together to represent woodlands, hunting parks are neatly fenced off, gently shaded hills indicate open plains, rivers are crossed by stone or timber bridges and towns bristle with church towers. Even the Rollright stones at Long Compton are shown. Woven into one of the tapestries' texts is a landscape mystery, which relates that the land near a village south of Edgbaston, named as 'The Worldesend', 'was dryven

Detail of a 'map tapestry' commissioned in the 1580s by Ralph Sheldon, showing part of Warwickshire.

downe by the removyng of the ground'. Whether this sudden change in the land's appearance was caused by a natural disaster or by a mining or quarrying catastrophe, the tapestry does not tell.

One exceptionally grand surviving landscape interior can be seen at the great Derbyshire prodigy house built by Bess of Hardwick. 'Hardwick Hall, more glass than wall', they joked at the time – and from inside, great windows, fully glazed at staggering expense, frame the surrounding landscape in a new and dramatic way. Hardwick Hall is not only a spectacle in itself; it provides one, too. In the High Great Chamber, an upper room of grand proportions where Bess received her most important visitors, above a rich run of tapestries wrapped around the top part of the wall is a panoramic plaster frieze, completed about 1599, showing a magnificent wooded landscape. Here is the court of Diana, the virgin goddess and huntress – intended by Bess as a flattering allusion to Queen Elizabeth, the Virgin Queen – while nearby a boar hunt crashes through the foliage. The frieze's plasterwork gives the figures and attendant deer, elephants,

Real saplings adorn the landscape frieze in the High Great Chamber at Hardwick Hall, Derbyshire, c. 1599.

camels, lions, dogs and other animals a sculptural solidity. And far from fading into the background, the trees, constructed from real saplings nailed to the laths, come forward too.[48]

Standing in the High Great Chamber at Hardwick, our ideas of inside and outside are given a playful spin: the view from the window turns the surrounding landscape into a picture, while real trees contribute to the room's pictorial forest. This brilliant conceit makes the room one of the most perfect expressions – along with the vanished court masques – of the Elizabethan and Jacobean ability to combine a love of symbolic and metaphysical thought with an unabashed desire for extravagant worldly display.

John Dunstall, *A pollard oak near Westhampnett Place, Chichester,* c. 1660.

III

DISCOVERY

And I with my black lead pen took the prospect
John Evelyn, *Diary*

AN ART SOE NEW IN ENGLAND

Once upon a time there was a gentleman of Antwerp who, having recently
returned to the city from a journey to Liège and the forest of Ardennes,
paid a visit to a friend to tell him about his travels. His friend, a painter,
continued to work at his easel while he listened to a rapturous account of
the scenery his visitor had witnessed. Intrigued and inspired, he quickly
replaced his picture with a fresh canvas without attracting attention and
began quietly to paint the landscape that was so enthusiastically being
described to him – the sweeping valleys! the dense forests! the alpine
rocks! the great castles! At length his visitor happened to glance at the
artist's canvas, and was astonished to see a visual record of his own
journey. It was just as though his friend had been beside him, and seen
the landscape with his own eyes.

And that was the beginning of landscape painting.

This story – a foundation myth for the genre – was related by the
English artist and musician Edward Norgate in his widely read treatise
on miniature painting, *Miniatura*, written in 1627–28 and revised exten-
sively some twenty years later.[1] Urbane, able and abounding in talents,
Norgate came to the court's notice and was employed by James I and,
later, his son Charles I in various capacities – the Cavalier poet Robert
Herrick described him in verse as 'one so rarely tun'd to fit all parts...
one to whom espous'd are all the Arts'. He was a skilled painter of por-

trait miniatures and illuminator of heraldic documents, and, above all, well connected: his patron was the Earl of Arundel, the most ambitious and discerning collector of the Stuart court, his 'Cousinell' was the miniaturist Peter Oliver and his brother-in-law was the connoisseur and collector Nicholas Lanier.[2] When Anthony van Dyck made his second visit to England, he initially lodged with Norgate; when Arundel wanted to acquire drawings by Rubens, he asked Norgate to step in; when the King wanted to commission Jacob Jordaens to paint a decorative scheme on the subject of Cupid and Psyche at the Queen's House in Greenwich, Norgate did the negotiating.

Norgate's knack for being in the right place at the right time extended to the age more generally. The first half of the seventeenth century saw a new and enlightened attitude to visual art at the British court that contrasted sharply with the insularity that had prevailed under Elizabeth I; Charles I was a passionate collector who actively imported paintings, sculpture and indeed artists themselves from the Continent, surrounding himself with architects, designers and connoisseurs and building a collection of legendary status. One of the new ideas to arrive at this time of cultural ferment was the concept of landscape painting. Norgate devoted a section of *Miniatura* to landscape, but even twenty years later, when he set about revising his treatise, he still felt he had to begin this section by explaining what it actually was. Landscape painting, he claimed, lacked a proper name: it was 'An Art soe new in England, and soe Lately come a shore, as all the Language in our fower Seas cannot find it a Name, but a borrowed one…'. The word Norgate proposed for this new arrival, *Lanscape*, is based on the Dutch *landtschap* on the grounds that the Netherlands was generally regarded as the birthplace of the genre. He glosses it as 'shape of Land', and explains that it 'is nothing but a picture of *Gli belle Vedute*, or beautifull prospect of *Feilds, Cities, Rivers, Castles, Mountaines, Trees* or what soever delightfull view the Eye takes pleasure in'.

Nowadays, given the strong tradition of landscape painting that was subsequently to develop in Britain, it seems almost comic that the concept had so earnestly to be explained. But – surely a pertinent question to ask with two chapters of this book already behind us – was 'lanscape' (or 'landtskip' or 'landskip', as it was often called at this time) really such a

foreign concept in the first half of the seventeenth century? Or did it mean something subtly different to writers of this era and their readers? Norgate evidently thought that foregrounding landscape as a subject by itself in an oil painting or watercolour drawing was fundamentally different from creating a decorative frieze of a wooded landscape, drawing a bird's-eye view for military or other practical purposes, or staining decorative cloths with depictions of trees and hills in tapestry-like 'verdure'.

Edward Norgate was writing in extraordinary times. It is hard, now, to imagine the excitement connoisseurs at court must have felt as precious works of art, newly shipped to London, emerged from their packing cases. Seeing a painting by Titian for the first time, illuminating a sombre Stuart interior with its rich Venetian tones, must have seemed like a magical experience. As more and more pictures and sculptures arrived, each adding as much to the store of knowledge as to the collection itself, it was a time for those who gathered around the king at Whitehall to look with greater discernment, to compare one artist with another and, importantly, to establish genres. It was no wonder that they were in a mood to treat the landscape paintings that began to arrive from the Continent as a new phenomenon; a *'Noveltie'*, according to Norgate; an 'Invention of these later times'.[3]

Norgate narrowed his definition of landscape painting as an 'absolute and intire Art' down even further, careful to draw a distinction between pictures whose whole subject was a view over a natural scene from those which focused on human subjects, though they might have landscape backgrounds. 'For it doth not appeare,' Norgate writes,

> that the antients [Old Masters] made any other Accompt or use of it, but as a servant to their other peeces, to illustrate, or sett off their *Historicall* painting, by filling up the empty Corners, or void places of Figures, and story, with some fragment of *Lanscape*...[4]

For Norgate, landscapes that 'fill[ed] up the empty Corners' were hardly worthy of the name. We might not agree with him: the glorious hilly, wooded landscapes glimpsed over the shoulders of so many Virgin and Child subjects, receding into misty blues, seem fascinating to modern

eyes. But Norgate was busy making sense of the genre of landscape, and suppressing its grey areas helped to bring it into focus.

So what kinds of pictures *did* he include in this new genre? He had access, of course, to the best collection in the land, and points out in *Miniatura* that landscape painting is 'now a *privado* [private friend or confidant] and Cabinet Companion for Kings and Princes'; Charles I hung landscape paintings in his Cabinet Room and nearby bedchamber, the inner sanctums of his private apartments at Whitehall where he kept his most precious and prized works of art. Among a number of small pictures on the densely hung walls of his Cabinet – where it rubbed shoulders with paintings by Leonardo and Raphael – was a small landscape by Paul Bril.[5] Born in Antwerp, Bril went on to live and work in Rome, where his precise northern European style was transformed by the light, atmosphere and drama of the Italian campagna as much as by contact with Italian landscape painters. The king's *A Landscape with Goatherds* (*c.* 1620) was a small-scale 'cabinet picture', so-called because paintings of this kind were made to be enjoyed in domestic interiors rather than in grander, more public spaces. Painted on smooth copper rather than textured canvas, Bril's view of a hilly, wooded scene has an enamelled brilliance. It is a seductive painting, one that opens a little window to give us a glimpse of a far-away Arcadia, a place of gentle sun and deep shadow where goatherds ramble at their ease in picturesque costumes, and shelter from the sun in a tree's cool shade.

If a 'beautifull prospect' such as this was Norgate's idea of landscape, it was, it has to be said, a carefully staged one: the hill and trees frame the distant view, drawing our eyes towards it. Bril's landscape has more than a touch of theatre about it. Norgate knew the artist, and in *Miniatura* passes on a tip to add drama to a painting: 'one generall rule I had from my old friend Paulo Brill,' he remarks confidentially, 'which hee said will make a *Lanscape Caminare*, that is move or walke away, and that is by placing Dark against Light, and light against Darke'.[6] *Landscape with Goatherds* displays just this contrast, which connoisseurs of the time called by its Italian name, chiaroscuro.

Norgate had absorbed some of these lessons in landscape himself. Having skilfully prepared the king's elaborately decorated state letters for

many years, in 1633 he was appointed Windsor Herald, and among his tasks for the College of Arms was to illuminate letters patent and other heraldic documents. A Grant of Augmentation of arms from Charles I to Sir William Alexander, First Earl of Stirling, created in 1634, is thought to have been drawn by him. The text of the document is all but overwhelmed by its intricate decoration, including landscape vignettes indebted to the so-called 'Dutch–Italianate' artists, among whom Bril was a pioneer. This group of artists had travelled from the Netherlands to settle in Rome, where they expanded their repertoire of landscape motifs and generally revelled in the golden light, so different from the prosaic northern light of home. In one of Norgate's little drawings a procession wends its way down a winding path between dramatic rocky outcrops and tall trees, while others show scenes of hunting, each in a fully realized setting of woods or open valley. They are views of his invention, *jeux d'esprit* rather than sober transcripts.

The College of Arms grants an augmentation of arms with a document richly decorated with imaginary landscape scenes.

In early seventeenth-century Britain there were no native landscape painters such as those in the Netherlands and Italy; the nation's dearth of fine artists in general was deeply entrenched and slow to change. Charles I and his small circle of connoisseurs were obliged to look to the Continent, gathering works of art from far and wide. Even a hundred years later, the portraitist and influential art theorist Jonathan Richardson could still only look forward in hope to a day when matters might improve: 'Thus a thing as yet unheard of, and whose very Name (to our Dishonour) has at present an Uncouth Sound may come to be Eminent in the World, I mean the *English School of Painting*....'[7] Nor were there British dealers with anything approaching the stock of foreign paintings that could be found in cities like Venice, Rome, Antwerp and Amsterdam, so agents had to be dispatched abroad to find pictures. But by the 1630s, artists were being tempted over by the English court: Francis Cleyn to work at the tapestry factory at Mortlake, Hubert Le Sueur to practise as a sculptor, Peter Paul Rubens to paint the ceiling of the Banqueting House at Whitehall and Anthony Van Dyck to be the court portraitist. All well and good, but where were the landscape painters? Not a single artist who specialized in landscape was lured over the North Sea to work for the court. Was the British landscape deemed too dull to have its portrait painted? Or was the very point of landscape painting that it revealed distant and romantic places that one could not otherwise see?

Things were soon to change. In inviting Rubens and Van Dyck to the English court, Charles I inadvertently imported two artists who loved to draw and paint landscapes. In 1630 Rubens, temporarily in London as a diplomat, began a painting that he explained was 'in honour of England'. It depicts Charles I as England's patron saint St George. He has just slain a dragon that had been terrorizing a surprisingly large group of women, who express their gratitude while yet more people look on from the safe haven of a capacious tree. A pair of putti clutching laurel and bay celebrate with aerial gambols in a bright shaft of sunlight. Paradoxically, what makes this exuberant baroque fantasy with its rosy flesh and gleaming armour so improbable are its elements of realism. For one thing, the king makes a peculiarly un-heroic St George – a few years later Van

Dyck would just about get away with perching this neat figure with his air of fastidious reserve on the back of a monumental charger, but here Rubens stretches credulity to breaking point. But what really undercuts the painting's high-key themes of death, horror and salvation is its recognizably English landscape, with its gently sloping fields, clumps of trees and meandering river. Rubens set his theatrical tribute to England on the rather mundane banks of the Thames. It might even partly be based on the specific view from his lodgings at the palatial York House – which stood near the present-day Embankment underground station – looking southwest towards Lambeth Palace on the opposite bank.[8]

Anthony van Dyck – Rubens' sometime pupil – paid an even greater degree of attention to the actual landscape during his visits to England. He took his pens, inks and watercolours out into the fields to capture details of the natural world on paper. He looked intently at the fall of light on foliage and how it changes when blown in a breeze. He sat down

A study of trees by Anthony van Dyck, drawn while he was working for the English court in the 1630s.

to draw prospects of distant hillsides, and he got up close to sketch the complicated tangle of plant growth. This elegant, urbane visitor, with his illustrious contacts throughout the Netherlands and Italy, must have cut an unlikely figure in the English rural landscape of the 1630s, down on his hands and knees in a field, painstakingly drawing a clump of weeds that he identifies in an inscription as 'Soufissels [corn sow-thistle], nettels, gras'. One wonders what the field workers made of him.[9] But most of all, when he made these trips into the country Van Dyck drew trees: oaks and elms standing singly or in clumps, almost always in full leaf (he was evidently a fair-weather sketcher). He might have made these drawings, in part, for pleasure; but he also referred back to them when planning a composition. When he came to paint his great equestrian portrait of King Charles, now in the National Gallery in London, he sifted through his studies and found one in which he had captured a group of mature trees in watercolour, pale colours highlighting the outer foliage and darker tones giving a sense of the volume and commanding presence of these leafy giants. Choosing one, he used it as a model for a tree in the middle distance, just to the left of the king's horse. A good deal of rhetoric is involved in this royal portrait, but by including this natural detail painted from his own observation, Van Dyck shifts to a more subtle use of symbolism. He places the king within his own native landscape.

Although for centuries there had been depictions of the British landscape – whether decoratively in stained glass and painted cloths, in the margins of manuscripts, or in bird's-eye views made for military or legal purposes – it took these two ultra-sophisticated artists from Antwerp to demonstrate that the hills, fields and trees of Britain could be Art with a capital A.

TAKING LANDSKIPS

Drawing came naturally to the diarist John Evelyn, and he began to sketch the world around him even before he went to school. As an adult he drew the landscapes and buildings around his home in red chalk, and when he set out to plan his celebrated, now lost, gardens at Sayes Court, Deptford,

the first thing he did was to take up pen and paper.[10] Naturally, when in the mid-1640s he embarked on a long tour through Europe, he packed his drawing materials, recording many occasions in his diary when he 'tooke a Landskip'. In November 1664 he climbed up to the inn at Radicofani, where at the top they reached a

> most serene heaven…for we could perceive nothing but a Sea of thick Clowds rowling under our feete like huge Waves, ever now and then suffering the top of some other mountaine to peepe through…. This was I must acknowledge one of the most pleasant, new and altogether surprizing objects that in my life I had ever beheld….

'Here we dined,' he continued, 'and I with my black lead pen took the prospect.'[11] In February the following year, Evelyn climbed Mount Vesuvius and looked down at the Bay of Naples. Again, he could not resist getting out his 'black lead pen' to draw what he saw in front of him: 'one of the goodliest prospects in the World', he declared; '…nothing can be more great and delightfull'.[12] Although the pencil drawing that he did on the spot that day (now in the British Museum) could not be called a great work of art, it speaks of the exhilaration Evelyn felt, and of his careful efforts to create a visual record of this remarkable landscape so that he would not forget it.[13]

Art – or drawing, at least – was not just practised by professionals. It began to be recognized as a practical skill, something that would prove useful to 'all such that either study the Mathematicks, mean to follow the wars, or travell into forreine countries', as the schoolmaster Henry Peacham had put it in his book *The Art of Drawing with the Pen, and Limning in Watercolours* (1606). Peacham's was the earliest manual professing to teach the rudiments of drawing and to advise on materials and subjects, but many were published in Britain over the course of the seventeenth century, as the appeal of sketching gradually widened; from its initial status as a useful masculine pursuit, it began to be seen as an amusing pastime. Peacham incorporated his earlier chapters into his celebrated and widely circulated 'courtesy' book *The Compleat Gentleman* (1634 and 1661), designed to advise young men in correct conduct, prepare them for positions in public life and instil a broad range of knowledge from the

physical fabric of the world to culture, including cosmography, geometry, poetry, music and the visual arts.

Peacham was writing before artists' suppliers existed, so he had to begin by explaining the basic materials one would need to gather: 'you must first get you blacke lead sharpned [sic] finely: and put fast into quils, for your rude and first draught, some ten or twelve' (cedarwood casings to hold sticks of graphite more conveniently were not invented until later in the century); and 'you must not be without as many Sallow coales [charcoal sticks], sharpned at the ends'. There was more advice for fashioning homespun materials: he instructs his readers in making 'small pencils of Broome' by chewing a stalk 'till it be fine and grow heary at the end like a pensill [brush]', to acquire raven's quills 'to write faire, or shadow fine' and goose quills 'for the bigger or ruder lines'. But for all his belief in the importance of drawing, he cautions his gentlemen readers not to take up art as a profession ('never leave the Mistresse to court the maid', he warns in his preface), but instead to practise it as an 'accomplement required in a Scholler or Gentleman'.[14]

'Landtskip' is high up in the list of subjects Peacham thinks suitable for the gentleman amateur – it is a Dutch word, he says, 'expressing of the land by hilles, woods, Castles, Seas, vallies, ruines, hanging rocks, Cities, Townes, &c. as farre as may be shewed within our Horizon'. He is full of advice for those about to embark on a landscape drawing: always show either an overcast sky or a clear one, he suggests; show the sun either rising or setting and avoid painting a night sky; make sure the shadows follow the sun, that objects a long way away are not depicted in too much detail and that you paint the distant landscape with 'a thinne and ayerie blew, to make it seeme farre off'. As inspiration, he ambitiously suggests we think of 'the most beautiful Landtskips in the world': Mount Lebanon, Constantinople, Mount Ida in Crete, the banks of the Rhine and Spain 'toward the Seaside neere Cartagena'. If we must confine ourselves to English views, then he recommends Windsor and surrounding country and the City of London from Highgate (he evidently thought impressive architecture would benefit our compositions).

But perhaps he realized that many of his readers would be just as happy sitting at home inventing compositions; he also suggests that they

should practise their skill by representing 'the abstract or labour of every moneth'. A 'winter peece', he advises,

> should be graced and beautified with all manner of workes and exercises of winter, as foot-ball, felling of wood, sliding upon the yce, batfowling by night, hunting the Beares, or Foxe in the snow, making you trees every where bare or laden with snow, the earth without flowers, and catell, the ayre thicke with clouds, rivers and lakes frozen, which you may shew by cartes passing over, or Boyes playing upon the same, and a thousand the like.

It was a place full of people, games and incident of the kind Pieter Bruegel the Elder would have recognized. 'If you draw your Landtskip according to your invention,' continues Peacham, 'you shall please very well'.[15]

But, delightful as his evocation is, would the idea behind it not have sounded a little old-fashioned in Stuart England? Peacham's idea that his readers should represent scenes emblematic of the annual cycle of months suggests that they should rely on tradition and convention rather than going out into the world and looking with fresh eyes. Edward Norgate took a different view. Although he thought it perfectly alright to pay attention to 'those representations you find in your owne fancy', better by far, according to him, was 'diligent observation of the Life'. It was there, and only there, 'where in you will find that infallible helpe and direction, for your improvement and proficiency in the Art, as is not in the power of a pen to describe'.[16]

Someone who might well have followed Norgate's advice was John Dunstall, a schoolmaster and self-professed 'Teacher of the Art of Drawing' who lived on the Strand in London and is thought to have been born in West Sussex. He intended to publish a treatise on drawing himself, and six volumes of his manuscript notes on geometry and the delineation of faces, trees, houses, flowers and fruits, which remained in his possession at his death in 1693, are now in the British Library.[17] One fine summer's day around 1660, Dunstall was in the village of Westhampnett on the outskirts of Chichester, near his purported birthplace. He took a chair and placed it at the side of the road in front of a dead pollarded oak, sat

down and began to draw, first sketching the broad shapes with what he would have called 'black lead', which we now know as graphite. He continued with watercolours, each of which he would probably have prepared himself, grinding pigments together with a binder such as gum arabic (made from the sap of acacia trees) or gum hedera (extracted from ivy) and, when he was ready to use them, mixing them with a little water in a mussel shell. The watercolour he made shows the meticulous attention to detail he brought to this scene, tracing every branch and twig of the oak, the delicate texture of its bark and the shiny leaves of its bushy crown of ivy (see p. 72). Dunstall painted this venerable oak standing on a bank bursting with vigorous new growth, against a landscape of young trees in full leaf. It is hard not to see his picture as a tender deathbed portrait of a favourite old tree – perhaps one he had known as a child.

There is something valedictory, too, about the materials Dunstall chose. He painted on vellum, which had begun to pass out of common usage and was more strongly associated with legal documents than landscape studies – though it was still recommended by Peacham and Norgate for portrait miniatures, with Peacham telling his readers to buy 'the fine skin of an Abortive, which you may buy in Pater noster row, and other places, (it being the finest parchment that is)'.[18] Vellum provided a smoother surface for the watercolour paint than paper, and lent Dunstall's portrait of the oak a static, emblematic air. There is no weather in this picture, no wind to stir the tree's branches. In fact, his picture seems to look both backwards and forwards: its vellum and high-definition brushwork hark back to a medieval and Elizabethan past – compare it to Van Dyck's lively, brushy landscape watercolour – but its dedication to the peculiarities of this particular tree, standing in this particular place with its rutted road and springing weeds, is thoroughly modern.

Dunstall's oak could be seen as a harbinger of the passion for drawing and painting that was to seize the middle and upper classes over following decades. Throughout the eighteenth and nineteenth centuries, up and down the land pencils would be sharpened, watercolours mixed and brushes poised over sketchbooks, as successive generations of amateur artists tried their best to capture views on paper.

A COUNTRY THAT ABOUNDS WITH RARITIES

Rather than a drawing, the Derbyshire squire Charles Cotton chose to capture the essence of his native county in a long poem, *The Wonders of the Peake* (1681). His perspective was not, however, a flattering one. He described a stretch of country

> ...so deform'd, the *Traveller*
> Would swear those parts Natures *pudenda* were:
> Like *Warts* and *Wens*, hills on the one side swell,
> To all but *Natives* inaccessible;
> Th'other a blue scrofulous scum defiles,
> Flowing from th'earths impostumated boyles;
> That seems the steps (Mountains on Mountains thrown)
> By which the *Giants* storm'd the *Thunderers* throne,
> This from that prospect seems the sulph'rous flood,
> Where sinful *Sodom* and *Gomorrah* stood.[19]

Cotton plays it for laughs with the extravagance of his exaggerations, setting out his stall in these opening lines: the hills and moorlands of the Peak District were, according to the standards of his day, ugly and bleak, the kinds of places to be avoided, not sought out. He is not going to try to persuade us otherwise. What he does instead is to invite us on a tour of the wells, caverns, hill and house that constituted the seven 'Wonders' of the Peak, beginning at Poole's Hole and St Ann's Well at Buxton and going via the Ebbing and Flowing Well at Tideswell and Eldon Hole near Peak Forest, visiting Mam Tor in Castleton, Peak Cavern (also known as the Devil's Arse or Peake's Arse in Cotton's day) and ending up at Chatsworth. On the way, we get rather more than we bargained for.

Cotton's itinerary had its roots in medieval tales of 'marvels and wonders', such as Caxton's account of the remarkable features of the Peak District in his *Description of Britain*. But another inspiration of sorts was a poem published earlier in the century. The philosopher Thomas Hobbes had toured the area back in 1626, and ten years later he published *De Mirabilibus Pecci*, in which he wrote of the same sites: 'Of the high Peak

are Seven wonders writ. / Two Fonts, two Caves, one Pallace, Mount and Pit'.[20] Hobbes was in a mood to examine these so-called 'wonders', and to try to understand the physical laws that created such strange – or even, according to local legend, supernatural – effects. After visiting the Ebbing and Flowing Well at Tideswell, we can almost see him glancing suspiciously back at it over his shoulder as he rides away:

> Our journey we hast on, but as we go,
> We searching strive by ev'ry sign to know
> From what hid cause, so great a strife should Spring,
> For neither saltness, nor yet any thing
> That's common to the Water of the Sea,
> Are in this Fountain ever found to be...
> What then should be the cause? in short 'tis this.
> The water which from under ground doth rise
> And with its forreign stream fills up the Well,
> Does not come thither brought by 'ts own Cannel
> And willingly anothers right invades

In a stream of explanatory rhyming couplets, Hobbes goes on to describe the 'swelling tides' and 'swift currents' of subterranean waters that would produce such an effect, only stopping when he notices that evening has come and it is high time for a warm bath and supper.[21] Cotton takes a different approach. He offers his reader the visceral sensations of what it is like to be in this peculiar landscape, inviting us to imagine being overwhelmed by the thundering noise of rushing water; to think of how it feels to descend into a cave, with a narrow path of slippery rocks underfoot and a terrible drop on one side. He has been down there before, and can tell us that it is 'steep, / Craggy, and wet', and that 'None who has any kindness for his bones, / Will venture to climb'. 'I did once' he admits, adding disarmingly: 'A certain symptom of an empty sconce'.[22] We descend with him into Poole's Cavern, where

> ...a roaring *Torrent* bids you stand,
> Forcing you climb a Rock on the right hand,

Which hanging, pent-house like, does overlook
The dreadful Channel of the rapid Brook,
So deep, and black, the very thought does make
My brains turn giddy, and my eye-balls ake.
Over this dangerous *Precipice* you crawl,
Lost if you slip, for if you slip you fall;
But whither, faith 'tis no great matter, when
Y'are sure ne'er to be seen alive agen[23]

Cotton's Derbyshire landscape is dangerous, tricky and perverse. Its caves open up at our feet like chasms into Hell; its hills are treacherous; a little innocent-looking stream will suddenly boil up and become a torrent. It doesn't even smell like a normal landscape – with characteristic plain-spokenness, Cotton tells of one cave that 'yields a scent / Can only fume from *Satan's* fundament'.[24]

Cotton does not want Hobbes to spoil it all with his rational explanations. Anyway, he contends, 'To seek investigable *Causes* out, / Serves not to clear, but to increase a doubt' – though he does not sound as though he has entirely succeeded in convincing even himself.[25] No matter. What he offers is fun: the seventeenth-century equivalent of an amusement park ride. His verse invokes the same exhilaration of organized terror – although in place of the ride's mechanisms keeping us safe (at least in theory) while appearing to plunge and spin us into oblivion, here we can lean gratefully on sturdy local guides: 'Two Hob-nail Peakrills, one on either side, / Your arms supporting like a bashful Bride'. We, his readers, can enjoy the Wonders of the Peak vicariously, following in Cotton's footsteps and smiling at his tall tales. And if our hair is not standing on end at the very thought of them, lifting our hats clean off our heads – which he promises will happen if we dare to glimpse down Elden Hole – he might even persuade us to visit.[26]

But despite Cotton's persuasive good humour and love of a yarn, it was Hobbes's more scientific point of view that prevailed. A new spirit of enquiry opened up intellectual horizons in the second half of the seventeenth century, sweeping away the old reliance on literary description

and time-honoured tradition. Rather than telling extravagant stories about curious features of the landscape, people began to give them serious attention. Thomas Browne caught the mood of the times when, in his spiritual testimony *Religio Medici* (the Religion of a Doctor, 1643)

Francis Barlow, two men examining Kit's Coty House,
the remains of a long barrow in Kent, 1650s.

he described nature as 'that universall and publike Manuscript, that lies expans'd unto the eyes of all'.[27] Experiments began to uncover the secrets of the physical world, and direct experience was valued above all. The motto of the Royal Society (founded in 1660), *'Nullius in verba'* – take no one's word for it – reflected this new attitude. Britain's landscape, with its geological features, its prehistoric monuments and its towns and cities, was raw material that now began to be investigated with unprecedented rigour.

'I was inclin'd by my genius, from my childhood to the love of antiquities,' recalled the antiquary John Aubrey, 'and my fate dropt me in a countrey most suitable for such enquiries'. The Wiltshire countryside where Aubrey grew up was indeed a suitable 'countrey' for a boy with an interest in ancient and mysterious sites; 'Salisbury-plaines and Stonehenge', he recalled, 'I had knowne from eight years old'. In some ways, his method was simple: instead of relying on written authorities, he got on his horse and went to see for himself. '[E]ven travelling', he writes, '(which from 1649 till 1670 was never off horseback) did gleane some observations, of which I have a collection in folio of 2 quiers of paper plus a dust basket, some wherof are to be valued'.[28] It was a radically new way of doing things. Above all, Aubrey looked analytically – he wanted to know *why* things looked as they did. What could ruins, monuments and smaller historical fragments that had survived what Francis Bacon had called the 'shipwrack' of time – particularly the depredations of the English Reformation and then later the Civil War, which was raging while Aubrey was an undergraduate – tell us about the past?[29]

At Christmas 1648, Aubrey, then twenty-two, was invited to stay with his friend Lord Francis Seymour at his Wiltshire home, Wolfhall. The morning after twelfth night there was a meet of the hunt at the 'grey wethers', a littering of sarsen stones on the turf not far from Avebury. 'These Downes', observed Aubrey,

> look as if they were sown with great Stones, very thick, and in a dusky evening they look like a flock of Sheep: from whence they take their name: one might fancy it to have been the scene where the Giants fought with great stones against the Gods.

The hounds picked up a scent that took the hunt into Avebury village, and it was then that Aubrey made one of his greatest discoveries – the Avebury stone circle.

> I was wonderfully surprised at the sight of those vast stones, of which I had never heard before, as also the mighty bank and graffe [ditch] about it. I observed in the enclosure some segments of rude circles made with these stones, whence I concluded they had been in the old time complete.

'I left my Company a while', he continues, 'entertaining myself with a more delightful indagation'.[30] Of course, people knew these great stones were there before Aubrey chanced upon them that day; what made the difference was his ability to look at them in relation to the landscape in which they sat and to other stone circles. His revelation was born of knowledge and experience.

Years later, Aubrey's investigations brought him to the notice of Charles II. One day the king was talking of Stonehenge, when someone repeated to him Aubrey's opinion that Avebury 'did as much excell Stoneheng as a Cathedrall does a Parish Church'. Having not previously heard of Avebury, the king asked Aubrey to join him and the court at Marlborough, where the antiquary showed him what he called 'that stupendous Antiquity' – noting with satisfaction that 'with the view thereof he and his Royal Highness the Duke of Yorke were very well pleased'. The king asked Aubrey to give an account of 'the old Camps and Barrows on the Plaines', then his eye fell on Silbury Hill, 'which he had the curiosity to see, and they walkt up to the top of it'. Charles subsequently instructed Aubrey to survey Avebury, which he did 'with a plain-table and afterwards tooke a review of Stoneheng'.[31] It was then that he discovered the ring of chalk pits just inside the ditch surrounding Stonehenge that now bear his name: the Aubrey holes.

Aubrey thought it likely that these ancient monuments were pagan temples, and his historical imagination pictured Druids as their most probable priests. He knew that he was not quite there, but that he was tantalizingly close. '[T]his Inquiry, I must confess, is gropeing in the Dark',

he wrote, 'but although I have not brought it into a cleer light yet I can affirm that I have brought it from utter darkness, to a thin Mist'.[32] Aubrey recorded his findings on Avebury and Stonehenge, and his articles were later developed in his great work *Monumenta Britannica, or, A miscellanie of British antiquities*, a description of ancient sites around Britain written between *c.* 1665 and 1693. Although not published in his lifetime, it has aptly been called the 'foundation text of modern archaeology'.[33]

The image of Aubrey standing on top of Silbury Hill with Charles II, knowing that he had caught the king's interest and eagerly pointing out this and that ancient site in the beloved 'countrey' of his childhood, is a perfect reflection of this age of discovery. The view may have been slightly misty, but Aubrey and other antiquaries were beginning to see deep history emerging from the landscape.

British artists did not, apparently, share Aubrey's passion for field trips – or at least, not until much later. The first to roam the landscape in search of its views and prospects and to draw and paint its curiosities came from overseas. Wenceslaus Hollar was among the earliest of these pioneers. Born in Prague, by the 1630s he was living in Cologne, making topographical sketches of the Rhine and taking expeditions up to Mainz and down to Amsterdam. In 1636, he was discovered by Thomas Howard, Earl of Arundel, who, remarking that he 'drawes and eches Printes in stronge water quickely, and with a pretty spiritte', scooped this talented, busy, cheerful man up in his retinue and, after some further travel, brought him to London.[34] Hollar was equally happy looking at things close by and at a distance, and switches almost disconcertingly between the two views. He was a virtuoso with the etching needle, an artist who could capture the soft folds of a fur muff with the attentiveness of a fetishist and yet also create astonishingly detailed and accurate bird's-eye views of London, Windsor and elsewhere. These landscapes were probably inspired by the pioneering maps drawn by Leonardo da Vinci in the early years of the sixteenth century, which were then among the treasures of Arundel's collection.

One of Hollar's most touching views is a modest work, part of a set of six etchings commissioned by Lord Arundel to depict Albury, his

The grounds of Albury, Lord Arundel's manor house in Surrey,
by Wenceslaus Hollar, 1645.

manor house in Surrey. Arundel loved walking through the grounds of Albury; according to Aubrey, he 'had many Grotts about his house, cutt in the Sandy sides of hills, wherein he delighted to sit and discourse' – although he nearly came to an untimely end when one day the sandy bank collapsed. Hollar's etching shows a river with a church spire on the far side, tall trees, a broad path bordered by a high bank and Arundel and his party out for a stroll on a summer's afternoon – the kind of day on which the Lord liked to imagine Albury to be an Italian landscape, and himself an English version of a Medici prince.[35] The group strolls slowly away from us, the nearest a woman holding the hand of a young girl. We can easily picture ourselves falling into step behind them. But by the time Arundel commissioned the set of prints from Hollar in 1645, he was living in exile in Antwerp, never to set foot in England again. This print, and the others describing Albury, were in some way a substitute for the real thing; portraits of a beloved place he had left behind. What is most remarkable is that Hollar was also in Antwerp, and made the views from memory.[36]

Despite these commissions from Arundel and a reputation for being 'really the most indifatigable man that ever liv'd', Hollar was forever in need of funds.[37] Consequently, he became increasingly focused on creating saleable images, particularly collectable series of prints – of insects, for

example, or ships, or the seasons. He was too occupied with his copper plates and *aqua fortis* in his lodgings on Gardiner's Lane, Westminster, to take up a sketchbook, head for the country and wander in a spirit of speculation as he had done in his youth. The Dutch artist Willem Schellinks, by contrast, came to England with a commission that gave him free rein. When Laurens van der Hem, a member of a wealthy family in Amsterdam, decided to assemble a collection of topographical views, Schellinks was among the artists he commissioned to travel through Europe and England and make sketches that could later be worked up into finished pictures. Van der Hem's collection grew so prodigiously that at the time of his death it filled forty-six volumes. Surviving sketches, now in the British Museum, bear witness to what caught Schellinks's eye over his two-year stay between 1661 and 1663, and to the subjects he thought worthy of van der Hem's album.

Schellinks sought out the most extravagantly strange landscape features England had to offer. He travelled as far as Cornwall, where he drew the granite tor known as the Cheesewring; his washy ink makes the top-heavy tower look cloudy and insubstantial, rather like a ghost spiralling up out of the earth. Perhaps somebody had told him the local legend that the Cheesewring was the result of a rock-throwing contest between a giant and St Tue – the frail saint was helped by the power of prayer, and the great stones he heaved seemed as light as air: he won. Schellinks visited Stonehenge – he could even have coincided with Aubrey,

Willem Schellinks, *The Cheesewring, near Liskeard, Cornwall*, 1661–63.

busy conducting his Review. If they had, Aubrey would probably have asked him for a drawing.

He drew St Michael's Mount in Cornwall, a natural and manmade wonder rolled into one, and sketched so many harbours, fortifications and naval ships at strategic locations such as Rochester, Chatham and Dover that he was suspected of working for the Dutch intelligence services. Perhaps he was. A large, rather bleak drawing, done in sombre tones of brown and grey and annotated with dense notes, shows a view of the Medway from a spot southeast of Rochester. The landscape on the far side of the river is obscured by a miasma of smoke. It records events of June 1667, when the Dutch fleet carried out a devastatingly successful attack on the unprepared English ships; in his diary Evelyn called it 'a Dreadfull Spectacle as ever any English men saw, and a dishonour never to be wiped off'.[38] Whether Schellinks had crossed the sea for another visit and was there in person on the Kent hillside to see, and draw, the English naval humiliation in real time, or whether he composed it from a mix of eyewitness reports and his earlier sketches of the area, remains a matter for debate.[39]

The late seventeenth century was not a good time to behave suspiciously in the landscape. Being in possession of a sketchbook and an enquiring mind was, in the contemporary climate, enough to make people suspect the worst. Francis Place came to know this well. Not a foreigner but a Yorkshire gentleman who delighted in making expeditions in the company of friends, fishing in rivers and making sketches along the way ('wee trudg here on at the old rate never Inquiring after any thing but where the best Ale is', he claimed), he was arrested twice at the time of the Popish Plot: once in Wales and once in Derby.[40]

If one set out to invent a figure perfectly reflective of the transition from seventeenth- to eighteenth-century ways of looking at the country, one might come up with a fair likeness of Place, a man who began as a cataloguer of places and ended as a landscape artist. As a young man, persuaded by his father to study law at Gray's Inn in London, he had met and become an intimate of Hollar, but was 'never his disciple', he lamented, 'which was my misfortune'.[41] Soon abandoning the law, he began to make the expeditions that would punctuate his life, travelling widely

Henry Gyles, *Stonehenge*, c. 1690.

throughout England, Wales, Ireland and Scotland and making drawings of the landscapes he found. He was among the very first English artists to do so. Place was fascinated by ancient sites, fortifications, ruins and natural 'wonders', and became a member of the York Virtuosi, a group of antiquarians, natural philosophers and artists who shared his interests, and who met at the home of the glass painter Henry Gyles. A drawing of 'Stonedge' made by Gyles in around 1690 bristles with the frustration of unanswered questions. With each emphatic stroke of red chalk one feels him wondering: How old is it? What did it mean to those who built it? Why does it look like this? For the York Virtuosi, these monuments were evidence of a deep, mysterious history embedded in the landscape, one that predated the Roman occupation and that must – surely – have profound implications for the origins of Britain. The intense observation involved in recording them in drawings was essential, they thought, if they were ever going to understand the history of the land.

Place may not have been Hollar's 'disciple', but his earlier drawings are full of his influence. Painstakingly linear, they are the work of a man full of curiosity about the world around him and keen to pin it down. In 1698 he travelled to Ireland, where he made a panoramic drawing of Drogheda from the opposite bank of the Boyne valley, in which he tried to represent every building, incline and natural feature with the fine nib of his pen. But Place's style changed. Rather than the contours of a distant vista, he became fascinated by the texture of natural forms: how light strikes a surface; where the shadows fall. So he adapted his drawing technique accordingly, using atmospheric washes and watercolour to

Francis Place, *The Dropping Well, Knaresborough*, 1711.

better represent his subjects. A large drawing of the Dropping Well at Knaresborough, made in 1711, reveals his old antiquarian fascination with natural wonders: the river Nidd has a high limestone content, and as it flows over a rocky crag it petrifies objects hung there. But his delicate treatment and meticulous focus on the rock face, which fills most of the drawing, suggests that he was also beguiled by the aesthetic qualities of this strange and fascinating landscape.[42] It was the beginning of a new era.

PROSPECTS

Rubens and Van Dyck may have demonstrated that the British landscape could be Art, but it took a later generation of artists to act on it. Before the middle of the seventeenth century, pragmatic concerns – the need for strategic coastal defences, the resolution of a legal dispute over property

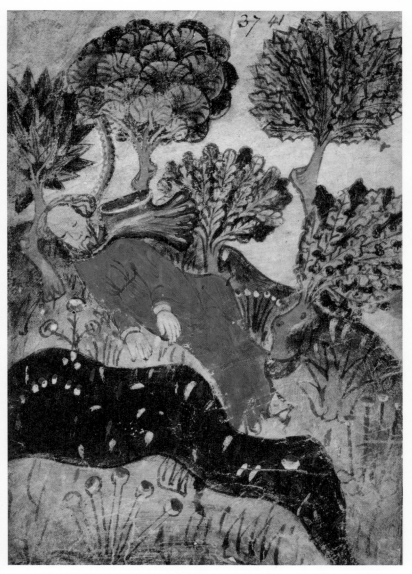

1 Searching for his 'precious perle wythouten spot', Pearl's narrator falls asleep by
the banks of a stream

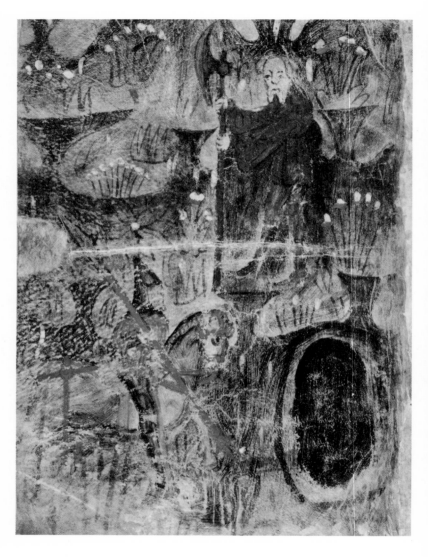

2 Sir Gawain meets the Green Knight at the Green Chapel in an illustration of *c.* 1400

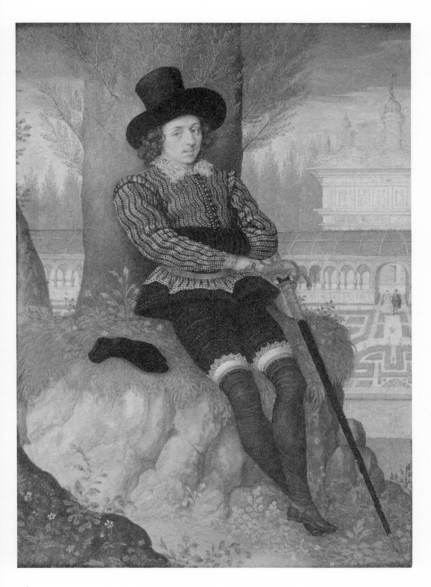

3 A portrait of a melancholy young man by Isaac Oliver, *c.* 1590–95

4 Jan Siberechts, *Nottingham from the East, c.* 1695

5 Richard Wilson, *View near Wynnstay, Llangollen,* 1770–71

6 Thomas Gainsborough, *Landscape with Cattle, c.* 1773

7 Philippe Jacques de Loutherbourg, *Coalbrookdale by Night,* 1801

A BALLOON PROSPECT *from* ABOVE *the* CLOUDS *see page* IIII c.
Publish'd May 1st 1786, by T. Baldwin Chester.

8 Thomas Baldwin, 'A Balloon Prospect from Above the Clouds',
from *Airopaidia*, 1786

9 Glass painting by Thomas Gainsborough, intended
to be viewed through the lens of his 'show-box'

10 'How gorgeously glowing!' Coloured lenses to enhance the landscape

11 J. M. W. Turner, *Prudhoe Castle, Northumberland*, c. 1826

12 John Everett Millais, *Ophelia*, 1851–52

boundaries – had periodically created the occasion for a pictorial map or bird's-eye view. But it was only now that the beauty and interest of Britain's valleys, woods, rivers, towns and ancient monuments began to swim into focus. For the first time, artists began to explore the landscape in search of prospects: its topography had become intrinsically interesting, its historical sites worth exploring. Times were changing and horizons expanding.

If you want a sense of the transformation in attitudes towards landscape in Stuart Britain, compare Edmund Spenser's descriptions to those of John Milton less than a hundred years later. The landscapes of Spenser's *Faerie Queene* do not appear to have grown so much as been wheeled on for his characters to negotiate, morally as much as physically. Reading the poem, we watch a shifting sequence of scenes unfold as if in a theatre. We get the sense that if we were to glance back, we would find that the wood, having served its allegorical purpose, has been tidied away by stage hands and the intrinsically unstable wandering islands 'which to and fro do ronne, / In the wide waters' have drifted elsewhere.[43] It would be hard to draw a map of the *Faerie Queene*'s topography.[44]

Milton, on the other hand, thought about the landscape as an entire composition – he considered how one element might balance with another, and weighed up the disposition of light and shade. Satan, having jumped over the wall into Eden, perches 'like a cormorant' on the highest tree in order to survey the scene, and we sit up there with him, seeing it through his eyes:

> Beneath him with new wonder now he views
> To all delight of human sense exposed
> In narrow room nature's whole wealth, yea more,
> A heaven on earth, for blissful Paradise
> Of God the garden was, by him in the east
> Of Eden planted...[45]

We follow his gaze as it roams over this 'happy rural seat of various view', taking in the trees and tracing the path of a river that passes in a channel underneath a 'shaggy hill', spotting a fountain that falls in little rills as it irrigates the garden, streams that roll 'With mazy error under pendant

shades', flower-strewn hills, dales, plains, sunny fields, shady bowers and the 'Groves whose rich trees wept odorous gums and balm', the lawns and level downs, palmy hillocks, 'umbrageous grots and caves / Of cool recess, o'er which the mantling vine / Lays forth her purple grape, and gently creeps / Luxuriant' – and finally a clear lake fringed with myrtle.[46] Eden is a site of overwhelmingly ideal beauty and fecundity, too 'like a cake *all plumbs*', as Thomas Gainsborough once described Antwerp, to suit post-lapsarian taste; but even so, it is also a convincing place, alive with its own rhythms of movement and growth.[47] Its water flows from one area to the next, changing form from a fountain to rills, from a large river to several streams; trees exude pleasant gums while the vine grows almost visibly; and each part balances another to create a harmonious environment for its inhabitants – to counter the hot sun on the plain, there is a shady bower or cool cave to offer shelter.

Milton is describing a garden, but it would not have been recognized as such in his contemporary Britain, where pleasure grounds were laid out formally in parterres, with geometrical 'plats' and lines of trees. In conceiving Eden as a place of meandering streams and clumps of trees, Milton thinks of it as a wide picturesque view rather than an assemblage of emblems – anticipating the eighteenth-century landscape garden. In the case of *Paradise Lost*, one really could draw a map – although a vast panoramic oil painting would suit the subject better.

In the late seventeenth century, the English landscape was at last becoming a subject for oil paintings, the most prestigious kinds of pictures. No longer merely appearing in the background of a portrait, or thought fit only for the decoration of overdoors and interior panelling, landscape was, at last, invited to share the limelight. Dutch and Flemish artists, steeped in their own highly developed landscape tradition, settled in England in such numbers at this time that we can only speculate about who was the first to paint the English landscape in this way, but the Flemish Jan Siberechts was certainly among the earliest. His presence in England had, it seems, been sought by the Restoration rake George Villiers, 2nd Duke of Buckingham, who had admired his landscapes during a visit to the artist's native Antwerp in 1670. Siberechts was a meticulous painter of views, who liked to climb up to a high vantage

point from which to survey every detail of a panoramic sweep. He was in Nottinghamshire, working for his patron Sir Thomas Willoughby of Wollaton Hall, when he took the path up high Colwick Hill and began to plan an ambitious view of the broad river valley with the city of Nottingham to the right, and Wollaton Hall itself in the distance (Plate 4). In his painting, completed in around 1695, he has given the landscape a more dramatic role than it has in reality, exaggerating the height of the surrounding hills and making the River Trent closer to the city than it really is. Nonetheless, that Siberechts gives centre stage to this specific, rural view appears to signal a new confidence in landscape as a subject. Here, it appears not as a backdrop to a hunting scene or a country house (in fact, the tables are turned), but for its own sake.

In some ways, though, Siberechts's pioneering paintings represent a false start. No matter how attractive the scene, few patrons would commission such pictures. While an artist could, in the vein of Francis Place, travel around with a sketchbook making drawings of whatever prospect caught his fancy, none in this period would risk making a speculative oil painting – the materials were expensive, and the time invested too great. So how could this new genre express itself? Perhaps portraiture had dominated British art for so long that landscape was obliged, at first, to share some of its qualities. People did commission Siberechts, or the Dutch artist Leonard Knyff, to paint landscapes – but central to these views were country houses and their estates. A compromise had been reached. The high-octane bird's-eye views these artists created were designed to impress, and they do. An aerial perspective suggests the benevolent, approving gaze of a deity, in a position to appreciate and admire the extent and magnificence of estates like Hampton Court, Longleat and Clandon. It reflected an aristocratic attitude to property ownership that had been transformed since the medieval idea of looking out *from* a castle and over its demesne, as demonstrated by the surveillance recorded in the fifteenth-century stained glass roundel. Now, it was all about looking *at* an estate. Look, these paintings say: here is my house, at the centre. Here are my formal gardens and avenues of trees. Here are my orchards and kitchen gardens. And here, all around, in the hazy distance, are the hills and plains of the countryside, a harmonious setting for the jewel of my property.

Leonard Knyff, *The North Prospect of Hampton Court, c.* 1699.

'Rich Industry sits smiling on the plains, / And peace and plenty tell, a Stuart reigns', wrote Alexander Pope in his poem 'Windsor Forest' in an appropriately tidy rhyming couplet. For many landowners, the decades following the Restoration were an era of prosperity and energetic country-house building, and Siberechts, Leonard Knyff and their fellow view-takers were on hand to reflect this confident vision of the land in spectacular canvases. The country, or what was worth recording of it, was revealed in these pictures to be an ordered, cultivated and fruitful place, embellished with spectacular buildings – with man in his rightful place at the centre of it all.

It was a view of the world of which Celia Fiennes would have approved. An indefatigable traveller, she made numerous expeditions around England

from the mid-1680s to around 1712, at first 'to regain my health by variety and change of aire and exercise' but later out of a restless curiosity to see and experience the land in which she lived. Unmarried and with wealthy relations usefully distributed about the country (although she travelled with her own bed linen for overnight stays in inns), she was in a position to do what she liked. Although it was still highly unusual for a woman to make lengthy excursions on horseback as Fiennes did – with, at times, only one or two servants to accompany her – in general people were beginning to travel more extensively, and to experience far more of the country than their forebears could ever have expected to see. The stagecoach had been introduced earlier in the century – though roads were often not equipped for such heavy vehicles, and tended to deteriorate as a consequence. Local knowledge was frequently found wanting ('The people here are very ill guides, and know but little from home', grumbled Fiennes near Penzance), but there was, at least, beginning to be some signage: 'at all cross wayes there are Posts with Hands pointing to each road with the names of the great town or market towns that it leads to'.[48]

Fiennes was no antiquarian. She was interested in new buildings, not ruins; in manufacture and mining rather than ancient customs. In her journals documenting her travels around the southern counties, Bath, Oxford, the North, Kent, Epsom, Hampton Court and Windsor and what she called her 'Great Journey to Newcastle and to Cornwall', what enthuses her most are towns and the busy commerce that went on in them. She writes in detail about building materials, streetscapes and local industries, admiring the stone buildings and fine streets of Nottingham, the ingenious water-house in Norwich ('a rich, thriving, industrious place', she notes with approval) and the manufacturing of serge in Exeter.[49] It was rare for her attention to be engaged in the same way by views of the countryside. Although she occasionally mentions an attractive 'visto' or 'prospect' that she has enjoyed from the road, one senses that her heart was not really in it; she rarely bothers to mention what these vistos and prospects were *of*. Faced with a particularly spectacular landscape, her praise is given in moderation, in conventional terms, with none of the gusto with which she describes a 'neat' newly built house or a bustling

factory. The Cornish coast, the Lizard Point and St Michael's Mount? All are swept together under a perfunctory 'very fine'.[50] When occasionally she encounters a view that interests her enough to describe it, it is usually of fertile, arable land. One day in 1698, during her 'Great Journey', while making her way from Trentham to Newcastle-under-Lyme, she saw a scene that gave her an unusual degree of aesthetic pleasure: she 'went on the side of a high hill below which the River Trent rann and turn'd its silver streame forward and backward into Ss which looked very pleasant circleing about the fine meadows in their flourishing tyme, bedecked with hay almost ripe and flowers'.[51]

As far as Fiennes was concerned, the countryside's chief interest lay in its effect on human lives and prosperity – an attitude that found a visual equivalent in the early eighteenth-century oil paintings of John Wootton, in which the landscape usually provides a backdrop for horses and sporting scenes. Wild stretches held little appeal for her. 'All Derbyshire', Fiennes complained near Chesterfield,

> is full of steep hills, and nothing but the peakes of hills as thick one
> by another is seen in most of the County which are very steepe which
> makes travelling tedious, and the miles long, you see neither hedge
> nor tree but only low drye stone walls round some ground, else its
> only hills and dales as thick as you can imagine…

But just as her focus is on the trades that animate towns, and on the domestic arrangements of country houses rather than just their outward appearance, here she begins to think about what lies beneath the surface, and her imagination, like Bede's a thousand years earlier, dives down into this otherwise unpromising ground:

> tho' the surface of the earth looks barren yet those hills are inpregnated
> with rich Marbles Stones Metals Iron and Copper and Coale mines in
> their bowells…

This balance was, for her, part of God's plan. In the contrast between a barren surface and an interior rich in mineral wealth 'we may see the

wisdom and benignitye of our greate Creator to make up the deficiency of a place by an equivalent as also the diversity of the Creation which encreaseth its Beauty'.[52] Fiennes's Christian faith informed her view of the world: the land was a place rich with resources for man to cultivate and exploit.

Daniel Defoe's *Tour Thro' the Whole Island of Great Britain*, published in three volumes between 1724 and 1726, tells the story of a land caught up in such rapid progress that his book was doomed to be out of date before it was even published: 'no description of Great Britain can be what we call a finished account,' Defoe admits in his preface, 'as no cloaths can be made to fit a growing child'. Some towns decay, he observed, while others are built; great rivers dry up, while small brooks expand into large watercourses; ports and harbours are constructed where there were none before. His *Tour* is an exhilarating account of a land in flux, and Defoe – a staunch man of the Enlightenment – was, like Fiennes, captivated by the idea of progress and industry. He was no antiquarian either, and the past was chiefly interesting to him as a foil to modernity: he warns us in his preface that 'looking back into remote things is studiously avoided'. Given his interest in manufacture and commerce, his focus, too, is naturally on towns and cities rather than the country – but he could hardly avoid an area of land as large as the Derbyshire Peak District. Perhaps he had no desire to; the famous 'Seven Wonders of the Peak' gave him the opportunity for a good deal of pleasurable eye-rolling over the tawdry sightseeing industry that had grown up to conduct tourists around the natural caverns and springs of the area. Defoe has his characteristic kind of grim fun at the expense of the seventeenth-century writers Hobbes and Cotton, whose 'strange long stories of wonders' were in his opinion 'most weakly call'd'. Pausing to catch our eye for a moment, he remarks wearily:

> I cannot but, after wondering at their making wonders of them, desire you, my friend, to travel with me through this houling wilderness in your imagination, and you shall soon find all that is wonderful about it.

The great rocks called Poole's Chair and the Flitch of Bacon? 'Nothing

but ordinary stones' that look nothing like the things they purport to resemble. Mam Tor? 'A very high hill…an exceedingly high hill. But this in a country which is all over hills, cannot be much of a wonder… there are several higher hills in the Peak than that, only not just there.' Tideswell spring, which is said to ebb and flow as the sea does? 'A poor thing indeed to make a wonder of'; it is only that writers 'are at a loss to make up the number seven without it'. According to Defoe, who ruthlessly whittles the seven wonders down to just two, these natural features are mostly 'wonderless, and empty of every thing that may be called rare or strange'.[53] Subjected to his withering scrutiny, the superstitions and stories that had explained and animated parts of the British landscape for time out of mind began to sound rather silly.

Defoe preferred his landscapes to show signs of honest industry, not to be gawped at by the credulous. Travelling downhill one day, towards Halifax, he was entranced by the sight of one steep hillside after another being used to dry pieces of newly milled cloth supported on 'tenters', wooden frameworks on which fabric was stretched to prevent it from shrinking. For Defoe, it was an almost religious experience. The cloths shone dazzlingly in the sun, and in every direction he looked there were more and more: 'look which way we would, high to the tops, and low to the bottoms, it was all the same; innumerable houses and tenters, and a white piece upon ever tenter'. Here, local industry and the land itself were in perfect harmony. It was, he wrote, 'the most agreeable sight that I ever saw'.[54]

Landscapes that could neither be inhabited nor exploited for industry seemed, to him, to be actively hostile. Travelling near Lancaster, Defoe found himself 'locked', as he revealingly put it, between prodigiously high hills on one side – higher than the clouds, he tells us – and the sea on the other, which he thought 'desolate and wild, for it was a sea devoid of ships, here being no nearby sea port or place of trade'. 'Nor', he continues,

> were these hills high and formidable only, but they had a kind of an inhospitable terror in them. Here were no rich pleasant valleys between them, as among the Alps; no lead mines and veins of rich oar [ore], as in the Peak; no coal pits, as in the hills about Hallifax, much less

gold, as in the Andes, but all barren and wild, of no use or advantage either to man or beast.[55]

Arriving in Westmoreland, he found 'a country eminent only for being the wildest, most barren and frightful of any that I have passed over in England, or even in Wales itself'. Mountains provoked emotions of 'horror'; near Kendal he found them 'terrible' and 'frightful'.[56] In Scotland he had to cross 'a most desolate and, in winter, a most frightful moor for travellers' which, he thought, would make a stranger think the whole country 'a terrible place'. 'Drumlanrig,' he writes, 'like Chatsworth in Derbyshire, is like a fine picture in a dirty grotto, or like an equestrian figure set up in a barn; 'tis environ'd with mountains, and that of the wildest and most hideous aspect in all the south of Scotland'.

And yet, he felt, it might be possible to salvage something from all this terrible, wild landscape. The mountains were unfortunate, and there was nothing to be done about those – but the Scottish landscape in general, he began to realize,

was not so naturally barren, as some people represent it, but, with application and judgement, in the proper methods of improving lands, might be made to equal, not England only, but even the richest, most fruitful, most pleasant, and best improv'd part of England[57]

Like a headmaster giving a pep talk to a wayward child, Defoe turned his attention to Scotland's moors and heaths. It could really make something of itself, he speculated, if it could only be persuaded to pull its socks up.

Defoe's attitude chimed with the tenor of the times – confident, progressive, mercantile. It would not be long, however, before his thrusting modernity would begin to look distinctly old-fashioned: other, more aesthetic considerations were about to sweep in, and when they arrived it was with surprising force and longevity. The landscape was about to be re-enchanted.

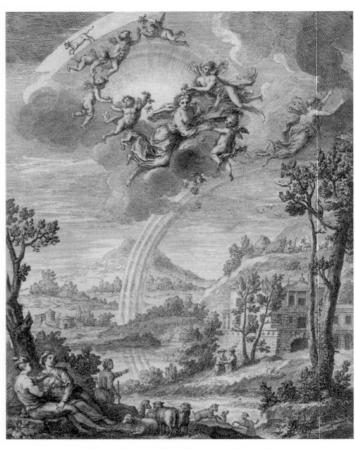

Nicolas Tardieu, after William Kent, 'Spring',
for James Thomson's *The Seasons*, 1730.

IV

IMAGINATION

Every journey is made through a succession of pictures
Horace Walpole, 'The History of the Modern Taste in Gardening'

THAMES-VALLEY CLAUDES

While Defoe was casting his acutely speculative eye over Britain's potential for profitability, a young man newly arrived in London was looking at its landscape in a different way: through glasses tinted with the subtle shades of seventeenth-century landscape paintings by Claude Lorrain and Gaspard Dughet. John Dyer had not yet had the opportunity to travel to Italy, as aristocratic youths of his generation were doing on their Grand Tours of the Continent; but even so, he was affected by the cultural climate they brought back along with the pictures and sculptures collected for their Palladian houses. Gradually this Italian atmosphere was to settle over the landscape of Britain, enveloping it in a new and seductively golden light.

At his home, Aberglasney House in Carmarthenshire, Dyer had dutifully – if somewhat reluctantly – been studying law when, around 1720, his father died, freeing him to head to London and pursue his interests in painting and poetry. Dyer cleverly killed two birds with one stone by becoming an apprentice in the Great Queen Street studio of Jonathan Richardson, who was not only among the most successful portrait painters of the time but was also a respected literary figure: he was Britain's leading art theorist, an authority on Milton, a great friend of Alexander Pope and – although his verse was not published in his lifetime – a prolific poet. Richardson, who came from a modest, artisanal background, had not had

the opportunity to travel himself, but had enjoyed the artistic treasures of Holland, Flanders, France and Italy vicariously through his son Jonathan Richardson the Younger, who made two extensive trips abroad in 1716 and 1720. While Dyer was studying with Richardson, father and son were writing the joint book that resulted from these excursions, *An Account of Some of the Statues, Bas-Reliefs, Drawings and Pictures in Italy, &c. with Remarks*. The studio must have been alive with talk of these works of art.

It is unlikely that Dyer applied himself with any great dedication to the serious business of portrait painting during his years with Richardson – that was not really why he was there. What he *was* there for was the cultural and intellectual environment his master was able to magic up in his Great Queen Street house. In a pre-museum age, when most works of art were inaccessible except to the very wealthy, Richardson could introduce him to one of the greatest collections of Old Master drawings ever assembled; by the time of his death in 1745 he owned close to 5,000 works, including many by Rembrandt, Poussin, Claude, Rubens and Van Dyck.[1] In Richardson's home, Dyer would have joined a privileged inner circle of men who gathered to discuss the noble aims of painting, to pass drawings around for discussion and admiration and to talk of poetry.

Dyer was interested in landscape. Back in 1716 he had written the first version of his poem *Grongar Hill*, celebrating the beauty of a local landmark, a text to which he would return.[2] But there was a problem. British artists may have been starting to make landscape the principal subject of oil paintings – chief among the early specialists was George Lambert, whose portrait of 1727 is proudly lettered 'Georgius Lambert, Chorographiae Pictor' – but in the pecking order it was inferior to what was known as 'history painting' – pictures which took elevated subjects from the Bible, history or classical literature.[3] 'A History', Richardson wrote,

is preferable to a Landscape, Sea-piece, Animals, Fruit, Flowers, or any other Still-Life, pieces of Drollery, &c.; the reason is, the latter Kinds may Please, and in proportion as they do so they are Estimable, and that is according to every one's Taste, but they cannot Improve the Mind, they excite no Noble Sentiments; at least not as the other naturally does[4]

This hierarchy mattered to Richardson. The great majority of British artists were, like him, portraitists, who were often dismissed as mere 'face-painters' or even – one can almost feel Richardson wince – 'phiz-mongers'. One of his cherished projects was to elevate portraiture to the dignified status enjoyed by history painting – thereby raising the status of British art in general. Richardson argued that a painted portrait ought to do more than just capture a person at a particular moment; it should, he thought, carry a greater weight on its shoulders. A portrait, he opined, was 'a sort of General History of the Life of the Person it represents, not only to Him who is acquainted with it, but to Many Others, who upon Occasion of seeing it are frequently told, of what is most Material concerning Them, or their General Character at least'.[5] Could landscape be similarly elevated by ridding it of its incidental qualities – that untidy clump of brambles or that annoying tree blocking the vista of the church spire – until it became idealized, a 'sort of General History' of its best self? It is not hard to imagine Richardson scrutinizing one of his treasured, richly atmospheric landscape drawings by Claude Lorrain, and wondering whether it could provide a model for British landscape artists. After all, 'the business of Painting', he wrote in his *Argument in Behalf of the Science of a Connoisseur* (1719), was not so much to show what was actually there in front of you as 'to Raise, and Improve Nature'.[6] This was also, as events would show, the business of poetry and of the new art of landscape gardening.

Dyer, though enchanted by landscape, was slow to master the messy and demanding practicalities of pigments, oils and brushes – 'As yet I but in verse can paint' he admitted, after quite some time. But during the years he studied with Richardson he filled over sixty pages of his commonplace book with quotations from Greek and Roman authors, and most of all from *Paradise Lost*, extracting descriptions of the natural world, of trees and waterfalls.[7] In 1724 he left Richardson to spend two years in Italy, where he saw pictures by the most revered landscape artists: Claude Lorrain (known as Claude), who spent most of his working life in and around Rome, Gaspard Dughet (who later adopted the name of his brother-in-law, Nicolas Poussin) and Salvator Rosa, the painter of wild Italian scenes. It was no wonder that when Dyer returned to his beloved

Grongar Hill in Carmarthenshire, the view he saw was filtered through improving veils of poetry and painting.

Published in 1726, Dyer's *Grongar Hill* shows us how ways of looking at nature were changing in the early eighteenth century. If he had been born a generation earlier, his poem would have had an antiquarian air about it and concentrated on the topography of this particular local landmark, probably dwelling on the Iron Age hill fort on its summit. As it was, the art and poetry he had absorbed lead him to turn his back on the hill and use it as a vantage point to gaze at the countryside around, composing it as a work of art: 'Now, I gain the mountain's brow,' he exclaims, 'What a landskip lies below!' Like Satan in *Paradise Lost* surveying Eden, he allows his eye to wander over the scene, noting its contrasts and neatly coupling them, moulding them into a harmonious whole:

> The fountain's fall, the river's flow,
> The woody valleys, warm and low;
> The windy summit, wild and high,
> Roughly rushing on the sky!
> The pleasant seat, the ruined tower,
> The naked rock, the shady bower;
> The town and village, dome and farm[8]

Claude was the acknowledged master of the atmospheric landscape: the view towards distant hills, valleys and lakes, fading into bluish mist and framed by lofty trees, often with a fragmentary ruin on a high crag to cast a deliciously melancholic shadow over the scene, all bathed in the nostalgic golden glow of late afternoon light. In Dyer's description, the elements of the Welsh landscape as seen from Grongar Hill resolve themselves into a Claudean composition, with its nicely balanced contrasts of valley and summit, rock and bower. 'Each give each a double charm', as he puts it.

The hill itself has a lot to do in the poem. It dispenses peace to the over-stimulated soul – nature 'dresses green and gay, / To disperse our cares away' – and, by giving us a vantage point from which we can see a ruined tower, ' the raven's bleak abode', it also reminds us of the transience of human power and the swift passage of time. But most of all it is

there to give aesthetic pleasure: 'Ever charming, ever new, / When will the landskip tire the view!'[9] To do that, the views it affords must conform to the conventions of Italian landscape painting – suddenly, it seems, it will not do to be overly specific about the topography of the actual hill and its surrounding countryside. The curious contours of the hill fort are not mentioned once.

One was rarely alone in a landscape of the early eighteenth century. In the very first stanza of *Grongar Hill* we encounter two nymphs (one in charge of painting, the other of poetry), while the landscape of James Thomson's lengthy poem cycle *The Seasons* (1730) teems with personifications and figures from Greek myth. 'Come, gentle Spring', the narrator begins, 'on our plains descend', while over in the north surly Winter is trudging off, calling his 'ruffian blasts' to heel like so many fierce dogs. Nature herself is busy unthawing the earth, while 'rosy-footed May / Steals blushing on'. Muses hang about waiting for everyone to get out of bed and go for a walk, which they do just as soon as the 'powerful King of Day' starts rejoicing in the sky. Once outside, one may well bump into a whole assortment of allegorical beings, from 'rosy finger'd Hours' and drifting Zephyrs to 'timely Rains' and 'light footed Dews' performing a sprightly dance under the eye of the Seasons.[10]

If in *Grongar Hill* Dyer showed us a beautiful Claudean drawing, with *The Seasons* his friend Thomson guides us through an enfilade of gorgeously painted rooms. Gods and Zodiacal symbols are up there on the ceiling, while the walls are decorated with allegorical figures of the Seasons, the Months, the Muses and Nature. This is landscape filtered through the conventions of classical literature, myth and gracious ritual. Rain does not do anything so rude as fall – in this polite company, 'clouds consign their treasures to the fields'.[11] The morning does not simply arrive, but, like a nervous stage hand, 'trembles o'er the sky, / And, unperceived, unfolds the spreading day'.[12] The four frontispiece illustrations William Kent created for the first full edition of the poem capture Thomson's theatrical mood, with the allegorical company bursting riotously into the sky as a dazzling counterpart to the human dramas taking place below (see p. 106). For all its open-air setting, the scene is as crowded as a ballroom.

But underneath all this elaborate choreography, with *The Seasons* Thomson was doing something new. His huge cast of mythical figures, allegories and personifications is really only the chorus line, while the central character in this unfolding drama is nature itself (or, as Thomson would have said, Herself). As each season arrives, develops and gives way to the next, we are shown its effect on the landscape, from spring flowers to haymaking, harvest, autumnal fogs, yellowing leaves and snowstorms. Between the three of them, the seasons, the weather and the landscape put on a spectacular show. This was the first British poem in which nature had been offered such a starring role.

Reading *The Seasons* offers an emotional experience. The passing year is presented as a sweeping panorama of sentiment – moods of hope and joy in Spring and Summer give way to autumnal reflectiveness and eventually to horror at the dreadful power of Winter. And yet the prevailing mood of Thomson's landscape is emotionally uplifting. He greets the new day, flowers, birds, the view, sweet showers and gentle sunbeams with infectious enthusiasm and a liberal sprinkling of exclamation marks. One summer's evening, he cheerfully invites us on a walk up Richmond Hill (our narrator favours high ground and long views). 'Here let us sweep / The boundless landscape', he suggests,

> Heavens! what a goodly prospect spreads around,
> Of hills, and dales, and woods, and lawns, and spires,
> And glittering towns, and gilded streams, till all
> The stretching landscape into smoke decays![13]

Over and again Thomson asks us to respond to the landscape's beauty, and to look with him at another 'gaily chequer'd heart-expanding view, / Far as the circling eye can shoot around'. But the views at which he entreats us to gaze are not only of an aestheticized landscape laid out for our pleasure – Thames-valley Claudes, right down to the distant haze – but also of great prosperity. The richly varied landscape – or, at least, the populous, cultivated southeastern parts of it that Thomson writes about – reflects a more general sense of plenty. 'Happy Britannia!', he exclaims. 'On every hand / Thy villas shine. Thy country teems with wealth'.[14] As a

Scot, Thomson predicted in a letter to a friend that his panegyric on the landscape 'may perhaps contribute to make my poem popular. The English people', he added, 'are not a little vain of themselves and their country.'[15]

He was quite right. *The Seasons* was exceptionally popular; over four hundred editions were published until the tide finally began to turn in the 1870s, by which time it had become part of the mental furniture of five successive generations. '*That* is true fame!' observed Coleridge as he picked up a battered copy of the book in the parlour of a country inn.[16] Thomson appealed to an appetite that one might have thought long gone – for a guide to lead us through the year; a complete, satisfying cycle like the medieval labours of the months that ticked through comfortingly familiar annual events. But while medieval calendars were driven by the necessary work of growing crops and raising livestock, Thomson's *Seasons* reflects its modern age and readership. Its narrator is up-to-date, a man of leisure, no longer personally tied to the rhythms of the land. He is able to wander and observe at will, to be an observer rather than a participant. The land was not there for him to work, but to admire, like a play or a painting. And when labour does encroach, he surveys it from a distance – far enough away for it to look picturesque, rather than sweaty and exhausting: 'Now swarms the village o'er the jovial mead' he remarks, complacently. Everyone joins in – rustic youths, 'brown with meridian toil, / Healthful and strong', pink-cheeked young women, 'infant hands', even the elderly.[17] Well, nearly everyone. After all, someone had to take in the view.

The eagerness with which Thomson's *Seasons* was seized upon and the affection in which it was long held suggests that it struck a chord – and that chord was in a major key. Thomson recreated the British landscape for a new age. He flattered the south-eastern countryside with tacit comparisons to paintings by Claude; flattered Great Britain by alluding to her prosperity; and flattered his readers for grasping his classical allusions and for their discerning appreciation of the view. He framed the landscape like a picture and presented it to us tied up with fluttering ribbons, and it was as though we were seeing it for the first time. We had never realized it was so beautiful.

ARCADIA!

It was on his first visit to Italy between 1712 and 1718 that the young Thomas Coke began to plan the great Palladian house he was eventually to build near the north Norfolk coast. In his mind, Holkham Hall took shape around a growing art collection, with rooms purpose-built for the display of sculpture and paintings. He began to buy works of art on this Grand Tour, and spent large sums on many more when he returned to Italy some thirty years later. All were shipped back to England and carted up to Holkham.[18] There, he had an entire room lined with crimson damask and dedicated to landscape painting: the twenty-two gilt-framed pictures he hung in it include six works by Claude and others by Gaspard Dughet and Salvator Rosa. Today, to stand in the 'landscape room' at Holkham, where Coke's paintings still hang as he directed, in two or even three tiers, is to see these pictures through eighteenth-century eyes. 'Italian light on English walls' was how the poet William Cowper described the magical effect of paintings by Claude, Dughet, Rosa and others in the salons and picture galleries of grand houses, but nowhere does it play more enchantingly than on the damask and gilt at Holkham.[19]

Thomson characterized the three key artistic personalities of the age in his 1748 poem *The Castle of Indolence*:

> Whate'er *Lorrain* light-touch'd with softening Hue,
> Or savage *Rosa* dash'd, or learned *Poussin* drew[20]

But it was landscapes by Claude Lorrain that caught the imaginations of British aristocrats on the Grand Tour like those of no other artist. Claude opened windows on to enchanted landscapes, admitting, on the gentlest of breezes, the slightly melancholic grace of pastoral poetry, an air of the long-ago and far-away. His compositions gently brought the atmosphere of works such as Virgil's *Eclogues* and *Georgics*, once struggled inkily through at school, to vivid life. Paintings by the master, his assistants, copyists and imitators were bought, crated and shipped to British houses in staggering numbers, as aristocrats sought to own a piece of the classical past: it has been estimated that almost every single painting and drawing by

Claude has at some time been in a British collection, and many remain.[21]

The taste for Claude seeped into British art, affecting its compositions and even its colours. The most influential British landscape painter of the period, Richard Wilson, lived in Rome for several years in the 1750s, and on his return to Britain his brush magicked the native landscape into Claudean forms: in a dramatic view along the Dee valley towards Castell Dinas Brân painted for the wealthy landowner Sir Watkin Williams-Wynn, the Vale of Llangollen looks suspiciously as though it has dressed up for the day as the Roman campagna (Plate 5). But it was not just that artists were looking at the landscape through half-closed eyes while thinking hard of Claude. Parts of the countryside – those in the hands of wealthy landowners, who could afford to pay for the services of landscape gardeners – were actually changing shape. Rolling hills arose where there were none before; reflective lakes appeared; existing rivers adopted more pleasingly serpentine routes. The great estates were being made to look like Claudean compositions – all that was missing were shepherds and shepherdesses in colourful togas. As the author Hannah Jarvis succinctly puts it in Tom Stoppard's 1993 play *Arcadia*,

> English landscape was invented by gardeners imitating foreign paint-
> ers who were evoking classical authors. The whole thing was brought
> home in the luggage from the grand tour. Here, look – Capability Brown
> doing Claude, who was doing Virgil. Arcadia![22]

Among the first to 'do Claude' was the artist, architect and charismatic designer of gardens and interiors William Kent. In Horace Walpole's admiring words, he was

> painter enough to taste the charms of landscape, bold and opinion-
> ative enough to dare and dictate.... He leaped the fence, and saw that
> all nature was a garden. He felt the delicious contrast of hill and valley
> changing imperceptibly into each other, tasted the beauty of the gentle
> swell, or concave swoop, and remarked how loose groves crowned an
> easy eminence with happy ornament.[23]

Kent – 'il Signor', as he was affectionately known – was steeped in Italian art and culture, which he had seen at first hand. As a young man, he had travelled to Italy and trained in an artist's studio in Florence, from where, every Thursday – known as 'ye couriosty day' – he and his friends made excursions to see palaces and paintings.[24] On returning to England, he was at the forefront of a new, intensely Italophile generation of designers who helped to sweep away the old Dutch and French-inspired formal gardens of parterres and straight avenues, described by Walpole as 'unnatural' and by Lord Lovell as 'those cold & insipid strait walks wch make the signor sick'.[25] With Kent, Walpole continued, it was 'Adieu to canals, circular basons, and cascades tumbling down marble steps, that last absurd magnificence of Italian and French villas' and instead

> The gentle stream was taught to serpentise seemingly at its pleasure.... Its borders were smoothed, but preserved their waving irregularity. A few trees scattered here and there on its edges sprinkled the tame bank that accompanied its meanders; and when it disappeared among the hills, shades descending from the heights leaned towards its progress, and framed the distant point of light under which it was lost, as it turned aside to either hand of the blue horizon.
>
> Thus dealing in none but the colours of nature, and catching its most favourable features, men saw a new creation opening before their eyes. The living landscape was chastened and polished, not transformed.[26]

The garden had been eased out of its old constricting corsets and, re-christened a 'landscape garden', given a new wardrobe of elegant Italian clothes. Key to this new approach to garden design was the ha-ha, a sunken boundary fence that created the illusion of continuity between the garden surrounding the house and the wider park and farmland beyond. At a stroke, wide vistas opened up. Until one got close to a ha-ha, one did not know it was there, hence the exclamation of delighted surprise that gave it its name. Or, perhaps, it was what one shouted in dismay while accidentally tumbling into the ditch.

Stowe, where Kent worked from 1730, was the site of one of the very earliest ha-has. Under his control, the gardens became three-dimensional

Claudes or Gaspard Dughets, complete with lakes and classical temples. Drama unfolded within these natural stage sets – as one walked the paths, carefully contrived vistas would suddenly appear, dotted with intriguing buildings which invited further exploration. As Walpole observed of this kind of garden, 'every journey is made through a succession of pictures'.[27] At Stowe, the area Kent called the Elysian Fields was designed to be separate from the main gardens, so that it took one by surprise. At the highest point stood the circular colonnaded Temple of Ancient Virtue, based on the ancient Temple of Vesta at Tivoli and containing statues of Homer, Socrates, Lycurgus the lawgiver and the military leader Epaminondas. Nearby – satirically built as a ruin – was the Temple of Modern Virtue. Across the way was another of Kent's designs, the Temple of British Worthies, housing busts of figures including Shakespeare, Elizabeth I, Frances Bacon, John Locke, Isaac Newton and John Milton, while the narrow stretch of lake to one side was known as the Styx. To follow these carefully staged paths must have been like being part of a play – both audience and actor – without knowing one's lines in advance. It was, admittedly, a landscape for the highly educated.

There was a strong element of make-believe in all this, and a perfumed whiff of the dressing-up box. In 1753 the bluestocking Elizabeth Montagu described a picnic 'in the most beautiful rural scene that can be imagined':

> Mr. Pitt...ordered a tent to be pitched, tea to be prepared, and his French horn to breathe Music like the unseen genius of the wood.... After tea we rambled about for an hour, seeing several views, some wild as Salvator Rosa, others placid, and with the setting sun, worthy of Claude Lorrain.[28]

And where were these gloriously evocative views? On the Roman campagna? At Tivoli? Neither. The picnic was, in fact, held not far from Tunbridge Wells.

However many Kentian temples one carefully positioned on its slopes or Claudean views one contrived over its valleys, one had to remember that this was still the British landscape. The gardens at Stowe inspired Alexander Pope's lines:

To build, to plant, whatever you intend,
To rear the column, or the arch to bend,
To swell the terrace, or to sink the grot;
In all, let Nature never be forgot.
But treat the goddess like a modest fair,
Nor overdress, nor leave her wholly bare;
Let not each beauty ev'rywhere be spied,
Where half the skill is decently to hide.
He gains all points who pleasingly confounds
Surprises, varies, and conceals the bounds.

'Consult the *genius* [spirit] of the place in all', he continues.[29] In this transition from the old formal walks and parterres to the new idea of the 'landscape garden', the *genius loci* had been released from its bondage; now nature and artifice had to find a new balance.

Some, however, had fallen too deeply under the Claudean spell to compromise. When the banker Henry Hoare inherited Stourhead in Wiltshire in 1741, he not only hung copies of paintings by Claude in the house but also transformed the gardens to reflect his passion. He dammed the river Stour to form a lake and commissioned an architect to build classical temples of Flora, Apollo and the Pantheon, creating a vista that resembled Claude's 1672 painting *Landscape with Aeneas at Delos* – albeit under chillier northern skies. It was an act of homage on an extraordinary scale.

It was one of Kent's successors, Lancelot 'Capability' Brown – so-called because he would habitually remark on the 'great capabilities' of the places on which he was consulted – who created much of the rolling parkland that we now associate with natural English landscape, including Petworth in West Sussex, Croome Court in Worcestershire and Syon House in Middlesex. With the help of teams of men equipped with pickaxes, wheelbarrows and spades, Brown gave his clients apparently unbroken expanses of green sward, moulded the landscape into curves and planted great sweeps of trees – elm, oak, lime, beech, Scots fir, plane, larch and Cedar of Lebanon. He even invented a tree-carriage so that established specimens could be moved from one spot to another. His skilful use of

Thomas Hastings after Richard Wilson, *Syon Park and House*, 1821.

the ha-ha blended lawns imperceptibly with the rougher land far beyond, made smaller ponds and lakes appear to be one large, elegant body of water and brought trees and copses into alignment to frame distant views. His materials were earth and trees rather than canvas and oil paints, but he was creating an artistic composition nonetheless. Any landscape that did not pass muster was liable to be razed and remodeled to correspond to a Claudean ideal – whatever the disruption it caused to those unwittingly guilty of being an unsightly blot on the landscape. At Croome, he knocked down houses and moved the inhabitants to a new, out-of-sight settlement; the similar fate of Nuneham Courtenay, Oxford, was lamented by Oliver Goldsmith in *The Deserted Village* (1770), in which

> The man of wealth and pride
> Takes up a space that many poor supplied;
> Space for his lake, his park's extended bounds,
> Space for his horses, equipage and hounds.[30]

At Croome, even the medieval church had to go – it was too close to the house. Another, in the fashionable gothic style, was built on higher ground, where it also served as an eye-catcher.

The owners of the land also had to be prepared to endure a degree of discomfort – although they had rather more choice than their tenants in the matter. 'Prospects', noted Walpole in his essay 'On Modern Gardening', 'formerly were sacrificed to convenience and warmth. Thus Burleigh stands behind a hill, from the top of which it would command Stamford. Our ancestors…had an eye to comfort first….' No longer. The British climate was not Italy's, and not even the most ardent Claudeophile could maintain for long that the fashion for Palladian houses or exposed sites truly suited it in its more wintry moods – painted Italian light gave out no warmth. But the aesthetic and cultural value of the surrounding landscape, qualities so long under-appreciated, now trumped other considerations. Prospect was all.

On Brown's death, the writer of one obituary noted that his genius for imitating nature was so great that the designer himself would be forgotten, as his works would be mistaken for it.[31] He was half right. As the academic Bernard Nightingale remarks in *Arcadia,* on being shown a picture of a typically Brownean landscape of smooth, grassy slopes, a lake and clumps of trees, 'Lovely. The real England'. 'You can stop being silly now, Bernard', replies Hannah.[32]

SETTING THE THOUGHTS A-WORKE

You could dress the British landscape up in classical costume. You could populate it with imaginary nymphs and goddesses. You could even adorn it with temples sacred to Greek gods and think of it as a three-dimensional painting. But no amount of Italian light was going to bleach out one of its oldest connections: its relationship with melancholy.

One day in 1717, Alexander Pope made a solitary journey on horseback from Binfield in Windsor Forest, where he had lived as a boy, to Oxford via Stonor Park. He took it as an opportunity for solemn reflection:

Nothing could have more of that Melancholy which once us'd to please me, than that days journey: For after having Passd thro' my favorite Woods in the Forest, with a thousand Reveries of past pleasures; I rid over hanging hills, whose tops were edgd with Groves, & whose feet water'd with winding rivers, listening to falls of Cataracts below, & the murmuring of Winds above. The gloomy Verdure of Stonor succeeded to these, & then the Shades of the Evening overtook me, the Moon rose in the clearest Sky I ever saw, by whose solemn light I pac'd on slowly, without company, or any interruption to the range of my thoughts.[33]

The woods were as deep with associations as with fallen leaves, while the Chiltern hills that he had to cross to reach Oxford cast their own melancholy spell. The overwhelming feeling Pope expresses is one of shade and gloom; even when riding over the hills he mentions no long vistas of the kind Thomson would have greeted with a cheerful exclamation. Instead, he talks only of enclosure: he is shadowed by forest trees, surrounded by hills, and eventually enveloped by evening. It is a landscape with the potential to be every bit as oppressive and stifling as that described in *The Wife's Lament*. And yet there is a difference: the enfolding landscape through which Pope rides is not hostile but sympathetic, mirroring his preoccupations back at him and providing an arena for pleasantly melancholy reflections. In encouraging Pope to retreat into his own mind, landscape returns him to himself. As the light fades, it only becomes more resonant; he seems genuinely delighted to make the final leg of his journey in darkness.

The tradition of solitary wanderings and melancholy musings in the landscape stretches back at least to the Elizabethans, if not much further back to Old English poetry – but each era has its touchstone, its particular way of framing it. If, in the eighteenth century, Claude provided the principal visual model, Milton supplied the poetic ideal. Walpole found one Miltonic passage to convey the very essence of Hagley Hall in Worcestershire, while the description in book four of *Paradise Lost* almost uncannily anticipated Kent's gardens at Stourhead:

Southward through Eden went a river large,
Nor changed his course, but through the shaggy hill
Passed underneath ingulfed, for God had thrown
That mountain as his garden mound, high raised
Upon the rapid current...[34]

Britain's landscape gardeners must have worked some extraordinary magic indeed if they had transformed whole swathes of land into an Edenic paradise. But even more than *Paradise Lost*, the poems that shaped ideas about the British landscape were his 'Il Penseroso' (the thoughtful man) and its companion poem 'L'Allegro' (the cheerful man), two of the most phenomenally popular poems of the time. Together, they joined *The Seasons* in shaping ideas about the landscape for successive generations. Lines from the poems were quoted in countless albums and commonplace books all over the land, and artists continued to mine them for subjects until the late nineteenth century.

Milton's landscape in 'Il Penseroso' is full of quiet, shady places to be alone with one's thoughts and shelter from the common light of day:

And when the Sun begins to fling
His flaring beams, me, goddess, bring
To arched walks of twilight groves,
And shadows brown that Sylvan loves
[...]
There in close covert by some brook,
Where no profaner eye may look,
Hide me from Day's garish eye...

Like many an imagined riverside from Gildas's day onwards, this quiet brook can even entice visions; the 'waters murmuring' promising to lull you to sleep and bring 'some strange mysterious dream'.[35]

Retired, shady spots could always be sought out; but it was in the evening and at night that the landscape became a particularly conducive arena for melancholy reflections. The 'Graveyard Poets' were specialists in this area: they waylay us at night and beckon us to follow them to lonely

churchyards where they meditate on graves, worms and epitaphs. In, respectively, 'A Night Piece on Death' (1721) and *The Grave* (1743), Thomas Parnell and Robert Blair linger in the shadow of the 'black and fun'ral yew' or descend into the 'low-brow'd misty vaults' in order to meditate on 'joys departed, / Not to return', on the brief span of human life and on death as the great leveller.[36] This mid-eighteenth-century outbreak of melancholy was contagious – Blair's *Grave* was one of the bestsellers of the period, going through forty-seven editions before 1798. Not even Henry Fielding's hero Tom Jones was immune to it. At a particularly emotional moment, travelling late in the evening, Tom comes to a steep hill and is gripped by a desire to climb to the top because, he explains to his companion Partridge, 'it must certainly afford a most charming prospect especially by this light; for the solemn gloom which the moon casts on all objects is beyond expression beautiful, especially to an imagination which is desirous of cultivating melancholy ideas.' 'Very probably,' replies Partridge sensibly, 'but if the top of the hill be properest to produce melancholy thoughts, I suppose the bottom is the likeliest to produce merry ones, and these I take to be much the better of the two.'[37]

Thomas Gray's *Elegy Written in a Country Churchyard* was probably begun in around 1745, and was first published in 1751. The eighteenth century's most resonant hymn to the day's end, that potent in-between time when dusk falls and formerly bustling lanes and populous fields become empty and quiet, remains on the mental poetry shelf of many to this day:

> The curfew tolls the knell of parting day,
> The lowing herd wind slowly o'er the lea,
> The ploughman homeward plods his weary way,
> And leaves the world to darkness and to me.
> Now fades the glimmering landscape on the sight,
> And all the air a solemn stillness holds,
> Save where the beetle wheels his droning flight,
> And drowsy tinklings lull the distant folds;[38]

Gray imagines himself as a solitary consciousness, a mage in the gathering gloom. During the day everyone has their share of the busy landscape,

but as the bells and lowing fade and more magical, intimate dronings and tinklings take their place, he takes sole possession of it. Cleared of its quotidian inhabitants, its distracting details cloaked by the dusk, it becomes a stage to be filled by his unfolding meditations on life, death and obscurity. The most evocative, thought-provoking landscape was one you could barely see.

'...nothing can be said in [Henry VIII's] vindication,' wrote the young Jane Austen in her spoof 'History of England', 'but that his abolishing Religious Houses & leaving them to the ruinous depredations of time has been of infinite use to the landscape of England in general, which probably was a principal motive for his doing it...'.[39] The aesthetic charm of ruins that was a commonplace by Austen's day began to be widely felt in the middle of the eighteenth century, around the time that Gray's *Elegy* was published. New 'ruins' were actually built at grand estates like Hagley Hall to add romance and a stirring air of antiquity to their idyllic, Claudean views. But certain individuals had appreciated their evocative qualities long before that. In John Webster's *The Duchess of Malfi* (1612–13), Delio points out the remains of an abbey, and Antonio replies: 'I do love these ancient ruins. / We never tread upon them but we set / Our foot upon some reverend history....'[40] It is this sense of the landscape as a repository of history that John Aubrey evoked later in the seventeenth century, when he wrote: 'the Eie and Mind is no less affected with these stately Ruines, then they would have been when standing and entire. They breed in generous Minds a Kind of Pittie: and sett the Thoughts a-worke...'.[41] Aubrey, like Gray, was thinking about the landscape as a palimpsest on which numberless people over vast stretches of time had lived, loved, worked and died, and of whom the only traces were the 'stately Ruines' that marked out the spaces they inhabited.

Palladian houses may have asserted confidence, but the fascination with relics of the Catholic past that was so marked a feature of the second half of the century betrayed a less certain attitude. Ruins of ancient abbeys spoke of a once-great and unshakeable faith. In the cultural climate of the time, when Enlightenment certainties were beginning to waver, the spirituality with which they resonated exerted a powerful magnetism. The

cultural climate had changed since Defoe could look at Melrose Abbey and tut disapprovingly about 'seminaries of superstition'.[42]

For J. H. Pott, a young Cambridge graduate and future archdeacon of St Albans, Gothic ruins were a boon to the developing art of landscape painting in Britain. In 1782 he wrote an *Essay on Landscape Painting*, which has been described as the first manifesto of the English landscape school.[43] In it, Pott lists some of the advantages England offers to the artist: chief among them, he writes, is 'the beautiful verdure that prevails here through the year', though he acknowledges that the same conditions bring about the characteristic 'fogs and damps' of the climate. Next – and perhaps related – is the 'great variety and beauty of our northern skies; the forms of which are often so lovely and magnificent, where so much action is seen in the rolling of the clouds: all this is nearly unknown to the placid southern hemisphere'. And immediately following in his list of features are the remains of Gothic architecture, the 'many beautiful and venerable ruins' which 'are every where to be seen'. These have more than a merely aesthetic appeal, although he admits that the 'ivyed arch, the taper-shafted column, the shattered turret' would all make excellent subjects. There is, Pott writes, 'an awful romantic wildness in the Gothic remains, that moves the mind very powerfully'.[44] The ruins that studded the landscape provided a new focus for reflection, one that substituted the morbidity and frankly macabre preoccupations of the Graveyard Poets with a more subtle blend of history, nationalism and aesthetic beauty – bound together with the glue of melancholy.

The ghosts of pre-Reformation days might almost be spotted drifting through these ruins, if one chose to give oneself up to such feelings. Visiting Cumbria in 1794, Ann Radcliffe brought her vivid novelist's imagination to bear on the ruins of Furness Abbey. She relished the 'solemn yet delightful emotion' that filled her mind as she approached, admiring how overgrown and overshadowed with foliage from nearby trees it had been allowed to become, noting that 'every circumstance conspires to heighten the solitary grace of the principal object and to prolong the luxurious melancholy, which the view of it inspires'.[45] Sitting down to rest, 'the images and the manners of times, that were past' seemed all at once to rise up before her:

The midnight procession of monks, clothed in white and bearing lighted tapers, appeared to the 'mind's eye' issuing to the choir through the very door-case, by which such processions were wont to pass from the cloisters to perform the matin service, when, at the moment of their entering the church, the deep chanting of voices was heard, and the organ swelled a solemn peal. To fancy, the strain still echoed feebly along the arcades and died in the breeze among the woods, and the rustling leaves mingling with the close.[46]

If you were unable to experience the atmosphere directly, then there were countless opportunities to purchase evocative images of ruins. In 1795, the twenty-year-old watercolourist Thomas Girtin sat down to paint the ruins of Melrose Abbey in the Scottish borders. The watercolour, now in the British Museum, shows the scene from inside the ruined transept. Ahead is the great east window, its tracery framing a sunlit landscape beyond. On either side masonry soars upwards, drawing our eyes with it until they reach the broken arches, almost unbelievably still standing in the empty air. Blocks of grey and taupe watercolour describe the stones, and little dabs applied with the tip of the brush evoke the crumbling walls and encroaching foliage. The watery sunlight that bathes the scene provides a subtle counterpoint to the intrinsically melancholy atmosphere.

But Girtin had not set up his folding stool at Melrose, balancing his sketchbook on his knee and bracing himself against the blustery weather. Instead, he made his watercolour at his desk at home, copied from a view engraved by the topographical artist Thomas Hearne for his book *The Antiquities of Great Britain* (1786). This was one of many publications that catered for a public newly interested in British history. What had formerly been a minority interest pursued by passionate antiquaries such as Camden, Aubrey and later Francis Place had entered the mainstream; stories about the past, and engravings and watercolours of pre-Reformation relics, were suddenly at a premium. Hence Girtin's canny decision to make a highly saleable watercolour version of one of the book's plates – although, to achieve maximum contrast between former grandeur and present decay, he did replace Hearne's diligently

sketching artist with a scruffy figure lounging on a fallen log, and added a grazing mare and her foal.

In time, the exquisite topographical detail of watercolours such as this by artists such as Girtin, the specialist Michael 'Angelo' Rooker and the young Joseph Mallord William Turner relaxed into more atmospheric compositions, which placed ruins in a broader landscape context. Within five years of copying Hearne's *Melrose Abbey*, Girtin painted a watercolour of Kirkstall Abbey in Yorkshire in the soft light of a summer's evening. Rather than using a portrait format to emphasize architectural grandeur, he turned the paper by ninety degrees, responding to the lateral spread of the gently rolling fields and glassy foreground river that form the abbey's setting. The ruin sits in the Yorkshire landscape under the broken clouds of the evening sky as naturally as a hay barn.

Girtin's *Kirkstall Abbey* is now in the Victoria and Albert Museum, part of its outstanding collection of British watercolours. A trawl through the stores there will prove beyond doubt the phenomenal popularity of the monastic ruin as a subject: you can hardly pull out a single rack without at least one romantic representation of Melrose, Kirkstall, Rievaulx or Tintern rolling out to meet your eye. In the late eighteenth and early nineteenth centuries, abbeys that had, centuries earlier, deliberately been built in the most remote and unattractive spots had ironically become powerful magnets for watercolour artists attuned to a new appetite for British history. For all their subtly melancholy charm, Italianate landscapes had ceased to meet the brief; people had begun to want landscapes pregnant with the stories and spiritual resonance of their own national pasts.

OF HIS OWN BRAIN

If only 'the People with their damnd Faces would but let me alone a little' grumbled an exasperated and over-worked Thomas Gainsborough in a letter to his friend James Unwin at the end of another busy season in Bath.[47] He had built an exceptionally successful portrait business in the fashionable spa town, but his thoughts, as they so often did, were turning to landscape.

Unwin lived in Derbyshire, and Gainsborough allowed his imagination to wander over its features: 'I suppose your Country is very woody', he wrote; ' – pray have you Rocks and Waterfalls! For I am as fond of Landskip as ever.'

He had made a difficult choice. Until 1759, when at the age of thirty-two he left Ipswich to settle in Bath, he had been a painter of both portraits and landscapes. In his native Suffolk, surrounded by the country he had grown up with, he made countless drawings of the landscape around Sudbury and Ipswich, concentrating on details from which he would later construct compositions – a mossy bank, a path, a crumbling stone bridge, an elegant beech tree, thistles, a stile, the edge of a wood. He ticked over with moderate success, taking portrait commissions from the local gentry as well as selling his landscapes. But when he moved to Bath, Gainsborough made the decision to set landscape aside and to concentrate his energies on the more lucrative work of portraiture. For his finances, at least, it was a sensible decision: he quickly came to dominate the town's buoyant portrait business, with a steady stream of sitters from Bath's endlessly self-renewing transient population of the wealthy and titled enabling him to keep putting his prices up. But though necessary to support his wife and two daughters, his business kept him from the landscape painting he loved. 'I'm sick of Portraits', he wrote to his friend, the composer William Jackson,

> and wish very much to take my Viol da Gam and walk off to some sweet Village where I can paint Landskips and enjoy the fag End of Life in quietness & ease
>
> But these fine Ladies & their Tea drinkings, Dancings, Husband huntings &c &c &c will fob me out of the last ten years…[48]

It was, he concluded, 'd–mn'd hard'. He felt a genuine fear for his daughters: Bath was all too full of unscrupulous men with the leisure to enjoy themselves for months at a time before vanishing back to their estates. Gainsborough took pains to equip the girls with the means of making an income, so that, in this febrile environment, they did not have to depend on finding husbands:

you must know I'm upon a scheme of learning them both to paint
Landscape; and that somewhat above the common Fan-mount stile...
I think (and indeed always did myself) that I had better do this than
make fine trumpery of them, and let them be led away with Vanity,
and ever subject to disappointment in the wild Goose chace.[49]

Sadly, things turned out far worse than he expected. His daughters fell in
love with the same man, fell out with each other and then fell out with
him, ending up living together for the rest of their lives and becoming
ever more eccentric; their father's earnest hopes of their making a living
painting landscapes faded as quickly as a watercolour in sunlight.

Although Gainsborough's portrait business obliged him to capture
a likeness – when he first arrived in Bath he was described as a painter
who 'takes the most exact likenesses I ever yet saw' – he had an entirely
different attitude to landscape.[50] His paintings of the scenery could
rarely be said to describe specific places. Instead, when he was planning
a composition he turned to the rich stock of images salted away in his
sketchbooks and his mind, assembling elements in ways that pleased
him. Natural scenery was spliced with his deep knowledge of Dutch and
Italian landscape paintings. A picture such as *Landscape with Cattle*, now
in the Yale Center for British Art, takes closely observed elements – a
sandy bank of the kind he loved to draw, feathery trees – and transforms
them in the darkroom of his imagination into a scene that glows with
atmosphere (Plate 6). The painting is an exercise in colour and light,
an abstract idea of landscape that is hard to identify with anywhere in
England, but is not quite Italy either.

Gainsborough's own view of himself as an imaginative landscape
painter is set out in a revealing letter to Lord Hardwicke, who had evi-
dently asked him to paint views of his estate:

Mr Gainsborough presents his Humble respects to Lord Hardwicke;
and shall always think it an honour to be employ'd in anything for his
Lordship; but with regard to real Views from Nature in this Country,
he has never seen any Place that affords a Subject equal to the poorest
imitations of Gaspar or Claude[.] Paul Sanby is the only Man of Genius,

he believes, who has employ'd his Pencil that Way – Mr G. hopes Lord Hardwicke will not mistake his meaning, but if his Lordship wishes to have any thing tollerable of the name of G. the Subject altogether, as well as figures &c must be of his own Brain…[51]

Paul Sandby was a topographical watercolourist whose early work had been for the Board of Ordnance; from 1747, in the wake of the Jacobite Rebellion, he was made chief draughtsman in a military survey of Scotland. He went on to produce many views of Windsor Castle, Home Park and Great Park, painted with entrancing precision. Sandby creates a world of pristine watercolour wash in which each stone is indicated by a dab of the brush; gardeners heft watering cans, smartly dressed couples gaze at the view and soldiers flirt with pretty nursemaids. Everything in his neat world is laid out in the clear light of day for us to see – a far cry from the dark-toned, brushy mystery of a painting like Gainsborough's *Landscape with Cattle*. Sandby's watercolours were perfectly lucid prose to Gainsborough's lush poetry. It is not hard to see why Gainsborough turned Lord Hardwicke down; even in his early Suffolk paintings, landscapes that look every bit as though they faithfully record the local topography prove to be entirely misleading maps. It would be difficult to walk from one spot to another. He had no qualms about collaging one bit of landscape on to another, and a positively Brownean attitude to the re-siting of churches and villages.

Some of the most original products of Gainsborough's 'own Brain' are the drawings he made in the evenings for his own amusement, as he relaxed after a day's phiz-mongering. Calling for a small folding oak table which was kept under the kitchen dresser, he would gather a few household props together to make model landscapes: coal and cork both made convincing rocks, and sand and clay could be moulded into banks. He devised bushes of moss, looking-glass lakes and distant groves of broccoli trees. Moving them around, he would transform them into a huge variety of entirely convincing landscapes, which he would capture on paper in dense strokes of crumbly black chalk, rubbing here and there to achieve a smoky effect and occasionally reaching for the sugar-tongs to apply dabs from a little sponge dipped in watercolour.[52]

A landscape of the imagination: Thomas Gainsborough's
Wooded Landscape with Castle, c. 1785–88.

Any number of permutations came teeming from his creative and well-stocked mind – views that resembled parts of Suffolk or the country around Bath were spiced with the added drama of a supposed Italy, or the low-key shrubby charm of a Netherlandish landscape. These may have been landscapes of the imagination, but they were distilled from the data of a lifetime's looking.

If Gainsborough was making poetry out of landscape, Alexander Cozens was writing its grammar. Why, thought Cozens, should reason and scientific method not be applied to depictions of the landscape as they were to so many other aspects of the material world at the time? Surely it must be susceptible to rigorous systematic analysis. What we might describe as an audit of landscape, in which all its moods were catalogued and each one of its permutations docketed, occupied Cozens for much

of his working life. To the wealthy art collector William Beckford, one of his former pupils, he was 'almost as full of Systems as the Universe'.[53]

There are examples of Cozens painting views of actual landscapes, but he much preferred to invent imaginary ones. Like Gainsborough, his experiences of both real scenery and the work of other artists were thoroughly processed by his creative imagination into an ideal product. But while Gainsborough drew country scenes entirely for his own pleasure, Cozens was creating exemplary pictures for others to use, mapping out the available territory for landscape art and putting down markers at key points. The catalyst for his exercise was his long experience as a drawing master; he taught first at Christ's Hospital and later took rooms at Eton during term time in order to teach pupils at the school. He remained there throughout the 1760s and 1770s, giving lessons to hundreds of students.

In teaching his pupils landscape composition, Cozens was keenly aware that while he himself had travelled widely in Italy and seen many paintings and drawings, most of his pupils had a much more limited mental image library. Rather than leaving the workings of their imaginations to chance – or to whatever dull bits of scenery they happened to have witnessed – he began to plan a publication that, by including every kind of landscape he could think of, was intended to expand the scopes of their imaginations. As a project it was wildly ambitious, and it was never completed. One surviving part is a list titled *The Various Species of Landscape, &c., in Nature*, in which Cozens itemizes compositions under three headings.[54] Under 'Composition' are sixteen types, chosen to cover the general principles; they include 'The edge of a hill, or mountain, near the eye', 'A landscape on one hand, the sea on the other' and 'A track, road, path, river, or extended valley, proceeding forward from the eye'. 'Objects' were catalogued as 'Water', 'Ground, earth, or dry land', 'Woody, or vegetable' and so on, while a further category of 'Circumstance' laid out times of day, seasons, weather, extreme phenomena such as floods, fires and earthquakes, and ended with light and 'The intermixture of the sky, or clouds, with the landscape'. Cozens prepared sixteen small etchings, one to illustrate each of his 'Compositions'. A related venture, probably intended to be part of the *Various Species of Landscape*, was *The Shape, Skeleton and Foliage of Thirty-two Species of Trees* (1771).

Armed with such comprehensive catalogues and Cozens's schematic visual prompts, the student was able to wander in his mind's eye from bay to plain to mountain range. But even though aspiring artists had all these examples at their fingertips, Cozens still worried about them. Were their imaginations being sufficiently nurtured? He identified two pitfalls facing artists attempting to paint landscapes. One was to spend too much time copying the work of other artists; the other was to spend too much time studying nature.[55] In his view, the result of all this looking was a failure to develop the imaginative power necessary to bring about a happy synthesis – what Jonathan Richardson had in mind earlier in the century when he wrote warmly of Raising and Improving Nature. How might one summon up the necessary imagination to create views that were both original and ideal? This concern is the subject of Cozens's best-known work, *A New Method of Assisting the Invention in Drawing Original Compositions of Landscape*, an expanded version of his very first drawing manual of 1759, *An Essay to Facilitate the Inventing of Landskips, Intended for Students in the Art*. The *New Method* was published just before he died in 1786; it was a subject that had preoccupied him for his entire career. In the book, Cozens offers nothing less than a key with which to unlock the imagination. Paradoxically, this was to be found in the most unprepossessing of visual marks, normally associated with unsightly mistakes and accidents: an inky blot.

In his introductory essay, Cozens describes how, while reflecting on original landscape compositions in a lesson, his eye happened to fall on an inky scrap of paper. Its inchoate forms suggesting something like a landscape, he doodled on it and developed it into a landscape sketch. He then drew some rough forms with a brush on a new sheet and handed it to his pupil, 'who instantly improved the blot, as it may be called, into an intelligible sketch'.[56] An idea was born. It was only later, he claimed, that he discovered that none other than Leonardo da Vinci had also identified creative potential in the nebulous and the unformed. He quotes lines from Leonardo's *Treatise on Painting* (an English edition of 1724), which also gave him his title: 'I shall not scruple to deliver a new method of assisting the invention, which, though trifling in appearance, may yet be of considerable service in opening the mind, and putting it upon the scent

of new thoughts'. Leonardo recommends looking at accidental markings such as those found on dirty walls or streaked stones that might evoke 'landscapes, battles, clouds, uncommon attitudes, humorous faces, draperies, &c. Out of this confused mass of objects, the mind will be furnished with abundance of designs and subjects perfectly new.' 'I presume to think,' continues Cozens with an air of satisfaction, 'that my method is an improvement upon the above hint of Leonardo da Vinci, as the rude forms offered by this scheme are made at will; and should it happen, that a blot is so rude or unfit, that no good composition can be made from it, a remedy is always at hand, by substituting another.' Suitably evocative stains on old walls, he notes, 'seldom occur'.[57] One point to Cozens.

So what exactly does he mean by a blot, and how should one go about making one? A 'true blot', Cozens explains,

> is an assemblage of dark shapes or masses made with ink upon a piece of paper, and likewise of light ones produced by the paper being left blank. All the shapes are rude and unmeaning, as they are formed with the swiftest hand. But at the same time there appears a general

Alexander Cozens, a 'blot' landscape from *A New Method of Assisting the Invention in Drawing Original Compositions of Landscape, c.* 1785.

disposition of these masses, producing one comprehensive form, which may be conceived and purposely intended before the blot is begun. This general form will exhibit some kind of subject, and this is all that should be done designedly.[58]

A piece of semi-transparent paper should then be laid over the top of the blot, and the contours of a generalized landscape traced on to this fresh sheet. By being suggestive of landscape ('Possess your mind strongly with a subject', Cozens instructs the blot-maker) but not overly definite, the 'blot' was supposed to stimulate the imagination; it was, he quoted approvingly from a letter he had received, 'similar to the historical fact on which a poet builds his drama'.[59] After several pages of detailed instructions, right down to a recipe for making your own ink, Cozens reproduces prints of sixteen 'blots' from which the reader can create landscapes, as well as outlines describing different cloud formations. Armed with systems and typologies, and with the power to tap directly into their imagination, the artist was now free to invent any number of fantastical scenes.

But by the late eighteenth century, when Cozens published his *New Method*, Britain's very real landscape had begun to grip people's imaginations in an entirely new way. It was no longer necessary to invent wild and dramatic scenery; it had been there all along. People had become so used to averting their eyes in horror that it simply took time to recalibrate: it was time for Britain's hills and mountains to be discovered.

Thomas Hearne, *Sir George Beaumont and Joseph Farington Painting a Waterfall,* c. 1777.

V

SENSATION

'How gorgeously glowing!...How gloomily glaring!...
How frigidly frozen! What illusions of vision!'
Miss Beccabunga Veronica in James Plumptre, *The Lakers*

ASTONISHED BEYOND EXPRESSION

In November 1739, the young Horace Walpole and Thomas Gray, fresh from Cambridge, were making their way across the Alps towards Italy. It was a difficult and dangerous journey. At one point the path was so narrow that their carriage was taken apart and loaded on to mules, and the two men were carried on chairs supported by poles: Walpole was horrified when their bearers began quarrelling, and 'rushed [Gray] by me on a crag where there was scarce room for a cloven foot. The least slip had tumbled us into such a fog, and such an eternity, as we should never have found our way out of again.' Worse still, when Walpole let his beloved King Charles spaniel, Tory, out of the carriage next to a fir wood at the top of one of the highest peaks, it was snatched by a wolf.[1]

Even so, if you wished to point to a moment when mountains began to be appreciated for their aesthetic qualities, you could do worse than choose that autumn. Up until then they had generally been regarded as somewhere on the scale between unpleasant and horrific; Captain Burt, a surveyor working in the Highlands of Scotland in the 1720s under the command of General Wade in the wake of the 1715 Jacobite uprising, spoke for many when he characterized the mountains in the Highlands of Scotland as 'monstrous excrescencies'. He was writing to a friend in London who had asked him for an account – and as no one, to his knowl-

edge, had ever 'attempted a minute description of any such mountains' his words cannot be regarded as hastily thrown off, but carefully weighed. He considered them, he reported, to be 'rude and offensive...to the sight', things of 'frightful irregularity, and horrid gloom', the 'huge naked rocks... produc[ing] the disagreeable appearance of a scabbed head'. Even their colour – 'a dismal gloomy brown, drawing upon a dirty purple; and most of all disagreeable when the heath is in bloom' – was against them.[2]

The unfortunate incident with Tory may understandably have made Walpole change his mind ('Such uncouth rocks and such uncomely inhabitants!...I hope I shall never see them again!'), but at the beginning he was entranced. 'Precipices, mountains, torrents, wolves, rumblings, Salvator Rosa', were the evocative impressions with which he summed it all up in a letter from the Savoy mountains to his and Gray's school friend Richard West; 'the pomp of our park and the meekness of our palace! Here we are, the lonely lords of glorious desolate prospects.'[3] Gray, too, was a little ambivalent. 'Mont Cenis, I confess, carries the permission mountains have of being frightful rather too far', he wrote drily to West once they had reached the safety of Turin. And yet his experience of the mountains had affected him profoundly and unexpectedly:

> I own I have not, as yet, any where met with those grand and simple works of Art, that are to amaze one, and whose sight one is to be the better for: But those of Nature have astonished me beyond expression. In our little journey up to the Grande Chartreuse, I do not remember to have gone ten paces without an exclamation, that there was no restraining: Not a precipice, not a torrent, not a cliff, but is pregnant with religion and poetry.[4]

It being the eighteenth century, it was only a matter of time before someone came along to categorize the kinds of sensations Walpole, Gray and others were beginning to acknowledge. In his *Philosophical Enquiry into the Origin of Our Ideas of the Sublime and Beautiful* (1757), the young Irish lawyer Edmund Burke did just that, setting out not only to understand but also to anatomize this attraction for the steep and terrible, so different from the emotions evoked by the tranquil, Claudean scenes fixed as the gold

standard of taste in the public mind by writers like Thomson. Choosing the same word as Gray, Burke concluded that

> The passion caused by the great and sublime in *nature*, when those causes operate most powerfully, is Astonishment; and astonishment is that state of the soul, in which all its motions are suspended, with some degree of horror. In this case the mind is so entirely filled with its object, that it cannot entertain any other, nor by consequence reason on that object which employs it.[5]

He put his finger on the apparently paradoxical sensation in which one felt simultaneously fascinated and appalled: it was 'delightful horror'.[6]

Walpole and Gray were ahead of their time in their aesthetic and emotional response to the mountainous scenery in which Britain, of course, was also rich. In the first decades of the eighteenth century virtually no artist would bother going to North Wales, the Lake District or the Highlands of Scotland. Towards the end, they barely went anywhere else.

Twenty-six years passed before Thomas Gray experienced similar sensations again. In the late summer of 1765, towards the end of a stay at Glamis Castle, he wrote a long letter to a friend describing an excursion along the river Tay, noting how 'on either hand a vast chain of rocky mountains [...] changed their face & open'd something new every hundred yards, as the way turn'd, or the clouds pass'd', and concluding: 'in short since I saw the Alps, I have seen nothing sublime till now'.[7] On his return home, he reflected on his experiences to another friend, William Mason – the mountains had, his words suggest, called up answering echoes in hitherto unexplored caverns of his own soul:

> I am return'd from Scotland charm'd with my expedition: it is of the Highlands I speak: the Lowlands are worth seeing once, but the Mountains are extatic, & ought to be visited in pilgrimage once a year. none but those monstrous creatures of God know how to join so much beauty with so much horror. a fig for your Poets, Painters, Gardiners, & Clergymen, that have not been among them: their imagination can be made up of nothing but bowling-greens, flowering shrubs, horse-ponds,

Fleet-ditches, shell-grottoes, & Chiné-rails. then I had so beautiful an autumn: Italy could hardly produce a nobler scene, or a finer season.[8]

They were scenes that, even if they could not be visited, haunted the imagination. For all his even-handed parcelling-out of landscape into its various species, in his drawings and blots Alexander Cozens repeatedly returned to impossibly mountainous views, pinnacles of rock and vertical cliffs drawn in uncompromisingly monochrome ink. It was a fascination he shared with his friend William Beckford, whose 'long story', *The Vision*, dedicated to his former art master, conjures up a 'scene of melancholy grandeur' that could have been drawn by Cozens and was certainly influenced by his vision:

> …a gloomy dell skirted with huge masses of rock troubled by winds that howled desolation, an torrents that flowed in narrow encumbered channels sending forth a discordant hollow murmur. When I cast my eyes upwards, no cheerful object appeared to relieve them, no tree was rooted in the crevices, no shrub diversified the shaggy promontories… all served to abstract it from the more chearful scenes of nature and to stamp it with a cast of sublime singularity…[9]

In drawing after drawing, Cozens denies the viewer the customary terrace or agreeable spot of high ground from which to look out over the landscape. He offers instead a frighteningly inhospitable ledge from which to witness the rocky spectacles he conjures up in brush and ink. Where on earth are we balancing, we might ask, and how did we get up here? How do we get down again? We are no longer privileged to adopt a high vantage point, with its implications of pride and ownership in all we survey. From our vertiginous perch, Cozens makes sure that our pleasure is mixed with fear.

Gray, too, was alive to the sensations of danger a landscape could provoke – his experience of crossing the Alps made sure of that. During a tour of the Lake District in 1769, he described a journey through Borrowdale:

the crags, named *Lodoor-banks* now begin to impend terribly over your way; & more terribly, when you hear, that three years since an immense mass of rock tumbled at once from the brow, & bar'd all access to the dale (for this is the only road) till they could work their way thro' it. luckily no one was passing at the time of this fall; but down the side of the mountain & far into the lake lie dispersed the huge fragments of this ruin in all shapes & in all directions... soon after we came under *Gowder-crag*, a hill more formidable to the eye & to the apprehension than that of *Lodoor*; the rocks atop, deep-cloven perpendicularly by the rains, hanging loose & nodding forwards, seem just starting from their base in shivers: the whole way down & the road on both sides is strew'd with piles of the fragments strangely thrown across each other & of a dreadful bulk.

Gray's landscape is worryingly unstable. The pass not only bore the traces of a previous fall, but gave every impression that it might, without warning, rearrange itself again; 'the place reminds one of those passes in the Alps', he continues, 'where the Guides tell you to move on with speed, & say nothing, lest the agitation of the air should loosen the snows above, & bring down a mass, that would overwhelm a caravan. I took their counsel here and hasten'd on in silence.'[10] He may have been being over-dramatic – it was the beginning of October, and with no snow an avalanche was unlikely – but physical danger as well as feelings of awe were vital threads in Gray's conception of the landscape. When his account of his visit to the Lake District was printed as an appendix to the second edition of Thomas West's popular *Guide to the Lakes* in 1780, it reached a wide audience among those touring the district, and the sensations he so sensitively recorded set off many answering echoes.

Like the 'Pandemonium of Milton' – or so the landscape seemed to the writer Henry Kett as he made his way one night from Walsall to Birmingham, making notes for what would become his lengthy 'Tour to the Lakes of Cumberland and Westmoreland in August 1798'. Mountains had been there for millennia, even if they had only recently become sites of aesthetic appreciation and the exercise of 'astonishment'. But other parts of the

land were actually changing – and changing dramatically. Kett travelled through the industrial heartland of England, past coal and ironworks 'sometimes flaming and sometimes pouring forth vast clouds of illuminated smoke', turning the quiet evening into a spectacular theatrical show.[11] He happened to be passing on his way to more conventionally spectacular scenery, but for others, ironworks and mines were destinations in them-selves – places that were guaranteed to excite a frisson of Sublimity. Here is the Rev. William Bingley visiting the Anglesea copper mines:

> Having ascended to the top, I found myself standing on the verge of a vast and tremendous chasm. I stepped on one of the stages suspended over the edge of the steep, and the prospect was dreadful. The number of caverns at different heights along the sides; the broken and irregular masses of rock which every where presented themselves; the multi-tudes of men at work in different parts, and apparently in the most perilous situations; the motions of the whimsies [windlasses], and the raising and lowering of the buckets, to draw out the ore and the rubbish; the noise of picking the ore from the rock, and of hammering the wadding, when it was about to be blasted; with at intervals, the roar of the blasts in distant parts of the mine, altogether excited the most sublime ideas, intermixed, however, with sensations of terror.[12]

And that was before he had even crossed the threshold. Once there, he was 'fixed…almost motionless to the spot', the 'sulphureous fumes' from the kilns putting him in mind of Virgil's entrance into the hell-like abyss of Tartarus.[13] Though his scenes of stages, ropes and buckets high above might have been imagined by Piranesi and his references were classical, Bingley's attitude to these steamy modern marvels is not so far removed from the medieval sense of wonder.

For a sense of how attitudes to industry changed over the second half of the eighteenth century, compare Paul Sandby's 1751 drawing of Lord Hopetoun's lead mines with Philippe Jacques de Loutherbourg's *Colebrookdale by Night*, painted exactly fifty years later (Plate 7). Like one of the figures companionably chatting and gesturing towards the mine, Sandby shows us the machinery in considerable detail – one

Paul Sandby, *Lord Hopetoun's Lead Mines*, 1751.

could almost use his drawing to construct a model lead mine. But there, too, is the natural setting of Lanarkshire, the grazing cattle, the lake and the hills with a tumbling stream, with which the mine seems comfortably to coexist. Looking at de Loutherbourg's *Coalbrookdale by Night*, on the other hand, is like opening the door of a hot oven. Night work is taking place at the Bedlam furnaces on the bank of the river Severn in Shropshire, and in place of Sandby's clear depiction of the machinery, de Loutherbourg makes it hard to grasp what is happening – he does not want us to understand so much as to feel. Flames and smoke from the coke hearths fill the sky, seeming to push the moon itself off to one side, throwing the factory into silhouette while lighting up the hillside beyond. In this spectacular, uncomfortable, hard-working landscape, the very laws of nature seem to have been overturned.

At least at first, it does not seem to have occurred to travellers and seekers after sensation that the landscape was being violated by this heavy industry. Near Colebrookdale, the Rev. James Plumptre approvingly described the 'singular scene' he witnessed as he approached Iron Bridge:

To the right are limekilns burning close to the water's edge, whilst above them a hill rises with a swift ascent, covered with wood to the

top: at the foot of this runs the Severn crowded with masts of vessels, on the shore are large piles of coals; the bridge in front with the river, boats, furnaces and houses all intermingling with trees; the horse at the windlass drawing up the load added life to the scene, & a blast from one of the mouths spoke like thunder.[14]

Nowadays we expect industry to be separated from scenes of natural beauty – but Plumptre seems to have found the 'intermingling' of the two exceptionally engaging. It even seeps into his imagery: to him, a harnessed horse paradoxically had more 'life' than the natural scenery of woods and river, while a limekiln could emulate a storm with its thunderous noise. A similar reaction was recorded by D. C. Webb in 1812, after witnessing the ironworks at Bilston:

Plain narrative is inadequate to convey what I felt at this wonderful combination of the ingenious productions of man! I was not only astonished by the works of art, but Nature had also contributed to add terror to the scene, by the earth smoking at different places; in consequence of the burning coal-pits, by which these works are surrounded...[15]

This was progress. It is hard to imagine, in the first half of the eighteenth century, a poet like Thomson dwelling on a comparable note of 'terror' in the landscape – he embraced prosperity but believed it was inherent in the gentle pastoral scene, written into carefully tended farmland studded with neat towns and villages. By contrast, the concept of the Sublime walked hand-in-hand with the industrial revolution.

FAIRYLAND

If you had been walking down Drury Lane in March 1779 you might well have seen an advertisement for a pantomime at the Theatre Royal called *The Wonders of Derbyshire, or Harlequin in the Peak*. The play itself, a chaotic combination of harlequinade and travelogue, was not

among Drury Lane's most distinguished productions – 'The title of this pamphlet is a sufficient review of its contents', as the *Monthly Review* witheringly remarked, while the *Westminster Gazette* characterized the plot as 'absolutely contemptible'. But if you were not put off by the bad press or simply wished to be entertained by an undemanding bit of clowning, you would have seen something remarkable. For the first time, landscape itself was given a starring role.

The set designs were by the man who went on to paint the supremely theatrical *Colebrookdale by Night*; Philippe Jacques de Loutherbourg, an artist born in Alsace and trained in Paris. Soon after arriving in London in 1771, already a successful landscape painter, he was introduced to the great actor and theatre manager David Garrick. De Loutherbourg went to Garrick with a proposal: rather than hiring a succession of scene-painters, why not employ him, instead, to have overall control over stage scenery? Garrick agreed, giving him a salary of £300, rising to £500 during his second season. In return, de Loutherbourg transformed British stage design. He introduced a greater degree of illusionism, with subtle lighting and dramatic sound effects. He broke up the old convention of wing flats and painted backdrops, bringing freestanding aspects of the scenery downstage so that actors could move among them. But most of all, he brought his skills as an easel painter and his knowledge of seventeenth-century Dutch painting and the dramatic landscapes of Salvator Rosa to theatre design; this allowed him to introduce sophisticated ways of framing the view and to create the illusion of pictorial depth. In 1778 de Loutherbourg travelled to the Peak District in order to make preparatory sketches for his designs for *The Wonders of Derbyshire* on the spot. His model for a stage set of Peak Cavern – the Devil's Arse – is a rare survival, now in the Victoria and Albert Museum.[16] This particular design was unprecedented in its inventiveness. Incorporating multiple layers of boards with cut-out centres to suggest depth and freestanding boulders, the set gave the actors something to clamber over and step into – for the first time, they could interact with the scenery and move through the space of the cavern. From your place in the audience, you would have witnessed a newly immersive kind of theatre.

Set model by Philippe Jacques de Loutherbourg for *The Wonders of Derbyshire*, 1779.

When he left Drury Lane in 1781, de Loutherbourg went a step further in rethinking landscape's role on the stage. He created a miniature theatre, just eight feet wide and six feet high, in a large room of his house on Lisle Street in London. He called it his *Eidophusikon*, a term coined from the Greek meaning 'image of nature'. This was a theatre devoted to landscape and seascape – when figures did appear, they were incidental – and rather than being static, it was designed to move. Night after night, fashionable London flocked to see this novelty: storms at sea, sunsets, moonrises, mountainous landscapes and gentle pastoral scenes appeared to change and develop as rods and pulleys manoeuvred images of crashing waves, ships and figures back and forth, clouds painted on strips of linen were winched past and puffs of smoke created drifting mists and fogs.[17] For the first time, landscape was able to unfold its own story; to be the drama rather than the backdrop. '[B]y adding progressive motion to accurate resemblance', de Loutherbourg wrote in his prospectus, 'a series of incidents might be produced which should display in the most lively manner those captivating scenes which inexhaustible Nature presents

to our view at different periods and in different parts of the globe.'[18] But perhaps the most powerful tool in his theatrical box of tricks was light: coloured filters were used to create different atmospheres and to represent the changing times of day.

One visitor who found himself captivated by de Loutherbourg's experiments with the theatre of landscape was Gainsborough. He had not always been an admirer of de Loutherbourg's innovations at Drury Lane; far from it. When the designer began to use warmer, brighter colours in his stage sets, Gainsborough complained to his close friend Garrick with characteristic trenchancy: 'When the streets are paved with Brilliants, and the Skies made of Rainbows I suppose you'll be contented, and satisfied with Red blue & yellow', and predicted with grim satisfaction that 'when Eyes & Ears are thoroughly debauch'd by Glare & noise, the returning to modest truth will seem very gloomy for a time'.[19] But de Loutherbourg's *Eidophusikon* offered a range of subtle and changing effects that opened up new possibilities in Gainsborough's creative imagination. This new landscape-theatre, along with his admiration of work by the stained-glass artist Thomas Jervais, which mostly explored the effects of candlelight and moonlight, led Gainsborough to paint a group of sparkling landscapes on glass.[20] Using oil paint thinned with solvent so that the light would pass through the brushstrokes, he painted woodlands and downlands and lyrical river landscapes bathed in golden light; a gentle pastoral scene with sheep heading back to the fold under a darkening evening sky; a cottage in the moonlight, surrounded by trees, with a figure silhouetted in the light from the open door (Plate 9). He had a wooden 'show-box' made to create optimum viewing conditions – one looked through a viewing aperture fitted with a magnifying lens at a painting slotted into a groove (a system of internal cords and pulleys and a moveable carriage would hoist the required picture into position). At the back, up to three candles were placed to light the painting from behind, their light diffused through a silk screen. By varying the strength of light and the colour of the silk, Gainsborough was able to introduce to landscape painting what had always been a challenge to represent in oil paint: glowing, vivid light as it changed throughout the course of the day. The show-box creates an enveloping

experience: with one's eyes at the viewer, the reality of the room where it stands recedes as one becomes immersed in Gainsborough's magical, glowing landscape-world.[21]

As de Loutherbourg and Gainsborough created absorbing spectacles of landscape painting, so Paul Sandby sought to give a new, encompassing experience. In 1793, Sir Nigel Gresley invited him to paint the walls and ceiling of his dining room at Drakelow Hall in Derbyshire (now Staffordshire) with panoramic views of Snowdonia and the Peak District. Although Sandby, with his ordnance-survey background, could be relied upon to depict the landscape with a sober regard for topography rather than to put it into Claudean fancy dress like his friend Wilson, it was still an enterprise steeped in classical precedent. Vitruvius and Pliny both refer to classical villas decorated with illusionistic landscapes, and in 1530 the Ferrarese artist Dosso Dossi had been commissioned by the Duchess of Urbino to paint frescoes at the Villa Imperiale in Pesaro in this way.[22] Not long after its completion, the poet Anna Seward (the 'Swan of Lichfield') described Sandby's dining room as one of 'singular happiness':

> It is large, one side painted with forest scenery whose majestic trees arch over the coved ceiling. Through them we see glades, tufted banks, and ascending walks in perspective. The opposite side exhibits a Peak valley, the front shows a prospect of more distant country, vieing with the beauties of the real one, admitted through a crystal wall of window.... Real pales, painted green, and breast high, are placed a few inches from the wall and increase the deception. In these are little wicket gates that, half open, invite us to ascend the seeming forest banks.[23]

Sadly, the room no longer exists in its entirety. Drakelow Hall was demolished in 1934, but an interior section was rescued and bought by the Victoria and Albert Museum. From what survives, Sandby seems to have conceived of the room as two layers of landscape – that which immediately surrounded Sir Nigel and his guests framing views of more distant prospects beyond. The walls give the illusion that the dining room is set in a forest glade, surrounded by tall trees that send their highest branches

A room with a view: Paul Sandby's painted dining room from Drakelow Hall, 1793.

up the coving and flutter their leaves over the ceiling, while wispy white clouds animate the blue sky above. Here and there, grassy slopes and a river can be seen through the tree trunks. Set into these walls are alcoves that frame views of more open landscapes: Seward records a scene in the Peak District from one direction, while from another we can stand and marvel at a view of Dolbadarn Castle on the lake Llyn Peris, with Snowdon beyond. Although Sandby's woody landscape is encompassing, we are separated from it by a formidable barrier of smart trellis and stout fencing: we can see nature all around, but there is no danger here of caterpillars dropping on our heads or of tripping over old roots. Sir Nigel's dining room was a roofless summerhouse: nature was kept at bay, with occasional platforms to frame views of spectacular scenery beyond. It was admired, but kept at arm's length.

Occasionally an invention comes along that offers a new way of looking at the world. Thomas Baldwin saw himself as an explorer in a new element, a man with extravagant tales to tell of the 'glorious and enchanting Prospect' that unfolded before his eyes during an excursion he made

one extraordinary day in September 1785. Yet he did not go far afield, or indeed venture much beyond the fields and villages on the outskirts of Chester. What he could offer was the view from a novel perspective: the basket of a hot air balloon. Writing an account of his voyage soon afterwards from notes jotted down on the spot, he marvelled at how defective other balloonists had been

> in their Descriptions of aërial Scenes and Prospects: those Scenes of majestic Grandeur which the unnumbered Volumes of encircling Clouds, in most fantastic Forms and various Hues, beyond Conception glowing and transparent, portray to a Spectator placed as in a Center of the Blue Serene above them...a most exquisite and ever-varying Miniature of the *little Works of Man*, heightened by the supreme Pencil of Nature, inimitably elegant, and in her highest Colouring.[24]

Baldwin gives an account of the landscape as it appeared from the sky with a sense of wonder that still rings out from the page. It was the new perspective that astonished him most. He had been unprepared for the contraction of the view below him. And yet, he wrote, 'so far were the Objects from losing their Beauty, that EACH was BROUGHT UP in a new Manner to the Eye, and distinguished by a Strength of Colouring, a Neatness and Elegance of Boundary, above Description charming!' It was overwhelming, a kind of 'Fairy-Land', he thought, and he was so violently seized with delight that he shouted for joy – but was disconcerted at how thin and feeble his voice sounded, and that there was 'no Echo'.[25]

When he looked down, he saw that his new perspective made the earth look like a 'Miniature-Picture painted on the Bottom of the Bowl, on the Inside'. The images on the sides near the bottom, he notes, were 'rather obscure', while the sides to the top were 'fantastically grouped, spotted, and dash'd with Clouds dense and luminous, in the strangest and most grotesque Forms'. Looking down on what seemed to be 'A WORLD of *Clouds*', he saw them as 'steep and RUGGED MOUNTAINS seen in Perspective'. It was, he thought as he marvelled at the 'deep cerulean and pellucid Azure' sky above, a 'NOVEL EARTH', which appeared to be 'covered to a prodigious Depth, by successive Falls of Snow'.[26]

The effect of sunlight on the landscape below amazed him. The ground, of a 'gay green Colour, appeared like an inverted Firmament glittering with Stars of the first Magnitude' as the sun reflected off the surface of dozens of ponds. Strangest of all, the river Dee, which normally looked silvery, 'had now acquired the unvaried Colour of red Lead', and its meanders were 'infinitely more serpentine than are expressed in Maps' – while, seen directly from above, the city of Chester appeared 'entirely *blue*'.[27] It was all very strange. He seemed to have left the rules that governed the appearance of the world on the ground and ascended to a dreamlike place where nothing looked, or behaved, as it should.

Baldwin had taken his sketchbook up with him. He made drawings of the scene below which he later had professionally engraved, before colouring the impressions to be bound into copies of his book himself, wanting to capture the precise hues (Plate 8). One plate, his 'Balloon Prospect from Above the Clouds' ambitiously sets out to show 'the whole Extent of the aërial Voyage', showing the country between Chester, Warrington and Rixton-Moss. He has indicated the 'meandering Track of the Balloon throu' the Air' by superimposing a black line over the aerial landscape, and suggests that to 'form an accurate Idea of the Manner, in which the *Prospect below* was represented *gradually in Succession*, to the Aironaut', the reader should roll a piece of paper into a tube, put one eye to it while closing the other and follow the line as it loops and wheels gently over the countryside.[28] The strange, unsophisticated image with its drifting clouds and snaking pink river conveys his astonishment at this novel perspective on a familiar landscape. His only regret was that an artist of the stature of Angelica Kauffman had not been up there with him, ready with her paintbrushes to capture 'so much *variegated* Beauty'.[29]

For all the novelty of Baldwin's perspective, he was far from being alone in the strength of his response. A new culture of sensibility was sending ever more people out on summer tours of Britain, in search of sensation.

IN PURSUIT OF THE PICTURESQUE

A balloonist drifting above the Wye Valley on any fine summer's day towards the end of the eighteenth century would have been astonished at the number of pleasure craft plying the river between Ross and Chepstow. It had become a brisk commercial enterprise: for three guineas it was possible to hire a boat equipped with a canopy to protect you from the sun and showers and convenient little tables at which it was possible to draw or make notes. Another guinea would provide for the oarsmen. The point of the trip was solely to admire the spectacular, ever-changing scenery from the perspective of the river as you and your friends glided along.[30]

From the 1770s onwards, certain areas of Britain such as the Wye Valley and the Lake District went from being little visited – or indeed, in the case of the latter, actively avoided – to becoming hugely popular destinations. It was the age of the picturesque tour, when, armed with guidebooks, holidaymakers set out determined to see and to admire these places. The change had various causes: a rapidly expanding middle class with sufficient leisure and resources to take holidays; improved roads (broadly speaking); the gradual osmosis of Burkean ideas about dramatic countryside into the general consciousness; the increasing popularity of painted and poetic landscapes. But if any one individual can be held responsible for the unprecedented craze for travel that marked the decades on either side of 1800, it was a retiring clergyman–schoolmaster from Surrey, William Gilpin. Between 1768 and 1776, Gilpin made tours during his summer holidays and wrote up detailed accounts of all he had seen for private circulation. It was only at the insistence of his friends that he began to publish his descriptions, along with prints reproducing his brown-toned sketches of 'picturesque' scenery – charming, but, as readers pointed out, tricky to identify with a particular spot. Once in wider circulation, his books became phenomenally popular. The reason was simple: he instructed people not only on where to go, but on how to look at the landscape when they got there.

'The following little work', he writes at the beginning of his *Observations on the River Wye* (1782), 'proposes a new object of pursuit; that of not barely examining the face of a country; but of examining it by the rules

of picturesque beauty: that of not merely describing; but of adapting the description of natural scenery to the principles of artificial landscape'.[31] Untutored gazing, it seemed, was off the agenda. So what were these rules and principles? *Observations* bristles with them; even before he reaches the Wye Valley Gilpin is busy judging each view by how it would appear as an artistic composition. The landscape, on leaving Gloucester, is 'pleasing', comprising three elements: a 'foreground' of meadow, an intermediate 'screen' of woodland and a distant view, with the Malvern hills making 'a respectable appearance'. So far, so good. He found the view from the town itself, however, over a sweep of the Wye and the country beyond it, disappointing. It is 'amusing', Gilpin concedes, 'But it is not picturesque. It is marked by no characteristic objects: it is broken into too many parts; and it is seen from too high a point.'[32] If the tourist were to take Gilpin's ideas to heart, he or she would be far too busy discriminating to sit back and enjoy the view.

There was a fundamental problem with the landscape, Gilpin thought, and it was the fault of Nature herself. She could not be trusted to produce acceptable scenery because she was sadly incompetent when it came to composition. In her defence, Gilpin conceded, '[s]he is an admirable colourist, and can harmonize her tints with infinite variety, and inimitable beauty'; and yet when it came to conforming to the rules he had devised, she kept getting it hopelessly wrong.

> Either the foreground, or the background, is disproportioned: or some awkward line runs across the piece: or a tree is ill-placed: or a bank is formal: or something or other is not exactly what it should be.

Gilpin goes on to acknowledge, if somewhat grudgingly, that nature works on a '*vast scale* and, no doubt harmoniously', but his particular concern is with the artist's little 'span'. His earnest determination to squash nature into precise regulations of his own making reflects the strength of empirical thought towards the end of the eighteenth century as well as an increased capability for precise topographical measurement. What he called his 'little rules' are on a spectrum with the detailed measurements of the land with theodolite and triangulation that were being carried out in Scotland, resulting in the establishment in 1791 of the Ordnance Survey.[33]

Gilpin was largely satisfied with his journey along the Wye Valley, which presented him with 'a succession of the most picturesque scenes'. 'The beauty of these scenes arises chiefly from two circumstances', he announced; 'the lofty banks of the river, and its mazy course'.[34] Along with his friends he took a boat along the river, gazing at these unfolding and constantly changing views – unlike a jolting carriage, its gliding motion was perfect for the picturesque tourist equipped with a sketchbook. The low viewpoint added to the drama; everything looked so much more imposing from below.

Goodrich Castle was among the first highlights that was revealed to them, and, wrote Gilpin,

> we rested on our oars to examine it. A reach of the river, forming a noble bay, is spread before the eye. The bank, on the right, is steep, and covered with wood; beyond which a bold promontory shoots out, crowned with a castle, rising among the trees.

It was a view 'I should not scruple to call *correctly picturesque*', Gilpin noted with approval.[35] A little further along, however, Tintern Abbey was more problematic. On the one hand,

> A more pleasing retreat could not easily be found. The woods, and glades intermixed; the winding of the river; the variety of the ground; the splendid ruin, contrasted with the objects of nature, and the elegant line formed by the summits of the hills, which include the whole; make all together a very inchanting piece of scenery.[36]

But on the other, the ruins of Tintern's monastic buildings were not visible from the river, only the abbey church, and even that failed tantalizingly to appear 'as a *distant* object', as Gilpin had expected it to. 'Though the parts are beautiful,' he conceded, 'the whole is ill-shaped. No ruins of the tower are left, which might give form, and contrast to the walls, and buttresses, and other inferior parts.' Instead, 'a number of gabel-ends hurt the eye with their regularity; and disgust it by the vulgarity of their shape'. The idea of setting about them with a mallet crossed his mind. But

when he approached the abbey ruins, he found much to admire in the effects produced by time: the weathered, rounded edges of the masonry and the ivies, mosses and other plants growing from crevices.[37]

The spots where Gilpin put down his oars and took up his pencil were those in which nature was neither too bleak, nor too dull. His idea of the 'picturesque' was a middle ground between Burke's categories of the sublime – too stirring – and the beautiful – not quite stirring enough. It implied irregular country like the road towards Ross-on-Wye, which he described as 'woody, rough, hilly, and agreeable', with trees and shrubs that softened the edges of a landscape. A few years later, in an essay on 'Picturesque Beauty', he even illustrated his theory with his own drawings of two contrasting landscapes. The first, sadly lacking in picturesque qualities, consists of 'a smooth knoll coming forward on one side, intersected by a smooth knoll on the other; with a smooth plain perhaps in the middle, and a smooth mountain in the distance. The very idea', he continues, 'is disgusting.' He proposes a second, roughed-up version of the same landscape: one in which the uneven contours of the hills are further broken up by groups of trees and bushes, a cluster of buildings and a rutted lane with figures. Incident, variety and rough textures, contributing to a complex fall of light, are all essential to Gilpin's idea of picturesque beauty.

A trip to East Anglia, made in 1769, provided Gilpin with no such agreeable scenes. He had only gone there to look at the celebrated collection of paintings at Houghton Hall in Norfolk, but decided to make the most of his trip by making a 'hasty tour' of the area.[38] It was a terrible mistake, and genuine disgust rises from the pages of his travel notes like a miasma. First of all, there was the problem of the fens. Comparing them unfavourably with lakes, Gilpin found them stagnant and putrid. While lakes have 'a beautiful line formed by the undulation of the rocks', he wrote, the swampy soil of the fens allows no distinctive border but instead creates 'a line of decaying sedge, and other offensive filth'. 'Instead of the rocks, and woods, which so beautifully adorn the lake, the fen presents at best only pollard willows, defouled with slime, and oozy refuse hanging from their branches'. While 'the lake is a resplendent mirror', the fen, 'spread with vegetable corruption, or crawling with animal generation, forms a

Contrasting landscapes demonstrating William Gilpin's
theories of 'Picturesque Beauty'.

surface, without depth, or fluidity; and is so far from reflecting an image,
that, it hardly comes within the definition of a fluid'. And while Gilpin's
lakes are normally enlivened by light skiffs or fishing boats, fens have
no such 'chearful inhabitants' – only the odd miserable cow or beslimed
horse struggling to extricate itself from the mud.[39] Although he bravely
made a sketch of this flat landscape, which he did his best to enliven

with windmills, one gets the sense that he shrank from such bleakness. That was not the worst he encountered in the east. *En route* from Ely to Houghton and hoping to find a road across firmer, less fenny ground, he found instead a sandy country, every bit as 'wild, open, and dreary' and, if possible, 'still more disagreeable'. In place of the rough, hilly country he loved, he found himself in a place he could only liken to a desert. 'Not a tree was to be seen. The line of the horizon was scarcely broken with a single bush.' It was, he concluded bleakly, 'a little surprizing to find such a piece of absolute desert almost in the heart of England…. We had not even heard of it'.[40]

When Gilpin's observations of East Anglia were published posthumously in 1809, they were, to say the least, unlikely to have persuaded any potential tourists to visit the eastern counties of Britain in search of picturesque beauty. Many decades would pass before the low, watery landscapes and huge skies of Lincolnshire, Cambridgeshire and Norfolk would be thought worth looking at. Since the 1770s the fashion had been to go in the other direction: if not to the Wye Valley, then to the Lake District, where yet more dramatic scenery could be found and the impressions it produced savoured.

Tourists needed to know how to navigate this new territory, and the most popular publication to offer such help was *A Guide to the Lakes* by the Scottish antiquary Thomas West; first published in 1778, by 1799 it had been through seven editions. Gilpin's record of his visit to the Lake District in *Observations, Relating Chiefly to Picturesque Beauty* (1786) was influential, but, as the title made clear, it was principally concerned with aesthetics – and the opinions it recorded were personal to the point of downright eccentricity; he dismisses Kendal, for instance, as 'situated in a wild, unpleasant country, which contains no striking objects; and cannot be formed into any of those pleasing combinations, which constitute a picture'.[41] West's success with his *Guide* lay in his direct appeal to his middle-class readership, whom he flatters by suggesting that they are probably mentally and emotionally over-taxed, and their true thoughtful and imaginative natures would be nourished by the landscape. Back in 1726 John Dyer had seen nature as a form of therapy: she 'dresses green

and grey, / To disperse our cares away'. But West is probably the first writer explicitly to promote time spent in the landscape as a therapeutic antidote to urban life:

> Such as wish to unbend the mind from anxious cares, or fatiguing studies, will meet with agreeable relaxation in making the tour of the lakes. Something new will open itself at the turn of every mountain, and a succession of ideas will be supported by a perpetual change of objects, and a display of scenes behind scenes, in endless perspective. The *contemplative* traveller will be charmed with the sight of the sweet retreats, that he will observe in these enchanting regions of calm repose, and the *fanciful* may figuratively review the hurry and bustle of busy life (in all its gradations) in the variety of unshaded rills that hang on the mountains sides, the hasty brooks that warble through the dell, or the mighty torrents precipitating themselves at once with thundering noise from tremendous, rocky heights; all pursuing one general end, their increase in the vale, and their union in the ocean.[42]

Offering a combination of aesthetic and practical advice, West recommends a number of 'stations' where tourists could gather to view particularly spectacular scenery, and where artists might wish to sketch. 'Near the isthmus of the ferry point', he instructs under the heading 'STATION I' at Windermere, 'observe two small oak trees that inclose the road; these will guide you to this celebrated station. Behind the tree, on the western side, ascend to the top of the nearest rock, and from thence in two views command all the beauties of this magnificent lake.'[43] These 'stations' are clearly marked on plans of the lakes that were surveyed, drawn and printed by Keswick native Peter Crosthwaite, who exploited the sudden boom in tourism, calling himself 'Admiral of the Keswick Regatta...Guide, Pilot, Geographer & Hydrographer to the Nobility and Gentry who make the Tour of the Lakes'. Throughout the Lake District, innkeepers alert to the steady increase of visitors were raising their prices, while other enterprising individuals were offering guided tours or trips in canopied pleasure boats; but Crosthwaite operated on a wholly different level. He not only set up a museum in Keswick,

a tourist attraction that survived until 1870, but even altered the land-
scape itself to make it more convenient, cutting steps in the rocks for
tourists visiting Scale Force.[44]

In the second edition of *A Guide to the Lakes* (1780), West introduced
a more literary dimension, adding an appendix containing previously
unpublished accounts by writers such as John Brown (the 'Columbus of
Keswick') and Thomas Gray, as well as poems, forming an appealing liter-
ary anthology. It established a range of possible emotional and aesthetic
responses to the scenery, from Brown's somewhat portentous description
of Keswick as '*beauty, horror,* and *immensity* united' to Gray's gentler
and perhaps more enticing report of Borrowdale as 'the most delicious
view that my eyes ever beheld'.[45] These joined a burgeoning market in
watercolours, paintings and prints of Lake District views to create an
echo chamber of reassuring cultural associations.

West explicitly encourages his readers to look at the landscape as
though it were a series of pictures, reaching for the familiar triumvirate
of great seventeenth-century painters as he seeks to convey the variety
of lake-land scenery: 'The change of scenes is from what is pleasing,
to what is surprising', he writes; 'from the delicate touches of *Claude*,
verified on *Coniston* lake, to the noble scenes of *Poussin*, exhibited on
Windermere-water, and, from these, to the stupendous romantic ideas
of *Salvator Rosa*, realized on the lake of *Derwent*.'[46] And rather than
expecting his readers simply to admire views from his carefully selected
stations while bearing these artists in mind, West makes what at first
sight seems a strange recommendation: that they turn their backs to it
and look at its reflection in a 'landscape mirror', or what would become
known as a Claude glass (Plate 10). This popular bit of equipment would,
West promised, 'furnish much amusement in this tour. Where the objects
are great and near, it removes them to a due distance, and shews them in
the soft colours of nature, and in the most regular perspective the eye can
perceive, or science demonstrate.'[47] As its name suggests, it was supposed
to make the scene reflected over one's shoulder resemble a painting by
Claude, creating the perfect hybrid between a native and an Italianate
view. There could hardly have been a more perfect illustration of the
contemporary attitude to British landscape.

Thomas Gainsborough, drawing of a man using a Claude glass, *c.* 1750.

So how exactly was a Claude glass constructed? Despite its resonant name, it was simply a slightly convex oval mirror, about four by six inches in diameter, made with darkened – rather than the usual silvered – glass and mounted in a leather case with a clasp to keep it shut while travelling. West recommended its use in sunshine; on a dull day, a glass backed with silver foil would cast the scene in a more cheerful light. Any optician, he confidently predicts, would be able to supply one.[48] The reflection that appeared in the darkened glass was weaker than usual,

but this had the advantage of suppressing detail so that only the more prominent features of the landscape would appear. The vivid colours of nature were also muted in the reflection, so that the scene appeared to be bathed in soft tonalities. And most useful for aspiring artists, it would reduce a vast panorama to the scale of a small drawing. Gray frequently resorted to the glass to view particularly spectacular scenes, and indeed a version of it glazed in various colours became known as a Gray's glass. On 29 October 1769, he wrote to his friend Thomas Wharton: 'Dined by two o'clock at the Queen's Head, & then straggled out alone to the Parsonage, fell down on my back across a dirty lane with my glass open in one hand, but broke only my knuckles: stay'd nevertheless, & saw the sun set in all its glory.'[49] So popular was the Claude glass that some tourists even had large versions fixed to the windows of their carriages, so that as they travelled they could witness a sequence of scenes as though painted by the seventeenth-century master.[50] It was as odd as if nowadays one could buy a film for the back windows of a car that made every landscape seen from the road look like a picture by Constable. On the other hand, it was merely an external expression of a passion for Claude that, over the course of time, had penetrated deeply into people's minds.

A Gray's glass and a Claude glass; two volumes of William Cowper's poems; a drawing book; a compass and a pedometer; a magnifying glass for botanizing; a telescope and a barometer. These were the 'travelling requisites', or 'knick-knacks' listed by the clergyman James Plumptre, who journeyed extensively throughout Yorkshire, Northumberland, the Highlands of Scotland, the Lake District and North Wales, walking much of the distance – according to his pedometer, on one tour he notched up 1,774 and one-quarter miles on foot.[51] Of all this equipment, the sketchbook was the one found in most tourists' luggage. Not only did travellers have a passion to see these landscapes, they were also determined to record them with sketches and notes made on the spot. When back at home, these precious books recording details of journeys and responses to the landscape were circulated among friends.

Surprisingly few such manuscript journals survive, but one that does, now in the British Library, was kept by the poet Robert Bloomfield and records in great detail his 'Journal of a Ten Days' Tour from Uley

in Gloucestershire by way of Ross, down the river Wye to Chepstow, Abergavenny, Brecon, Hereford, Malvern, etc., Aug. 1807'. It includes topographical descriptions, pasted-in maps, anecdotes and Bloomfield's own drawings, including one of his party in the Severn Valley, admiring the view through a telescope. Bloomfield has ruled a vertical line down

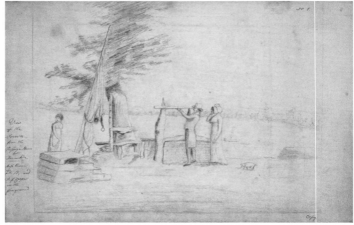

Robert Bloomfield's journal recording a tour down the river Wye in 1807.

every right-hand page to make a wide margin, leaving space to one side of his written account for notes and smaller drawings of curiosities encountered en route – a special boat built to convey horses and carriages across the Severn (annotated 'rough sketch from recollections'), Raglan Castle 'as seen from the skirts of the town', a Roman brick he found. There is a sketch tracing the course of the river Wye from Ross to Chepstow, so that the entire tour may be followed. The journal ends with his return home and a sketch of 'My Cat. In his usual attitude when warming himself at the fire'.[52]

On the grander end of the scale is a drawing by the topographical artist Thomas Hearne showing the wealthy amateur draughtsman and patron Sir George Beaumont (a former pupil of Alexander Cozens) and his friend, the diarist Joseph Farington, sketching at a waterfall at Lodore during Beaumont's first visit to the Lake District in 1777 (see p. 136).[53] Beaumont and Farington sit among the great boulders with easels and canvases propped in front of them, protected from the sun's glare, sudden showers and the spray from the falls by several capacious umbrellas managed by a servant. One assumes it was not a windy day. While most tourists and keen amateur artists would have made pencil sketches in pocket-sized books, perhaps adding a little watercolour, these men paint in oils – an ambitious proposition even outdoors in the gentlest of landscapes – with such apparent composure that they might have been in the studio.

THROWING A GILPIN TINT

'Good God! how delightful! – how charming! – I could live here for ever! – Row on, row on, row on, row on'. Having spent an hour exclaiming on Lake Windermere and half an hour at Ambleside, this particular gentleman was seen ordering his horses into his phaeton (the eighteenth-century equivalent of a Porsche) and speeding off in the direction of Derwent Water – which, one suspects, did not detain him for much longer.[54]

There was no doubt that the British had become infatuated with their mountainous landscapes, even if they did prefer to turn their backs on the real thing and view them in a Claude glass. As Dr Johnson's friend Hester

Lynch Piozzi wrote in 1789, there was a positive '*Rage for the Lakes*; we travel to them, we row upon them, we write about them, & about them'.[55] The exception that proves the rule was the Regency dandy Beau Brummell. When an acquaintance making a morning call went into raptures over his recent tour of the north of England and asked his host which of the lakes he preferred, an exasperated Brummell turned to his valet and demanded, 'which of the lakes do I admire?' to which the reply was 'Windermere, sir'. 'Ah yes, – Windermere', repeated Brummell to his guest.[56] Like any craze, this 'Rage for the Lakes' resulted in various annoying phenomena, not least from the locals' point of view – roads were churned up by carriages, lakes crammed with pleasure-craft and frequent, deafening reports sounded as canons were fired to demonstrate the effect of an echo among the mountains.[57] It was not long before the satirists began to sharpen their quills.

One of the first satires – published but never staged – was *The Lakers: A Comic Opera, in Three Acts* (1798) by Plumptre, the travelling clergyman. His heroine, Miss Beccabunga Veronica, is seized with a passion for the picturesque, and has a range of knick-knacks at her disposal – including a pocket viewing device from which she can unfold a variety of coloured glasses (Plate 10).

> 'Speedwell, give me my glasses. Where's my Gray? (*Speedwell gives glasses.*) Oh! Claude and Poussin are nothing. By the bye, where's my Claude-Lorrain? I must throw a Gilpin tint over these magic scenes of beauty. (*Looks through the glass.*) How gorgeously glowing! Now for the darker. (*Looks through the glass.*) How gloomily glaring! Now the blue. (*Pretends to shiver with cold.*) How frigidly frozen! What illusions of vision! The effect is inexpressibly interesting.'

'Pray, Miss, what's this you call your Cordovan?' asks Billy Sample, the bag-man. 'My Claude Lorrain!' replies Miss Beccabunga. 'It is a *deceptio visus*, an artifice to give the various tints of the changes of weather and season to the landscape.' 'Well, Miss,' says Sample, looking at it, 'if that's your fancy, I should think it would be less trouble always to wear a pair of green or yellow spectacles.' She ignores him.

If Miss Beccabunga's enthusiasm for viewing the scene through coloured glasses satirizes Gilpin's mania for 'improving' the natural landscape, her prose is every bit as garish:

> The amphitheatrical perspective of the long landscape; the peeping points of the many-coloured crags of the head-long mountains, looking out most interestingly from the picturesque luxuriance of the bowery foliage, margining their ruggedness, and feathering the fells; the delightful differences of the heterogeneous masses; the horrific mountains, such scenes of ruin and privation! the turfy hillocks, the umbrageous and reposing hue of the copsy lawns, so touchingly beautiful; the limpid lapse of Lowdore, the islands coroneting the flood; the water, the soft purple of the pigeon's neck, – are so many circumstances of imagery, which all together combine a picture, which for its sentimental beauty and assemblages of sublimity, I never exceeded in the warmest glow of my fancied descriptions.

On she goes in this manner, until finally concluding: 'I must take a sketch' and asking her three companions to form a picturesque group – a calculated insult, as one of Gilpin's well-known theories was that the correct number of cows to include in a drawing was the odd number of three, rather than the unpicturesquely even number of four.[58]

Perhaps best-loved of these satires was a poem by William Combe, *The Tour of Doctor Syntax in Search of the Picturesque* (begun in 1809 and published as a book in 1812), with illustrations by Thomas Rowlandson. Dr Syntax, a curate, was quite clearly based on William Gilpin. As he announces triumphantly to his wife at the beginning of the poem, *'I'll make a* TOUR – *and then I'll* WRITE IT'.

> You well know what my pen can do,
> And I'll employ my pencil too: –
> I'll ride and *write*, and *sketch* and *print*,
> And thus create a real mint;
> I'll *prose* it here, I'll *verse* it there,
> And *picturesque* it ev'ry where[59]

Poor Dr Syntax, however, finds that his expeditions in search of picturesque scenery are constantly interrupted by farce. His horse teeters precariously on the edge of a lake as, distracted, he concentrates on sketching the far shore; sitting in a field to draw, he is chased by a bull and obliged to shin up a tree, losing both his sketchbook and his wig; and he is sorely tested by the cacophonous moos, baas and brays of farm animals – though he concedes that, by '*picturesquish* laws', they look more interesting with their mouths open.[60]

Notwithstanding Miss Beccabunga Veronica or Dr Syntax, by the early years of the nineteenth century, familiarity with the rules of picturesque art had become as expected in upper-middle-class circles as any other polite accomplishment; young people would learn the 'correct' way of looking at the landscape alongside the skill of enlivening their sketches of it with watercolour washes. In Jane Austen's *Northanger Abbey* (1818), when clever but untutored Catherine Morland walks up to Beechen Cliff above Bath with Henry and Eleanor Tilney, she is disconcerted to find she has nothing to contribute to the conversation. 'They were viewing the country with the eyes of persons accustomed to drawing, and decided on its capability of being formed into pictures, with all the eagerness of real taste. Here Catherine was quite lost.' When she 'confessed and lamented

Thomas Rowlandson, *Dr Syntax Sketching the Lake, c.* 1812

her want of knowledge' and 'declared that she would give anything in the world to be able to draw', Henry immediately launches into a lecture on picturesque principles.

> He talked of fore-grounds, distances, and second distances – side-screens and perspectives – lights and shades; – and Catherine was so hopeful a scholar, that when they gained the top of Beechen Cliff, she voluntarily rejected the whole city of Bath, as unworthy to make part of a landscape.[61]

But how did this taste for the picturesque sit with practicalities? Here is Edward Ferrars defending himself in *Sense and Sensibility* (1811), having disappointed Marianne with an inadequate – or, to put it another way, down-to-earth – account of the surrounding countryside:

> I like a fine prospect, but not on picturesque principles. I do not like crooked, twisted, blasted trees. I admire them much more if they are tall, straight and flourishing.... I do not like ruined, tattered cottages. I am not fond of nettles, or thistles, or heath blossoms. I have more pleasure in a snug farmhouse than a watchtower – and a troop of tidy, happy villagers please me better than the finest banditti in the world.[62]

The application of picturesque principles to gardens and estates as well as wild and uncultivated landscapes had become a contentious issue at the end of the eighteenth century. The landscape gardener Humphry Repton, who introduced a new, picturesque naturalism and drama to his designs while maintaining the smooth Capability-Brown-style transition from garden to park, was at the heart of the debate; he is even named in *Mansfield Park* (1814) as a fashionable improver of estates. 'I think I had better have him at once', says Mr Rushworth. 'His terms are five guineas a day...Smith's place is the admiration of all the country; and it was a mere nothing before Repton took it in hand'.[63] The other protagonists were the landowners Richard Payne Knight and Uvedale Price, who put picturesque ideas into practice on their Herefordshire estates, Downton and Foxley, creating landscapes that emulated not only Claude, but also

Salvator Rosa and seventeenth-century Dutch painters such as Ruisdael, whom they admired for the greater ruggedness and variety of their landscapes. A drawing commissioned by Payne Knight from Thomas Hearne records the river Teme as it flowed through his grounds at Downton. It is the opposite of the panoramic, aerial estate views popular at the start of the century. The view is restricted, enclosed by nature; the sky has shrunk to a little opening in the leafy canopy, and the entire drawing froths with foliage and sparkles with reflected light. We cannot see far along the stony path – it soon winds out of sight and loses itself among the trees, while the rustic bridge, propped up by an old tree trunk, disappears into the opposite bank. From a sense of ownership conveyed by bird's-eye views, here the situation has been reversed: the low viewpoint puts us at a disadvantage. Nature is in charge, poised to surprise us, holding

Thomas Hearne, *The River Teme at Downton*, 1785–86.

back what lies just beyond our view. This is a landscape that grows and spreads at its own pace, with 'thickets of high-bow'ring wood, / Which hung, reflected, o'er the glassy flood', as Payne Knight approvingly put it in his poem *The Landscape*.[64]

Repton, unlike Payne Knight and Price, had to please clients, and this is where the picturesque approach to landscape was put to the test. He was famous for the ingenious 'Red Books' he produced for his patrons, which contained his watercolours showing 'before' and 'after' views. On lifting a paper overlay, one would find a Reptonian transformation: a dull landscape would become an 'improved' one. An uninteresting bank of shrubs disappears to reveal a view of a lake; a bare hill is clothed with an attractive copse. This was modern engineering: Repton was shaping pleasure grounds to human will with the same industrial zeal that his near-contemporary Thomas Telford was bringing to Britain's infrastructure.

Repton, along with his Red Books, is caricatured in Thomas Love Peacock's *Headlong Hall* (1816) as the landscape gardener Mr Milestone, who whips out his portfolio to show his 'before' and 'after' plans for Lord Littlebrain's park. 'This, you perceive,' he explains, 'is the natural state of one part of the grounds. Here is a wood, never yet touched by the finger of taste; thick, intricate, and gloomy. Here is a little stream, dashing from stone to stone, and overshadowed with these untrimmed boughs.' He could have been describing Hearne's drawing – or, indeed, Payne Knight's estate itself. 'Now', he continues,

here is the same place corrected – trimmed – polished – decorated – adorned. Here sweeps a plantation, in that beautiful regular curve: there winds a gravel walk: here are parts of the old wood, left in these majestic circular clumps, disposed at equal distances with wonderful symmetry: there are some single shrubs scattered in elegant profusion... The stream, you see, is become a canal: the banks are perfectly smooth and green, sloping to the water's edge: and there is Lord Littlebrain, rowing in an elegant boat.[65]

It was a travesty of Repton's thoughtful designs – but this interpretation of his interventions in the landscape, hinging in part on a misconception

that he was a follower of Capability Brown, provoked Payne Knight and Price to attack his work in, respectively, *The Landscape* and *An Essay on the Picturesque* (both 1794). These works defined and refined ideas of the picturesque, bringing intellectual heft and nuance to Gilpin's opinions.[66] Repton replied in a dignified letter, dryly pointing out that 'scenes of horror, well calculated for the residence of banditti' were, if 'introduced in the gardens of a villa near the capital...absurd, incongruous and out of character'.[67]

In some respects, the arguments that rumbled on for some time can now seem as rarefied as how many mountain goats can dance on a rocky pinnacle (three, probably). But two ideas emerged from these debates that would shape attitudes to landscape over the coming years: the concept of wildness, and the mental associations conjured up by particular sites.

John Ruskin, *Study of Gneiss Rock, Glenfinglas*, 1853–54.

VI

VISION

Nature twitched me at my heart strings
Samuel Taylor Coleridge, *Notebooks*

COLERIDGE GOES FOR A WALK

'I write to you from the *Leads* of Greta Hall, a Tenement in the possession of S.T. Coleridge. Esq. Gentleman-Poet & Philosopher in a mist'. This was Coleridge's self-portrait in July 1800, when, newly arrived in Keswick, he immediately shot up to the roof to marvel at the view. 'Yes – my dear Sir! here I am – with Skiddaw at my back – on my right hand the Bassenthwait Water with its majestic *Case* of Mountains, all of simplest Outline – looking slant, direct over the feather of this infamous Pen, I see the Sun setting – my God! what a scene!'[1] Coleridge hardly needed to risk the leads – from his first-floor study window he could see 'six distinct Landscapes – the two Lakes, the Vale, River, & mountains, & mists, & Clouds, & Sunshine make endless combinations, as if heaven and Earth were for ever talking to each other', while the panorama from his bedroom window was dangerously distracting. 'My Glass being opposite to the Window, I seldom shave without cutting myself. Some Mountain or Peak is rising out of the Mist, or some slanting Column of misty Sunlight is sailing cross me so that I offer up soap & blood daily, as an Eye-servant of the Goddess Nature.'[2] This constantly changing weather-drama delighted him so much that he even joked about 'writing a set of *Play-bills* for the vale of Keswick – for every day in the Year – announcing each Day the Performances, by his Supreme Majesty's Servants, Clouds, Waters, Sun, Moon, Stars, &c'.[3]

By the time the Coleridges moved to Keswick the tourist industry was, of course, firmly entrenched, and he recorded wry observations of visitors gathering at well-worn 'stations' to experience the recommended views. 'Gold-headed Cane on a pikteresk Toor' he noted with derision one day, and was amused by the sight of 'Ladies reading Gilpin's &c while passing by the very places instead of looking at the places'.[4] During the tourist season it must have been an exasperating influx. Looking on the bright side, 'It is no small advantage here,' he wrote to his patron Josiah Wedgwood on 24 July 1800, 'that for two thirds of the year we are in complete retirement – the other third is alive & swarms with Tourists of all shapes & sizes, & characters – it is the very place I would recommend to a novellist or farce writer.'[5]

Even so, Coleridge was unlikely to have to contend with any of them on his walks. He and the Wordsworths had explored every heath and combe of the Quantock Hills when they lived in Somerset – Coleridge in a cottage at Nether Stowey, the Wordsworths at a grand nearby house, Alfoxden – but the landscape of the Lake District opened up a new dimension in his approach to walking. As soon as he arrived in Keswick he began to explore the fells with a passion that bordered on obsession and an astonishing recklessness. 'You ask, in God's name, why I did not return when I saw the state of the weather?' he wrote to Thomas Wedgwood in January 1803, after getting caught in a storm on his way to the Wordsworths at Grasmere that slung rain so hard at his face that it seemed to cut into his flesh 'like splinters of Flint'. 'The true reason is simple, tho' it may be somewhat strange – the thought never once entered my head.'[6] When walking, he explained, it was as though his spirit was possessed, moved and uplifted by some force over which he had no control, but which gave him an intense feeling of being alive and impelled him to go on.

In simple earnest, I never find myself alone within the embracement of rocks & hills, a traveller up an alpine road, but my spirit courses, drives, and eddies, like a Leaf in Autumn: a wild activity, of thoughts, imaginations, feelings, and impulses of motion, rises up from within me – a sort of *bottom-wind*, that blows to no point of the compass, & comes from I know not whence, but agitates the whole of me; my

whole Being is filled with waves, as it were, that roll & stumble, one this way, and one that way, like things that have no common master. [...] The farther I ascend from animated Nature, from men, and cattle, & the common birds of the woods, & fields, the greater becomes in me the Intensity of the feeling of Life...[7]

A few days into another epic walk – a nine-day expedition during which he climbed Scafell – he wrote to his beloved friend Sara Hutchinson explaining his method of getting from the highest summits. Or rather, his lack of one:

When I find it convenient to descend from a mountain, I am too confident & too indolent to look round about & wind about 'till I find a track or other symptom of safety; but I wander on, & where it is first *possible* to descend, there I go – relying upon fortune for how far down this possibility will continue. So it was yesterday afternoon.

His fortune had nearly run out that day. Making his way from Broad Crag to Mickledore, he began to drop down via the rock face of Broad Strand, a series of ledges of smooth perpendicular rock, each about seven feet high, but soon came to a much bigger drop too dangerous to negotiate. Stranded, he could neither go on, nor go back. He lay down, his limbs trembling, and watched the crags above him and the swift passing clouds 'in a state of almost prophetic Trance & Delight'. He experienced a joyful sense of union with nature; a 'fantastic Pleasure, that draws the Soul along swimming through the air in many shapes, even as a Flight of Starlings in a Wind'. Getting to his feet, he spotted a narrow vertical rent in the rock, and got to safety by wriggling down it. Shortly afterwards, a thunderstorm came overhead. He found shelter among sheep-folds and wished for 'Health & Strength that I might wander about for a Month together, in the stormiest month of the year, among these Places, so lonely & savage & full of sounds!' When the storm had passed, he tested the echo in the vale by making it repeat back to him the names of those he loved.[8]

Given Coleridge's love of walking it is ironic that one of the poems for which he is best known, 'This Lime Tree Bower My Prison', should be

about not going for a walk. Written at Nether Stowey during a visit from Charles Lamb, it describes being confined to a garden seat (his wife had accidentally upset a pan of boiling milk over his foot) and unable to join his friends as they walked in the Quantock Hills. Instead he follows them in his imagination, anticipating their steps 'On springy heath, along the hill-top edge' to a wooded dell to inspect a weedy waterfall, then bursting out from the trees on to high ground:

> Now, my friends emerge
> Beneath the wide wide Heaven – and view again
> The many-steepled tract magnificent
> Of hilly fields and meadows, and the sea

This vivid mental picturing of a landscape he knew intimately injects a combination of emotion and intense physical imagination into the heart of nature writing – that 'springy heath' can only have been written by someone with a physical memory of tufty heath-grass under foot. Together, they ignite a joy that embraces the physical and spiritual sensation of experiencing the walk: 'A delight / Comes sudden on my heart,' he writes, 'and I am glad / As I myself were there!'[9]

Quite different from this intense mental and emotional projection were the observations and sensations Coleridge jotted down in the notebooks he took with him on his walks. Not far away, tourists were learning, with Catherine Morland, about the picturesque formulas of foregrounds and side-screens, and debating whether a view was more correctly categorized as 'sublime' or 'beautiful'. Coleridge, however, forged a way of describing nature that captured the particularity of individual landscapes. He wrote one of the most sustained and extraordinary of these descriptions on Sunday 31 August 1800, two months after his arrival in Keswick. Having completed a major section of the epic poem 'Christabel', which he planned to include in the 1800 edition of *Lyrical Ballads*, the collection he and William Wordsworth were jointly preparing, he stuffed the manuscript in his pocket, picked up his notebook and walked from Greta Hall to the Wordsworths' home at Dove Cottage in Grasmere, around twelve miles to the south. The manuscript was late – the publishers were becoming

impatient and Wordsworth irritated. Coleridge could have taken a quicker route. But how could he miss the opportunity of experiencing a landscape that had become such a vital part of his creative life? He decided to go by way of the entire ridge of the Eastern Fells, with frequent stops to write about what he could see, creating a record rarely found in the visual arts, where watercolourists such as Francis Towne nearly always chose lower viewpoints in order to emphasize the height of the peaks. 'Am now at the Top of Helvellin', Coleridge writes,

> a pyramid of stones – Ulswater. Thirlemere. Bassenthwaite. Wyndermere, a Tarn in Patterdale On my right Two tarns, that near Grasmere a most beautiful one, in a flat meadow –
>
> travelling along the ridge I came to the other side of those precipices and down below me on my left – no – no! no words can convey any idea of this prodigious wildness that precipice fine on this side was but its ridge, sharp as a jagged knife, level so long, and then ascending so boldly – what a frightful bulgy precipice I stand on and to my right how the Crag which corresponds to the other, how it plunges down, like a waterfall, reaches a level steepness, and again plunges! –

Francis Towne, *Grasmere from the Rydal Road*, 1786.

He is entranced by the 'Fine columns of misty sunshine sailing slowly over the crags', and wonders about the sounds he could hear in that strange, wild landscape: 'From this point I hear swelling & sinking a murmur – is it of water? or is it of falling screes?' Evening is coming on, but the temptation of another ascent is too much: 'I had resolved to pass by it; but Nature twitched me at my heart strings – I ascended it – thanks to her! Thanks to her – What a scene!' And again, on seeing a narrow ridge between two precipices: 'I will go up it'. Eventually, noticing a nearly full moon above Fairfield and realizing how late it was, he 'descended over a perilous peat-moss then down a Hill of stones all dark, and darkling' and finally burst into the garden at Dove Cottage at eleven o'clock.[10] The three friends sat and talked until half-past three (William, who had gone to bed, in his dressing gown), and Coleridge read them passages from 'Christabel'.[11] Three days later he returned to Keswick the way he had come, back over Helvellyn.

Walking and looking were, for Coleridge, two sides of the same coin. In August 1803, just two weeks into a lengthy tour of Scotland with the Wordsworths, he left his companions to it and set off alone, on foot, for Edinburgh. As the poet Rachael Boast eloquently describes it, '[t]he jaunting-car was too fast for your eye – / you'd rather have got out and walked...'.[12] His curiosity suited a walking pace. Much as he loved broad panoramas, sometimes deliberately not turning to look until he had reached the very summit so as to savour the full ecstasy of a view – '(O Joy for me!)', he parenthetically exclaimed on one such occasion – his attention was also absorbed by the ground under his feet.[13] Coleridge liked to describe textures – the 'splashy mossy path' with 'immense quantities of the Tremella', or the jelly fungus he saw as he walked under Caldbeck fells; the 'heathy, boggy ground' and 'rotten wet scarlet & yellow moss' over which he trudged above the vale of Keswick; and the 'moving stones under the soft moss' that hurt his feet as he bounded down a hill on his way to Grasmere.[14] For colours, he borrowed vocabulary from the kitchen garden and pantry: the 'so so soft [...] pea green' of Latterig; the 'raspberry & milk colored crags' of a ridge near Threlkeld.[15]

Like the *plein-air* oil sketches that John Constable would begin making in earnest towards the end of the decade, Coleridge's running

commentaries were a powerfully original response to the landscape. The not-for-publication observations scribbled in his notebooks as he walked enabled him to capture evanescent effects of light and weather before they changed, to describe the spectacular panorama of the landscape as he moved through it and to record his aesthetic, spiritual and emotional responses. He had invented a new kind of nature writing – eccentric, spontaneous, tender – to keep pace with a new way of being in the landscape.[16]

WILLOWS, OLD ROTTEN BANKS, SLIMY POSTS, & BRICKWORK

It was the late summer of 1792 when William Cowper left his home at Weston Underwood, near Olney in Buckinghamshire, to make the three-day journey to stay with a fellow poet at Eartham, near Chichester. For most people such an excursion would not have been of any great consequence, but for the reclusive Cowper, who had refused every invitation to leave his home for twenty-five years, it was little less than astounding.[17] He bore the journey as well as could be expected, but it was not the distance so much as the change in landscape that he found hard to cope with. Reflecting on his trip later, he admitted to having been 'a little daunted by the tremendous height of the Sussex hills':

> The cultivated appearance of Weston suits my frame of mind far better than wild hills that aspire to be mountains, cover'd with vast unfrequented woods, and here and there affording a peep between their summits at the distant ocean. Within doors all was hospitality and kindness, but the scenery *would* have its effect, and though delightful in the extreme to those who had spirits to bear it, was too gloomy for me.[18]

If he felt like that about Sussex, one wonders how he would have reacted to the Lake District. But perhaps he was wise not to get swept up in the contemporary fashion for 'Sublime' scenery. Cowper, who suffered from bouts of religious mania and was persecuted by the terrible conviction

that he was damned, had enough inner mountains and terrible drops with which to contend – he had no need of external stimulation. Instead, he remained faithful to the unspectacular lanes and fields of his beloved local landscape.

When challenged by a friend to write a poem in blank verse on the subject of a sofa, his response – *The Task* (1785) – soon got up from its comfortable seat to range over the state of England, religious faith, slavery, bloodsports and the clergy, as Cowper's thoughts rambled conversationally from one to another. But most of all, the poem celebrates the pleasures of a retired domestic life, gardening and walking in the local landscape. Landscape, for him, was something to experience with all the senses. Paintings, thanks to the artist's 'magic skill' that throws 'Italian light on English walls', are all very well, he says – no one could appreciate them more than he – but they can only show you what a landscape looks like.[19] It was not enough. So in *The Task* he writes about smelling the turf and fungi and wild thyme as he walks, and listening to the birdsong in the woods, feeling his feet sink into the soft earth of molehills and trudging along muddy paths in the countryside around Olney. He gets to know individual trees, comparing the pale grey foliage of the willow, poplar and ash with the dark elm and darker oak, and admires the glossy leaves of the maple and the changing colours of the sycamore. And he is attentive to the life force of the landscape, even when it is snowbound. In the final section of his poem 'The Winter Walk at Noon', he gazes at the brilliant whiteness of the fields under a clear blue sky and, pausing by a copse, watches a robin hop from twig to twig, shaking off little drops of ice that fall on to the foliage below with a tinkling sound, and he thinks about the intense stillness around him, pondering on how it is different from silence. This is the opposite of Gilpin's side-screens and distances, the Picturesque, one-size-fits-all formula that could be applied to any landscape – Cowper's local countryside may not have been breathtaking, but he knew it intimately, in its small details and all its moods and seasons. 'Scenes must be beautiful,' he concludes, 'which daily view'd, / Please daily, and whose novelty survives / Long knowledge and the scrutiny of years.'[20] When, having completed a revised draft of *The Task*, he tells a friend that his descriptions 'are all from Nature. Not one of them second-handed', we believe him.[21]

The Task was part of John Constable's mental furniture, a poem he knew so well that he casually wove lines from it into his letters. Writing in 1812 to his wife-to-be Maria, he lamented not being able to speak to her '"with Your Arm fast locked in mine", as Cowper says'.[22] Perhaps he had absorbed Cowper's attitude to landscape, too. The unemphatic farmland of Suffolk and Essex where Constable grew up, the cornfields, river, windmills, watermills, towpaths, millponds and locks, inspired him more than the most dramatic scenery. He went on a sketching tour to the Lake District in 1806 – a rare excursion for him into conventional 'picturesque' territory – but the watercolours he brought back in his portfolio were oddly unfocused, as though (try as he might) he was not quite able to get to grips with the Lake District. Whether or not 'the solitude of mountains oppressed his spirits', as his first biographer claimed, remains a moot point.[23] But it is obvious that his heart was not really in it. Where his art came fully alive was in familiar farmland – industrial landscapes, even – and his imagination was caught by the sorts of details that would have horrified his contemporaries brought up on the dictum that it was best to generalize, to adopt the classical 'grand manner' and shun mundane, unelevated subjects. Writing to a friend in 1821, he listed his favourite bits of the country – several of the very features that, fifty years earlier, had so appalled William Gilpin: 'the sound of water escaping from Mill-dams [...] Willows, Old rotten Banks, slimy posts, & brickwork. I love such things'.[24] Constable's sketchbooks are full of these seemingly insignificant details, to be salted away in his studio, sometimes emerging many years later when he wanted to add a broken-down bit of fencing to a towpath scene, or a stumpy pollarded willow. After he married and his visits to East Anglia became less frequent, these records became all the more precious, the pungent lifeblood of his art bottled up and stored in his Charlotte Street studio.

Sketchbooks were essential during the long summers Constable used to spend with his family at East Bergholt, before his marriage in 1816 – they fitted neatly in his coat pocket as he walked the fields for hours at a time, stopping to sketch not only landscape details and vistas, but also the labourers and livestock that caught his eye. But no matter how skilfully he could record the turn of a cow's head or the angle of a

scythe slung over a work-weary shoulder with his pencil, graphite could not capture nature on the move: foliage blown about on a breezy day, a drifting cloud, a patchwork of light and shadow changing the colour of a lane. So, although it was less convenient, he decided to take his oil paints outdoors.[25] He worked as neatly as he could, resting his paint box on his knee and pinning his sheets of paper to the inside of the lid (you can still see the pinholes in the corners). And he sat down to sketch, choosing to paint the sandy corner of a Suffolk lane on a windy day, his flicking brushstrokes deftly describing birds in flight. He studied dock leaves and undergrowth and a section of mossy tree-trunk bathed in pale sunlight; his art, he once wryly observed, 'is to be found under every hedge and in every lane, and therefore nobody thinks it worth picking up'.[26] One stormy evening he painted barges on the Stour at Flatford Lock, the sky almost as dark as the water. In years to come he would take his paint box on to the uplands of Hampstead Heath, where with quick strokes of a thick brush he could record cloud formations before they drifted away or changed shape, and study how they related to the tossing foliage beneath.

John Constable, *Cloud Study*, 1821.

John Constable, *Boat-Building near Flatford Mill*, 1814–15.

At least once Constable attempted to complete an entire composition out of doors, setting up his easel in front of his father's dry-dock at Flatford Mill on the navigable river Stour in the early autumn of 1814 and sitting down on a bank to paint as, below him, a barge was constructed. He knew when it was time to return home at the end of the day when, from his vantage point, he saw smoke rising from the kitchen fire. It was not the first time industry had dominated a landscape, but this picture was so full of information that it verged on the didactic – he shows a man planing a shaped timber, and a cauldron in which pitch is being heated, prior to caulking the hulk. One almost expects every piece of equipment and activity to be labelled with a letter that corresponds to a printed key. Although the ghost of Claude seems to be hovering about the surrounding trees and distant hills, *Boat-building near Flatford Mill* was an outspoken statement about what landscape looked and felt like to those who lived and worked in the country, and about what landscape

art could be if only artists and the picture-buying public would stop being so obsessed with a few areas deemed to be picturesque. Constable was the son of a wealthy miller brought up working in a business it was understood that he would one day take over – it was only when his younger brother Abram stepped in that he was freed to go to London to study at the Royal Academy Schools. So he knew how windmills worked, was so interested in ploughs that he painstakingly drew regional variations in his sketchbooks, and could tell you the week of the year by the colour of ripening corn in a picture. As he grumbled to a friend in 1821, 'The Londoners with all their ingenuity as artists know nothing of the feeling of a country life (the essence of Landscape) – any more than a hackney coach horse knows of pasture'.[27] His entire career can be seen as a struggle to redefine landscape – to rethink it as something that embraced the local, the everyday, the industrial, the inhabited.

John Clare's local Northamptonshire landscape bristled with memories every bit as much as Constable's East Anglia. Even as a man, he held on to his boy's-eye view of the countryside around Helpston, the village on the edge of the Lincolnshire fens where he had grown up. The son of a barely literate agricultural labourer, Clare had worked in the fields from the age of around ten, scaring birds, tending livestock and pulling up weeds. In his leisure time he hunted for birds' nests, climbed trees, played marbles outdoors and sheltered from summer showers in the hollow trunk of a tree. Coleridge had defied adult convention and caused consternation when he flung himself at the landscape, bounding, slithering and finding shelter from storms in rocky clefts. But Clare had absorbed that kind of hands-and-knees, heedless-of-danger attitude to nature in childhood. 'What a many such escapes from death doth a boys heedless life meet with I met many in mine', he observed: he nearly drowned in a pool when tending cows, and fell fifteen feet from an oak tree when the branch he was balancing on snapped.[28] His early experiences of working and playing in the fields and his natural fascination with animal, bird and plant life brought the kind of profound and detailed knowledge virtually absent from the work of more conventionally educated writers.

Clare grew up steeped in traditional ballads, tales and folklore – even his labour in the fields was made 'delightfull' by the women supervising the work, who passed the time with stories of 'Jiants, Hobgobblins, and faireys' (he had little truck with conventional spelling).[29] Yet it was Thomson's *Seasons* that, according to Clare's autobiographical 'sketches', made him a poet. When he was about thirteen a young man in the village showed him a mangled fragment of the poem, the opening lines of which made his 'heart twitter with joy'. 'I greedily read over all I could', he recalled, 'before I returned it and resolved to posses one my self'. He pestered his father for the price of the book and walked to Stamford, the nearest town with a bookshop, but it was Sunday and the shops were shut. During the following week, however, he had an idea: employed to tend horses, he paid another boy tuppence (one penny to look after his horses, another to keep quiet about it) and walked back to Stamford where, agricultural hours being different to trading ones, he had to hang around for hours waiting for the shop to open. He eventually bought a copy for a shilling. On his way back, not liking to be seen reading on the road on a working day, he climbed over a wall into the grounds of Burghley House and found a quiet patch of lawn where he sat down with his book.[30]

Although *The Seasons* made him fall in love with poetry, Clare needed to find a way of writing about the landscape from his own point of view. While for Thomson, labour happened so far away that he could imagine the workers as apple-cheeked and cheerful, Clare drew on his own experience and surroundings, writing in 'Mist in the Meadows' about a shepherd who looks as though he is 'walking without legs', and another, in 'Winter Fields', who picks his careful way along 'pudgy paths' by the sides of fields all 'mire and sludge', whistling for his understandably reluctant dog.[31] Clare understands all too well the hardship of country life. But his background also brings a perspective new in English verse. When his contemporary John Keats writes a poem about a nightingale his themes are poetry, transience and death, and he makes learned allusions to Lethe and Dryads; when Clare writes a poem about a nightingale it is an altogether more down-to-earth experience. Drawing close and lowering his voice, he invites us:

> stoop right cautious neath the rustling boughs
> For we will have another search to-day
> And hunt this fern strown thorn clump round and round
> And where this seeded wood grass idly bows
> We'll wade right through...[32]

Crouching in the undergrowth, he asks us to marvel with him at the drab, 'russet brown' dress the nightingale wears to sing so amazing a song, and to get as close as we can, close enough to see her wings tremble and her feathers stand on end.[33] Clare was always attuned to the humble within the magnificent, and down there with him in the bracken we see it too.

His poetry is also shaped by nostalgia for the lost landscape of childhood; what he was writing about was disappearing in front of his eyes. In 1809, when he was sixteen, the Inclosure Act, which had been transforming the English landscape since the 1750s, was passed for Helpston.[34] Over the following years the Act allowed landowners to appropriate common land and heaths, to cut down woods and divert or canalize rivers. Ancient rights of grazing livestock were taken away as profit was given priority. In Helpston as elsewhere, what had been common land began to be privatized and fenced off, cleared and made more profitable for landowners. Clare himself found work with the fencing and hedging gangs.[35] While he often looks back in his poetry to the landscape of his childhood, in the painful 'Remembrances' – its long, rhythmic lines making it read more like a protest song than a poem – he forces himself to confront present reality. In the first part of the poem Clare names the places he knew, handling each like a much-loved childhood toy: there was Langley bush, where he had played the children's games of clink and bandy chock; Eastwells spring, where he tied the willow boughs together to make a swing and fished with crooked pins and thread; Cross Berry Way; Cowper Green; the 'rolly poly up and down of pleasant Swordy well'; and Round Oaks narrow lane, where there was a hollow ash tree to shelter in. Each is given its own distinct personality. But it was a litany of loss.

> By Langley bush I roam but the bush hath lefts its hill
> On cowper green I stray tis a desert strange and chill

And spreading lea close oak ere decay had penned its will
To the axe of the spoiler and self interest fell a prey
And crossberry way and old round oaks narrow lane
With its hollow trees like pulpits I shall never see again
Inclosure like a buonaparte let not a thing remain
It levelled every bush and tree and levelled every hill
And hung the moles for traitors – though the brook is running still
It runs a naked stream cold and chill[36]

Clare identified with his local landscape to the extent that it *was* him: particular bushes, trees, copses, streams and heaths were repositories of his memories, places to which he was 'fondly attached' and would visit in his leisure time on Sundays. All 'met with misfortunes', as he put it – favourite trees were hacked down and a willow bower he had created destroyed.[37] It is hard not to associate the mental disorder that afflicted Clare from the 1830s onwards with this wholesale desecration of his landscape, and to see his sense of self as another casualty of the Act.

VALLEYS OF VISION

Northern light filtered through the windows of 47 Queen Anne Street in Marylebone, just south of Regent's Park. It fell across a sturdy table, on which was laid a sketchbook containing slight pencil drawings, a sheet of good-quality paper, a box containing cakes of watercolour pigment, brushes and a glass of water. And it fell on the hands of a short, stocky man sat frowning at the table as he turned over the sketchbook pages, finally choosing an opening. The picture that J. M. W. Turner planned was to represent a distant view of Prudhoe Castle in Northumberland – it was some years since he had been to the area, and it was the sketchbook he had carried in his pocket then that he now fished out and placed before him.[38] It had not been hard to find; he numbered his sketchbooks carefully so that he could navigate the vast store of topographical information they contained. The slight pencil drawing of Prudhoe, which runs over a double-page opening, did not offer a great deal of detail – not much more

than the basic contours of the hills and the castle – but it was enough to rebuild the memory in Turner's mind. When he picked up his brush to mix the first pale watercolour wash and lay it on the sheet, he was not only consulting the summary sketch in front of him, but reinventing that particular landscape, drawing on his huge visual experience. What he began to create in the prosaic light of his painting room was a sweeping landscape, glowing with the warm colours of late afternoon, the castle silhouetted against the sky and the distant hills dissolving vapourishly in the pale sunlight.[39] The town of Prudhoe and signs of industry along the Tyne have also tactfully faded away in this, one of Turner's most Claudean visions of England.

Prudhoe Castle, Northumberland (Plate 11) was eventually published in *Picturesque Views in England and Wales* (1827–38), a project proposed by the publisher Charles Heath that occupied Turner for over a decade, and for which he eventually made ninety-six watercolours to be reproduced as engravings.[40] Although not a financial success, the venture – along with a commission to illustrate a set of editions of Walter Scott's novels that sent him to Scotland in the early 1830s – resulted in one of the most wide-ranging inventories of the British landscape ever conducted. Turner was allowed to choose the sites himself – Lancaster Sands; Ullswater, Cumbria; Richmond, Yorkshire; Llanthony Abbey; Mont St Michel, Cornwall. And, sitting in his painting room looking back over his sketchbooks and reviewing the memories they evoked, he became a society portraitist for landscapes, cladding these spectacular examples of scenery in the most enchantingly ethereal costumes light and weather could furnish, excising without compunction elements he did not wish to include while introducing others: figures, weather effects, animals, even literary allusions. He was an oyster, applying layer upon layer of memory, experience and imagination to the kernel of observed landscape until the gritty pencil sketch became a watercolour pearl.

By editing and manipulating, Turner was not attempting to falsify but to organize his observations, memories and reflections into episodes in an epic story. The *England and Wales* commission gave this visual novelist the opportunity to set out the story of these countries: through the lens of landscape he tells of industrialization and the growth of new cities,

of traditional forms of rural life side-by-side with the urgent activity of modern manufacture, of canal and river traffic, of new forms of agriculture, of factories rising next to cathedrals, of fields crossed by turnpike roads and busy with coaches, of shipwrecks and storms, of sailors and soldiers and all the restless busyness of human life. Despite the title's promise of 'picturesque' views, the landscape in these magnificent watercolours is not something separate, to be framed, but a vital part of a great national story in which history, tradition, progress, social life, commerce and modernity are all intimately connected.

If anyone had asked Constable, Turner's contemporary and rival, to undertake a project such as *Picturesque Views in England and Wales*, he would probably have refused. And if he had said yes, it is unlikely to have been a success. While Turner travelled extensively in Britain and on the Continent every summer to find his subjects, Constable stayed close to home. 'I should paint my own places best', he once said – and indeed his work is dominated by the places he knew well: East Bergholt, where he grew up; Hampstead, where he lived with his family; Salisbury, the home of his close friend John Fisher; and Brighton, where his wife stayed in the hope of improving her health.[41] When, late in life, Constable decided to take stock of his career by publishing prints of some of his paintings, the title he chose, *Various Subjects of Landscape, Characteristic of English Scenery* (1830–32 and 1833), was frankly misleading. Anyone reasonably expecting to find a geographically representative selection of English views would have been baffled by the portfolio's contents. The subjects were, rather, characteristic of Constable's scenery: the small repertoire of places in certain corners of southern England that he knew intimately. He had given himself away with that title, worn his heart too prominently on his sleeve. These were the landscapes of his soul, repositories of memory and emotion. When he confided to a friend that, as far as he was concerned, painting was 'but another word for feeling', he was privately acknowledging the spiritual and emotional value of landscape.[42]

Back in 1798, Wordsworth had reflected on the way in which certain landscapes enter the bloodstream and play on the mind even when one is far away. In 'Lines Written a Few Miles Above Tintern Abbey, on Revisiting the Banks of the Wye during a Tour. July 13, 1798', he writes of returning

to the Wye valley after an absence of five years. Lying under a sycamore to contemplate the beauty of the river and the 'steep and lofty cliffs', his vision is infused with memories from his previous visit:

> Though absent long,
> These forms of beauty have not been to me,
> As is a landscape to a blind man's eye:
> But oft, in lonely rooms, and mid the din
> Of towns and cities, I have owed to them,
> In hours of weariness, sensations sweet,
> Felt in the blood, and felt along the heart,
> And passing even into my purer mind
> With tranquil restoration[43]

Vision and memory together combine to form a powerful tonic, capable of flushing urban chaos out of the system with rural balm, which could be stored up and released at a future time of need:

> And now, with gleams of half-extinguished thought,
> With many recognitions dim and faint,
> And somewhat of a sad perplexity,
> The picture of the mind revives again:
> While here I stand, not only with the sense
> Of present pleasure, but with pleasing thoughts
> That in this moment there is life and food
> For future years.

For a writer like Wordsworth, as much as an artist like Constable, the visual aspect of landscape was richly interleaved with potent layers of memory and association. As in Wordsworth's 'Poems on the Naming of Places', in which the names of friends are bestowed on rocks, dells and peaks, in 'Tintern Abbey' the landscape is transformed by thought and experience until mind and nature became part of one great living, moral, educative entity: 'The anchor of my purest thoughts, the nurse, / The guide, the guardian of my heart, and soul / Of all my moral being.'[44]

These rich associations were just as likely to have a literary dimension. Would Queen Victoria and Prince Albert have fallen so deeply in love with the landscape of Scotland and acquired the Balmoral Estate if it had not been for Sir Walter Scott? Quite possibly not. Both Victoria and Albert had grown up relishing the stirring combination of Scottish history and landscape Scott created in novels such as *Waverley* (1814) and *Rob Roy* (1817); as a girl Victoria dressed her dolls as characters from his stories, and Albert's father's library at Schloss Rosenau was largely inspired by his own passion for Scott.[45] The couple's first visit to Scotland in 1842, just two years after their marriage, did not disappoint. 'Every spot is connected with some interesting historical fact', Albert told his grandmother, 'and with most of these Sir Walter Scott's accurate descriptions have made us familiar.'[46] Many years of visits and tours did nothing to diminish the queen's enthusiasm either for the landscape or for Scott. 'The scene of our drive today is all described in *Rob Roy*' she wrote approvingly in her journal as late as 1869, during a September tour to the country around Loch Lomond. Writing in her journal the following morning, she recalled her impressions of high rocks with trees growing amongst them, flowering heather and fine lochs; at Loch Ard she thought that 'a lovelier picture could not be seen', so although they had only gone a few yards from where they had stopped for lunch she had insisted on getting out of the carriage again to capture it in pencil and watercolour. At evening, when the sun began to set, the scene had been so beautiful that only lines from Scott's narrative poem *The Lady of the Lake* (1810) could do it justice, so she added these to her account:

> The Western waves of ebbing day
> Rolled o'er the Glen their level way;
> Each purple peak, each flinty spire,
> Was bathed in floods of living fire.[47]

But it was not only Scott who seemed to inhabit every loch and glen. Her beloved Albert, who had died eight years earlier, was there too. That afternoon they had been to Ellen's Isle, a lake island on Loch Katrine, where she remembered 'the little wooden landing place' from an earlier visit.

'Very melancholy & sweet were my feelings when I landed', she wrote, '& found the same white pebbles, which dearest Albert picked up & had mounted as a bracelet for me.' The couple were in the habit of picking up attractive little stones as sentimental souvenirs of their excursions, but these had greater resonance than usual; Scott, in *The Lady of the Lake*, had written of this very island and even described its 'beach of pebbles bright as snow'.[48] In 1869, the widowed Victoria picked up a handful of pebbles and carried them away – a queen with a bit of the landscape in her pocket to remind her of a place, a poem and a time when she was happy.

Growing up in South London, on the eastern fringes of Walworth, Samuel Palmer often went on long walks with his father. They could reach the pretty village of Dulwich on foot from their home, and Palmer later called it 'the gate into the world of vision' because of the mysterious, dream-haunting beauty of the countryside that lay beyond.[49] It is easy to imagine him on those boyhood visits, reluctant to turn towards home, longing to plunge on into the hills and lanes of Kent. It was then that a hook lodged in his heart. In his late teens Palmer filled sketchbooks with intricate drawings of the landscape and natural forms around Dulwich, concentrating on the small, the closely observed, the warp and weft of his immediate surroundings. He was the opposite of Turner with his restless novelist's brain, conjuring dazzling epics from summary sketchbook drawings in his London painting-room. When Palmer opened his sketchbook, he focused on what was in front of him – he was rarely thinking of grand compositions. So he drew a group of trees with his quill pen, trying to capture the textures of the bark and the protruding knots with fine lines, tiny dots and crosshatching, making his nib follow the forms. He stared so hard that they began to look strange, exaggerated, their outlines over-emphatic. Even when he drew ploughed fields, their furrows snaking off into the distance, it was with a miniaturist's sense for detail, pattern and texture. When he does raise his eyes to the horizon, he finds that it is not far away; in Palmer country, we are gently enclosed by locality. Later, he began to realize it was not enough merely to visit: he had to live in that country, to immerse himself in it. In the spring of 1826, when he was twenty-one, he and a friend, the sculptor and miniaturist Frederick Tatham, joined

forces and moved to the village of Shoreham. For the next decade this small rural settlement on the river Darent, five miles from Sevenoaks, was the emotional centre of Palmer's world, his 'valley of vision'.[50]

Palmer had two great mentors. One was John Linnell, an established artist who had, wrote Palmer somewhat histrionically, been sent 'as a good angel from Heaven to pluck me from the pit of modern art'; it was Linnell who had encouraged him to look at engravings and woodcuts by Albrecht Dürer and his contemporaries.[51] Through the prints he saw in the British Museum, Palmer discovered that the emphatic dots and lines with which Dürer imagined the middle-eastern landscape in, for example, *The Flight into Egypt* (c. 1504) spoke more eloquently of the Kentish landscape than any number of modern brushstrokes. These prints inspired him to a new way of seeing his surroundings. The other great service Linnell performed for Palmer was to introduce him, in 1824, to the man who would become his other mentor, the poet–painter William Blake, then living in two small first-floor rooms in a house just south of the Strand in central London. It was, for Palmer, like meeting a modern prophet, and he would kiss the bell-handle when visiting.[52] Recalling the meeting many years later, Palmer wrote:

> In him you saw at once the Maker, the Inventor; one of the few in any age: a fitting companion for Dante. He was energy itself, and shed around him a kindling influence; an atmosphere of life, full of the ideal. To walk with him in the country was to perceive the soul of beauty through the forms of matter; and the high, gloomy buildings between which, from his study window, a glimpse was caught of the Thames and the Surrey shore, assumed a kind of grandeur from the man dwelling near them. Those may laugh at this who never knew such a one as Blake; but of him it is the simple truth.[53]

In making the introduction, Linnell had, however, sown the seeds of a rift between him and his young protégé. Palmer found himself between two opposing influences, as Linnell attempted to guide him towards rigorous observation on the grounds that it could lead to saleable work, while the example of Blake's work, shaped by a powerful inner vision, suggested

a new and seductive way of seeing the world. Much as Palmer tried to please Linnell – 'I may safely boast', he wrote in September of 1828, 'that I have not entertained a single imaginative thought these six weeks, while I am drawing from nature vision seems foolishness to me' – there was, at this early stage in his life, no real contest.[54] 'I will, God help me,' he had admitted to a friend not long before, 'never be a naturalist by profession'.[55]

Among the images that changed the way Palmer saw the world were Blake's illustrations for a new school edition of poems by the ancient Roman poet Virgil, the *Pastorals*, commissioned in 1819 by the publisher R. J. Thornton, a friend of Linnell. Blake was trained as an engraver on copper, but Thornton wanted wood engravings, which he could print alongside raised type. It was, however, a different skill, and what Blake created was typically idiosyncratic. While at this time professional wood-engravers worked by cutting away the areas of the wood-block not to be printed, so that the lines to appear black were left standing in relief – imitating the lines of a drawing – Blake did the reverse. He cut his designs directly into the block, so that when it was printed the lines appeared white against a black background. When he submitted his illustrations, Thornton was horrified by the crude handling and technical failings of the prints, and was only persuaded to publish them in 1821 after the President of the Royal Academy, Sir Thomas Lawrence, intervened – and even then with a disclaimer. They are strange, melancholy little images, coloured by Blake's own unhappy experience of rural life as well as his impatience with classical authors.[56] But Palmer, entranced by these moonlit visions in which man appeared to live in harmony with nature, saw something quite different: 'visions of little dells, and nooks, and corners of Paradise'. It was the quality of light that drew him most strongly. 'There is in all such a mystic and dreamy glimmer', he continued, 'as penetrates and kindles the inmost soul, and gives complete and unreserved delight, unlike the gaudy daylight of this world.'[57]

Blake's Virgil illustrations unlocked landscape for Palmer. In a series of drawings in brown ink and sepia, mixed with gum arabic so that they gently shine, he reimagined the country between Dulwich and Kent with them in mind. A hare pauses on a tree-lined path to look over its shoulder at us; rounded hills thick with ripe corn are echoed by the thatched roofs

William Blake, wood-engravings illustrating Virgil, 1821.

of cottages; a man reclines on a hillock surrounded by the crop, reading, while above him a huge harvest moon rises in the sky; a bright cloud billows over a fertile valley. Palmer accompanied most of the sepia drawings with quotations – from Lydgate's *Complaint of the Black Knight*, from Shakespeare's *As You Like It*, from the Psalms.[58] Just when the rigorously observed mode of landscape painting practised by Constable seemed to be the future, Palmer reinvented it in an unapologetically archaic way, using his literary imagination to suggest a mystical world, charged with joy and wonder, shining through the tangible everyday one.

But Palmer had not retreated from observation into a private world

Samuel Palmer, *The Valley Thick with Corn*, 1825.

of vision. It was more that he sought out unconventional subjects and chose unconventional times of day. After moving to Shoreham in 1826, he and his friends (Palmer enfolded in a greatcoat with extra-large pockets for sketchbooks, made for him by his indulgent former nurse) set out on nocturnal rambles around the lanes that made the local people wonder what they were up to. Mistaking their easels for telescopes, they muttered to each other that they must be 'extollagers', out to study the night sky. They were not so wide of the mark. On these expeditions, using black ink and brown watercolour, Palmer painted a vast full moon rising over a dark hill watched by a shepherd, lighting up clouds from below; they echo a flock of sheep sleeping in the meadow. He studied moonlight as it glimmered through foliage, and made the steeple of a church shine with a silvery brightness. He even drew the stars, each with a little aureole of glimmering light.

Palmer's monochrome drawings and paintings intensify the dream-like nature of the landscape, but when he began to use colour it burst on to the paper with a shocking intensity – as though the whisper to which

we had been listening had suddenly become a joyful shout. He became fascinated with the huge, ancient oak trees in nearby Lullingstone Park, not only because of their surface appearance, 'the moss, and rifts, and barky furrows', mesmerizing as it was; he also strove to capture their inner energy, the 'grasp and grapple of the roots; the muscular belly and shoulders; the twisted sinews'.[59] The intensity of his vision is expressed in vivid egg-yolk yellows and emerald greens. He was also riveted by the growth of moss on the thatched roofs of barns – in a watercolour now in the Victoria and Albert Museum, *A Cow-Lodge with a Mossy Roof*, most of the pigment is brushed on in a fairly summary way, but not in this area: his attention was evidently gripped by its colours and textures which stand out in a hallucinatory way. Although dilapidated, tumbledown buildings had been a staple of 'picturesque' views for decades, this was

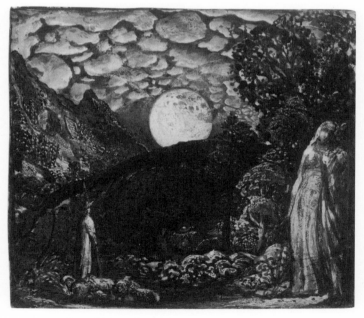

Samuel Palmer, *Shepherds under a Full Moon*, c. 1826–30.

something different. When making this kind of drawing, Palmer became so absorbed by his subject that he would enter into what he called an 'eclipse of thought' in which he became oblivious to cold, fatigue and hunger.[60]

Perhaps such visionary intensity, like a firework, cannot blaze for long. Palmer eventually left his 'valley of vision' and sought inspiration elsewhere, travelling to Italy, Devon and Wales, and settling in London. In 1837 he married Linnell's daughter Hannah, and with a wife to support and the prospect of a family, he was obliged to turn his attention from the absorbing minutiae of natural forms and to think instead of creating more saleable compositions. 'Real life began', he remarked ruefully.[61]

A few years after leaving Shoreham, Palmer returned to the area and decided to paint the view of a hillside near Sevenoaks.[62] He created a balanced composition with – for him – an unusual sense of distance and space, painted with restrained, faintly autumnal colour harmonies and in which most, if not quite all, of his eccentricity is suppressed. There is a faint moon waxing in the early evening sky, but it is nothing like the luminous globes that used to cast their unearthly glimmer over the landscape of Shoreham.

But if the light of common day had finally bleached the magic from his world, this was precisely the kind that, two decades later, would be actively sought out by artists. The 'mystic and dreamy glimmer' sacred to Palmer was willingly exchanged for a light brilliant enough to distinguish every leaf and blade of grass.

ACCUMULATED TRUTH

The young John Everett Millais suffered for his art. From July to October of 1851, he sat cross-legged under a small umbrella on a bank by the Hogsmill River at Ewell, near Kingston, Surrey, and later at Worcester Park Farm near Cheam, to paint the background to a picture. It was to depict Ophelia drifting to her death, draped in her flowery garlands and chanting old songs, having – according to Gertrude's account in *Hamlet* – fallen into the brook from an overhanging willow tree (Plate 12). But she would come later. The important thing was to get the setting right, and

that was proving a problem. 'My martyrdom is more trying than any I have hitherto experienced', Millais complained to a friend from his nearby lodgings. 'The flies of Surrey are more muscular, and have a still greater propensity for probing human flesh...I am threatened with a notice to appear before a magistrate for trespassing in a field and destroying the hay...am also in danger of being blown by the wind into the water....' There was, additionally, a threatening bull, and two swans that stationed themselves precisely where he wanted to paint and stared at him. In his attempts to scare them away he upset his brushes, his palette and his picture as well as his temper, while the swans merely looked on with a faintly admonitory air.[63] No wonder most artists only went outside to make their preparatory drawings, retreating into their comfortable studios to paint the actual picture.

But Millais was determined that the landscape in his picture should look real: the field-rose tumbling down the riverbank; the scrubby old willow; the forget-me-nots in the foreground. Painting them from sketches made on the spot, even from specimens taken into the studio, as Constable used to, was not enough. He wanted to kick away the obstacles that stood between him and nature and paint his direct experience of it. So he sat there on the riverbank with his canvas and scrutinized the leaves, flowers and waterweed (the little the swans had not eaten) with the attention of a botanist, his gaze making its ant-like progress over each tiny section as he painted. The colours had to look as they did outdoors on a summer's day, not as they would under studio lighting, so he first applied a layer of white paint that made the pigments glow with luminous intensity. Millais's decision to paint the riverbank first reversed normal priorities: any other artist of this time would have added the figure first and then worked around her. But for him, the detail of the landscape was every bit as important as Ophelia herself, and his model Elizabeth Siddal had to wait until the autumn before beginning her four-month stint posing for Ophelia, lying in a bath heated by lamps. Predictably, she caught a severe chill when they went out; Millais was so absorbed in his work that he did not notice.[64]

Millais's harrowing experience (though perhaps not Siddal's) was necessary if British art was to have the intended rocket put under it. He,

alongside Dante Gabriel Rossetti and William Holman Hunt, belonged to a radical group of artists who despised what they saw as the meretricious, sentimental rubbish that comprised most contemporary painting, and believed that it urgently needed to be reformed. When they got together in the autumn of 1848, their choice of name – the Pre-Raphaelite Brotherhood – signalled their conviction that in order to change the present they had to reach far back into the past; they aimed to produce serious, beautiful paintings that incorporated the clear colours, technical rigour and emotional sincerity they found in early Italian and Flemish pictures. Each one of the Brotherhood's works was a visual manifesto. It is possible to look at the world differently, these pictures proclaimed: artists have been slaves to convention for too long, adding pictorial tricks of recession and atmospheric effects. Look at my truthful detail: this is how nature really appears to your eyes.

Whether this was the case – and there were plenty of critics who did not agree, including one who thought that Millais's leaves in *Ophelia* looked as if 'cut out of sheet metal painted green' – the eye-popping clarity of the Pre-Raphaelites' early work caught the attention of John Ruskin, the leading art critic of the day.[65] It chimed with his profound reverence for nature, and his conviction of the importance of paying attention to the intricate details of natural form. As a boy walking along an ordinary street in southeast London one day, Ruskin had had an epiphany. He happened to spot some tendrils of ivy growing around a hawthorn stem; it looked picturesque, and so he decided to get out his sketchbook and draw it. As he looked, and drew, and looked again, all that he had learned from his art teachers dropped away. For the first time he began to draw what was really there in front of him.[66] It was the beginning of a love of nature, and of what he perceived to be the divine in nature, that would shape his life and thought.

When Ruskin came to write the first volume of his influential *Modern Painters* (1843), he urged young artists to avoid emulating the work of others or striving after style and beauty in their pictures. Instead, he advised them to 'go to Nature in all singleness of heart, and walk with her laboriously and trustingly, having no other thoughts but how best to penetrate her meaning, and remember her instruction: rejecting nothing,

selecting nothing, and scorning nothing'.[67] It was all so simple: just draw
what was there, and do not shrink from attempting to replicate the detail
you see. And if you don't like delicate detail, he says, then, evidently, you
don't like Nature either! A good picture, he tells us, has nothing to do
with beauty or style, but is one in which the artist – here he reels off a
list of exemplars from Titian, Tintoretto and Veronese to Memling and
Dürer – has tried their best to achieve 'consummate and accumulated
truth'.[68] As far as Ruskin was concerned, it was God, and not the devil,
who was in the detail.

For Ruskin, the Pre-Raphaelites and indeed a wider circle of contem-
porary painters who were determined to look at nature with fresh eyes, the
foreground became art's new focal point. The particular took precedence
over the general. Earlier in the century, landscape painters had scanned
the horizon. Now they turned their gazes downwards and inwards,
absorbed in ever-smaller details. The sky often disappeared completely.
Paintings got darker. Landscape subjects began to include woodland clear-
ings; boulders and waterfalls; overgrown cave entrances and tree-trunks
covered in ivy. Henry Bowler, a teacher at the South Kensington Schools,
painted Luccombe Chine on the Isle of Wight as though he was about to
plunge headlong into the stream, to lose himself among its weedy rocks
and dank undergrowth. As a young artist in the early years of the century,
William Henry Hunt had used to go sketching at Kensington Gravel Pits
with his friend Linnell; but a disability made it increasingly hard for him
to get around, and so he began to bring nature into his studio instead. In
later life he was celebrated for his illusionistic tablescapes, consisting of
things he brought inside: bird's nests, primroses, moss, apples and grapes.
He reproduced textures – the bloom of an eggshell, the rough, springy
texture of moss – with exceptional fidelity (Plate 13). Hunt's watercolours
were landscapes in miniature. Richard Dadd, incarcerated in Bethlem and
later in Broadmoor, painted whole fairy worlds in the undergrowth, rituals
glimpsed through a mesh of daisies and grasses (Plate 14). Something
strange was happening to scale and perspective. Ruskin himself rarely
troubled to finish his own drawings, and so they provide us with little
context with which to orientate ourselves. As a result one can badly mis-
interpret them, ending up with an oddly vertiginous feeling as what we

initially took to be a mountainous landscape seen from a great distance suddenly resolves itself into a wild strawberry plant.[69] As spectators of these vivid new inward-looking landscapes, we seem to shrink and grow as disconcertingly as Lewis Carroll's Alice.

Two years after *Ophelia*, Millais found himself working under Ruskin's exacting eye: he had accepted a commission to paint the older man's portrait. Millais had never visited Scotland, so during the summer of 1853 Ruskin invited him and his brother to Brig o' Turk, in the Trossachs near Stirling. Ruskin's young wife Effie was with them. A site was chosen at Glen Finglas, where Ruskin would be depicted standing in front of a fast-flowing stream and a steep rocky bank, dark with foliage and mosses, looking downstream in a contemplative way; no sky would be visible in the portrait; the foaming, cloud-reflecting water would form the only bright area. Millais might have escaped the silent stare of the swans this time, but instead he had Ruskin standing over him, keeping him, he said, up to the Pre-Raphaelite degree of finish he had come to expect.[70] It cannot have been comfortable. As with *Ophelia*, it was not the figure that was Millais's main problem (he painted Ruskin from life in his London studio the following year, hence the incongruous figure he cuts in his morning clothes and shiny black city shoes), but the background – Millais had, Ruskin reported, taken three months to complete a mere two-foot section. When, having left Scotland in October without finishing the picture, Millais eventually proposed travelling to Capel Curig in Wales to work from similar rocks, Ruskin strongly objected on the grounds that their geological formation was not identical. The artist was forced to return to the Trossachs the following June, to spend a further ten days on the spot.[71]

Ruskin himself saw this painting as much as a landscape as a portrait. He even predicted that it would 'make a revolution in landscape painting' – if only, he added with some exasperation, Millais could get it finished.[72] For him, a close-up was every bit as valid as a long view – perhaps more valuable, if it could provide an insight into the intricate secrets of nature. Two years earlier, in his pamphlet *Pre-Raphaelitism*, he had even compared his twin poles of landscape painting, J. M. W. Turner, whom he idolized, and Millais. Picturing them both in a mountain valley, he imagined Turner

painting the 'aerial mystery of distance' and Millais, by contrast, record-
ing 'the leaves on the branches, the veins in the pebbles, the bubbles in
the stream', choosing a small slice of the infinite scene and calculating
'with courage the number of weeks which must elapse before he can do
justice to the intensity of his perceptions, or the fulness of matter in his
subject'.[73] He saw Millais as a miniaturist, but one destined to work on a
large canvas. And while Millais was plugging away at his picture in Glen
Finglas, painstakingly adding the lichens on the rock and the bubbles
in the water, Ruskin was on the bank too, within instruction-shouting
distance of his young protégé, making his own portrait of the gneiss rock
face opposite (see p. 172). Ruskin worked on this drawing obsessively for
two months, intent on describing every detail of the striations, folds and
hollows of this tightly focused landscape. So entranced was he with the
rocky bank, with the information its sinuous bands silently held about
its formation in intense heat and under huge pressure millions of years
before – ideas that had circulated widely since the 1830s and the publi-
cation of Charles Lyell's *Principles of Geology* – that he failed to notice
the human drama unfolding in front of him day by day. Millais and Effie
were falling in love, an event that led to Ruskin and Effie's traumatic
and horribly public divorce. An impartial observer on the riverbank also
enduring the showers and midges during that summer of 1853 might have
wondered whether this, too, was a question of perspective.

October 5th, 1858. It is early evening at Pegwell Bay in Kent and the last
rays of evening sun are making the water in the rock pools gleam with
yellowish light, throwing the weedy boulders into sharp relief, their raking
light spotlighting the patterns and textures of each shell and stone. There
is a melancholy, end-of-season air. A family prepares to go back to its
lodgings, perhaps to return home at the end of its holiday, but lingers a
while on the emptying sands; a little boy with a spade pauses and turns for
one last look out to sea, standing absorbed in thought as though storing
up memories to sustain him over the winter. His two aunts, wrapped up
in warm shawls against the autumn evening, are still engrossed in their
search for shells, while his mother has walked a few paces further from
the sea, sensibly leading the way back to the warmth of the parlour and

tea. But even she hesitates and looks back, her expression hard to read under the shadowy privacy of her hat. Behind them stand chalk cliffs like ungainly monsters in wrinkled trousers, crammed with the fossils of creatures that lived millions of years ago when this part of Kent was under the sea. A little way off, near the foot of the cliffs, the boy's father stands with his back to the group, head tilted back, gazing at something in the sky. Faint against the washed-out blue, a comet makes its slow progress through another part of the universe.

The coast seemed somehow to be a good place to contemplate change, both endings and beginnings. This painting by the Aberdonian painter William Dyce, now in Tate Britain (Plate 15), is about time and place. Its title, *Pegwell Bay, Kent – A Recollection of October 5th 1858*, fixes it nostalgically to one particular day that can never come again, at the end of a family holiday – the last shells picked up to be admired, the last deep breaths of sea air. But the cosy shawl of nostalgia it appears to offer is whipped away by the simultaneous, discomforting story it tells of unimaginably vast tracts of geological time: the cliffs, their flint-encrusted strata painted with such intense regard for detail, had recently been exposed as repositories of deep history, witnesses to the fact that the earth was far older than had previously been supposed. It was a fact they regularly mentioned, in their own fashion, by regurgitating fossils. That specific date, 5 October, was when Donati's comet, one of the most brilliant to appear in the nineteenth century, looked brightest in the sky – here, says Dyce, is another, larger context for thinking about time and space. The date he is thought to have begun the painting, 1859, is also the year in which Charles Darwin's *On the Origin of Species* was published.

Leaving aside the fossils, the comet and the foreboding sense of change and endings, Pegwell Bay has other resonances, too. It was the place where St Augustine first landed in 597, having been sent from Rome to introduce Christianity to Britain. It is also on the eastern tip of Kent: if the light in the painting is fading fast, it will return all the sooner the following morning. The night is a hinge, not a dead end. *Pegwell Bay* pivots on an unstable axis, tilting and tilting and tilting again as we look at it: last year, millions of years ago; a local site, the universe; doubt, faith.[74]

In 1858 the writer Edmund Gosse was about the same age as the little boy in the painting. He spent much of his time pottering about amid rock pools further west, helping his zoologist father in Dorset, Devon and Wales as he gathered material for his books; in fact, P.H. Gosse's book *A Naturalist's Rambles on the Devonshire Coast* (1853) helped to spark the mid-Victorian craze for sea shores and the collecting of natural specimens which Dyce records in *Pegwell Bay*. In his memoir *Father and Son* (1907), Edmund Gosse recalls how, as a boy, he had secretly longed to walk out over the surface of the sea and lie face down to peer into its depths.[75] His father was a fundamentalist Christian, struggling to reconcile his own research into natural history and the new geological discoveries being made with the Biblical account of Creation. His solution was to publish *Omphalos: An Attempt to Untie the Geological Knot* (1857), in which he suggested that the earth was created suddenly, complete with pre-existing fossils, in order to make it appear older than it was. His argument was, his son ruefully recorded, inevitably coarsened by the press to become: 'God hid the fossils in the rocks in order to tempt geologists into infidelity'.[76]

The more closely people peered at nature, the more disquieting it became. The mid-Victorian fascination with the natural world reflected the new discoveries that forced many to rethink their relationship with it, and many, too, to reassess their religious positions. As Ruskin admitted in a letter to a friend, 'You speak of the Flimsiness of your own faith. Mine, which was never strong, is being beaten into mere gold leaf, and flutters in weak rags from the letter of its old forms.... If only the Geologists would let me alone, I could do very well, but those dreadful Hammers! I hear the clink of them at the end of every cadence of the Bible verses.'[77] In this new age of discovery, landscape painting assumed a new significance and seriousness. Unimaginably older and less predictable than previously thought, its appearance the result of erosion from wind and water and sedimentation, the land – especially its rocks – held new fascination and posed urgent problems. It was as though geologists had discovered the earth's portrait in the attic and people stood mesmerized by the ancient fissures marking its face. Of the disconcerting new facts to digest, not least was that the natural forces that had made the land look as it did were

ongoing, as inevitable and unstoppable as the tide. People no longer felt they were standing on stable ground, and they were quite right.

Dyce's choice of the coast as a setting for his pin-sharp meditation on arrivals and departures, recent events and deep time, was entirely apposite: each tide changed the shingle and sandscape, while the chalk cliffs were constantly eroding, disclosing yet more of their ancient secrets. The coastal edge of the landscape also drew Matthew Arnold, who, in 'Dover Beach' (composed around 1851), wrote of the sea of faith that was 'once, too, at the full, and round earth's shore':

> But now I only hear
> Its melancholy, long, withdrawing roar,
> Retreating, to the breath
> Of the night-wind, down the vast edges drear
> And naked shingles of the world.[78]

This unstable landscape offered a fitting metaphor for the times.

Clare Leighton, 'Ploughing', from *The Farmer's Year*, 1933.

VII

FEELING

'I am at one with it,' he said to himself,
'the river and I, I and the river.'
Frank Halton in E. F. Benson, 'The Man Who Went Too Far'

MOORS, MARSHES AND SHIVERING SANDS

> For my part I am free to walk on the moors – but when I go out there
> alone – everything reminds me of the times when others were with
> me and then the moors seem a wilderness, featureless, solitary, sad-
> dening – My sister Emily had a particular love for them, and there is
> not a knoll of heather, not a branch of fern, not a young bilberry leaf
> not a fluttering lark or linnet but reminds me of her[1]

Charlotte Brontë was writing in 1850, a year and a half after Emily's death,
her grief still making the familiar landscape seem strange and sad. To many,
though, her characterization would have seemed perfectly reasonable. The
moors were widely regarded as wild and featureless, with no value either
agricultural or aesthetic; a non-landscape. But Charlotte and her sisters
had no choice in the nature of the country outside the front door of the
parsonage at Haworth; the only alternative was to stay indoors. And so
they scrambled down boggy tracks and over rocks and hummocky grass
in their heavy woollen skirts and shawls in all seasons until they came to
know, and to love, every inch; and as Charlotte suggests, it was Emily who
loved the moors most. When, for a brief period in 1835, they left Haworth
together, Charlotte to teach and Emily to study, Emily 'became literally ill
from home-sickness, and could not settle to anything, and after passing

only three months at Roe Head [School], returned to the parsonage and the beloved moors', notes her biographer Mrs Gaskell .[2] A 'native and nursling of the moors', as her sister described her, Emily Brontë knew the landscape from the roots of its heather to its cloud-hazed horizons. It was this unconventional knowledge that took landscape in its bleakest, most unconsidered form and put it at the heart of Victorian literature.

People and landscapes get muddled up in *Wuthering Heights* (1847). Heathcliff – his very name proclaiming his bleak and uncompromising nature – often seems more like a slice of the landscape come to life than a man. Catherine Earnshaw describes him to Isabella as 'an unreclaimed creature, without refinement, without cultivation; an arid wilderness of furze and whinstone'.[3] The moors are also necessary to her own spirit, capable, she thinks, of returning her to herself – and to Heathcliff. 'I wish I were out of doors', she cries as she lies dying. 'I wish I were a girl again, half savage and hardy, and free…I'm sure I should be myself were I once among the heather on those hills…. Open the window again wide, fasten it open!'[4]

Emotions, too, are best expressed in terms of landscape; Catherine explains that her love for Linton 'is like the foliage in the woods. Time will change it, I'm well aware, as winter changes the trees. My love for Heathcliff resembles the eternal rocks beneath – a source of little visible delight, but necessary.'[5] The novel ends with the narrator, Lockwood, finding a shepherd boy in tears because he has seen the ghosts of Heathcliff and Catherine and dare not pass them. The idea that their spirits have returned to haunt the moors – together – is both comforting and frightening. They are back where they belong, their ghostly status returning to them the freedom they enjoyed as children; but these *genii loci* have given the moors another dimension of terror.

Emily Brontë had observed nature closely enough to have no illusions about it. 'All creation is equally mad', she reflected in 1842 from a school in Brussels. 'Nature is an inexplicable problem; it exists on a principle of destruction. Every being must be the tireless instrument of death to others, or itself must cease to live, yet nonetheless we celebrate the day of our birth, and we praise God for having entered such a world.'[6] Thomas Hardy would have agreed with her; in fact, his Egdon Heath in *The Return*

of the Native (1878) makes the wild, treacherous moors around Wuthering Heights look almost benign. For sheer unpleasantness it is in a class of its own, hostile and overbearing, to be endured if possible – though it claims the lives of several characters. "'You hate the heath as much as ever'", remarks Damon Wildeve to Eustacia Vye, on the eve of the former's marriage to Thomasin Yeobright. "'I do'", she murmured deeply. "'Tis my cross, my shame, and will be my death!" "'I abhor it too'", he replies.[7] Yet the lovers know this place so intimately that even at night they can see it 'by ear', as Hardy puts it, able to tell from the subtle changes in the sound of the wind where the tracts of heather begin and end, where the gorse is tall and where it has been cut, where the firs stand and how close the holly grows.[8] They are pitch-perfect experts – but their knowledge does not save Eustacia's fears from coming true. The pair drown in the pool beneath Shadwater Weir, while the determined Mrs Yeobright is over-come by adder's venom, heat and misery after a fruitless walk across the shelterless heath to visit her son.

Egdon Heath is not so much a setting as an unpredictable character of monstrous power, the presence of whom seeps on to every page. It is introduced in the novel's first sentence as a 'vast tract of unenclosed wild', as it had been for time out of mind; recorded, Hardy tells us, in the Domesday Book as 'heathy, furzy, briary wilderness', and described centuries later by Leland as 'Overgrown with heth and mosse'.

> The untameable, Ishmaelitish thing that Egdon now was it always had been. Civilisation was its enemy; and ever since the beginning of vegetation its soil had worn the same antique brown dress, the natural and invariable garment of its particular formation…. To recline on a stump of thorn in the central valley of Egdon, between afternoon and night, as now, where the eye could reach nothing of the world outside the summits and shoulders of heathland which filled the whole cir-cumference of its glance, and to know that everything around and underneath had been from prehistoric times as unaltered as the stars overhead, gave ballast to the mind adrift on change, and harassed by the irrepressible New. The great inviolate place had an ancient per-manence which the sea cannot claim. Who can say of a particular sea

that it is old? Distilled by the sun, kneaded by the moon, it is renewed in a year, in a day, or in an hour. The sea changed, the fields changed, the rivers, the villages, and the people changed, yet Egdon remained.[9]

Hardy wrote *The Return of the Native* in the Dorset market town of Sturminster Newton, where he had settled with his new wife in the spring of 1876, but he was thinking about the landscape of his childhood, further south in the small village of Higher Bockhampton, where the family's cottage had stood on the edge of the heath. As a boy he had walked the three miles to school in Dorchester and back every day, getting to know the woods, tracks and open land, the birds, animals and insects.[10] As Hardy noted in a preface, Egdon Heath was a composite of around a dozen areas of Dorset heathland he knew; for the frontispiece to the first edition of the novel, he drew a 'sketch map of the scene of the story', as though anxious to give the place visual form. The result is not so much a useable map as a dreamed-about landscape of lunar bleakness, sketched on waking. The few habitations are pushed to the edges by the heath's knobbly spine.

Like his characters, Hardy knew the Dorset landscape by ear as much as by sight, and the wind on Egdon Heath has a virtuosic repertoire of noises. It deploys them with a keen sense of irony, emulating the sound of a devout congregation in quiet prayer as it blows through the reeds behind the Quiet Woman Inn, or adding mood music to Wildeve and Eustacia's fraught conversation by whistling through the thorn trees, producing a sound like dirges sung through clenched teeth.[11] When the wind blows from the northwest, it makes three distinct sounds: lowest is the hum as it blusters against hills and hollows; then there is the 'baritone buzz' as it blows through the holly branches. But the sound that can be heard nowhere else has a higher note, a 'worn whisper, dry and papery', made by the wind blowing on the previous summer's dried-out heath-bells, rustling around the cavity of each tiny hollow flower.[12] It is an uncanny susurration, like a person – or a spirit – speaking through each dead flower at once.

Egdon Heath occasionally bestows a blessing. When Clym Yeobright goes out to cut the furze, it comes to vivid life. Bees hum about his ears 'with an intimate air'; amber-coloured butterflies alight on his back and sport with his raised hook; emerald-green grasshoppers leap over his feet.

Thomas Hardy's map of Egdon Heath, reproduced in the first edition of
The Return of the Native, 1878.

Brilliant blue and yellow snakes glide in and out of fern dells and young rabbits watch as they sun themselves on hillocks, the delicate skin of their ears turning blood-red as the sun shines through them. None of these sociable, dazzling creatures fears him.[13] The landscape can even issue a warning, after its fashion: Eustacia's last journey takes her on the path towards Rainbarrow, the prehistoric burial mound. The heath responds by putting twisted furze roots in her path, over which she stumbles, and by excreting 'oozing lumps of fleshy fungi, which at this season lay scattered about the heath like the rotten liver and lungs of some colossal animal'.[14] But most of all, Egdon Heath acts as an ancient, unchanging backdrop. For Clym, making his sad way home, 'there was only the imperturbable countenance of the heath, which, having defied the cataclysmal onsets of centuries, reduced to insignificance by its seamed and antique features the wildest turmoil of a single man'.[15] Yet the novel ends with a kind of truce: having become an itinerant preacher, Clym chooses Rainbarrow as a platform so that he can be seen from a distance away. Those who come to hear him sit casually pulling heather, stripping ferns and tossing pebbles down the bank as they listen:[16] Egdon Heath has finally become a place whose natural resources can be turned to human advantage, rather than simply grimly endured.

On 30 March 1851, a census was taken that revealed a profound change in peoples' lives. Since the late eighteenth century, thousands of individuals and families had been packing up their belongings, loading carts and making their way from hamlets and villages to towns and cities in search of work. Their children, born to urban life, often knew no other kind. What the census showed was that by the middle of the nineteenth century a tipping-point had been reached: for the first time, there were more people living in urban areas than in the country. The age-old balance between town and country, between manufacturing, trade and agriculture, was lost. Towns and cities expanded exponentially to meet demand, and the resulting building boom extended suburbs far into what had been market-gardens, farmland and heath.

Perhaps it was inevitable that, from an increasingly urban perspective, people would begin to see the countryside in a new light. Having once

been part of daily life for the majority, when viewed from the town the hills, fields, heaths and marshes were no longer understood in the same practical way. Areas of uncultivated land – flat land in particular, rather than places that might be regarded at this date as picturesque – became places to fear. A horror of the countryside was born in the Victorian era – one that has never quite gone away.

This was a huge change in attitude. Only think, for example, of Mary Shelley's *Frankenstein or the Modern Prometheus*, first published little over thirty years before, in 1818. In the summer of 1816 Shelley was staying near Lake Geneva in Switzerland when, over a night made sleepless by a disturbing conversation in which Lord Byron and Percy Bysshe Shelley discussed the possibility of reanimating a corpse with a galvanic battery, she had a vision of 'a pale student of unhallowed arts' recoiling from his creation. Opening her eyes 'to exchange the ghastly image of [her] fancy for the realities around', she later recalled not only the room with its shutters and moonlight but also, though she could not see them, her vivid sense of the 'high white Alps' beyond.[17] She folded this Swiss landscape into her emerging novel: to be wild enough for her audacious story, its setting had to be on the Continent. Neither the Lake District nor even the Highlands of Scotland would quite do for her Creature, though we learn that he has stealthily followed Victor Frankenstein as he makes a conventional tour of picturesque sights – had he made himself visible, he would have been all too likely to come face to face with a group of middle-class tourists. The earliest readers of *Frankenstein* would have been familiar with Britain's mountain scenery at least through books, watercolours and prints; these previously fearsome features had, to some degree, been culturally domesticated. Instead, one of the Creature's earliest appearances is in the Alps near Geneva, when Victor catches a glimpse of him by lightning as he climbs the near-perpendicular rock-face of Mont Salêve. The novel's dénouement takes place at a yet more extreme and hostile environment, the North Pole. It ends with the Creature standing alone on an ice-raft, drifting away into the darkness – perhaps the bleakest literary landscape since Hamlet's 'sterile promontory'.

The one location in the British Isles Shelley considered far-flung enough to accommodate a visit from the Creature was the geographically remote

Orkney – she had, in fact, never visited, but she has Victor describe it as 'hardly more than a rock, whose high sides were continually beaten upon by the waves' and 'desolate and appalling'.[18] But the tide had turned, and these remote and desperate literary landscapes had become old-fashioned. Writers had begun to discover a capacity for terror in countryside far less mountainous than Shelley's, and uncomfortably close to home.

Charles Dickens was not a country child. Born in Portsmouth, as a small boy he lived in Chatham in Kent, moving to London with his family when he was ten. A solicitor's clerk from the age of fifteen, he gained an intimate familiarity with London's streets – from Bow to Brentford, as another clerk admiringly recollected – that was every bit as detailed as John Clare's of the countryside around Helpston.[19] Dickens's countryside is seen from the viewpoint of the town; like Lady Dedlock at the opening of *Bleak House*, we seem to gaze at it through the window in a mood of mounting dismay. *Great Expectations* (1861) is haunted by the 'marsh country' where Pip lives, a Kentish landscape Dickens knew from his childhood. When Pip encounters Magwitch for the first time, he pauses to look over his shoulder as he runs home – and what he sees is a world transformed by fear and danger:

> The marshes were just a long black horizontal line then, as I stopped to look after him; and the river was just another horizontal line, not nearly so broad nor yet so black; and the sky was just a row of long angry red lines and dense black lines intermixed.[20]

This landscape scrawls and crosses itself out, reducing itself in a destructive rage to the most basic of elements.

Wilkie Collins was not a country child either. In his 1868 novel *The Moonstone*, the landscape does not merely house potential killers; it is one. Near to the house is a lonely bay between two rocky spits, between which,

> shifting backwards and forwards at certain seasons of the year, lies the most horrible quicksand on the shores of Yorkshire. At the turn of the tide, something goes on in the unknown deeps below, which sets the whole face of the quicksand shivering and trembling in a manner most remarkable to see...[21]

Known locally as 'The Shivering Sand', it becomes a source of horrified fascination – and eventual tragedy – for the maid, Rosanna Spearman:

> 'Look!' she said. 'Isn't it wonderful? Isn't it terrible?'...I looked where she had pointed. The tide was on the turn, and the horrid sand began to shiver. The broad brown face of it heaved slowly, and then dimpled and quivered all over. 'Do you know what it looks like to me?' says Rosanna, catching me by the shoulder again. 'It looks as if it had hundreds of suffocating people under it – all struggling to get to the surface, and all sinking lower and lower in the dreadful deeps!'[22]

The very ground under one's feet could no longer be trusted. At the beginning of his phenomenally successful novel *Aylwin* (1898), Theodore Watts-Dunton introduces another dangerously unstable coastline – here given to 'sudden and gigantic landslips'. It is a place where even a coast-guard might return home to find a cove where, half an hour before, he had left his cabbages growing.[23] As the landscape dramatically reshapes itself with landslides and subsequent settlements, it becomes an active protagonist in the drama, with the power to hurt and to kill, to conceal and to reveal. The moors around Baskerville Hall in Arthur Conan Doyle's *The Hound of the Baskervilles* (1901–2) are yet more treacherous; the great Grimpen Mire is a piecemeal network of quicksand, each patch disguised with lush green foliage. We first encounter the Mire in the act of swallowing a wild pony (its second in as many days, we learn), and in the end the villain himself, Jack Stapleton, is also sucked into 'the foul slime of the huge morass'. It is not only unreliable, however, but actively hostile: Conan Doyle hints at a supernatural dimension, as though the mire not only absorbs bodies like a sprawling carnivorous plant, but is also alive with a demonic force:

> Its tenacious grip plucked at our heels as we walked, and when we sank into it it was as if some malignant hand was tugging us down into those obscene depths, so grim and purposeful was the clutch in which it held us.[24]

The great Grimpen Mire is so highly developed a character that it does everything, in fact, except speak.

Unlike Dickens and Collins, Richard Jefferies *was* a country child. Born on a farm managed by his father at Coate, near Swindon, he could write with authority about what would happen, year by year, if the land suddenly stopped being cultivated – or indeed inhabited. The opening section of his science fiction novel *After London* (1885) describes the fields, hills and lanes in the years following a natural disaster. 'It became green everywhere in the first spring,' the narrator remarks, 'after London ended'. Crops go unharvested, meadows unmown, footpaths untrodden. In the autumn the summer's growth is beaten down by the storms, and next spring hardier weeds grow up through the matted straw. Hedges widen and brambles meet in the centres of fields. Saplings grow unchecked and the land becomes thickly wooded. Marshland spreads around every stream. 'By the thirtieth year there was not one single open place, the hills only excepted, where a man could walk'. London itself is in far-from-picturesque ruins, the buildings standing on high ground cracked by trees, their crumbling brick overgrown with ivy, while those built on low-lying ground are submerged beneath a stinking, pestilential swamp: 'The black water bears a greenish-brown floating scum, which for ever bubbles up from the putrid mud of the bottom.... There are no fishes, neither can eels exist in the mud, nor even newts. It is dead.'[25] It would be some thirty years before landscapes of comparable nihilism would be described; but the second time it would be reportage, and their recorders official war artists.

If at any time during the 1880s or 1890s you were to visit the Royal Academy summer exhibition, held, as now, at Burlington House in London's West End, however hard you searched among the crowded hang of paintings you would not have found many depicting lonely marshes under angry skies – and probably none at all of person-devouring quicksands, collapsing cliffs or putrid swamps where a capital city once stood. Contemporary British artists such as Robert McGregor, George Clausen and H.H. La Thangue had begun to paint the physical hardship of field labour and the discomfort and isolation of country life, but those who were willing to depict the dark side of the landscape remained in the minority. Looking

back over the history of oil paintings and watercolours, we tend to focus on successive avant-garde movements at the expense of popular taste; open any one of the Royal Academy's exhibition catalogues, and a different history emerges. Chosen at random, a single page of that for 1890 includes titles such as *Landscape, and Cattle in Repose* (no. 139, Alfred V. Poncy), *Summer Twilight, Isle of Arran* (no. 140, Wellwood Ratray), *A Sussex Ox-Team* (no. 145, Arthur Lemon) and *A Calm December Morning* (no. 174, Arthur P. Robinson). Other titles on the page – *Low-land*; *An autumn evening*; *A March gloaming*; *Pastures by the Sea*; *Spring-time*; *Lingering light*; *Evening* and *'The stilly hours when storms are gone; When warring winds have died away'* (quoting Thomas Moore's ever-popular verse drama *Lalla Rookh*) – also promise views of landscape in its gentler forms.[26] The titles promise respite, solace and calm. Landscape – in visual form – had become therapy, and neither artists nor potential buyers at the conservative Royal Academy would have been greatly perturbed when Oscar Wilde dismissed sunsets as provincial in his brilliant essay 'The Decay of Lying'.[27] They sold.

A Victorian public might have thrilled to read about apocalyptic and treacherous landscapes, but they did not want to live with them on their parlour walls. They wanted the opposite: level or gently hilly country, often pasture or arable land, usually inhabited or showing signs of human presence and bathed in gentle light. Among the most successful paintings of this period was *February Fill Dyke* (Plate 16) by Benjamin Williams Leader, first exhibited at the Royal Academy in 1881. Widely reproduced, the occupants of many a middle-class home lived with its image in the form of a framed engraving. The landscape it shows is unspectacular and flat, and it has rained heavily. But, moving towards evening, the cloud is beginning to break up and the weak setting sun is momentarily reflected in the pools of water lying in the meadows and on the muddy ruts of the track, turning them pale gold. There is a cottage with a cheerfully smoking chimney promising supper and a church tower evoking community and faith; the figures with their dogs pause for a moment on their way to their fireside, about to shut their door against the evening. The landscape is momentarily transfigured by the sun; the ordinary made extraordinary. The painting carries overtones of spirituality, for those

inclined to see them. The title, too, is subtly designed to ring bells deep in the mind by evoking the old country rhyme 'February fill the dyke, / Be it black or be it white; / But if it be white, / it's the better to like'. Leader, among the most successful landscape painters of the age, was a master of understated atmosphere. He had a gift for evoking nostalgic feelings in the picture-buying public – for an unchanging countryside, ticking along from month to month according to the annual natural rhythms that they, their parents or even their grandparents had abandoned when they opted for town life. It is no coincidence that so many landscape paintings of the latter nineteenth century are evening scenes. They evoked the sense of an ending that so many had begun to feel.

SPIRITS OF PLACE

It was the summer of 1865, and a young man lay on the grass at the top of a hill in Wiltshire. Woods hid the scattered hamlets and farmhouses below, and he was alone in the landscape. If a wandering shepherd had stumbled upon him, he would have assumed he was resting – but not a bit of it. This reclining figure was, in fact, caught up in what he later described as 'a whirlwind of passion'. He was imagining the ground holding him up far beneath the short turf and wild thyme he could feel under his fingers. He was gazing into the sky, higher and higher until he seemed to see the stars; he was picturing the deep ocean as though he were flying over it; and he was thinking of the vast sun rolling through endless space. With his rapturous face buried in the grass, he felt his body, mind and soul lost and absorbed into the fabric of the vast universe. Up there, away from everyday concerns and troubles, he was allowing his parched soul to drink.[28]

This was the nature writer Richard Jefferies in his 1883 spiritual memoir, *The Story of my Heart*, recalling his first experiences of the mental and emotional process he called 'soul thought'. He described the particular 'thinking places' within reach of his home where he could feel absorbed in the natural world: one was the base of a great oak; another the foot of a grassy tumulus.[29] It was here that he began to commune not only with the natural world, but with the deep past. The man buried in a barrow seemed

connected to him, as though individuals were merely part of one general life force: 'As my thought could slip back the twenty centuries in a moment to the forest-days when he hurled the spear, or shot with the bow, hunting the deer, and could return again as swiftly to this moment,' he wrote, 'so his spirit could endure from then till now, and time was nothing.'[30] His experience of being in the landscape allowed Jefferies to think with such visionary intensity that time itself came to seem insignificant.

Gerard Manley Hopkins was also attuned to powerful spiritual forces within the landscape, though as a Jesuit novice and later priest, his expression of them was shaped by his Christian faith. As a young man, Hopkins was among the many who had come under Ruskin's spell, so much so that he had originally intended to be an artist. He gave it up while studying at Oxford, but the passion for looking that Ruskin instilled in his followers was instead channelled into the prose of his journals, which bristle with curiosity, full of the writer's determination to find the words, no matter how unconventional, to fit the colours and contours of the landscape. One December day, on a monthly holiday from the Lancashire countryside where he was studying towards ordination, he described the ground as being 'sheeted with taut tattered streaks of crisp gritty snow.... When there was no snow and dark greens about, as I saw it just over the stile at the top of the Forty-Acre the other day, it made bats and splinters of smooth caky road-rut colour'. Another day, walking back to Stonyhurst from Blackburn, he noted Parlick ridge looking 'like a pale goldfish skin without body'. He was particularly fascinated by landscape's moving parts: the sky and the sea, which he had leisure to study on community holidays to the Isle of Man. He was entranced by the sea's endlessly changing shapes and colours. 'I was looking at high waves', he begins in one description of August 1872:

> The breakers always are parallel to the coast and shape themselves to it except where the curve is sharp however the wind blows. They are rolled out by the shallowing shore just as a piece of putty between the palms whatever its shape runs into a long roll. The slant ruck or crease one sees in them shows the way of the wind. The regularity of the barrels surprised and charmed the eye; the edge behind the comb or crest was as smooth and bright as glass. It may be noticed

to be green behind and silver white in front: the silver marks where the air begins, the pure white is foam, the green solid water. Then looked at to the right or left they are scrolled over like mouldboards or feathers or jibsails seen by the edge. It is pretty to see the hollow of the barrel disappearing as the white comb on each side runs along the wave gaining ground till the two meet at a pitch and crush and overlap each other.[31]

This patient, curious, eccentric nature-observation lay at the heart of his poetry; kindling material that, in verse, was ignited by the flame of his faith.

In 1877 Hopkins was in his final year of study at St Beuno's in North Wales, a place he called his 'true Arcadia of wild beauty'.[32] It was then, despite admitting to a profound weariness brought on by studying moral theology, that he wrote such poems as the ecstatic 'Hurrahing in Harvest':[33]

Summer ends now; now, barbarous in beauty, the stooks rise
Around; up above, what wind-walks! what lovely behaviour
Of silk-sack clouds! has wilder, wilful-wavier
Meal-drift moulded ever and melted across skies?
I walk, I lift up, I lift up heart, eyes,
Down all that glory in the heavens to glean our Saviour;
And, eyes, heart, what looks, what lips yet gave you a
Rapturous love's greeting of realer, of rounder replies?

Christ, the poem argues, shines through the air and is the very ground under our feet – 'the azurous hung hills are his world-wielding shoulder / Majestic'.[34] They do not *seem to be* – they actually *are*. Hopkins's gloriously playful metaphors of movement melt away in the solid presence of God.

But the land that was charged with such potent and life-affirming spirituality for writers such as Jefferies and Hopkins was under threat. A sonnet Hopkins wrote at the time, 'God's Grandeur', reveals a bleak pessimism about the impact of industry on contemporary life:

Generations have trod, have trod, have trod;
And all is seared with trade; bleared, smeared with toil;
And wears man's smudge and shares man's smell: the soil
Is bare now, nor can foot feel, being shod.[35]

Hopkins was ordained in 1877, and as a Jesuit priest was regularly posted to different places as a curate and teacher. Having grown up in comfortable Hampstead in north London, he now experienced at first hand the great industrial cities of Sheffield, Liverpool and Glasgow. It came as a shock. 'My muse', he remarked sadly to his friend Robert Bridges from Chesterfield in 1878, 'turned utterly sullen in the Sheffield smoke-ridden air'.[36] The lime kilns and furnaces that had so thrilled visitors of the early nineteenth century, even those on the banks of the river Severn, were no longer thought beautiful. The age of industrial spectacle was long gone. 'If Drayton were with us again to write a new edition of his incomparable poem', E. M. Forster was to remark in *Howards End* (1910), 'he would sing the nymphs of Hertfordshire as indeterminate of feature, with hair obfuscated by the London smoke'.[37]

Under the newly built houses and roads, which reached far into former fields and multiplied at a staggering rate, something precious was disappearing. Alongside the Victorian gusto for building campaigns and engineering projects a sense of unease grew, as people became newly sensitive to the countryside's emotional value. In a poignant essay of 1899 commemorating an unusually unspoiled valley near London, the essayist Max Beerbohm pointed out humanity's 'ogre-ish' tendency to destroy what it claimed to love most. 'Month in, month out,' he lamented,

with tears blinding our eyes, we raise tombs of brick and mortar for the decent burial of any scenery that may still be lying exposed. A little while, and English landscape will have become the theme of antiquarians, and we shall be listening to learned lectures on scenology and gaping at dried specimens of the trees, grasses, and curious flowers that were once quite common in our Counties.[38]

By the late nineteenth century official attention was turning towards preservation. When the National Trust for Places of Historic Interest or Natural Beauty was founded in 1895, its mission was to protect green spaces as much as to safeguard buildings. And the landscape was not the only cause for concern; the history and customs of rural areas were also recognised as being under threat. In 1890 Charlotte Sophia Burne, the first female president of the Folklore Society (est. 1878), made a plea for local stories and traditions to be collected in a systematic way. 'If the folk-lore of England is not recorded soon,' she warned, 'it will never be recorded at all, for these "foot-prints in the sands of time" are fast being trampled by the hurrying feet of the busy multitudes of the Present.'[39] As a result, the largely non-industrial south and south-west, with their concentration of prehistoric standing stones and long barrows, came to be regarded as repositories of British history and identity. The narrator of Forster's novel *The Longest Journey* (1907) declares the fictional Cadbury Rings near Salisbury the heart of Britain: 'the Chilterns, the North Downs, the South Downs radiate hence. The fibres of England unite in Wiltshire, and did we condescend to worship her, here we should erect our national shrine.'[40]

Old traditions, old stories, old customs, the ancient heart of the country itself – all needed to be cherished. But, swept up in the onrush of modernity, how could one get at the past? Could it be found deep within the present, like a living germ within a sooty husk? 'Forget six counties overhung with smoke', William Morris commands his readers at the beginning of his answer to Chaucer's *Canterbury Tales*, *The Earthly Paradise* (1868–70),

> Forget the snorting steam and piston stroke,
> Forget the spreading of the hideous town;
> Think, rather, of the pack-horse on the down,
> And dream of London, small, and white, and clean,
> And the clear Thames bordered by its gardens green[41]

Many writers at this time began to think and dream of the layers of historical memory and spiritual resonance buried in the countryside. Quite suddenly, ghosts and other supernatural figures, which with a few notable

exceptions throughout the eighteenth and nineteenth centuries had been largely urban phenomena, began to haunt the landscape. 'Pallinghurst Barrow', a short story by a Canadian writer, Grant Allen, published in the Christmas number of 1892's *Illustrated London News*, puts it most explicitly. Our hero Rudolph Reeve is sitting atop a prehistoric barrow in Hampshire near sunset, around the autumn equinox, when he becomes aware 'through no external sense, but by pure internal consciousness, of something living and moving within the barrow'.[42] Late that night he is drawn inexorably back to the site, where he encounters the ghosts of prehistoric men and women still occupying the land, personifying its deep history.

When Rudyard Kipling needed to invent a *genius loci*, or spirit of place, for England, he chose the fairy Puck, who in the 1906 children's story *Puck of Pook's Hill* fuses history with the supernatural when he describes himself as 'the oldest Old Thing in England'. The children Una and Dan, he explains, have conjured him up by their halting attempts to perform a play in a particularly ancient and enchanted spot:

> what on Human Earth made you act *Midsummer Night's Dream* three times over, *on* Midsummer Eve, *in* the middle of a Ring, and under – right *under* one of my oldest hills in Old England? Pook's Hill – Puck's Hill – Puck's Hill – Pook's Hill!

Over the course of the summer Puck conjures up a series of historical figures – ghosts, essentially – to instruct and entertain Una and Dan in their little corner of Sussex. England, implies Kipling, is a palimpsest of stories that are intimately tied up with the landscape itself.

But not all spirits of place were benign. Things hidden underground in the country are best left undisturbed – or so it turns out in several of the ghost stories the Cambridge scholar and Director of the Fitzwilliam Museum, Montague Rhodes James, wrote to entertain his friends over successive Christmases. In 'Oh, Whistle, and I'll Come to You, My Lad' Professor Parkins, on holiday at the East Anglian coast, digs up a whistle buried on the site of an ancient church built by the Knights Templar. It is late afternoon when he unwisely puts it in his pocket, before heading back to the Globe Inn as the light is beginning to fade.

> Bleak and solemn was the view on which he took a last look before starting homeward. A faint yellow light in the west showed the links... the squat martello tower, the lights of Aldsey village, the pale ribbon of sands intersected at intervals by black wooden groynes, the dim and murmuring sea.

It is on this cheerless stretch of coastal landscape that Parkins first sees the terrible 'figure in pale, fluttering draperies', as yet indistinct, that will relentlessly pursue him through the landscapes of his mind as he drifts to the edge of sleep.[43] Another story, 'A Warning to the Curious', involves a double unearthing. A silver crown, long buried in a hillock near the East Anglian coast, is thought to protect the land against invaders. When an amateur archaeologist ignores local folklore, digs it up and claims it, he is pursued by the ghost of William Ager, the last of the family who had been responsible for its protection. Although buried in the churchyard, he unearths himself in order to honour his obligation.

Now stationed in the countryside, ghosts had become the fiercely protective custodians of British history. If one tried to relieve the landscape of its treasures, whatever one's intentions, retribution was automatic. The land would fight back.

Listen. Do you hear? At first it sounded like the wind blowing through the reeds, but surely it is music – a free-flowing melody with no beginning and no end, music so enchanting that it will draw us after it and lead us deep into the woods. And look: do you see? Someone was peeping at us through the leaves – a mischievous eye; a curling horn – there, quick! A long, goat-like face. It is the great god Pan, and he has come to haunt the British landscape.

Pan and his entourage had been sent packing from oil paintings of the early nineteenth century. Constable could hardly contain his contempt for the dinosaurs at the Royal Academy, whose tastes still ran to tired old Claudean views complete with classical figures – those, as he put it in a letter of 1829, who preferred the '*shaggy posteriors of a Satyr* to the *moral feeling of landscape*' (his own irascible emphasis).[44] There was no place for satyrs, or nymphs come to that, on his Suffolk towpaths or in his father's

boatyard. Later, the most earnestly *plein-airist* Pre-Raphaelite painters were hardly going to shoulder their easels and lug their equipment out to riverbanks and harvest fields, only to invent mythical creatures when they got there. But the gods were merely biding their time. The hoof-prints of Pan – libidinous, rambunctious, disruptive Pan, god of fields and groves – can be tracked through many late Victorian and Edwardian stories by, among others, Beerbohm, Algernon Blackwood, E. M. Forster, Kenneth Grahame, Somerset Maugham and Robert Louis Stevenson.[45]

If he was to be truly unnerving, Pan had to be elusive. In visual art he is exposed to our gaze –Edward Burne Jones's tender *Pan and Psyche* (1872–74) puts him on a rocky pedestal, comforting the nymph Psyche in full view – but in literature he could conceal himself.[46] His presence deep in the woods is merely implied in Arthur Machen's sinister story of 1894, 'The Great God Pan', while in Saki's 'The Music on the Hill' (1911), he is visible as a small bronze statue in a copse, while a beautiful boy with a mocking laugh and evil eyes, only glimpsed, may or may not be Pan himself. Saki's brief, brutal story is a cautionary tale for the middle classes who were, at this time, beginning to move back to the country, or at least to buy second homes there. He warns of consequences for incomers if they failed to respect its ways – or, as his story puts it, if they dared to disbelieve in Pan. Pan even passes through Edwardian children's literature, not as a terrifying presence but as a kindly 'Friend and Helper' to animals, a springer of traps and binder of wounds. In the strange, visionary chapter 'The Piper at the Gates of Dawn' in Kenneth Grahame's *The Wind in the Willows* (1908) he appears to Rat and Mole, who instinctively bow down and worship him – though afterwards, as though waking from a dream, neither animal can quite remember what he saw. All that is left is the distant sound of music in the reeds.

The desire to encounter Pan in person drives E. F. Benson's 1912 story, 'The Man Who Went Too Far'. It begins with a scene that comes close to parodying Jefferies' memoir: Frank Halton, a man who cultivates an intensely close relationship with nature, bathes in the river Fawn at the bottom of his garden and talks to himself. "'I am one with it," he said to himself, "the river and I, I and the river. The coolness and splash of it is I, and the water-herbs that wave in it are I also. And my strength and my

Aubrey Beardsley, title-page design for Arthur Machen's
The Great God Pan and The Inmost Light, 1894.

limbs are not mine but the river's. It is all one, all one, dear Fawn.'[47] He describes to a visiting friend the steps by which he has given himself up, body and soul, to nature, sitting on the riverbank in dappled sun and shade and doing nothing but looking and listening; sleeping out of doors until dawn then wandering through the quiet woods in a haze of happiness; prostrating himself on the turf and burying his face in the daisies and cowslips in a Jefferies-like ecstasy. He begins to hear the enchanting sound of Pan-pipes, first faintly then more loudly and insistently, and realizes that he is being courted and invited to go further in his devotion to nature. He readies himself for the final revelation: a meeting with Pan himself. He has, however, forgotten one crucial factor – the inherent cruelty of natural processes, the fact that, as Emily Brontë observed, nature 'exists on a principle of destruction'. After the goat-god has finally revealed himself to him, Halton is found close to death. His face – formerly transfigured with the appearance of youth and beauty – is contorted with terror, repulsion and anguish, and his body is marked with pointed prints as though 'caused by the hoofs of some monstrous goat that had leaped and stamped upon him'.[48]

BLUE REMEMBERED HILLS

It was 24 June 1914, just a few weeks before the outbreak of the Great War, when Edward Thomas's train made an unscheduled stop at Adlestrop, a village in Gloucestershire. The sudden, unexpected stillness imposed a quiet pause on every passenger's day. It broke through Thomas's thoughts – whether he was reading, or daydreaming – and made him look up through the dust motes drifting in the warm stuffy air of the carriage and listen. No one about, and the hot June air filled with birdsong. The pregnant hush of the moment struck him as being obscurely important, and was enough to make him take out his notebook: 'through the willows could be heard a chain of blackbirds songs at 12.45,' he scribbled, 'and one thrush and no man seen, only a hiss of engine letting off steam'.[49]

It would be two years before Thomas shaped the events and emotions of this moment into one of his best-known poems, 'Adlestrop'.

The biographer and author of lyrical country books who got on the train that day had not even begun to write poetry – he would not compose his first until December of that year – although, with a strange appropriateness, he was on his way to Ledbury in Herefordshire to see his friend Robert Frost, who persuaded him to begin. By the time Thomas wrote 'Adlestrop' in 1916 he had joined the Artists' Rifles; the following year, April 1917, he was killed by a shell blast in the first hour of the battle of Arras. Over the space of two traumatic years he had written some 140 poems. In retrospect, the wartime poem breathes the air of nostalgia and loss: for Thomas's life and for the lives of all who died at the Front; for Adlestrop and for the entire landscape of Britain, which would never be seen in the same light again.

> Yes. I remember Adlestrop—
> The name, because one afternoon
> Of heat the express-train drew up there
> Unwontedly. It was late June.
> The steam hissed. Someone cleared his throat.
> No one left and no one came
> On the bare platform. What I saw
> Was Adlestrop—only the name
> And willows, willow-herb, and grass,
> And meadowsweet, and haycocks dry,
> No whit less still and lonely fair
> Than the high cloudlets in the sky.
> And for that minute a blackbird sang
> Close by, and round him, mistier,
> Farther and farther, all the birds
> Of Oxfordshire and Gloucestershire.

The Western Front and the muddy horror of the trenches were no distance away at all; close enough, on a still day, for the sound of the big artillery guns to be heard echoing across the channel. And yet it was indescribably far from the British landscape of the imagination. The Flanders ground was churned up by shellfire, and when it rained the water gathered in

fetid pools, prevented from draining away by the heavy clay soil. Slimy duckboards criss-crossed the mud and trees were reduced to broken stumps. In contrast to this Bruegelian hell, the British landscape began to seem like a pastoral paradise: the sinister dangers that had been posed in the Edwardian era by Pan, ghosts and other lurking supernatural beings evaporated like a bad dream on a summer's morning. In the face of so terrible and tangible a threat, landscape became instead a repository for precious memories. The composer and poet Ivor Gurney, who fought at Passchendaele in 1917, turned to landscape to express the pain of loss in his poem 'To His Love', which begins with a recollection of carefree tramping:

> He's gone, and all our plans
> Are useless indeed.
> We'll walk no more on Cotswold
> Where the sheep feed
> Quietly and take no heed.[50]

Nearly ten years after the end of the First World War the war poet Siegfried Sassoon mined his pre-war diaries for a prose work, *Memoirs of a Fox-Hunting Man* (1928). The Kentish landscapes which form a backdrop to the hunt meets, walks and cricket matches of this lightly fictionalized autobiography appear, before the war and his posting to France, uncomplicatedly to reflect the narrator's state of mind back at him:

> The air was Elysian with early summer and the shadows of steep white clouds were chasing over the orchards and meadows; sunlight sparkled on green hedgerows that had been drenched by early morning showers. As I was carried past it all I was lazily aware through my dreaming and unobservant eyes that this was the sort of world I wanted. For it was my own countryside, and I loved it with an intimate feeling, though all its associations were crude and incoherent.

But when he was able to return to his beloved landscape, the mirror had broken and he found himself subtly alienated. 'I cannot think of it now

without a sense of heartache,' he continues, 'as if it contained something which I have never quite been able to discover.'[51]

Every now and then, a book captures the spirit of an age – and of the volumes of poetry that men took with them to the trenches, among the most popular was A. E. Housman's *A Shropshire Lad* (1896). Its melancholy reflections on the brevity of life and elegiac commemoration of brave, light-footed lads now lying quietly in the Shropshire loam chimed tragically with the times. '"Good-bye, young man, good-bye"' ends one verse, words that might well serve as an epigraph for the book. At the heart of the collection is a repeated insistence on place. The poems weave their stories around specific locations that recur with the power of incantation: the Clee hills; Ludlow; Wenlock Edge; the Wrekin; the Severn; Bredon Hill. But one place is nameless:

Into my heart an air that kills
From yon far country blows:
What are those blue remembered hills,
What spires, what farms are those?
That is the land of lost content,
I see it shining plain,
The happy highways where I went
And cannot come again.[52]

Housman expresses an intense feeling of loss through landscape; this is a poem about a profound and irreversible dislocation and alienation. *Good-bye, young man, good-bye.* To be cast out from one's own setting is to be cast out indeed.

We are Making a New World (Plate 17) is the title of a landscape painted by Paul Nash in 1918, based a drawing made on the spot at Inverness Copse, near Ypres in Flanders. It is a bitter joke. You would not be able to walk, perhaps not even breathe, in this new world: the sludgy green earth is cratered with deep shell holes, filled with greyish water and thrown into sinister humps. Without exception, the trees of the copse have been shattered, their limbs torn off by shelling, and the obscene stumps stand in the dawn light like a nightmare that will not disperse. The sun, appear-

ing over a ridge of brick-red clouds, is, for once, shining on something new: a world so disfigured that it is hard to recognize as a spot on earth. There is no one there, but the landscape tells the most recent episode in its human story all too plainly. *Good-bye, young man, good-bye.*

The air that blew into Nash's heart as an infantry officer in the Artists' Rifles and later as an Official War Artist did not kill him, but it introduced a feeling for the monstrous and threatening in the landscape that was not there before and that afterwards never left him. The billowing, mushroomy trees and welcoming fields that had happily populated his drawings and watercolours before the war – a land of lost content if ever there was one – were no longer adequate in the face of a horror that he told his wife was 'the most frightful nightmare of a country more conceived by Dante or Poe than by nature, unspeakable utterly indescribable'.[53]

After the war Nash and his wife moved to Dymchurch, a small village on the Kent coast. It was a strange, bleak place, with the Romney Marsh stretching to the horizon on three sides and, on the fourth, a wall

Paul Nash, *The Tide, Dymchurch*, 1920.

233

protecting it from flooding. Nash could have chosen to settle some-
where with a gentler landscape, but – as though requiring a period of
quarantine before returning to his beloved rich pasture of hills, copses
and single trees – he was drawn to Dymchurch. The sea and the sea wall
became his obsession: the restless waves breaking against groynes and
breakwaters gripped his imagination. Nash drew this endless combat
between the natural and the manmade in pen, pencil and watercolour
and painted it in oils. But mostly he preferred black and white media,
capturing its choppy geometry using different printmaking techniques:
he could summon the sharpest, thinnest lines and most razor-sharp
edges by engraving a copper plate with a burin; create blocky, choppy
contrasts by cutting into the hard end-grain of boxwood; muster a foggy
indistinctness by printing from a lithographic stone painted with thick,
viscous ink. By 1925, the Dymchurch obsession had run its course. 'I shall
never work there any more,' Nash said, 'a place like that and its effect on
me – one's effect on it. It's a curious record formally and psychologically
when you see the whole set of designs together.'[54] It is indeed: nothing
less than a diary of his gradual emotional recovery, expressed in terms
of landscape. Viewed chronologically, Nash's seas become calmer as the
years pass, and the conflict between waves and wall begins to be resolved.

If you had lived in the village of Shoreham in Kent in the early 1920s,
you might one day have spotted a group of young strangers, dressed up
in Regency-style cloaks and paying an inordinate amount of attention to
certain cottages, rutted lanes, arable fields and mossy-roofed cowsheds.
You would probably have been mystified by their eccentric behaviour. At
that point, Samuel Palmer and his fellow 'Ancients' (the name the group
chose for themselves) were hardly household names – it was not until an
exhibition of their work was held at the Victoria and Albert Museum in
1926 that their early, visionary output became widely known and their
connection with Shoreham cemented. But from the moment that Graham
Sutherland and his friends first saw an etching by Palmer, bought by a
fellow student at Goldsmiths' College of Art from a shop on the Charing
Cross Road in London, they fell under his spell. Dressing up as the
Ancients and looking at the landscape that inspired Palmer was their way

of paying homage to this extraordinary artist, who had responded with such intense emotion to the Kent countryside a hundred years before.[55]

Sutherland was drawn to the hyper-real in Palmer's work, his way of distorting and magnifying natural forms while remaining faithful to their essence. 'It seemed to me wonderful', Sutherland later wrote, 'that a strong emotion, such as Palmer's, could change and transform the appearance of things'.[56] He was specializing in etching at Goldsmiths', and Palmer's densely worked prints, in which evening landscapes glimmered with pinpricks of light, showed him a way forward. He had a contemporary mentor in F. L. Griggs, who since 1900 had been producing topographical illustrations for the popular *Highways and Byways* books and was also a passionate devotee of Palmer, having discovered a book about him in the Mechanics' Institute library as a young man. Griggs was primarily an architectural draughtsman, although his imaginative compositions reveal an intense feeling for the rural scene. He was a master of the etching process, who would return to the same plate over a period of years to squeeze every last drop of emotional intensity from it; he worked on *Sellenger* (1917–22)

Frederick Landseer Maur Griggs, *Sellenger*, 1917–22.

for almost six years, changing the sky and balancing light and dark tones until he was satisfied that he had caught its magic. In 1925 Sutherland and his fellow student Paul Drury went to stay with Griggs in Chipping Campden, where they learned how to derive the most from an etching plate not only by controlling the length of time in which the acid was allowed to bite into the copper, but also by subtly manipulating the inking process and the precise amount of pressure used during printing. Among Sutherland's intensely worked images of this period is his 1925 etching *Cray Fields*, which shows a scene at St Mary Cray in Kent, not far from Palmer's own Valley of Vision – it was probably based on drawings he and Drury made on one of their visits to the area. Like Palmer, Sutherland bathes an agricultural landscape, with foreground plough, hop poles and ripe corn, in a rich atmosphere of reverence. The setting sun and the vast rising star

Graham Sutherland, *Cray Fields*, 1925.

both seem to bless the scene. The early 1920s were, in fact, as the 1820s had been, deeply unhappy ones for farmers and agricultural labourers; global markets for corn collapsed and the government reneged on its promises of financial protection. But one would not guess it from Sutherland's image of timeless peace and harmony. In their desire to represent the spirit of the landscape, he, Drury and Griggs each used etching as a distorting lens, just as Palmer had done. Griggs even created imaginary compositions in which he restored ruins to completeness; one is reminded of M. R. James's ghost story 'A View from a Hill', in which a bewitched pair of binoculars reveal a medieval abbey – long since fallen down – in its heyday.

The etchers were not alone in their reverence for rural Britain. In the interwar years, commercial publishers capitalized on the enthusiasm for the British countryside – at least in its more picturesque forms – that had grown since the First World War. From the 1930s, Batsford brought out a series of books devoted to the UK's rural heritage, with dust wrappers decorated with colourful modernist designs by Brian Cook. One could immerse oneself in *The Villages of England* (1932), *The Landscape of England* (1933), *The Face of Scotland* (1933), *The Old Inns of England* (1934), *The Spirit of Ireland* (1935), *The Parish Churches of England* (1935), *The Beauty of Britain* (1935) and *British Hills and Mountains* (1940). A new generation of motorists explored the countryside with lively and attractive Shell Guides in their glove compartments – a series instituted in 1932 under the general editorial control of John Betjeman. *The Fallow Land* (1932) and *The Poacher* (1935), novels by H. E. Bates steeped in rural life and custom, found their way into many homes, and his nature essays were just as popular. In 1933, writer and wood-engraver Clare Leighton told the story of *The Farmer's Year*, pointedly connecting modern-day farming to the medieval yearly calendar with illustrations and texts that suggest an ancient, symbiotic relationship between man and land (see p. 208). The first book of what became *Lark Rise to Candleford*, Flora Thompson's bestselling trilogy about her country childhood at the end of the nineteenth century, came out in 1939. The countryside, even if it was being explored at speed by road, was infused with the scent of the past – a past that generally began on the far side of the First World War. Immersion in its history seemed to answer an emotional craving for

comfort and continuity after the trauma of war. As Mary Webb put it in the foreword to her rural melodrama *Precious Bane*, first published in 1924,

> To conjure, even for a moment, the wistfulness which is the past is like trying to gather in one's arms the hyacinthine colour of the distance. But if it is once achieved, what sweetness! – like the gentle, fugitive fragrance of spring flowers, dried with bergamot and bay.

There were those, however, who had not buried their noses in the dusty pot-pourri of the olden days. These others were concerned with modernity, speed and new ways of looking at the world. Flora Poste, the heroine of *Cold Comfort Farm* (1932), Stella Gibbons's brilliant parody of books by D. H. Lawrence, Mary Webb and Sheila Kaye-Smith, descended on her rustic and backward relations, the Starkadders, with an air of brisk determination and a copy of a 'guide for civilized persons' called *The Higher Common Sense*.[57] Not for nothing does she leave at the end of the novel in an aeroplane.

HURRAH FOR MOTORS! HURRAH FOR SPEED!

But wait. Before we leave the ground we might reflect that modernity and speed were things the Victorians knew all about. Long before aeroplanes gave us a new perspective on the landscape, the railways had made an indelible mark both on the country itself, and on how people saw it.

John Ruskin, usually so expansive on the subject of his hero J. M. W. Turner, could not bring himself to write a single word about *Rain, Steam, and Speed – the Great Western Railway* (Plate 18) when it was exhibited at the Royal Academy in 1844. He only broke his silence when someone asked him one day why he supposed Turner had painted a steam engine. 'To show what he could do even with an ugly subject', he replied sourly.[58] Others were more inclined to appreciate Turner's audacious novelty. 'The world has never seen anything like this picture', marvelled William Makepeace Thackeray. 'There comes a train down upon you, really moving at the rate of fifty miles an hour, and which the reader had best make

haste to see, lest it dash out of the picture and be away to Charing Cross through the wall opposite.'[59] Boats and ships were familiar subjects, but this was the first time a train had shot across a canvas at the Royal Academy – even though they were increasingly frequent sights cutting through the actual landscape. What Ruskin failed to see was how ideal a subject the railway was for Turner. He had long been fascinated with marine themes, and with the drama that unfolds when great ships are pitted against the forces of nature – even if the story that he had made sailors tie him to the mast of a ship in a storm in preparation for painting *Snowstorm: Steam-Boat off a Harbour's Mouth* (1842) was probably *just* a story. Train travel introduced another exciting clash between machines and elemental forces – a phenomenon he had been studying for decades. *Rain, Steam and Speed* gave rise to a remarkably similar anecdote as soon as it was exhibited at the Royal Academy: in preparing to paint it, Turner had apparently stuck his head out of a railway carriage window for some nine minutes in order to experience a storm.[60] It is probably equally untrue, although both stories tell us a lot about what people wanted – still want – to believe about Turner's desire to experience the wild elements, and his ability to translate his sensations into a swirling vortex of oil paint. Turner's railway painting gives us the vicarious sensation of speed, of the velocity of the oncoming train and its dark path through the landscape, the hare streaming along the tracks at full stretch, forever just ahead. He gives us an exhilarating bird's-eye viewpoint: our imaginary theatre seats are in mid-air, close enough to be buffeted by the displaced air as the train whooshes past.

The world had, indeed, never seen anything like it. Despite Ruskin's fogeyish attitude to train travel – he thought it was like 'being "sent" to a place, and very little different from becoming a parcel' – it was transforming how people saw the landscape.[61] Cheap tickets were opening places, especially coastal resorts, up to visits from people from a wide social spectrum. A paean to paddling, flirting and reading the newspapers, William Powell Frith's *Ramsgate Sands* (*Life at the Seaside*) (1851–54) records the Kent resort that became newly fashionable in the 1840s, when it was made accessible by train. His painted crowd was so popular when it was exhibited at the Royal Academy that a guard rail had to be installed to

protect it from the real crowd, who pressed so close that they threatened to damage their counterparts. In Frith's painting the Ramsgate sands themselves are mostly hidden beneath skirts, shawls and parasols – it must be among the most densely populated landscapes in British art. His later painting *The Railway Station* (1862), takes a railway terminus itself, Paddington, as its subject. Frith's paintings spawned a host of imitators – pictures focusing on the crowded interiors of rail carriages and omnibuses, as holidaymakers set off on excursions out of the city.

But what about the view *from* the train; the spectacle of a landscape passed through at speed? The Victorian Symbolist painter George Frederic Watts was among the first to realize that this could be the subject of a picture. In 1899, reflecting on his experience of a railway journey probably not far from his home at Compton in Surrey, he painted *Seen from the Train*.[62] Trees on a railway embankment, just beginning to put on their autumn colours, whizz past, slightly blurred. The view is almost abstract, colours and shapes glimpsed before the eye can quite focus. What Watts and the rest of us see from the train is not a beautiful landscape that one might seek out, or a local one that one has walked and come to know intimately, but views that no one has chosen on aesthetic grounds: a random, endlessly self-renewing spool of anonymous cuttings, banks, farmland, marshes, sewage farms, back gardens and the buddleiaed outskirts of towns. Train travel has made us all into passive spectators of what W. G. Sebald described as an 'onward roll...past the back gardens, allotments, rubbish dumps and factory yards'.[63] On an unfamiliar journey we can be delighted as a spectacular view suddenly opens up – Lindisfarne gloriously appearing through the windows of the London to Edinburgh train – while on an over-familiar daily commute particular landscapes become the backdrop to our lives, as they roll predictably past the grubby windows of the train.

Thomas Baldwin had achieved immense height in 1785, and had rhapsodized over the strange beauty of the landscape he saw over the edge of his hot air balloon basket. But it was not until the early twentieth century that speed was added to the equation. On Sunday 7 June 1914, a short but startling article appeared in the *Observer* alongside adverts for Cockle's

13 William Henry Hunt, *Apples, Grapes and a Cob-Nut, c.* 1850

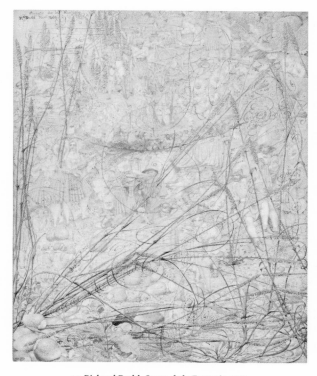

14 Richard Dadd, *Songe de la Fantasie,* 1864

15 William Dyce, *Pegwell Bay, Kent –
A Recollection of October 5th 1858*, c. 1859–60

16 Benjamin Williams Leader, *February Fill Dyke*, 1881

17 Paul Nash, *We are Making a New World*, 1918

18 J. M. W. Turner, *Rain, Steam and Speed –
the Great Western Railway*, 1844

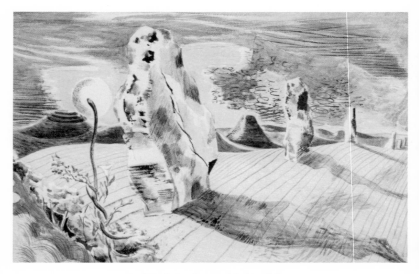

19 Paul Nash, *Landscape of the Megaliths*, 1937

20 Eric Ravilious, *The Vale of the White Horse*, c. 1939

21 Graham Sutherland, *Green Lane*, 1945

22 Ivon Hitchens, *Autumn Painting*, 1945

23 Derek Jarman, stills from *A Journey to Avebury*, 1971

24 John Piper, 'Approach to Gordale Scar',
illustration to *English Scottish & Welsh Landscape*, 1944

25 Clare Woods, *Daddy Witch*, 2008

26 Joanna Kirk, *The Battle of Nant y Coed*, 2013

27 Roger Coulam, *Red Lake*, 2016

Antibilious Pills and Poulton & Noels ox tongues. Calling itself a 'Futurist Manifesto' and signed by the Italian poet and impresario Filippo Marinetti and the English avant-garde artist C. R. W. Nevinson, it railed against the 'worship of tradition' in English art; the love of the 'pretty-pretty, the commonplace, the soft, sweet, and mediocre, the sickly revivals of mediævalism, the Garden Cities with their curfews and artificial battlements, the Maypole Morris dances, Æstheticism, Oscar Wilde, the Pre-Raphaelites' and much else besides. 'Forward! HURRAH for motors! HURRAH for speed!', the manifesto exclaimed, before proposing a new kind of English art that was 'strong, virile and anti-sentimental' and recommending that 'English artists strengthen their Art by a recuperative optimism, a fearless desire of adventure, a heroic instinct of discovery, a worship of strength and a physical and moral courage'.[64] Nevinson himself created fractured images celebrating dynamic, fast-paced movement: London underground trains, traffic on the Strand, the arrival of a ship at a port. Men and machines mingled until they were hard to distinguish in his paintings.

But by 1917, when Nevinson became an Official War Artist, he had gone into retreat from his radical stance. Life, in the shape of a fully mechanized war, was imitating art too closely.[65] Among the images created for the British Government by this recovering Futurist was a set of six lithographs on the subject of flight, entitled 'Britain's Efforts and Ideals'. Two of these, *Banking at 4000 Feet* and *In the Air*, reveal an almost tender feeling for the tree-lined fields and river below. Even the other aircraft appear to be drifting unhurriedly. There is no overt drama; in fact Nevinson seems to have taken pains to present the land below as a tidy, well-managed place. The images of futuristic, mechanized combat that the government's head of propaganda had hoped for did not appear, and he was disappointed. Paradoxically, it was Nevinson's experience of modern aviation, strapped into the seat behind the pilot, that caused him to become captivated by the pastoral landscape that opened up so spectacularly below.

It was not until 1960 that the experience of flight would be fully realized in visual art. The previous autumn, the Cornish landscape painter Peter Lanyon had begun to learn to fly a glider, and he transformed his airborne encounters with wind, weather and thermals, and his sight of

C. R. W. Nevinson, *In the Air*, 1917.

the land and sea from new and exciting angles as the aircraft banked and soared, into exuberant brushstrokes. Although his pictures appear abstract at first sight, Lanyon's thick, swooping strokes of colour are equivalent to what he saw and felt. By giving him the freedom to spiral,

climb and sink through this airy dimension above the land, gliding gave him a totally new perspective on his environment.

Back in the interwar period, the idea of flight had worked its magic even on earthbound artists. When William Nicholson – immaculately dressed in his customary white trousers and high collar – painted the Sussex downs near his home in Rottingdean or, later, the Wiltshire downs, his folding chair was no doubt firmly rooted to the ground. Perhaps he was even settled comfortably in his studio, working from sketches. Yet paintings like *The Downs with Distant Windmill, Rottingdean* (1910) or the near-abstract *Snow in the Horseshoe* (1927) frame the view from such an elevated vantage point that it is hard not to imagine that Nicholson was hovering in the air like a dandified skylark as he conjured up the muscular contours of the downland and its lingering snow with such assured sweeps of oil paint.[66] He was not alone; although as an asthmatic Paul Nash was not able to go up in an aeroplane, he too saw himself as defying

William Nicholson, *Snow in the Horseshoe*, 1927.

the laws of gravity as soon as he abandoned conventional perspective: 'Once the traditional picture plan was abandoned in favour of flying in space...I was airborne', he explained.[67] In the late eighteenth century the artist's viewpoint had typically been low down, emphasizing the towering height of the mountains; now, to suit a twentieth-century perspective, it had achieved lift-off.

Another new landscape opened up at this time – and was to become increasingly ubiquitous as the decades went by. It was illuminated by car headlights, divided by a road and seen through the frame of a windscreen. Many artists filtered these prosaic matters out, and continued to paint their surroundings as though nothing had changed. Gertrude Hermes, a master of wood-engraving – a medium usually deployed to evoke a timeless, bucolic world – was among the first to depict the landscape as it was so often seen. In her print of 1929, *Through the Windscreen*, the car's headlights brilliantly light up foliage and telegraph poles, and just as suddenly allow others to recede into darkness. Half-lit trees rustle their leaves as though caught in some furtive act. A bend in the road is

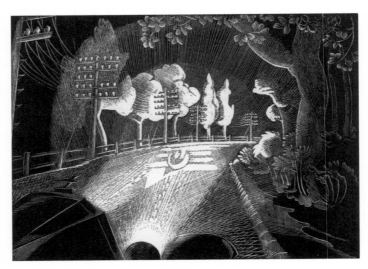

Gertrude Hermes, *Through the Windscreen*, 1929.

coming; a new landscape is about to open up ahead. As viewpoints go, James Thomson would not have thought much of it. But it was the new reality, and it was here to stay.

Looking out of a train window is a passive experience; one is free to contemplate, or indeed ignore, the unscrolling of the outside world. In the front seat of a speeding car one cannot always enjoy such contemplative, detached observations. Here is Wyndham Lewis in his 1937 novel *The Revenge for Love* describing Margot's experience of being driven, at speed, by Victor:

> The car swept forward over the road, perversely ridged and gouged, and half the time they appeared to be shooting through the air, rather than running along a plane which should have been there but wasn't....
>
> Meanwhile trees, rocks, and telegraph poles stood up dizzily before her and crashed down behind. They were held up stiffly in front of her astonished eyes, then snatched savagely out of the picture. Like a card-world, clacked cinematographically through its static permutations by the ill-bred fingers of a powerful conjurer, everything stood on end and then fell flat. He showed you a tree – a cardboard tree. Fix your eye upon this! he said. Then with a crash it vanished. Similarly with a segment of cliff. Similarly with a telegraph pole.
>
> Her head ached with the crash of images. Every time a telegraph pole fell down she felt the shock of its collapse in the picture-house of the senses. This rushing cosmos filled her with a bleak dismay. She had not foreseen their mad charge through this forest of objects; and her senses quailed.[68]

And yet for all the alarming and brashly modern ways that cars were making the landscape behave, they were, paradoxically, beginning to take people to its most ancient sites. The megaliths, stone circles, barrows and hill figures that could be reached by road would offer an antidote to the frenetic cinema of speed.

Keith Arnatt, *Self-Burial (Television Interference Project)*, 1969.

VIII

PRESENCE

I cannot but admit that it possesses an element of disquiet
Graham Sutherland, letter to Colin Anderson

MEGALITHS AND MONSTERS

The landscape that Edith Olivier saw through her car windscreen on a darkening October afternoon in 1916 was dreary with rain. A writer in peacetime, during the First World War Olivier had been appointed superintendent of the Wiltshire Women's Land Army, and she was driving home after another day of farm visits. It was not bad as war work went, though prosaic enough. But near Avebury, something happened that fixed that day in her mind for the rest of her life. She left the main road and, as though bursting through an invisible door, entered the past – although she did not find that out for some years. She recalled that she drove along a great avenue, past 'a succession of huge grey megaliths which stood on either hand, looming like vast immovable shadows within a curtain of softly falling rain', and, feeling overwhelmed with a sense that she 'was nearing an ancient and very wonderful place', reached Avebury's great prehistoric stone circles. At the surrounding earthwork she got out of her car and climbed up the bank where she watched a village fair taking place among the megaliths, her view of it 'partly obscured by the failing light and the falling rain, but...fitfully lit by flares and torches from booths and shows'.[1] She gazed for a short while, watching primitive swing-boats, a coconut shy and people wandering about among the stones, until the rain began to drip down the back of her collar. Then she returned to her car, and drove back into the autumn of 1916. Much later, Olivier made

two disconcerting discoveries: one was that the fair had not taken place since 1850; the other that the avenue of monoliths had been destroyed before 1800. Whether a genuinely supernatural experience or some kind of dream or vision, her belief in it was telling. At ancient places like Avebury, it felt as though the past was simmering away just under the surface, liable at any minute to erupt into the present.

Thomas Hardy was aware of this suppressed energy too – when he describes the Iron Age hill fort of Maiden Castle near Dorchester, his sense of it shadows his rational words like ink showing through a flimsy page. 'The profile of the whole stupendous ruin' is, he writes,

> varied with protuberances, which from hereabouts have the animal aspect of warts, wens, knuckles, and hips. It may, indeed, be likened to an enormous many-limbed organism of an antediluvian time, partaking of the cephalopod in shape – lying lifeless and covered with a thin green cloth, which hides its substance, while revealing its general contour. This dull green mantle of herbage stretches down towards the levels, where the ploughs have essayed for centuries to creep up nearer and yet nearer to the base of the castle, but have always stopped short before reaching it.[2]

Although Hardy seems at pains to suggest that Maiden Castle is as inert as a fossil or a skeleton, another possibility lurks around his words: what would happen if a plough did not stop short? Would it nudge this bumpy animal shape, all knuckles, hips and legs, hunched untidily under its thin grassy eiderdown, into some kind of awful life?

Standing stones and circles, hill figures and ancient earthworks: they had been of some interest to the Romantics – Constable and Turner had both painted Stonehenge under dramatic skies – but, on the whole, the Victorians had averted their collective gaze with a baffled shrug.[3] It was in the early years of the twentieth century that these ancient, manmade landscapes began to exert an attraction every bit as powerful as mountains had in the eighteenth century. Professional archaeology had arrived towards the beginning of the twentieth century and serious, if not always well-judged, excavations began in earnest.[4] Concerted efforts were made

to engage the public's interest: digs at places like Maiden Castle were often open to all, and the eminent archaeologist O. G. S. Crawford regularly wrote on prehistory in the pages of the *Observer*. 1914 saw the publication of R. Hippisley Cox's *The Green Roads of England*, a book that argued for the importance of ancient tracks connecting forts and stone circles, and suggested a higher level of communication, trade and civilization than had previously been thought. It captured people's imaginations: by 1934 it was in its fourth edition, with illustrations and foldout maps. In 1925 Alfred Watkins, an antiquarian and amateur archaeologist, went a step further with his classic book *The Old Straight Track*, which set out his theory of a network of alignments – ley lines, as he called them – connecting monoliths, camps, forts, hilltops, ancient churches and other prominent or elevated sites. Although he was making the point that these were principally routes created by traders carrying necessities such as salt and flint from one region to another, he admitted an element of mysticism into his theories.[5] Watkins's book would have a stranger afterlife than he could have imagined, inspiring such classic countercultural works as John Michell's *The View Over Atlantis* (1969). This search for the ancient stories ingrained in the land resulted in two divergent visions – one based on painstaking research and evidence; the other on vision and intuition. Both profoundly affected how artists saw the landscape.

John Piper and his wife Myfanwy Evans knew and admired Crawford; driving through Wessex with him one February day in 1937, they noticed how alive he was to traces of the past in the land. Myfanwy noted in her diary that 'OGS got everything he possibly could out of every camp, barrow, track celt field church ditch and spring on the way'.[6] His vision of the landscape as 'a palimpsest, a document that has been written on and erased over and over again' sharpened the eye and piqued the imagination, with its evocation of the countless human stories absorbed by the land, the only traces remaining where the earth had been disturbed to make a ditch or lay foundations.[7] Piper became fascinated by the aerial photography used by archaeologists like Crawford, which showed the 'shadow sites' that appeared when the sun was low in the sky and cast its raking light over tell-tale bumps and ridges; the contours of ancient fields were revealed as if by magic. He thought the photographs made large earthworks look

delicate and subtle, more integrated into their surroundings compared to earlier drawings and plans, and he made connections between these functional records and art, noticing similarities between the seemingly abstract patterns in aerial photographs and contemporary paintings, and their common lack of a horizon line. He put all this in a remarkable article for the avant-garde magazine *Axis*, 'Prehistory from the Air', in which he juxtaposed an aerial photograph of Silbury Hill with a drawing of 1723 by the antiquary William Stukeley.[8] The latter, he observed, was as much about Stukeley's experience of laboriously clambering up the steep hill as what it actually looked like. It was, in fact, every bit as subjective as a painting of a wine glass by Picasso.

Despite his fascination with the objective facts revealed by aerial photography, however, Piper was made uneasy by the combatively dry academic stance adopted by some archaeologists. Writing about Stonehenge, he remarked that if one dared to acknowledge an atmosphere of worship, or hazard a guess about the site's origin, one was likely to be accused of being 'drunk and disorderly. The archaeologists have had a great deal to put up with at Stonehenge', he continued wryly, 'and this is their reply'.[9] Paul Nash was less magnanimous. Visiting Stonehenge in 1927 he proposed that anyone 'airing archiological [*sic*] small talk should be fined five shillings and hustled into the highway with the utmost ignominy conceivable'.[10] In 1933 Nash got to Avebury just in time, before the archaeologists came to tidy things up. The stones, he recalled,

> were then in their wild state, so to speak. Some were half covered by the grass, others stood up in cornfields [or] were entangled and overgrown in the copses, some were buried under the turf. But they were always wonderful and disquieting, and, as I saw them then, I shall always remember them. Very soon afterwards the big work of reinstating the Circles and Avenues began, so that to a great extent the primal magic of the stones' appearance was lost.[11]

Avebury would haunt Nash's imagination. As though attempting to reinvest the stones with 'primal magic', he returned again and again to the subject with the same obsession he had brought to Dymchurch in

Silbury Hill, Avebury, Wiltshire. (Top) After Wm. Stukeley, 1723. (Bottom) Air photo (Crown copyright reserved). Opposite : Painting by JOAN MIRO

Illustrations to John Piper's article 'Prehistory from the Air', *Axis*, 1937.

the wake of the First World War. In 1934 he painted *Druid Landscape*, a single Avebury stone filling the canvas and glowing with rich colours, its title a deliberate provocation to archaeologists busy pouring cold water over the idea that such circles were Druidical temples. In the same year he made the semi-abstract *Landscape of the Megaliths*, in which we look down on stony forms as though hovering above them in the air; we watch as they bulge and dissolve, while a dream version

of Silbury Hill has duplicated itself in the background. A watercolour of the same name (1937; Plate 19), with its snake's head silhouetted against a huge setting sun, ushers us into an ancient, mystical ritual. As in Edith Olivier's vision, Nash has reinstated Avebury's avenue of standing stones; they march towards the horizon, inviting us to follow their route.[12] As Myfanwy Evans observed, Nash 'has no interest in past as *past*, but the accumulated intenseness of the past as *present* is his special concern and joy'.[13]

Like Nash, Eric Ravilious loved the presence of the manmade in the landscape. The clean lines of chalk hill figures like the Long Man of Wilmington and the Uffington White Horse (Plate 20) suited the deft edge of his brush, as did the short-turfed Sussex and Oxfordshire downs. These were already enchanted sites, but Ravilious casts his own magical light over them and asks us to look at them afresh. Sometimes he carefully framed his subject – like the placid Westbury steed glimpsed through the window of an empty third-class train carriage, for which he bought a return ticket and travelled backwards and forwards until he had got it down on paper – but his Uffington horse, a constellation fallen to earth, forever caught mid-gallop at the very top of its hill, is almost incidental to his picture. Ravilious is just as keen to rhyme the rain with the grass stalks, and to express the strangeness of the downs themselves, the swelling rises and smooth hollows and the sense of muscular power bulging beneath. Focus on the chalk figure if you want, he seems to say, but look: the downs themselves, under this rainy, brightening sky, are every bit as ancient and as full of mystery.

Prehistoric monuments, the repositories of ancient human history, were not the only objects in the landscape with personality. It was, in fact, Nash's preoccupation with megaliths that made him aware of its other enigmatic inhabitants. He called these things 'object personages'. 'I gave this designation', he explained, 'to the strange phenomena (of the Vegetable and Mineral Kingdoms) which seems to possess a character beyond their nature, something which gives them a distinct *personality* of a human or animal tendency'.[14] He went out hunting for these 'personages' with a Surrealist's eye for oddness, whether stones, bones

Paul Nash, *Monster Field*, 1938.

or fallen trees. Sometimes he would invent what he called 'equivalents', populating a landscape with forms like children's building blocks, or he would contrive a meeting between a tree stump and a vast tennis ball. But photography made him focus on nature's own contributions to Surrealism. In 1931, having been given a Kodak camera, Nash began to stalk the *genii loci* of the landscape, waiting until the light was just right to capture these craggy personages on film. Among them were fallen trees that lurked in the fields like prehistoric monsters, scaly and wrecked but retaining a distinct presence, as though they might ponderously rear up on their splintering old limbs. If you spotted one on a walk you might take the long way round, just in case.

Once Nash had begun to find monsters in fields it was suddenly apparent that they were everywhere. The sinister dimension of the *fin-de-siècle* landscape, which had faded like distant pan-pipes with the First World War, rushed back in the run-up to the Second, nurtured by a climate of disquiet. It could not be dispelled by aeroplanes or automobiles or any of the other trappings of modernity. 'The spirit of place is a strange thing', D. H. Lawrence had mused pessimistically in 1921:

Our mechanical age tries to override it. But it does not succeed. In the end, the strange, sinister spirit of place, so diverse and adverse in differing places, will smash our mechanical oneness into smithereens...[15]

It was as though something in nature itself had gone bad, like a plant deprived of light and grown distorted and grotesque. Samuel Palmer's glowing landscape idylls had been held up as a talisman against the horrors of one world war; they could not stand up to another.

If you were to put reproductions of all Graham Sutherland's etchings and paintings in a flick-book and riffle through the pages, you would see, as in a horror film, the moment a sinister presence came to haunt the cosily idyllic world of woods and villages he had catalogued in etching after etching. It first appears, ironically, in a print with the gentle title *Pastoral*. At first sight it fits with its contemporaries: there are leafy trees, a garden wall and early evening sunshine casting shadows that twinkle with pinpricks of light. But look again: why is that dead, hollow tree on the right leaning forward with such intent, as though it is on the move, shuffling closer until it threatens to block out the light? What are those pale, bare branches on the left reaching for, waving like supple tentacles?

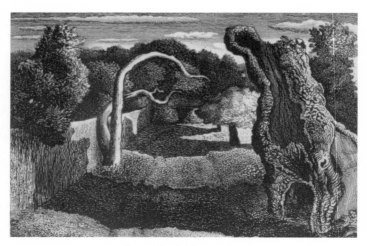

Graham Sutherland, *Pastoral*, 1930.

254

Both seem to have crept in from somewhere else; but like Nash's personages, once they have established a presence in the landscape they are there to stay.

In 1937 Sutherland was asked to design a poster for the petroleum company Shell-Mex. Their publicity manager, Jack Beddington, had been commissioning artists to produce images of British landmarks to be pasted to the sides of petrol tankers since 1931: Frank Dobson's Cerne Abbas Giant had been trundling along the roads for some years, brandishing his club at fellow road users (though with a strategically placed cloud shadow), while Edward McKnight Kauffer invited motorists to admire Stonehenge by the light of car headlamps. The Shell poster campaign gave artists huge scope for invention and playfulness – but Sutherland's 1937 contribution introduced a new note of disquiet. He chose Brimham Rocks in North Yorkshire, great boulders of Millstone Grit that had been sculpted into fantastic shapes by millennia of rough weather and among the most extraordinary of British landscapes. Idol Rock, a vast bulging boulder balancing on a small tapered foot like a Beryl Cook lady in stiletto heels, stands at the centre of his composition. 'To visit Britain's Landmarks', the lettering reads, 'You can be Sure of Shell' – but few would care to

Graham Sutherland, *Brimham Rock, Yorkshire*, 1937.

visit the scene Sutherland depicts. A lunar landscape appears in shades of ochre and umber, dotted here and there with featureless blocks of stone. Dominating the scene under fast-moving clouds, Idol Rock reflects distorted versions of the colours around it, making dour greys of the sky and a sinister blood-red of the ground. Rotten and unstable, threatening and grotesque, this fungoid rock – an 'object personage' from a nightmare – looks ready to implode or topple over. As a landscape, it was a far cry from the Kentish valleys of former years.

In 1934, the thirty-year-old Sutherland had had an epiphany. A friend had persuaded him to visit Pembrokeshire, and it was here, among the rocky paths and green lanes, the headlands and bays, the cairns and cromlechs, that this printmaker, teacher and designer became a landscape painter. 'I wish I could give you some idea of the exultant strangeness of this place', he wrote to his patron Colin Anderson,

> for strange it certainly is, many people whom I know hate it, and I cannot but admit that it possesses an element of disquiet. The left bank as we see it is all dark – an impenetrable damp green gloom of woods which run down to the edge of low blackish moss-covered cliffs – it is all dark, save where the mossy lanes (two each side) which dive down to the opening, admit the sun, hinged, as it were, to the top of the trees, from where its rays, precipitating new colours, turn the red cliffs of the right-hand bank to tones of fire…
>
> The whole setting is one of exuberance – of darkness and light – of decay and life. Rarely have I been so conscious of the contrasting of these elements in so small a compass.[16]

If Sutherland had previously seen the landscape through a Palmerish filter, here in Wales he began to know it viscerally, as though he were a part of it and it him. He walked the lanes until, as he said, he was 'soaked' in it. When particular natural forms caught his eye he would scribble drawings in a sketchbook or on the back of an envelope, and only later allow his sensations to filter through into paintings. The Welsh landscape flooded his mind and his emotions too much to hope to paint a scene out of doors; he needed to let it settle in his imagination. When he did take

up his brushes he painted the raw, bursting energy of growth that gave Dylan Thomas the title of his 1933 poem 'The Force that Through the Green Fuse Drives the Flower': 'tree-forms' blindly pushing their snouts out of the deep green shade, a tough old gorse crooking its twiggy fingers. When Sutherland paints a green lane (Plate 21), it is ambiguous: both threatening and inviting. Its black shadows warn us off; its glowing interior invites us in. If we follow it we, too, will be immersed and changed – but into what?

Coming late to landscape painting allowed Sutherland to negotiate a new, more equal relationship with the natural world. He plunged right in, sought out the monsters and treated with them.

FIGURES IN A LANDSCAPE

It was the morning of 22 September 1941, and the Royal Librarian, Owen Morshead, was showing John Piper around Windsor Castle. Piper would no doubt have been entranced by the paintings they passed by: Holbein, Van Dyck and Rubens; the great sequence of portraits by Sir Thomas Lawrence in the Waterloo Chamber. But he was not there to look at works of art. The purpose of his visit was to study the unfolding grey form of the castle itself, its wards, gateways and towers, its massive sprawl over the mound high above the town. Morshead would have taken Piper to the north-facing state apartments, with their views over the playing fields towards Eton College and distant Slough; to the rooms on the other side that looked down the Long Walk into the Home Park; and up the great flight of stone steps that led to the top of the tallest part of the Castle, the Round Tower, from the roof of which they would have seen panoramic views of the countryside all around. Queen Elizabeth, consort of George VI, wished to commission a series of watercolours of the Castle and Park, and Kenneth Clark, then Surveyor of the King's Pictures, had proposed Piper. He was surveying the scene for viewpoints.

What Queen Elizabeth had in mind was an update of Paul Sandby's many scenes of Windsor, watercolours under Morshead's care in the Royal Library, which Piper had been 'instructed to look at earnestly before starting'.[17] But Sandby's sunny, populous views were out of step with the

times. The Castle was an obvious target for aerial attack – it had in fact been targeted by the German air force's X-beam on the night Coventry was bombed on 14 November 1941 – and over the course of twenty-six watercolours of the building and its surrounding landscape and parkland, Piper painted this threat from above. Against his oppressive, lowering clouds, the buildings are illuminated with a silvery storm light. He had already painted Coventry Cathedral the morning after the bombardment, when the fires were still burning. His Windsor Castle – which he climbed all over, preferring to scale precipitous external ladders to reach the tops of towers than to stay indoors and look through windows – has the beleaguered air of a deserted fortress, a ruin in the making.[18]

The same mood pervades the lithographs Piper made for *English Scottish & Welsh Landscape Verse* (1944), an anthology chosen during wartime by John Betjeman and the Irish poet Geoffrey Taylor. Among the twelve images – intended to be independent of the poems, rather than illustrations – are the spectacular waterfalls of Pistyll Cain in North Wales and Weathercote Cave in Yorkshire, steep Grongar Hill in Carmarthenshire and the great ravine of Gordale Scar (Plate 24), all printed in stark black, yellow and white.[19] They are landscapes of unease, described with a shaky hand by an artist hurriedly making notes before pocketing his sketchbook and running from the oncoming apocalypse. There are no human figures – they have already fled in search of shelter. Piper is the only remaining witness. He draws these landscapes, like Windsor Castle, as though they are teetering on the edge of obliteration.

But landscape, at a time of war, could also offer refuge. Among the lithographs completed by the younger artist John Craxton for another wartime anthology, *The Poet's Eye* (1944), sits a man in profile in a mountainous, night-time landscape. His profile is echoed by the moon, and his knees by the peaks; moonlight casts its blue, silvery light on landscape and man alike. There is no doubt that he and his surroundings are on the best of terms. Two years earlier, Craxton had been living in a maisonette in St John's Wood in North London, with Lucian Freud making intense, linear studies of dead animals upstairs – they once had to hide a decomposing specimen in the oven when Kenneth Clark paid them

John Craxton, *Dreamer in Landscape*, 1942.

a visit.[20] It was here that he made a powerful black and white drawing, *Dreamer in Landscape*. In his imagination he transformed the plants on the windowsill and the pollarded trees he could see in the street into a dense jungle.[21] Craxton's Dreamer (modelled by a German refugee who was staying with them) seems to have plunged right into one of Graham Sutherland's landscapes, and been embraced by the tree forms and twisted things that lurked there so ambiguously. Is he dreaming them? Are they dreaming him? United, in wartime, against a common enemy, humans and landscape were experiencing the beginning of a new mutual tenderness – or at least a temporary cessation of hostilities.

Like Craxton, Henry Moore looked at the landscape and saw reflections of the human figure; and he looked at the human figure and heard echoes of the landscape. Was it possible, he wondered, for one to fade into another, so that the transition was imperceptible? If it was, it was a marriage that could only be achieved in sculpture. Drawing and painting involved interpretation, the use of pens, inks, watercolours, oil paints to

describe a scene; by sculpting, one could work with the very material of which landscape was made. In 1938, Moore spent £50 on three blocks of Green Hornton stone, a Jurassic limestone that had been quarried near Banbury in Oxfordshire, and had it taken to the garden of his cottage, Burcroft, in Kent. It was there that he carved one of the first sculptures to realize his human/landscape vision, *Recumbent Figure*.[22]

Working with chisels, hammers and files, Moore and his assistant began to carve, working eight, nine, even ten-hour days, until a figure started to emerge from the stone: a rounded head, powerful shoulders, projecting breasts and knees.[23] At the same time, a landscape was revealed: mountains, hillsides, hollows, caves. The smooth dips and holes resemble those you sometimes see worn into rock: 'Pebbles', wrote Moore, 'show nature's way of working stone'.[24] The Green Hornton stone was not chosen to mimic flesh; in fact it draws attention to its stoniness, putting us in mind of the land: fossils and iron minerals speckle its surface.

Recumbent Figure had been commissioned by a Russian émigré architect, Serge Chermayeff, for Bentley Wood, his modernist home in Sussex. The house was long and low, looking out over the Downs – so, Moore

Henry Moore, *Recumbent Figure*, 1938.

recalled, as there 'seemed no point in opposing all these horizontals', it was to be a reclining figure. 'My figure', he wrote,

> looked out across a great sweep of the Downs and her gaze gathered in the horizon. The sculpture had no specific relationship to the architecture. It had its own identity and did not need to be on Chermayeff's terrace, but it so to speak *enjoyed* being there, and I think it introduced a humanizing element; it became a mediator between modern house and ageless land.[25]

Looking out over the countryside, *Recumbent Figure* stands in as a proxy for us, like a great-coated figure in a painting by Caspar David Friedrich, seen from the back as he scans the distant horizon. But Moore's sculpture is also an image of the landscape itself, the slopes of the Downs, the object of our gaze. This subtle and ambiguous figure seems to propose a new harmony between humanity and the natural world.

'It's truly grand country', wrote Barbara Hepworth in 1940, soon after leaving Hampstead and setting up home in the Cornish fishing port of St Ives with her husband Ben Nicholson, '...very fertile. Unconquerable and strange, and my God, how sculptural.'[26] Perhaps it was inevitable that what she described as the 'remarkable pagan landscape which lies between St. Ives, Penzance and Land's End' would draw her away from the purely abstract sculpture that she had successfully practised in London, and persuade her to begin a dialogue with the Cornish landscape.[27] The question was: how, as a sculptor, to respond to such a sculptural landscape? Among her earliest works inspired by this new environment was *Landscape Sculpture* (1944), which she described in specific terms as 'a transcription of the felt "pull" existing between two hills, in Uny Leleant, near the Cornish coast'.[28] Hepworth carved it from elm in a supple concave form like a musical instrument, threaded with strings that, she wrote, 'were the tension I felt between myself and the sea, the wind or the hills'.[29] Like an Aeolian harp, it looks as though if it were left on a windowsill the landscape would speak through it, playing strange wind- and hill-music on its strings. By combining her understanding of abstract forms with her new, intense sensory experience of a particularly

Barbara Hepworth, *Landscape Sculpture*, 1944.

dramatic stretch of country, Hepworth invented a new way of expressing not just the landscape, but the place of people within it.

In the summer of 1940, enemy bombs fell close enough to Ivon Hitchens's Hampstead home and studio to shake the building and badly damage his studio. It was enough: he and his wife, with an infant son, decided not to risk another bombing raid. They were lucky enough to have somewhere to go. The previous summer they had bought six acres of wooded land in Lavington Common, a secluded corner of Sussex near Petworth, and stationed a vardo, or Romani wagon, on the site: what they had envisaged as a place for holidays became their home for the next forty years.[30] They called it Greenleaves, and set about building a studio and single-storey house that gradually expanded as funds allowed – although the vardo remained to serve as a picturesque guest room.

The move from London to Sussex transformed Hitchens's painting, but not in an obvious way. Greenleaves might have been surrounded by open expanses of Downland, but Hitchens was not, like Nicholson or Nash, an artist of the distant prospect. So he largely ignored it. Instead he focused on the trees and vast rhododendrons in his private wilderness; they filled his field of vision and got in the way of long views, but that suited him down to the ground. He lived as a semi-recluse, rarely visit-

ing London and discouraging most visitors – if you had not been told exactly how to find the entrance to Greenleaves, you would miss it – but his surroundings offered enough inspiration for a lifetime's painting. He immersed himself in the leafy shade, letting the colours, birdsong, dampness and breezes sink slowly through his mind and into his art. A latter-day Cowper, he wanted to express the whole sensory experience of the patch of landscape he had come to know so intimately, not just what it looked like. So he would trundle his painting equipment outside in a wheelbarrow and settle for the day amidst the trees and bushes of his private world, translating sights, sounds and sensations into sweeps and dabs of glowing pigment.

Hitchens loved music, and often listened to records on the gramophone as he painted; it seeped into his work, and pictures like *Autumn Painting* (Plate 22) unfold like symphonies. 'My pictures are painted to be "listened" to', he wrote.[31] After his move to Sussex he also adopted an unusual, panoramic format, a double square that invites the eye to move over the painting from left to right. Like pieces of music or short stories, his pictures are episodic, not offering a single perspective but an unfolding sequence of viewpoints. In this autumnal arabesque, a dramatic early movement of choppy horizontals and verticals is followed by a climactic sunburst, which then fades at the right into lyrical, mellow horizontals. A bird calls once, twice: he records it in two bright green aerial loops that punctuate the final passage.

Hitchens was particular about how his pictures were framed, insisting on deep mouldings that have the effect of funnelling and concentrating the view. Looking at a single painting, one finds oneself as absorbed in its world as he was. His brushstrokes communicate in an idiosyncratic language of his own devising – not quite abstract, nor quite figurative either – yet we find, almost to our surprise, that it is instinctively legible. Hitchens, immersed in his leafy Sussex shade, invites us to stand quietly next to him, listening to the rustling of the beech trees, smelling the damp earth underfoot, alert to the landscape's passing moods.

HAUNTED GROUND

Orford Ness is a spit of shingle just off the coast of Suffolk, beginning at Aldeburgh, stretching south past the village of Orford and petering out at the single line of sea-facing houses known as Shingle Street. It did not always extend so far; once upon a time Orford, with its twelfth-century castle and church, was blessed with a thriving harbour, but little by little the action of longshore drift heaped up shingle between it and the North Sea. Over the years, salt marshes developed on the spit and cattle and sheep were grazed there. But for those who lived nearby, the landscape of Orford Ness never shook off an atmosphere of eeriness. It attracted strange tales – such as the merman-like creature fished out of the sea in the late twelfth century, first identified in 1200 by Ralph of Coggeshall as the Wild Man of Orford.[32] He was taken to the castle, where despite being cruelly tortured it was found that he would not – or could not – speak. He eventually escaped, disporting himself in the sea by the peninsula before swimming away. Half man, half fish, he could almost have been the spirit of the strange, unstable land the sea had deposited. Even the embrace of reason and progress brought by the Enlightenment could not dispel the Ness's mystery: in 1749 the *Gentleman's Magazine* published a letter describing a 'sea monster' with the head and tail of an alligator, five rows of sharp teeth and large, wing-like fins that a fisherman had caught in his net near Orford.[33] The remains of this doubtful being were exhibited to crowds up and down East Anglia.

In the twentieth century, a new, more sinister chapter was opened when Orford Ness was acquired by the Ministry of Defence, which used it throughout both World Wars and the Cold War as a testing ground for experiments with radar, ballistics, aircraft and the atomic bomb. It became a place of secrecy and mystery, inviting yet more speculation. Stories were whispered about wartime operations on the peninsula that had gone terribly wrong and had had to be hushed up, records destroyed. Or about invading Nazi troops that had actually landed at the southern tip, only to be incinerated by a wall of fire. Eventually, in a thunderous finale to the peninsula's military episode, vast quantities of munitions were destroyed there in the 1970s.

When the writer and academic W. G. Sebald was rowed over to Orford Ness in the late summer of 1992 it was a desolate place. He carefully photographed the deserted concrete pagodas used as test laboratories in the development of the atomic bomb: physical reminders of its recent history. The following year, the land would be sold by the Ministry of Defence to the National Trust because of rare plants growing on the shingle. But at that time, almost no one went there. As Sebald walked along an overgrown tarmac track the eerie emptiness of the landscape struck him: 'With each step that I took,' he wrote, 'the emptiness within and the emptiness without grew ever greater and the silence more profound.' He began to feel as though he had slipped out of time – not back into the past like Edith Olivier, but forward: in his mind he became a lone survivor in a post-apocalyptic future. The pagodas had, at first, reminded him of ancient burial mounds,

> But the closer I came to these ruins, the more any notion of a mysterious isle of the dead receded, and the more I imagined myself amidst the remains of our own civilization after its extinction in some future catastrophe…. Where and in what time I truly was that day at Orfordness I cannot say, even now as I write these words.[34]

Sebald described his experience on Orford Ness in his book *The Rings of Saturn* (1995), his account of a reflective journey on foot down the Suffolk coast with digressions on subjects ranging from the peregrinations of Thomas Browne's skull to the decoration of the sailors' reading room at Southwold. As he walked, his experience of the landscape and the thoughts and memories that came to him began to flow into each other. Sebald's melancholy experience of visiting the peninsula and his uncanny sensation of slipping into a different time has since become part of the Ness's strange history, quietly settling to form another layer of significance. More layers have continued to accumulate: in 2005, Louise K. Wilson created the site-specific audio work *A Record of Fear*, and in 2008 Emily Richardson made the film *Cobra Mist*, which explores the relationship between the landscape of Orford Ness and its military history. From April to October 2019, Antony Lyons's 'geo-poetic' exhibition 'Sensitive Chaos',

comprising images, videos and soundscapes, was shown at Orford, while Robert Macfarlane's experimental book *Ness* (2019), with illustrations by Stanley Donwood, makes the place the subject of a modern mystery play.

Like Sebald, the artist and film director Derek Jarman was drawn to the eeriness and ambivalence of edgelands. He made his home, Prospect Cottage, in Dungeness on the Kent coast: a shifting spit of shingle, flat and exposed as far as the eye can see. The garden he created in this inhospitable environment, using hardy coastal plants like sea kale, horned poppy, valerian and santolina, was not fenced in but extended to the horizon; like William Kent, Jarman saw all nature as a potential garden. And like Paul Nash, who had found inspiration in the equally bleak setting of Dymchurch just a few miles up the coast, he was fascinated by ancient landscapes, the flints, stones and sticks he arranged in his garden echoing prehistoric dolmens and henges.

Sebald's journey to Orford Ness took him to a relatively new landscape; Jarman, in his *Journey to Avebury* (1971; Plate 23), visits an ancient one. But just as Sebald felt time shifting and flickering in the deserted and uncanny place he had chosen to visit, Jarman, using grainy Super 8 film, generates a comparable sense of unease as modern technology rubs up against the deep past. In a series of static images he shows us a path; a field; a copse; standing stones. The landscape flickers, pulses and bleeds to an insistent electronic soundtrack, notes rising and falling in a hypnotic rhythm. Although it is high summer and we hear intermittent birdsong, this is no conventional country walk: the camera jumps nervily from one view to the next as though scanning the landscape for danger, expecting it at any moment. A dark copse is framed, then a lone tree; a solitary sheep stares blankly at us; our road stretches uncertainly ahead. Suddenly we are among the stones of Avebury, but too close to get a sense of their relationship to each other; indistinct dark shapes, one after another, confront us, pulsing and bulging with the jumpy film as though alive. Why have we been taken there? Is some dark ritual about to take place? A feeling of unease rises: something is brewing. Lowering clouds turn grey then dirty pink, the colour of a coming storm. The fields bleed from green to rust. The film's oppressive atmosphere traps us like flies in a bottle.

Influenced by Nash at the time he made *A Journey to Avebury* in 1971, Jarman was thinking, as Nash had before him, of how the past can blur into the present – a question raised by the stone circle of Avebury itself. The blots, blurs and scratches so characteristic of Super 8 film suggest, in Jarman's hands, something long covered up and beginning to seep through, buried layers of history clawing their way up to the surface.[35] Jarman's vision of the landscape, which spiked the pastoral with an enigmatic sense of horror, was prophetic. Our sense of the landscape as a repository of human history has grown.

Three years later the film *Penda's Fen*, written by David Rudkin and directed by Alan Clarke, was shown on BBC television as part of its 'Play for Today' series. Like *A Journey to Avebury* it is concerned with the sparks generated when the ancient past rubs up against the present. Stephen, the adolescent son of a vicar, opens up a faultline by refusing to conform to middle-class conservative norms: he discovers his homosexuality, learns that he was adopted as a baby and resists both his school's military-style authority and the bullying of other boys. For him, the landscape – the Malvern Hills around the village of Pinvin in Worcestershire – becomes a place of visions, of angels and demons, where the past can erupt into the present. His love of Edward Elgar's *The Dream of Gerontius* (1900) conjures up the composer's ghost (who reveals to him the secret of the *Enigma Variations*), while the pagan king, Penda, who died in 655, appears to him in the hills and blesses him. 'I am nothing pure!' Stephen cries at the film's climax. 'My race is mixed. My sex is mixed. I am woman and man, light with darkness, nothing pure! I am mud and flame!'

With *Penda's Fen* Rudkin re-thought the pastoral: he made it a place that could field famous ghosts to teach non-conformity and independence of thought. But this was a period in which the countryside came to be associated not only with mystery, but also became, again, a place of disquiet. As Ronald Blythe's 1969 book *Akenfield: Portrait of an English Village* so vividly reveals, the mid-twentieth century was rather similar to the early nineteenth century in that many people, especially the young, left rural villages at that time to find work in towns and cities. What followed was another period in which the countryside, newly defamiliarized, became fertile ground for horror. On the one hand, the 'backwardness' sometimes

assigned to country people began to be reimagined as paganism. Two key films of the time – *Robin Redbreast* (1970), set in a Worcestershire village, and *The Wicker Man* (1973) which takes place in the remote Hebridean island of Summerisle – are about savage atavistic rituals practised in isolated country places, their plots pivoting on human sacrifice. On the other hand was plain old prejudice – the racism and homophobia underlying the 'norm' enforced at the beginning of *Penda's Fen*. In the late 1980s, Ingrid Pollard produced a series of photographs called *Pastoral Interludes*. By placing black people in rural landscapes, the project raises questions about race and British identity, ownership and exclusion. In one image, a woman holding a camera in her lap sits on a drystone wall in front of hills divided into fields by hedges. It could almost be a holiday snap – and yet she seems to be on edge, looking sharply off to one side with an expression that is hard to read. Behind her is a fence, with two rows of barbed wire starkly silhouetted against a cloudy sky. Underneath, as though capturing her inner thoughts, is a label: '…it's as if the Black experience is only lived within an urban environment. I thought I liked the Lake District; where I wandered lonely as a Black face in a sea of white. A visit to the countryside is always accompanied by a feeling of unease; dread….'[36]

Many artists and writers have since delved into such themes of alienation and disquiet – not least the painter Clare Woods. When in 2008 she moved her painting studio from Bethnal Green to a small town in Herefordshire, Woods had her own uncanny experience. Among the postcards she pinned up on her studio noticeboard was Graham Sutherland's *Black Landscape*, painted in Wales in the early years of the war. She had brought it from London, but perhaps the light fell on it differently in the new place; to her surprise there was an amorphous patch of pinky-red at the far left that she had hardly noticed before, like the glow from a great fire. While other parts of the painting were static, enclosed inside black borders, this part appeared to move: Sutherland's apocalyptic, wartime landscape seemed now to be animated by a sinister presence, a spirit of dark places.[37] If it was, it was one that had already taken up residence in Woods's own work. Her large oil painting *Daddy Witch* (2008; Plate 25) exerts a horrible fascination: she takes us down to a dark, dank corner

of a wood and requires us to look into the sky-reflecting pool ringed with jagged foliage and nasty-looking scum, overhung by a dead branch. We want to look away, unwilling to confront what we might spot in the undergrowth – a knife, a dead animal, something unspeakable – but the scale and strange beauty of her painting grasp and hold our attention. This is a place no one normally looks, an unfrequented edgeland left to its own dark devices: a stage set for a horror story.

There is no horizon in Joanna Kirk's pastel landscapes, either; no long vista to enjoy. Her dark visual fairytales take us up close to rocks and trees, seen in so much detail that it is like looking through the lens of a microscope. It feels as though gazing for too long at *The Battle of Nant y Coed* (2013; Plate 26) might leave you bewitched, trapped in a dense tangle of branches with an impossible puzzle to solve before you are freed. There is no respite from the intense blue pigment, no variation in colour to help negotiate this oppressive dreamworld. Standing in front of Kirk's intensely detailed drawings, it is no longer possible to think of landscape as a passive object laid out for our gaze. It bristles back at us with its own inscrutable codes and intentions.

In recent decades, landscapes that hold the past in safekeeping, ready to return it to us whether we like it or not, have haunted our collective imagination. Some landscapes have long memories. Coastlands in particular have a disconcerting habit of returning what the waves once carried away – in some form or another – as though imperfectly recalling a long-ago event. Robert Aickman, a writer of what he himself described as 'strange stories', plays on this to horrific effect in his 1964 story 'Ringing the Changes', which begins with a honeymooning couple, Gerald and Phrynne, taking an evening walk on a beach in a small Suffolk town and listening as more and more bells begin to ring from the surrounding churches. No matter how far they walk out towards the sea, it remains distant, the tide drawn out preternaturally far. What the receding waters expose the couple cannot quite see in the dark, but as they stumble onwards over the flat marshy ground of the newly revealed seabed, Phrynne steps on something, releasing a stench so appalling that they turn in horror and hurry back inland, the cacophonous peals of

every bell in the district resounding in their ears. As they discover later that night, they had caught the sea in the act of giving up its dead. The townspeople had been ringing to wake them.

Echoes of a similarly dark understanding between the sea and the coast pervade Andrew Michael Hurley's 2014 novel *The Loney*. Its eponymous Lancashire setting is a 'wild and useless length of English coastline. A dead mouth of a bay that filled and emptied twice a day'. It is the kind of place that would have given Defoe, Dickens and Wilkie Collins nightmares; a bleak, uncultivable stretch of land with treacherous sands and a horrifyingly fast incoming tide, frequently fatal even to experts:

> the neap tides would reveal the skeletons of those who thought they
> had read the place well enough to escape its insidious currents. There
> were animals, people sometimes, the remains of both once – a drover
> and his sheep cut off and drowned on the old crossing from Cumbria.
> And now, since their death, for a century or more, the Loney had been
> pushing their bones back inland, as if it were proving a point.[38]

The unnerving idea of being cut adrift on a patch of land by an incoming tide had been given a gothic dimension by Susan Hill in her 1983 novella *The Woman in Black*, in which the causeway linking Eel Marsh House to the mainland is not only intermittently flooded and made treacherous by quicksand, but is also haunted. In Hurley's book, however, the sense of active intimidation turns out to be a red herring. Although the landscape of Hurley's novel is a poisonous place of mud and barbed wire, hazed and sodden with perpetual drizzle and smelling of rot and brine, at the heart of it is something worse: a devastating revelation of nature's indifference to human concerns.

Away from the coast the ground may be free from the daily dealings of tides and currents, but not from human agency. We bury what we fear and what we wish to hide, but we cannot guarantee that these things will never resurface; and poets can be as adept as ploughs at the business of unearthing and exposing. As a young poet Seamus Heaney – who resolved to dig with his pen in one of his earliest published poems – was preoccupied with the archaeological excavations reported in *The Bog People*,

a book first published in 1965 by the Danish archaeologist P. V. Glob.[39] It describes ancient corpses mummified by their burial in peat bogs. Found throughout Northern European countries, the UK and Ireland, these bodies – some thousands of years old – bear remarkably similar signs of having been the victims of ritual killing: their throats, for example, have usually been cut, and they wear few garments save for headgear and, often, a noose. Votive offerings were also thrown into the bog: it must have been recognized as earth that would preserve, not destroy. And perhaps – like St Guthlac's demon-infested island in the Fens – the bog was seen as an in-between land, a place not so much natural as supernatural. Heaney's collections *Wintering Out* (1972) and *North* (1975) both include poems about the apparently magical alchemy by which the sacrificed bodies have become hard to distinguish from the landscape: his Grauballe Man has wrists that resemble bog-blackened oak; his girl's head in 'Strange Fruit' hair like the damp fronds of a fern.[40] But these proto-Arcimboldos retain enough humanity to haunt the bog, reminding us, as ghosts are said to do, of their violent deaths and the belief systems that led to their execution or sacrifice. In 'The Tollund Man' Heaney draws contemporary comparisons, recognizing echoes of these ancient victims in particular murders connected with the Troubles which left a similarly gruesome legacy, scattered along miles of train track. Killing embeds its stories of violence and desolation into the landscape as much now as it did in the deep past; it is also a wearyingly familiar story, repeating itself from place to place, bodies of the murdered being unearthed throughout human history. The poem ends with a bleak acknowledgement of affinity.[41]

Other great changes that have reshaped the landscape are distinctly of their time. At the beginning of the Industrial Revolution, Daniel Defoe stood in the Calder Valley in Yorkshire and watched as newly woven textiles were laid out to dry on its slopes.[42] A little over two hundred years later, Ted Hughes, born in Mytholmroyd in the same narrow valley linking Lancashire's cotton towns and Yorkshire's woollen towns, saw the heavy industry that had developed and thrived since Defoe's time gradually collapse. 'Throughout my lifetime, since 1930,' Hughes recalled in 1979, 'I have watched the mills of the region and their attendant chapels die.

Within the last fifteen years the end has come.'[43] He was writing in the preface to *Remains of Elmet*, a sequence of poems about the landscape of the Calder Valley suggested to him by a series of black and white photographs taken by Fay Godwin. The title poem faces Godwin's photograph of the former mill town of Todmorden from Blackshaw Head, a shaft of weak sunlight serving only to throw the town with its tall chimneys and the surrounding moors into deeper shadow. In its five brief verses, 'Remains of Elmet' sets out the area's trajectory from creation to ruin: from the geological forces that formed it and the people who settled, farmed and died there, to the coming of heavy industry that drew more workers in, to its decline and abandonment. Starved of the workers that fed it with their worn-out bodies, the ravenous landscape of Hughes's poem has died. It has nothing to offer but what in his preface he calls the 'spectacular desolation' of its remains. The old spirit of place has faded, a casualty of the changing economic climate; but another, more indifferent to human lives, has taken its place. *Remains of Elmet* has a tension at its heart, as Hughes's poems and Godwin's photographs meditate bleakly on the landscape's history and legends while at the same time celebrating its wild beauty, as nature absorbs the traces of industry back into the ground.

No such regeneration is discernable in Roger Coulam's photographs. A violet pool; orange sands; rust-red rock: he seems to have been inventorying the bizarre terrain of a distant planet (Plate 27). For ten years between 2008 and 2018, he visited Blast Beach on the Durham coast, photographing the mile-long stretch that once supported Dawdon Colliery.[44] The resulting images are like photographs from a crime scene. Dawdon was the largest coalmine in Europe, and until a recent clean-up operation led by the National Trust it was among the most polluted landscapes in the world. Every year two and a half million tonnes of colliery waste were dumped on the beach. Instead of sand there is pyrites; instead of clear water, the acid tint of mining chemicals. It is a landscape about which Coulam feels ambivalent: 'It is a space I know intimately', he has said, 'and one that appals and enthrals in equal measures. It can be a strange, frustrating, empty and desolate place, but the pollution and the final traces of heavy industry are vanishing rapidly as time and tides scour away our violent

marks.'[45] What does not vanish, however, are the plastics and other detritus Coulam finds on the beach, which he takes home and photographs against a black background in rows as neat as a Victorian's butterfly collection: a doll's leg; a crumpled bottle; a tangle of colourful fishing lines. Another kind of pollution, another layer in the landscape's story: these are among the contributions we are making to future generations.

YOU ARE *IN* NATURE

In October 1969 viewers of West German television witnessed a strange and disturbing phenomenon. For nine consecutive days, the programme shown at peak viewing time was interrupted for a few seconds by an enigmatic photograph that appeared unannounced and disappeared just as suddenly, with no explanation; the programme simply resumed as though nothing out of the ordinary had happened.[46] The first photograph to appear on screens showed a casually dressed man standing on a patch of exposed earth surrounded by scrubby ground against a backdrop of hills. It was unremarkable in every way. But in the second, something had subtly changed: although the man continued to look unperturbed, his feet and lower legs had inexplicably sunk into the ground. In the third, he was buried up to his knees; in the fourth, to his thighs; in the fifth, to his waist; and so on until only the top of his head was above ground, then, in the last photograph of the sequence, not even that. The land had, apparently, swallowed him whole. What had been a landscape with a figure was simply a landscape. What was causing this? Was the man being driven in like a nail by unseen forces from above? Or pulled down from below? All the viewers could see, day by day, was photographic evidence of a man slowly but surely sinking into the ground. It was as though the earth were demanding a ransom that nobody knew how to pay.

The artist behind *Self-Burial (Television Interference Project)* (see p. 246) was Keith Arnatt, and the site he chose for his disappearance was Tintern in Monmouthshire. Whether he intended to evoke Wordsworth's famous poem, 'Lines Written a Few Miles Above Tintern Abbey', with its reflections on the profound spiritual connections between man and nature,

and how a landscape can be absorbed to the extent that it becomes part of one's very being, is a moot point. But *Self-Burial*, which manages to be both horrific and funny, could be interpreted as landscape's act of reciprocation. Let's face it – up until that point, things had been a little one-sided.

Elsewhere artists were rethinking their relationship with landscape in terms that, if less drastic, were every bit as far-reaching. In 1967, Richard Long was hitchhiking from his home in Bristol back to London, where he was studying at St Martin's School of Art. In Wiltshire, between lifts, he left the road and found a field. There, he proceeded to walk up and down in a straight line until he had flattened the turf underfoot so that it reflected the light differently from its untrodden margins. The photograph he took, in which the trodden grass looks paler and more silvery, records *A Line Made by Walking*. As an intervention in the landscape it was subtle and evanescent – it would be erased in a matter of days by wind, rain, new growth, the scurrying feet of animals. And yet the line he made that day marked the beginning of a new way of thinking about landscape, both for him and for many land artists to follow. It was no longer to be the passive object of the artist's or writer's gaze; it was about to become an active partner in the creative process.

Walks through landscapes around the world became central to Long's art. He has made patterns in mud and sand by dragging his heel or scraping with his fingers, and paused to create circles and lines of slate or stone. Often he has left no obvious physical trace in the landscape at all, but, instead, has painstakingly recorded his experiences there. One day in 1985 he walked in another straight line, this time on Dartmoor. He headed north, keeping to his chosen route regardless of paths or obstacles. As he walked the wind blew on him from the east; then it blew from the northeast; then from the east again; then from the south-east; then very nearly from the south; then from the east; and again; and again, but a little more from the south; then from the southeast; then from the southeast again; then from the southeast again; then more from the east; then from the northeast; then from the southeast; then from the south-southeast; then from the east; then from the southeast; then from the east; then from the northeast; then from the east; and finally, when he was nearing his

destination, it blew, again, from the northeast. Long recorded these events in *Wind Line* (1985), a sheet of paper printed with arrows indicating small changes in wind direction arranged in a vertical line from the top to the bottom of the page.[47] At first, the data he provides seems obsessive, a catalogue of angsty minutiae of the kind one of Samuel Beckett's characters might voice. Yet its form faithfully echoes the route he took. The precisely vertical wind-line is a wry visual representation of the straight line he walked – albeit one that is silent about the physical difficulties arising from such a radical and downright bloody-minded decision (going for a walk with Long would be almost as bad an idea as going for one with Coleridge) – and the changes in angle from one arrow to the next, if we pay attention to them, invite us to follow the walk episode by episode, imagining the artist being buffeted by the changing breezes as he kept doggedly to his course. In landscape art we unthinkingly privilege the visual, Long seems to say: why not other sensory data, that tells us just as much about what it is like to be in the countryside? It may not be the whole story; but, then, nothing ever is. Like Craxton, like Hitchens, like Arnatt, Long rethinks landscape by immersing himself in it.

Nature itself could play an active part in land art, putting in at least half the effort involved. On a level eminence of a hillside in the Ffestiniog Valley stands *Ash Dome*, a living sculpture begun in 1977 by David Nash. He planted twenty-two ash saplings in a circle thirty feet in diameter, and used hedge-laying skills to make bends and cuts in their trunks every winter, influencing their direction of growth, sending each leaning solicitously towards its right-hand neighbour and encouraging their topmost branches to meet overhead.[48] This magic circle of trees, all knobbly knees and elbows, bends willingly into its choreographed dance. They might have been expected to continue for another hundred years, but the trees have contracted ash dieback and Nash has decided not to intervene by attempting treatment. 'It's a work depending on natural forces,' he has said, 'so ash dieback is a natural force. I have to accept that as part of the original concept.'[49]

If Nash is a farmer, maintaining a carefully calibrated tension between human will and natural growth, then Andy Goldsworthy is a hunter-gatherer. He has an eye for the beauty and oddity of ephemeral things:

he has suspended a snowball in the branches of winter trees; modelled horse-chestnut leaves into a spiralling horn; floated a vivid circle of dandelion heads in a sea of bluebells.[50] A little nudge here, a playful intervention there, and things regarded as mundane and inconsequential become astonishing. Nature herself is teased into a playful mood. Goldsworthy's light touch is matched by his methods: if he wants to link horse-chestnut twigs together, he uses thorns; if he wishes to peg bracken leaves to the ground to make a serpentine line, he uses their sturdy stalks. He rethinks what landscape art can be, arranging brown, red and yellow leaves together in glowing bands around the rim of a hole, binding birch twigs in vortical circles, sculpting snow into serpentine arches. He captures his intervention in a photograph, and then leaves it to blow away, collapse, melt: the British weather will decide how long it lasts. By drawing, painting and sculpting with earth, leaves, twigs, flowers, slates, moss, clay, sticks, stones and boulders, letting their own forms and colours dictate the composition, Goldsworthy alters the balance of power between artist and landscape – in the latter's favour.

More conventional materials do not necessarily imply conventional methods; using the traditional media of inks or oil paints, other artists have immersed themselves in the landscape every bit as much as land artists. Wherever John Virtue has lived he has delved deeper and deeper into the countryside around himself, pacing the same route with his sketchbooks, getting to know its lanes and fields, its coasts and woods, season by season. Now living in Norfolk, every week, whatever the weather, he sets out with a sketchbook from Cley to Blakeney Point on the north Norfolk coast, always taking the same route. He stops, sketches, trudges on, stops again, sketches again, eventually turns and retraces his steps – literally, where possible, stepping back over his own footprints.

The thumbed and rained-on sketchbooks in which Virtue records the landscapes he encounters, battered relics of his walks, are a crucial part of his working process. His large-scale drawing *Landscape no. 67* (1987) was created when he lived in Devon, and is based on sketches made in the lanes near his home. Once back in the studio, he worked over each small, rectangular drawing with white gouache, pencil, charcoal and black

Andy Goldsworthy, *Leaf Horn, Penpont, Dumfriesshire*, 1986.

ink, and finally assembled them into a composite work. Rather than a single viewpoint, *Landscape no. 67* more subtly and accurately reflects the artist's visual experience over the course of his walk. And rather than claiming to capture a particular scene witnessed some time before, these visual impressions, overlaid with Virtue's reflections, memories and emotions as his mind processed and filtered them, offer a more truthful representation of the way we experience landscape.

In recent years, following his move back to England from California, David Hockney has been reacquainting himself with the East Yorkshire Wolds he knew as a child. Setting up his easel in front of the scene, he sat down to paint steep Garrowby Hill with its winding road; the hawthorn blossom swarming like fat white caterpillars over the foliage; copses extending their spring-sprouting fingers against a milky sky; a river of

felled trees, glowing a vivid ochre by the side of a conifer plantation. He appointed himself chief cataloguer of the Wolds, trying, like Virtue, to capture it from every angle and in every mood. As well as painting with oils in colours that frequently burst into hyper-reality – purple tree-trunks, pink ploughed earth – he used modern technology, shooting digital videos and creating iPad drawings that he then blew up on large sheets. Scale was important in this immersive landscape project: some oils were painted on several canvases, which fitted together to form massive composite images. It took him six weeks to paint the fifty panels that make up *Bigger Trees Near Warter*, his largest work to date, working on each one outdoors. After it was exhibited at the Royal Academy Summer Exhibition in 2007, it remained on the wall when the other works were taken down and photographed, and two digital prints on the same scale as the original were hung on the walls to either side.[51] To stand in the gallery, surrounded on three sides by Hockney's great copses of trees just coming into leaf, is to be caught and held in nature's embrace.

Iris Murdoch understood this compulsion to plunge right in and immerse oneself in the natural world. It is rare, in fact, for her characters to remain dry, such is their propensity to tumble into deep watery chasms and underground streams. '[T]here is water in all the books', she once said, 'I used to be absolutely fearless in the sea, but I nearly drowned once, and I'm now much more cautious'.[52] In *The Nice and the Good* (1968), John Ducane is swept into an underwater cave, the entrance to which disappears when the tide comes in, while in *The Sea, The Sea* (1978), Charles Arrowby falls (or, as he believes, is pushed) into Minn's cauldron, a rocky hole filled with churning waves, from which he is only rescued by his Buddhist cousin James's spiritual powers.[53] In *Nuns and Soldiers* (1980), Tim Reede slips down a bank into a canal, is carried along by its current and finds himself hurtling through an underground channel before being deposited on a bank at the other end, where, like Coleridge's Ancient Mariner, he achieves redemption by blessing the sky, the sun, and even the canal itself.[54] These journeys to the underworld are a Murdochian rite of passage, a terrifying process of near-death and rebirth that her characters must undergo in their journeys towards greater wisdom.

John Virtue, *Landscape no. 67*, 1987.

A desire to benefit from a gentler kind of immersion in land and water lies at the heart of much recent nature writing. As the environmental crisis affects our lives ever more tangibly, our desire to experience nature in physical, emotional and spiritual ways seems to grow. Merely walking through the landscape is no longer enough – we have to get inside it.

'A mountain', observed Nan Shepherd in the last years of the Second World War 'has an inside.' Shepherd was a patient observer of the Cairngorms in northeast Scotland. When she wrote about this moun-

tain range, which she spent a lifetime getting to know, she described not the thrill of reaching summits but the slow discovery of what she called her 'way in'.[55] She was fascinated by the interior spaces she found within the mountains: a 'bolder-strewn plain' on a high plateau almost completely enclosed by towering cliff faces, or a vertiginous drop within Loch Etchachan, the distant bed seen through water of exceptional clarity. Even colours could have an interior: a rose and violet hue that spread over sky and snow one evening 'seemed to have its own life, to have body and resilience, as though we were not looking at it, but were inside its substance'.[56] Key to her experience of the mountain range's interior was a heightened awareness of her bodily presence within the landscape. Shepherd writes exhilaratingly about this complex and volatile relationship, and thinks about how each of the senses could be cultivated in order to experience the mountains more subtly. On touch, she enumerates:

> textures, surfaces, rough things like cones and bark, smooth things like stalks and feathers and pebbles rounded by water, the teasing of gossamers, the delicate tickle of a crawling caterpillar, the scratchiness of lichen, the warmth of the sun, the sting of hail, the blunt blow of tumbling water, the flow of wind – nothing that I can touch or that touches me but has its own identity for the hand as much as for the eye.

With practice, the ear, too, can become attuned to silence – a rare phenomenon where there is so often wind and running water, but when it comes it is so profound it is, she writes, 'like a new element' in which one can seem to slip out of time.[57]

At the end of her book Shepherd thinks about the ways in which journeys into the natural world transform the self. 'I believe that I now understand in some small measure why the Buddhist goes on pilgrimage to a mountain,' she concludes. 'It is a journey into Being; for as I penetrate more deeply into the mountain's life, I penetrate also into my own... I am not out of myself, but in myself. I am. To know Being, this is the final grace accorded from the mountain.'[58]

Shepherd did not find a publisher in 1945, and put the manuscript of her book, *The Living Mountain*, in a drawer where it remained for over three decades until, in 1977, tidying her possessions, she rediscovered it and it was published by Aberdeen University Press.[59] Only more recently, however, has her intense, precise, poetic meditation on the Cairngorms come to be valued for its reassessment of humanity's relationship to landscape. Her book has found its time.

Two writers on landscape and nature who, in recent years, have also opened doors into landscape's interior are Roger Deakin and Robert Macfarlane. In *Waterlog* (1999), which charts his swims through Britain's moats, lakes, rivers, steams, lochs and fens, Deakin observes that entering the water is 'a crossing of boundaries', where 'something like metamorphosis happens':

> You see and experience things when you're swimming in a way that is completely different from any other. You are *in* nature, part and parcel of it, in a far more complete and intense way than on dry land, and your sense of the present is overwhelming.

And in this state of immersion, writes Deakin, one can be healed both physically and emotionally. One has only to put oneself in nature's hands:

> Natural water has always held the magical power to cure. Somehow or other, it transmits its own self-regenerating powers to the swimmer. I can dive in with a long face and what feels like a terminal case of depression, and come out a whistling idiot. There is a feeling of absolute freedom and wildness that comes with the sheer liberation of nakedness as well as weightlessness in natural water, and it leads to a deep bond with the bathing-place.[60]

Macfarlane shares Deakin's gift of showing us that the natural world that surrounds us can be an enchanted place. In books such as *The Wild Places* (2007), *The Old Ways* (2012) and *Underland* (2019) he climbs remote peaks, follows ancient paths, descends into deep caverns. Some of his readers may be inspired to lace up their boots and follow in

his footsteps; for most of us, the vicarious experience is exhilarating enough. But as well as the remote or dangerous places he describes, Macfarlane also draws our attention to what, quoting Paul Nash, he calls the 'unseen landscapes' that lie all around us: those field margins and 'rough cusps of the country' where unexpected beauty and significance can be found. These places do not have to be on a large scale: in *The Wild Places*, with his friend Deakin, he crawls inside a hedge to discover its hidden inner world.[61] It turns out that there is a whole miniature landscape in there.

Macfarlane proposes a new and deeper way of thinking about being in the landscape. He not only interleaves accounts of often-gruelling and dangerous expeditions with layers of reflection on history, literature and language, but also introduces a moral dimension – even a moral imperative. We *must* know more, and care more, about our landscape. A contemporary sage, Macfarlane writes books that offer to reconnect us with our precious environment, to immerse us in it like a baptism – just at the point it is at its most threatened.

Once a rival to London in its scale and influence, the Suffolk coastal city of Dunwich tipped into inexorable decline in the late thirteenth century when three great storms hit it in quick succession, and over time it was abandoned. Coastal erosion has been eating away at it ever since, at the rate of around a metre a year. 'Dunwich, with its towers and many thousand souls, has dissolved into water, sand and thin air', writes Sebald. 'If you look out from the cliff-top across the sea towards where the town must once have been, you can sense the immense power of emptiness.' There is, indeed, not a great deal left of Dunwich now. To walk on the cliffs of this 'melancholy region' is to feel the eerie sensation of knowing that the ground under one's feet will not be there for much longer.[62] As climate change causes sea levels to rise and severe storms become more frequent, Dunwich's story is all the more likely to be repeated around the UK.

The east coast of England, which is particularly vulnerable to erosion and flooding caused by rising sea levels, has long drawn artists and writers. Among them is the Dutch artist Bettina Furnée, who in 2005 created

Bettina Furnée, *Lines of Defence*, 2005.

Lines of Defence at Bawdsey, just up the coast from Shingle Street and Orford Ness. Flags, each marked with a letter, stretched back from the cliff edge in lines. Together they spelled out the warning 'SUBMISSION IS ADVANCING AT A FRIGHTFUL SPEED'.[63] Furnée filmed the flags with a time-lapse camera, starting the day they were installed in January and ending just eight months later, when the final flag toppled over on to the beach. As the words disintegrated and the final letter vanished along with the cliff, the work of art laconically proved its point.

Every year not just coastal erosion but floods and wildfires reshape the British landscape before our eyes. Seasons have become unpredictable, and Titania's words have come true:

> The spring, the summer,
> The chiding autumn, angry winter change
> Their wonted liveries, and the mazèd world
> By their increase now knows not which is which.[64]

But the cultural climate is changing too, and new generations of artists and writers are reinventing what landscape means and how it can express our most profound preoccupations. Writing about nature and place, whether in novels, memoirs or focused studies, has in recent years become a cultural phenomenon. Genres cheerfully spill over into each other – fiction is spiked with real on-the-ground knowledge; non-fiction is shaped by novelistic techniques – and each is enriched. What is striking is how many of today's nature writers focus on landscapes of a scale we can readily grasp, those that correspond to a human span. John Lewis-Stempel asks us to consider a meadow; Mark Cocker draws our attention to the crow; Rob Cowen leads us into an overlooked strip of land on the outskirts of a Yorkshire town; Olivia Laing takes us on a walk along the banks of Sussex's river Ouse.[65] In the face of an overwhelming environmental crisis it seems as though, like Bede, we have become miniaturists, finding meaning and symbolism in details. Inspiraton, too: these writers reflect the small, local ways in which most of us experience the natural world. By paying such close attention to our landscape, they invite us to do the same.

EPILOGUE

I admit to being more of a Cowper than a Coleridge. My regular walk takes me on a familiar route out of the Suffolk village where I live, past allotments and a cemetery, round a lake, up a hill, across a field and down a shady lane that skirts a patch of woodland planted in 2000 to celebrate the millennium. Daily viewed, it pleases daily, as Cowper put it, and its novelty has, so far, survived; it is always different. I have made several more ambitious expeditions over the course of writing *Spirit of Place*, but mostly I have – like William Harrison, the sixteenth-century chronicler of Britain – 'sayled around the country within the compass of my study', tracing its changing moods and seasons through the pages of books.

But perhaps I had been thinking about landscapes of the imagination for long enough. At the end of the book, it was time for an outing.

If, I thought, there was a single place where I could reflect on the themes of *Spirit of Place*, it would be Yorkshire Sculpture Park, which since 1977 has occupied the 500-acre Bretton Estate, near Wakefield. First laid out in the eighteenth century, the park echoes the ideal landscapes invented by Claude Lorrain, with sweeping lawns, scattered trees, a lake that reflects the house and a ha-ha that seamlessly connects the near-at-hand with distant views. But in place of the picturesquely odd-numbered groups of cows or horses that William Gilpin would have demanded, there, instead, are works of art. Huge figures by Henry Moore recline and stretch; building blocks by Sol LeWitt form a pleasingly architectural structure; amoeba-like forms in polished granite by Masayuki Koorida create a disconcerting presence on the turf. All these works are both about the landscape and also of the landscape. Outdoors, they have the independent existence they lack in a gallery context; once a landscape is brought into the equation, the dynamic between sculpture and viewer changes utterly. It seems to become more equal, as though, outside, the sculptures can get on with their inner lives and do not really mind whether we come to look at them or not. Perhaps this is what Barbara Hepworth had in mind when she spoke of allowing works to 'expand and breathe' outdoors.[1] Their appearance changes constantly, with the passing of the

sun and the slow turn of the seasons. I found I wanted to spend an hour with Hepworth's *Squares with Two Circles* (1963), watching its shadow slide over the hillside; walk up and down David Nash's *Seventy-One Steps* (2010) made of charred and oiled oak and designed to erode gently back into the landscape; discover each one of Alec Finlay's nest-boxes and tease out the meanings of their poetic, enigmatic inscriptions. But the work of art I had come particularly to see was *Deer Shelter Skyspace* (2006) by the American artist James Turrell.

The structure, which once served as a refuge for deer, was constructed in the 1770s: an enclosure created by a drystone wall, encompassing an elegant triple-arched shelter that backs on to a low hill. By the late twentieth century, however – Bretton Hall having had no deer to shelter for many years – the structure had partly collapsed, and two of its arches been bricked up. When, in the 1990s, Yorkshire Sculpture Park launched a project to restore the Park's original buildings and commission artists to work with the historic landscape, they identified the potential of the deer shelter. So did Turrell. Turrell's idea was to restore the arched shelter to its original form, but to create an entrance from its back wall, with a corridor leading right into the hillside itself. From there he excavated a chamber in which he made an opening in the ceiling, out to the top of the hill.[2]

Today, walking into the hillside feels like the beginning of a fairytale. Entering the *Skyspace*, I find myself in a light-filled chamber that does indeed feel magical. I sit on a bench that runs around the edge, look up and see the sky, crisply framed. *Skyspace* works with great simplicity and gentle insistence; it asks us to focus, to think about nature, and art, and how, consciously or unconsciously, we frame the world around us. The aperture becomes a metaphor for the pupil of the eye. Observed in this way, curiously, the sky appears to be closer, 'no longer "out there"', as Turrell has said, but 'brought down into our territory'.[3] Like James Thomson in *The Seasons*, Turrell seems to package a piece of nature and give us ownership of it. It works in reverse too; *Skyspace* also invites our thoughts to fly up into the infinite world beyond.

As I focus on this curious window that Turrell has made on to the world and watch as gauzy clouds drift across the pale blue sky overhead, I think about all the artists and writers who have gone 'skying', as

Constable called it – those, like de Loutherbourg and Turner, Coleridge and Hopkins, who have tried to capture landscape at its most fleeting and elusive.[4] Among the most recent is Tacita Dean, whose materials of spray chalk and schoolroom slate, with their implications of erasure, perfectly reflect her cloud subjects.[5] Her clouds cause us to reflect on the relationship between a specific moment of observation and a universal idea. And, setting aside aircraft and their vapour trails (although Dean loves to draw those too), the sky is a good place to look because it is among the few parts of landscape that – despite never being the same – has not changed. We can know that, centuries ago, men and women looked up and saw a close version of what *we* see. But how it was coloured by what they thought, felt and believed – thereby hangs a tale.[6] As we go into an uncertain future, one thing we can predict is that the landscape will continue to claim the attention of successive generations of artists and writers, who will invent fresh versions of it to suit their world – and that alongside anxiety and unease, beauty and wonder will be there too.

Before I leave, I think of St Cuthbert in his cell on Inner Farne, throwing his head back and gazing up towards the heavens through his patch of sky.

NOTES

Introduction

1 Samuel Palmer to John Linnell,
 21 December 1828, in *The Letters
 of Samuel Palmer*, ed. Raymond
 Lister, 2 vols (Oxford, 1974), I,
 p. 47. The phrase is from John
 Milton, 'Il Penseroso', line 135

2 Daniel Defoe, *A Tour Through the
 Whole Island of Great Britain*, ed.
 P. N. Furbank and W. R. Owens
 (New Haven and London, 1991),
 p. 323

3 Thomas Gray to Richard West,
 16 November 1739, in *Thomas
 Gray Archive* <http://www.
 thomasgray.org/cgi-bin/display.
 cgi?text=tgal0084#ft> [accessed 16
 February 2019]

4 Ashmolean Museum, Oxford,
 WA1908.224

I Mystery

1 *Two Lives of Saint Cuthbert: A
 Life by an Anonymous Monk
 of Lindisfarne and Bede's Prose
 Life*, ed. and tr. Bertram Colgrave
 (Cambridge, 1940), p. 217

2 William of Malmesbury, *Gesta
 regum Anglorum; The History of
 the English Kings*, ed. and tr.
 R. A. B. Mynors, R.M. Thomson
 and M. Winterbottom, 2 vols
 (Oxford, 1998), I, p. 51

3 Quoted in A. W. Oxford, *The
 Ruins of Fountains Abbey* (Oxford,
 1910), p. 165

4 N. J. Higham, 'Old light on
 the Dark Age landscape: the
 description of Britain in the *De
 Excidio Britanniae* of Gildas',
 Journal of Historical Geography,
 17 (1991), pp. 363–72 (364)

5 Gildas, *The Ruin of Britain and
 Other Works*, ed. and tr. Michael
 Winterbottom (London and
 Chichester, 1978), p. 17

6 *Ibid.*, pp. 29, 52

7 Bede, *The Ecclesiastical History
 of the English People; The Greater
 Chronicle; Bede's Letter to Egbert*,
 ed. Judith McClure and Roger
 Collins, tr. Bertram Colgrave (1994;
 Oxford, 1999), pp. 9–10

8 Gildas, *Ruin of Britain*, p. 17

9 I am grateful to Benedict Gummer
 for this observation.

10 Bruce Mitchell and Fred C.
 Robinson, *A Guide to Old English*
 (4th edn, rev., Oxford, 1986), p. 255

11 *Ibid.*, p. 256

12 *Ibid.*

13 See Leonard Neidorf (ed.), *The
 Dating of Beowulf: A Reassessment*
 (Cambridge, 2014)

14 Anon., *Beowulf*, line 94

15 *Ibid.*, lines 1357–64. In *Beowulf*,
 ed. and tr. Michael Swanton
 (Manchester, 1978), p. 198,
 Swanton notes that this vision is
 likely to have a literary source:
 a description of a damp, chilly
 Christian Hell as related in the
 Visio Pauli or *Apocalypse of
 Paul*, part of the New Testament
 apocrypha.

16 *Beowulf*, line 1366

17 *Ibid.*, lines 1368–72

18 *Ibid.*, lines 103–4 and 162

19 *Ibid.*, line 710

20 Francis Pryor, *The Making of
 the British Landscape: How we
 have Transformed the Land, from
 Prehistory to Today* (London,
 2011), p. 383

21 *Felix's Life of Saint Guthlac,* ed. and tr. Bertram Colgrave (Cambridge, 1956), pp. 87, 103

22 *Ibid.,* p. 93

23 See Sarah Semple, 'A Fear of the Past: the Place of the Prehistoric Burial Mound in the Ideology of Middle and Later Anglo-Saxon England', *World Archaeology*, 30/1 (June 1998), pp. 109–126 (113)

24 Mitchell and Robinson, *Guide to Old English,* pp. 249–50

25 Sarah Semple also hypothesizes that 'the woman is not a living exile, but dead' in 'A Fear of the Past', p. 111

26 Gerald of Wales, *The Journey Through Wales and The Description of Wales,* tr. Lewis Thorpe (London, 1978), p. 185

27 *Ibid.,* p. 108

28 *Ibid.,* pp. 194–5

29 *Ibid.,* p. 195

30 *Ibid.,* pp. 187–8

31 See Alexandra Walsham, *The Reformation of the Landscape: Religion, Identity, and Memory in Early Modern Britain and Ireland* (Oxford, 2011), p. 9

32 Gildas, *Ruin of Britain,* p. 17

33 William A. Chaney, *The Cult of Kingship in Anglo-Saxon England: the Transition from Paganism to Christianity* (1970; 2nd edn., Manchester, 1999), pp. 188–9. See also Christina Hole, *English Custom and Usage* (1941; rev. ed. London, 1944), p. 4

34 *Caxton: The Description of Britain,* tr. Marie Collins (London, 1988), pp. 41, 44–5

35 The Devil's Arse also goes by the politer name of 'Peak Cavern'.

36 For the stories outlined here I am indebted to Jennifer Westwood and Jacqueline Simpson's compendious book *The Lore of the Land: a Guide to England's Legends, from Spring-Heeled Jack to the Witches of Warboys* (London, 2005)

37 Geoffrey of Monmouth, *The History of the Kings of Britain,* ed. Michael D. Reeve, tr. Neil Wright (Woodbridge, 2007), p. 4

38 William Camden, *Britannia: or, a Chorographical Description of the Flourishing Kingdoms of England, Scotland and Ireland, and the Islands Adjacent; from the Earliest Antiquity,* ed. and tr. Richard Gough, 4 vols (London, 1806), I, pp. xxxvii, 33–4. The poem Camden quotes is the *Architrenius* by Johannes de Hauvilla.

39 *The Lore of the Land,* pp. 468–9

40 See Geoffrey Ashe, *From Caesar to Arthur* (London, 1960), pp. 168–9; *The Landscape of King Arthur* (London, 1987), passim; and Nicholas J. Higham, *King Arthur: The Making of the Legend* (London, 2018), pp. 229–33

41 Gerald of Wales, *De Principis Instructione, c.* 1193

42 Thomas Malory, *Le Morte d'Arthur* (1485), book 21, ch. VII

43 Anon., *Sir Gawain and the Green Knight,* lines 1694–6

44 *Ibid.,* line 150

45 *Ibid.,* lines 506–7, 516, 527

46 *Ibid.,* line 701

47 *Ibid.,* lines 709, 713–14

48 *Ibid.,* lines 742–5

49 *Ibid.,* lines 749, 730, 732

50 *Ibid.,* line 722.

51 *Ibid.,* lines 2080–1

52 *Ibid.,* lines 2180–4

53 *Ibid.,* lines 2185 and 2187–8

54 *Ibid.,* lines 729–30

55 Geoffrey of Monmouth, p. 6

56 William Langland, *Piers Plowman*, ed. A. V. C. Schmidt, 2 vols (London and New York, 1995), I, p. 2

57 Anon., *Pearl*, lines 38, 48

58 *Ibid.*, lines 80, 82

59 *Ibid.*

60 *Dafydd ap Gwilym: His Poems*, ed. and tr. Gwyn Thomas (Cardiff, 2001), no. 83, pp. 169–70

61 *Ibid.*, no. 29 ('The Holly Grove'), p. 62

62 *Ibid.*, no. 121, p. 235

63 *Ibid.*, no. 68, pp. 140–1

64 *Ibid.*, no. 65, pp. 134–5

65 See the British Library's medieval manuscripts blog for May 2018, 'A Calendar Page for May 2018' <https://blogs.bl.uk/ digitisedmanuscripts/2018/04/a-calendar-page-for-may-2018.html> [accessed 11 February 2019]

II Reflection

1 John Leland, 'The New Year's Gift, 1546', in *John Leland's Itinerary: Travels in Tudor England*, ed. John Chandler (Stroud, 1993), p. 9. See also John Chandler's introduction, pp. xi–xxxvi

2 William Camden, *Britannia: or, a Chorographical Description of the Flourishing Kingdoms of England, Scotland and Ireland, and the Islands Adjacent; from the Earliest Antiquity*, ed. and tr. Richard Gough, 4 vols (London, 1806), I, p. 155

3 Quoted in John Chandler's introduction to *John Leland's Itinerary*, p. xvi. John Bale was writing in his preface to Leland's 'New Year's Gift', where he put this opinion in the mouth of an unnamed mutual friend.

4 William Harrison, 'An Historicall Description of the Islande of Britayne', *Holinshed's Chronicles*, 2 vols (London, 1577), I, f.36r

5 William Harrison, *The Description of England: The Classic Contemporary Account of Tudor Social Life*, ed. Georges Edelen (1968; Washington and New York, 1994), p. 5

6 *Ibid.*, p. 277

7 Camden, *Britannia*, I, pp. xxxvii, xxxv

8 *Ibid.*, III, p. 4; II, p. 415; I, p. 34

9 Richard Benese, *The Maner of Measurynge of all Maner of Lande, as well of woodlande, as of lande in the felde, and comptynge the true nombre of acres of the same* (London, 1537), n.p.

10 An impression is now in the British Museum, 1895,0122.1192-1197. See also Peter Barber and Tom Harper, *Magnificent Maps: Power, Propaganda and Art* (London, 2010), p. 30

11 William Cuningham, *The Cosmographical Glasse* (London: John Day, 1559), pp. 6–7

12 See P. D. A. Harvey, *Maps in Tudor England* (London, 1993), p. 17

13 <https://www.bl.uk/collection-items/map-of-the-coast-of-dorset-from-poole-harbour-to-lyme-regis> [accessed 23 January 2020]. See also Anthony Gerbino, 'The Paper Revolution: The Origin of Large-Scale Technical Drawing under Henry VIII', in Anthony Gerbino and Stephen Johnston (eds), *Compass & Rule: Architecture as Mathematical Practice in England* (New Haven, 2009), pp. 31–44

14 Edmund Spenser, *The Faerie Queene*, V, Proem, stanza 1

15 Robert Burton, *The Anatomy of Melancholy*, ed. Thomas C. Faulkner, Nicolas K. Kiessling and

Rhonda L. Blair, 6 vols (Oxford, 1989–2000), I, p. 243 (part 1, sect. 2, memb. 2, subs. 6)

16 See Simon Schama, *Landscape and Memory* (London, 1995), p. 141

17 William Shakespeare, *As You Like It*, I.1, lines 109–111

18 *Ibid.*, IV.1, lines 10 and 15–16

19 *Ibid.*, II.7, lines 12–14

20 William Shakespeare, *King Lear*, II.4, line 297

21 William Shakespeare, *Macbeth*, I.3, line 76

22 *Anatomy of Melancholy*, I, pp. 85 and 88 ('Democritus to the Reader')

23 Edmund Spenser, 'January' in *The Shepheardes Calendar*, stanza 4, lines 1–2

24 *Ibid.*, 'June', stanza 1, lines 1 and 6; stanza 2, line 2

25 William Shakespeare, *Hamlet*, II.2, lines 296–7

26 Edmund Spenser, *The Faerie Queene*, book I, canto i, stanza 8

27 *Ibid.*, book II, canto xii, stanza 50

28 William Shakespeare, *As You Like It*, IV.3, lines 112–4 and line 76; III.2, lines 171–2

29 *Ben Jonson*, ed. C. H. Herford and Percy and Evelyn Simpson, 11 vols (Oxford, 1926–52), VII, pp. 170–1

30 See John Peacock, *The Stage Designs of Inigo Jones: the European Context* (Cambridge, 2006), p. 159

31 John Harris, Stephen Orgel and Roy Strong, *The King's Arcadia: Inigo Jones and the Stuart Court* (London, 1973), p. 84, and Peacock, *Stage Designs of Inigo Jones*, p. 158

32 *The Cambridge History of English Literature*, ed. A. W. Ward and A. R. Waller, 15 vols (Cambridge, 1932), VI, p. 371

33 Quoted in D. J. Gordon, 'Poet and Architect: The Intellectual Setting

of the Quarrel between Ben Jonson and Inigo Jones', *Journal of the Warburg and Courtauld Institutes*, 12 (1949), pp. 152–78 (154)

34 *The King's Arcadia*, pp. 165–6, 180

35 Quoted *ibid.*, p. 202. John Peacock points out that here Jones's model was an engraving by Hendrik Goudt after Adam Elsheimer, *The Flight into Egypt* (1613) (F.W.H. Hollstein, *Dutch and Flemish etchings, engravings and woodcuts c. 1450–1700* (Amsterdam, 1949), 3)

36 Michael Drayton, *Poly-Olbion*, song 1, lines 1, 8 and 11–16 <http://poly-olbion.exeter.ac.uk/> [accessed 14 August 2019]

37 *Ibid.*, song 3, line 348

38 *Ibid.*, 'To the General Reader'

39 *Ibid.*, song 2, lines i–viii of the Argument

40 *Ibid.*, song 3, lines 44, 68, 107, 109, 116–20, 166–7 and 178–80

41 *Ibid.*, song 3, lines 261, 263–4, 278, 279–80 and 284–5

42 Harrison, *Description of England*, p. 197 and James Ayres, *Domestic Interiors: The British Tradition 1500–1850* (New Haven and London, 2003), p. 131

43 Ayres, *Domestic Interiors*, p. 131

44 *Ibid.*, pp. 131–3

45 A. J. K., *Gentleman's Magazine*, vol. CIII, part II, 1833, pp. 393–4. See also Eric Mercer, *English Art 1553–1625* (Oxford, 1962) pp. 110–11

46 *The Works of Henry Vaughan*, ed. Leonard C. Martin, 2 vols (Oxford, 1914), I, p. 10

47 See Peter Barber and Tom Harper, *Magnificent Maps: Power, Propaganda and Art* (London, 2010), pp. 56–7

48 Mark Girouard, *Hardwick Hall, Derbyshire, A History and a Guide* (London, 1976), pp. 65–6

III Discovery

1 The story is a paraphrase of Edward Norgate, *Miniatura or the Art of Limning*, ed. Jeffrey M. Muller and Jim Murrell (New Haven and London, 1997), pp. 83–4

2 *Ibid.*, p. 64

3 *Ibid.*, p. 83

4 *Ibid.*

5 *Charles I: King and Collector*, exh. cat. (London, 2018), p. 250; RCIN 403033. See also Vanessa Remington and Lucy Whitaker, 'A "more solitary place": Charles I and his Cabinet', *ibid.*, pp. 205–231 (pp. 207–9)

6 Norgate, *Miniatura*, p. 87

7 Jonathan Richardson, *A Discourse on the Dignity, Certainty, Pleasure and Advantage, of the Science of a Connoisseur* (London, 1719), p. 51

8 Edward Croft-Murray, 'The Landscape Background in Rubens's St. George and the Dragon', *The Burlington Magazine for Connoisseurs*, 89/529 (1947), pp. 89–93 (pp. 90 and 93)

9 British Museum, London, 1885-5-9-47

10 British Museum, London, 1911-10-18-2. Antony Griffiths, 'The etchings of John Evelyn', in David Howarth, ed., *Art and Patronage in the Caroline Courts: Essays in Honour of Sir Oliver Millar* (Cambridge, 1993) pp. 51–67 (66, n. 7)

11 Entry for 2 November 1644, *The Diary of John Evelyn,* ed. John Bowle (Oxford, 1985), p. 74; and *The Diary of John Evelyn*, ed. Austin Dobson, 3 vols (London, 1906), I, p. 151

12 Entry for 7 February 1645, *The Diary of John Evelyn* (1985), p. 91

13 British Museum, London, 1911-10-18-2. See Kim Sloan, 'A Noble Art': Amateur Artists and Drawing Masters c. 1600–1800* (London, 2000), pp. 20–21

14 Henry Peacham, *The Gentlemans Exercise* (London, 1634), p. ix

15 *Ibid.*, pp. 38–43

16 Norgate, *Miniatura*, p. 87

17 British Library, Add. MS 5244. See Sloan, pp. 23–4. Dunstall describes himself as 'Teacher of the Art of Drawing' at the beginning of his treatise.

18 Peacham, *Gentlemans Exercise*, p. 88

19 *Poems of Charles Cotton*, ed. John Buxton (London, 1958), p. 52

20 Thomas Hobbes, *De Mirabilibus Pecci: being the Wonders of the Peak in Darby-shire, Commonly called The Devil's Arse of Peak*, tr. 'a Person of Quality' (London, 1678), p. 14

21 Hobbes, *De Mirabilibus*, pp. 62–70

22 *Poems of Charles Cotton*, p. 59

23 *Ibid.*, p. 55

24 *Ibid.*, p. 75

25 *Ibid.*, p. 64

26 *Ibid.*, p. 66

27 Thomas Browne, *Religio Medici*, section 16 <http://penelope.uchicago.edu/relmed/relmed1645.pdf> [accessed 14 August 2019]

28 Quoted in the introduction to *Aubrey's Brief Lives,* ed. Oliver Lawson Dick (London, 1949; repr. 2016), p. lxxxv

29 *The Works of Francis Bacon: Volume 4, Translations of the Philosophical Works 1*, ed. James Spedding, Robert Leslie Ellis and Douglas Denon Heath (London, 1858), p. 303

30 Quoted in Anthony Powell, *John Aubrey and his Friends* (London, 1948), p. 60

31 *Ibid.*, pp. 106–8
32 *Ibid.*, p. 108
33 Adam Fox, 'Aubrey, John (1626–1697), antiquary and biographer', *Oxford Dictionary of National Biography*, 2008 <https://doi.org/10.1093/ref:odnb/886> [accessed 28 November 2018]
34 The Earl of Arundel to the Reverend William Petty, May 1636; quoted in Richard T. Godfrey, *Wenceslaus Hollar: A Bohemian Artist in England* (New Haven and London, 1994), p. 7
35 David Howarth, *Lord Arundel and his Circle* (New Haven and London, 1985), pp. 124–5
36 Antony Griffiths and Gabriela Kesnerová, *Wenceslaus Hollar: Prints and Drawings* (London, 1983), pp. 84–5
37 George Vertue on Wenceslaus Hollar, in 'Vertue Note-Books: II', *The Volume of the Walpole Society*, 20 (1931–2), pp. 1–158 (156)
38 Entry for 11 June, 1667, *The Diary of John Evelyn* (1985), p. 219
39 Lindsay Stainton and Christopher White, *Drawing in England from Hilliard to Hogarth* (London, 1987), pp. 157–8
40 Richard Tyler, *Francis Place 1647–1728* (York, 1971), p. 14; 'Vertue Note-Books: I', *The Volume of the Walpole Society*, 18 (1929–30), pp. 22–161 (74–5); and 'Vertue Note-Books: II', *The Volume of the Walpole Society*, 20 (1931–2), pp. 1–158 (35)
41 'Vertue Note-Books: I', p. 34
42 Sloan, *'A Noble Art'*, p. 35
43 Edmund Spenser, *The Faerie Queene*, book II, canto xii, stanza 2
44 See Bernhard Klein, 'Imaginary journeys: Spenser, Drayton, and the poetics of national space', in Andrew Gordon and Bernhard Klein, *Literature, Mapping and the Politics of Space in Early Modern Britain* (Cambridge, 2001), pp. 204–23 (215). As Klein observes, 'Spenser's allegorical landscapes are realms of constant illusion and deceit, posing challenges which the characters first need to successfully confront before they can safely move on.'
45 John Milton, *Paradise Lost*, book IV, line 196 and lines 205–10
46 *Ibid.*, lines 247, 223, 224, 239, 248 and 257–60
47 Thomas Gainsborough, quoted in the *Whitehall Evening Post*, 21–3 August 1798. Quoted in James Hamilton, *Gainsborough: A Portrait* (London, 2017), p. 329
48 *The Journeys of Celia Fiennes*, ed. Christopher Morris (London, 1947), pp. 1, 261 and 188–9
49 *Ibid.*, pp. 72, 147–8 and 245
50 *Ibid.*, p. 264
51 *Ibid.*, p. 176. See also introduction, p. xxxvii
52 *Ibid.*, pp. 96–7
53 Daniel Defoe, *A Tour Through the Whole Island of Great Britain*, ed. P. N. Furbank and W. R. Owens (New Haven and London, 1991), pp. 241 and 248–9
54 *Ibid.*, pp. 256–7
55 *Ibid.*, p. 291
56 *Ibid.*, p. 291–2
57 *Ibid.*, pp. 301, 323 and 302

IV Imagination

1 See Carol Gibson-Wood, '"A Judiciously Disposed Collection": Jonathan Richardson Senior's cabinet of drawings', in Christopher Baker, Caroline Elam and Genevieve Warwick (eds), *Collecting Prints and Drawings in*

Europe, c. 1500–1750 (Aldershot, 2003), pp. 156–8 and *passim*.

2 J. P. Hylton Dyer Longstaffe, 'John Dyer as a Painter', in *Collections Historical & Archaeological relating to Montgomeryshire, and its Borders*, 48 vols (London, 1868–1943), XI, pp. 396–402 (397)

3 A mezzotint of 1727 by John Faber reproduces a lost original portrait by John Vanderbank. See National Portrait Gallery, London, NPG D5006

4 Jonathan Richardson, *Two Discourses*, 2 vols (London, 1719), *I. An Essay on the Whole Art of Criticism as it relates to Painting*, pp. 44–5

5 *Ibid.*, p. 45

6 Jonathan Richardson, *Two Discourses*, 2 vols (London, 1719), *II. An Argument in Behalf of the Science of a Connoisseur*, p. 12

7 Belinda Humfrey, *John Dyer* (Cardiff, 1980), p. 13 and Hylton Dyer Longstaffe, 'Dyer as a Painter', p. 401

8 John Dyer, *Grongar Hill* (London 1726), lines 41-2, 106-112

9 *Ibid.*, lines 113, 102-3, 77, 104-5

10 Thomson, *The Seasons* (London, 1730), 'Spring', lines 1, 4, 12, 486–7; 'Summer', lines 81, 122, 123, 124

11 *Ibid.*, 'Spring', line 172

12 *Ibid.*, 'Autumn', lines 151–2

13 *Ibid.*, 'Summer', lines 1407–8, 1437–40

14 *Ibid.*, 'Autumn', lines 40–41; 'Summer', lines 1441, 1452–3

15 James Thomson to David Mallet; quoted in Malcolm Andrews, *The Search for the Picturesque: Landscape Aesthetics and Tourism in Britain, 1760–1800* (Stanford, 1989), p. 11

16 William Hazlitt, 'My First Acquaintance with Poets', *The Liberal*, April 1823

17 Thomson, *The Seasons*, 'Summer', lines 352, 353–4, 358

18 See James Stourton and Charles Sebag-Montefiore, *The British as Art Collectors: from the Tudors to the Present* (London, 2012), pp. 90–91

19 William Cowper, *The Task* (London, 1785), line 425

20 James Thomson, *The Castle of Indolence* (London, 1748), stanza XXXVIII, lines 8–9

21 Martin Sonnabend and Jon Whiteley, *Claude Lorrain: The Enchanted Landscape* (Oxford, 2011), p. 17

22 Tom Stoppard, *Arcadia* (London, 1993), p. 36

23 Horace Walpole, 'The History of the Modern Taste in Gardening', in *Anecdotes of Painting in England*, 4 vols (London, 1786), IV, p. 289

24 Quoted in John Harris, 'William Kent', *Oxford Dictionary of National Biography* (2007) <https://doi.org/10.1093/ref:odnb/15424> [Accessed 26 February 2019]

25 Walpole, *Anecdotes of Painting*, IV, p. 266

26 *Ibid.*, pp. 291–2

27 *Ibid.*, p. 309

28 *The Letters of Mrs Elizabeth Montagu*, 3 vols (London, 1813), III, pp. 235–6. See Andrews, *Search for the Picturesque*, p. 39

29 Alexander Pope, 'Epistle IV: to Richard Boyle, Earl of Burlington' [London, 1731], lines 47–57

30 Oliver Goldsmith, *The Deserted Village* [London, 1770], lines 275–8. The poem was written as a reproof to the 1st Earl Harcourt.

31 Dorothy Stroud, *Capability Brown* (1950; 4th edn, London, 1984), p. 202

32 Stoppard, *Arcadia*, p. 36

33 Alexander Pope to the Blount sisters, 1717; quoted in Morris R. Brownell, *Alexander Pope & the Arts of Georgian England* (Oxford, 1978), p. 93

34 Walpole, *Anecdotes*, IV, p. 268; John Milton, *Paradise Lost*, book IV, lines 223–7

35 John Milton, 'Il Penseroso', lines 131–4, 139–41 and 147

36 Thomas Parnell, 'A Night Piece on Death', line 53, and Robert Blair, *The Grave*, lines 17 and 109–10

37 Henry Fielding, *The History of Tom Jones* [London, 1749], VIII, ch. 10

38 Thomas Gray, *Elegy Written in a Country Churchyard*, lines 1–8

39 Jane Austen, 'The History of England from the reign of Henry the 4th to the death of Charles the 1st' British Library, Add. MS 59874, pp. 14–15 <http://www.bl.uk/onlinegallery/ttp/austen/accessible/introduction.html> [accessed 14 August 2019]

40 John Webster, *The Duchess of Malfi*, V.3, lines 1–12

41 *Aubrey's Brief Lives*, ed. Oliver Lawson Dick (1949; London, 2016), p. lx

42 Daniel Defoe, *A Tour Through the Whole Island of Great Britain*, ed. P. N. Furbank and W. R. Owens (New Haven and London, 1991), p. 339

43 John Gage, *A Decade of English Naturalism*, 1810–1820, exh. cat. (Norwich and London, 1969–70), p. 2

44 J. H. Pott, *An Essay on Landscape Painting* (London, 1783), pp. 54–60

45 Ann Radcliffe, *A Journey Made in the Summer of 1794* (Dublin, 1795), pp. 487–8

46 *Ibid.*, pp. 490–1

47 Thomas Gainsborough to James Unwin, 25 May 1768; *The Letters of Thomas Gainsborough*, ed. John Hayes (New Haven and London, 2001), p. 53

48 Thomas Gainsborough to William Jackson, 4 June (year unknown); *ibid.*, p. 68

49 Thomas Gainsborough to James Unwin, 1 March 1764; *ibid.*, p. 26

50 William Whitehead to Viscount Nuneham, 6 December 1758; quoted in Susan Sloman, *Gainsborough in Bath* (New Haven and London, 2002), p. 38

51 Thomas Gainsborough to Lord Hardwicke, date unknown; *Letters of Thomas Gainsborough*, p. 30

52 'An Amateur of Painting' [William Henry Pyne], *Somerset House Gazette*, I (1824), p. 348. See also Susan Sloman, *Gainsborough's Landscapes: Themes and Variations* (London, 2011), pp. 8–9

53 Quoted in A. P. Oppé, *Alexander and John Robert Cozens* (London, 1952), p. 44

54 Kim Sloan, *Alexander and John Robert Cozens: The Poetry of Landscape* (New Haven and London, 1986), pp. 54–5

55 Alexander Cozens, *A New Method of Assisting the Invention in Drawing Original Compositions of Landscape* (London, 1785–6), p. 3

56 *Ibid.*, p. 4

57 *Ibid.*, p. 6

58 *Ibid.*, pp. 4–7

59 *Ibid.*, pp. 23 and 29

V Sensation

1 Horace Walpole to Richard West, 11
November 1739; *The Yale Edition of
Horace Walpole's Correspondence*,
ed. W. S. Lewis, 48 vols (New
Haven, 1937–83), XIII, p. 189

2 Edward Birt, *Letters from a
Gentleman in the North of Scotland
to his Friend in London*, 2 vols (4th
edn., London, 1815), II, pp. 4–13

3 Horace Walpole to Richard West,
28 September 1739; *Walpole's
Correspondence*, XIII, p. 181

4 Thomas Gray to Richard West,
16 November 1739; *Thomas
Gray Archive* <http://www.
thomasgray.org/cgi-bin/display.
cgi?text=tgal0084#ft> [accessed 16
February 2019]

5 Edmund Burke, *A Philosophical
Enquiry into the Origin of our Ideas
of the Sublime and Beautiful*, ed.
Adam Phillips (Oxford, 1990), p. 53

6 *Ibid.*, p. 67

7 Thomas Gray to Thomas
Wharton, *c.* 30 September 1765;
Gray Archive <https://www.
thomasgray.org/cgi-bin/display.
cgi?text=tgal0466#ft> [accessed 19
March 2019]

8 Thomas Gray to William Mason, 8
November 1765; *Ibid.*

9 William Beckford, *The Vision*,
c. 1777, quoted in Kim Sloan,
*Alexander and John Robert Cozens:
The Poetry of Landscape* (New
Haven and London, 1986), p. 77.
I am indebted to Kim Sloan for
this observation. See also <http://
beckford.c18.net/wbthevision.
html> [accessed 16 March 2019].
On the relationship between
Beckford and Cozens, see Sloan,
pp. 73–8

10 Thomas Gray to Thomas
Wharton, 29 October 1769;

Gray Archive <https://www.
thomasgray.org/cgi-bin/display.
cgi?text=tgal0466#ft> [accessed
24 March 2019]

11 Henry Kett, 'A Tour to the Lakes of
Cumberland and Westmoreland
in August 1798', in William Mavor,
*The British Tourist's, or Traveller's
Pocket Companion, through
England, Wales, Scotland, and
Ireland*, 6 vols (3rd edn, London,
1809), V, 119. I am indebted to
Esther Moir's excellent chapter
'Horrid and Sublime: Mines, Mills
and Furnaces', in her book *The
Discovery of Britain: the English
Tourists* (London, 1964), pp. 91–107

12 William Bingley, *North Wales*, 2
vols (London, 1804), I, pp. 309–10

13 *Ibid.*, pp. 310–11

14 Cambridge University Library MS.,
Add. 5811, f.69; here quoted from
Moir, *Discovery of Britain*, p. 98

15 Daniel Carless Webb, *Observations
and Remarks during Four
Excursions made to various parts
of Great Britain in the years 1810
and 1811* (London, 1812), p. 186

16 I should like to acknowledge the
help of the late Merryl Huxtable,
former Senior Paper Conservator
at the V&A, who discussed this
model with me when she was
preparing it for display.

17 William T. Whitley, *Artists
and their Friends in England
1700–1799*, 2 vols (New York and
London, 1928), I, p. 353

18 *Ibid.*, II, p. 352

19 Thomas Gainsborough to David
Garrick, [n.d.] 1772; *Letters of
Thomas Gainsborough*, p. 107

20 Jonathan Mayne, *Thomas
Gainsborough's Exhibition Box*
(London, 1965; repr., 1971), pp. 4–5.

21 The 'show-box' (P.44-1955) and

ten surviving paintings on glass (P.32 to 37-1955, P.39-1955 and P.41 to 43-1955) are in the V&A, and are usually on display in the museum's paintings galleries. Sadly, the 'show-box' is no longer illuminated.

22 Catalogue entry for P.12-1934, Victoria and Albert Museum <http://collections. vam.ac.uk/item/O91228/ landscape-with-castle-fresco-from-fresco-sandby-paul/> [accessed 14 August 2019]

23 *The Letters of Anna Seward Written Between the Years 1784 and 1807*, ed. Archibald Constantine, 6 vols (Edinburgh, 1811), III, pp. 380–1

24 Thomas Baldwin, *Airopaidia: containing the narrative of a balloon excursion from Chester, the eighth of September, 1785, taken from minutes made during the voyage* (Chester, 1786), pp. 39 and 2–3

25 *Ibid.*, pp. 37–8

26 *Ibid.*, pp. 136–7

27 *Ibid.*, pp. 42–3

28 *Ibid.*, n.p. [vii–viii]

29 *Ibid.*, p. 123

30 See Moir, *Discovery of Britain*, p. 125

31 William Gilpin, *Observations on the River Wye, and several parts of South Wales, etc. Relative Chiefly to Picturesque Beauty, made in the Summer of the Year 1770* (London, 1782), pp. 1–2. Although not published until 1782, twelve years after his trip, his 'Observations' had been circulating in manuscript for at least a decade by then. See Malcolm Andrews, *The Search for the Picturesque: Landscape Aesthetics and Tourism*

in Britain, 1760–1800 (Stanford, 1989), p. 86

32 Gilpin (1782), p. 6

33 *Ibid.*, p. 18

34 *Ibid.*, p. 7

35 *Ibid.*, pp. 17–18

36 *Ibid.*, p. 32

37 *Ibid.*, pp. 32–4

38 William Gilpin, *Observations on several parts of the counties of Cambridge, Norfolk, Suffolk, and Essex. Also on Several Parts of North Wales; relatively chiefly to Picturesque Beauty, in Two Tours* (London, 1809), p. 1

39 *Ibid.*, pp. 16–18

40 *Ibid.*, pp. 28–9

41 William Gilpin, *Observations, Relating Chiefly to Picturesque Beauty, made in the year 1772, on several parts of England; particularly the Mountains, and Lakes, of Cumberland, and Westmoreland* (London, 1786), p. 79

42 Thomas West, *A Guide to the Lakes, in Cumberland, Westmorland, and Lancashire* (2nd edn; London, 1780), pp. 3–4

43 *Ibid.*, p. 56

44 Peter Bicknell, *Beauty, Horror and Immensity: Picturesque Landscape in Britain, 1750–1850* (Cambridge, 1981), pp. xii, 48

45 West, *Guide*, pp. 194, 203

46 *Ibid.*, p. 10

47 *Ibid.*, pp. 11–12

48 *Ibid.*,p. 200

49 Thomas Gray to Thomas Wharton, 29 October 1769; *Gray Archive*, <https://www. thomasgray.org/cgi-bin/display. cgi?text=tgalo565> [accessed 22 March 2019]. See also West, *Guide*, p. 200 for Gray's mention of a trip to Appleby giving 'much employment to the mirror'.

50 See catalogue entry for P.18-1972, Victoria and Albert Museum <https://collections.vam.ac.uk/item/O78676/claude-glass-unknown/> [accessed 4 April 2019]

51 See Bicknell, *Beauty, Horror*, pp. 50–51

52 Robert Bloomfield, 'Journal of a Ten Days' Tour from Uley in Gloucestershire by way of Ross, down the River Wye to Chepstow, Abergavenny, Brecon, Hereford, Malvern, etc., Aug. 1807', British Library Add. MS 28267, ff. 6r, 39r, 51r, 57v

53 Felicity Owen and David Blaney Brown, *Collector of Genius: A Life of Sir George Beaumont* (New Haven and London, 1988), pp. 28–9

54 William Hutchinson, *An Excursion to the Lakes in Westmoreland and Cumberland, August 1773* (London, 1774), here quoted from Andrews, *Search for the Picturesque*, p. 153

55 Hester Lynch Piozzi, 'Journey through the North of England & Part of Scotland, Wales etc.' (1789), John Rylands Library MS. 623, f.167; quoted from Andrews, *Picturesque*, p. 153

56 Captain Jesse, *The Life of George Brummell, Esq., commonly called Beau Brummell*, 2 vols (London, 1844), I, p. 118

57 See Andrews, *Picturesque*, pp. 153–4

58 James Plumptre, *The Lakers: A Comic Opera, in Three Acts* (London, 1798), pp. 19–20

59 William Combe, *The Tour of Doctor Syntax in Search of the Picturesque* (London, 1812), canto I, lines 124–30

60 *Ibid.*, canto XIV, line 258

61 Jane Austen, *Northanger Abbey* [London, 1818] vol. I, ch. 14

62 Jane Austen, *Sense and Sensibility* [London, 1811], vol. I, ch. 18

63 Jane Austen, *Mansfield Park* [London, 1814], vol. I, ch. 6

64 Richard Payne Knight, *The Landscape: A Didactic Poem in Three Books* (2nd edn., London, 1795), p. 25

65 Thomas Love Peacock, *Headlong Hall and Nightmare Abbey* (London, 1910), p. 56

66 For a discussion of the political context and ramifications of this controversy, see Ann Bermingham, 'System, Order, and Abstraction: the Politics of English Landscape Drawing around 1795, in *Landscape and Power*, ed. W. J. T. Mitchell (Chicago and London, 1994; 2nd ed., 2002), pp. 77–101

67 Humphry Repton, *Landscape Gardening and Landscape Architecture*, ed. J. C. Loudon (Edinburgh, 1840), pp. 101–3

VI Vision

1 S. T. Coleridge to Samuel Purkiss, 29 July 1800; *Collected Letters of Samuel Taylor Coleridge*, ed. Earl Leslie Griggs, 6 vols (Oxford, 1956–71), I, p. 343

2 S. T. Coleridge to Josiah Wedgwood, 1 November 1800; *ibid.*, I, p. 644; Coleridge to Francis Wrangham, 19 December 1800; *ibid.*, I, p. 658

3 S. T. Coleridge to Sara Hutchinson, 27 July 1802; *ibid.*, II, p. 825

4 *The Notebooks of Samuel Taylor Coleridge*, ed. Kathleen Coburn, 3 vols (London, 1957–73), I, 508, f.59 and 760, f.6v

5 S. T. Coleridge to Josiah Wedgwood, 24 July 1800; *Collected Letters*, I, p. 610

6 S. T. Coleridge to Thomas Wedgwood, 9 January and 14 January 1803; *ibid.*, II, pp. 914, 916

7 S. T. Coleridge to Thomas Wedgwood, 14 January 1803; *ibid.*, II, 916.

8 S.T. Coleridge to Sara Hutchinson, 6 August 1802; *ibid.*, II, pp. 841–4

9 Samuel Taylor Coleridge, 'This Lime-Tree Bower my Prison' [composed 1797, first published in *Sibylline Leaves*, 1800], lines 7, 20–23, 43–5

10 *Notebooks of Coleridge*, I, 798, ff.39v–40v; f.29v; ff.29–29v; ff.37–37v; f.38; f.41

11 Richard Holmes, *Coleridge: Early Visions* (London, 1989), p. 282

12 Rachael Boast, 'The Notebook (Coleridge's Tour of Scotland)', *Pilgrim's Flower* (London, 2013), p. 25. See also Holmes, *Coleridge*, I, p. 353

13 *Notebooks of Coleridge*, I, 798, f.31v

14 *Ibid.*, I, 828, f.50; 798, f.27v; 798, f.38

15 *Ibid.*, 804, f.48; 798, f.29

16 Holmes, *Coleridge*, I, p. 281

17 John D. Baird, 'William Cowper (1731–1800)', *Oxford Dictionary of National Biography* <https://doi.org/10.1093/ref:odnb/6513> [accessed 17 April 2019]; James King, *William Cowper: A Biography* (Durham, NC, 1986), pp. 242–3

18 William Cowper to John Newton, 18 October 1792; *The Letters and Prose Writings of William Cowper*, ed. James King and Charles Ryskamp, 4 vols (Oxford, 1984), IV, p. 216

19 William Cowper, *The Task* (London, 1785), I, lines 422, 425

20 *Ibid.*, lines 177–9

21 William Cowper to William Unwin, 10 October 1784; *Letters and Prose Writings*, II, p. 285

22 John Constable to Maria Bicknell, 24 April 1812; *John Constable's Correspondence*, ed. R. B. Beckett, 6 vols, II (Ipswich, 1964), p. 65. See also Michael Rosenthal, *Constable: the Painter and his Landscape* (London, 1983), pp. 49 and 51. Constable was thinking of the lines: '…dear companion of my walks, / Whose arm this twentieth winter I perceive / Fast locked in mine…' (*The Task*, I, lines 144–6)

23 C. R. Leslie, *Memoirs of the Life of John Constable*, ed. Jonathan Mayne (1951; 3rd edn, London, 1995), p. 15

24 John Constable to John Fisher, 23 October 1821; *Constable's Correspondence*, VI (Ipswich, 1968), p. 77.

25 See Mark Evans, *John Constable: Oil Sketches from the Victoria and Albert Museum* (London, 2011), pp. 18–19 and *passim*.

26 Leslie, *Memoirs of John Constable*, p. 174

27 John Constable to John Fisher, 1 April 1821; *Constable's Correspondence*, VI, p. 65

28 *John Clare's Autobiographical Writings*, ed. Eric Robinson (Oxford and New York, 1983), pp. 35–6

29 *Ibid.*, p. 3

30 *Ibid.*, pp. 9–10

31 *Selected Poems and Prose of John Clare*, ed. Eric Robinson and Geoffrey Summerfield (Oxford, London and New York, 1978), pp. 154, 139

32 *Ibid.*, p. 74

33 *Ibid.*, p. 73

34 See Jonathan Bate, *John Clare: A Biography* (London, 2003), pp. 46–50

35 *Ibid.*, p. 80

36 *Selected Poems and Prose*, pp. 175-6

37 *John Clare's Autobiographical Writings*, pp. 34–5

38 *Prudhoe Castle from the Tyne Valley* (1817), f.78r and 77v (D12417 and D12416), Turner Bequest CLVII, Tate

39 See Eric Shanes, *Turner's Picturesque Views in England and Wales 1825–1838* (London, 1983), pp. 26–7 and Kim Sloan, *J. M. W. Turner: Watercolours from the R. W. Lloyd Bequest to the British Museum* (London, 1998), p. 27

40 *Turner 1775–1851*, exh. cat. (London, 1974), p. 121; Andrew Wilton, *Turner in the British Museum: Drawings and Watercolours* (London, 1975), pp. 20–21 and Shanes, *Turner's Picturesque Views*, passim

41 John Constable to John Fisher, 23 October 1821; *Constable's Correspondence*, VI, p. 78

42 *Ibid.*

43 William Wordsworth, 'Lines Written a Few Miles Above Tintern Abbey, on Revisiting the Banks of the Wye during a Tour. July 13, 1798' [first published in *Lyrical Ballads*, 1798], lines 5 and 23–31

44 *Ibid.*, lines 59–66 and 110–12

45 A. N. Wilson, *Victoria: A Life* (London, 2014), p. 295

46 Quoted in Christopher Hibbert, *Queen Victoria: A Personal History* (London, 2000), p. 175

47 Queen Victoria, journal entry for 2 September 1869, vol. 58, pp. 223–8 <http://www. queenvictoriasjournals.org/home. do> [accessed 6 November 2019].

The lines quoted are from Walter Scott's *The Lady of the Lake*, canto I, lines 184–7

48 *The Lady of the Lake*, canto XVII, line 12. On pebble jewellery see Charlotte Gere, 'Love and Art: Queen Victoria's Personal Jewellery', in *Victoria & Albert: Art & Love: Essays from a Study Day held at the National Gallery, London on 5 and 6 June 2010*, ed. Susanna Avery-Quash (London, 2012), pp. 12–13 <https://www. rct.uk/sites/default/files/V%20 and%20A%20Art%20and%20 Love%20%28Gere%29.pdf> [accessed 6 November 2019]

49 Samuel Palmer, sketchbook note; see *The Sketchbook of 1824*, ed. Martin Butlin (London, 2005), p. 210, note to f.81

50 Sketchbook, 1825; and Samuel Palmer to George Richmond, 14 November 1827; quoted in Geoffrey Grigson, *Samuel Palmer's Valley of Vision* (London, 1960), p. 20

51 A. H. Palmer, *The Life and Letters of Samuel Palmer, Painter and Etcher*, ed. Raymond Lister (2nd edn, London, 1972), p. 14 (quoting from a lost notebook of 1823–4)

52 Robert N. Essick, 'William Blake (1757–1827)', *Oxford Dictionary of National Biography* <https://www. oxforddnb.com/view/10.1093/ ref:odnb/9780198614128.001.0001/ odnb-9780198614128-e-1001485> [accessed 6 May 2019]

53 Samuel Palmer to Alexander Gilchrist, 23 August 1855; *The Letters of Samuel Palmer*, ed. Raymond Lister, 2 vols (Oxford, 1974), I, p. 506.

54 Samuel Palmer to John Linnell, 1828; quoted in William Vaughan, *Samuel Palmer: Shadows on the*

Wall (New Haven and London, 2015), p. 162

55 Samuel Palmer to George Richmond, September to October 1828; *Letters of Samuel Palmer*, I, p. 36

56 See David Bindman, *Blake as an Artist* (Oxford, 1977), pp. 204–5 and Vaughan, *Samuel Palmer*, pp. 82–3

57 *Life and Letters of Samuel Palmer*, pp. 15–16

58 See Vaughan, *Samuel Palmer*, pp. 101–15

59 Samuel Palmer to John Linnell, 21 December 1828; *Letters of Samuel Palmer*, I, pp. 47–8

60 Samuel Palmer to George Richmond, 14 November 1827; *ibid.*, I, p. 15

61 Samuel Palmer to Frederic George Stephens, 1 November 1871; *ibid.*, II, p. 824

62 Samuel Palmer, *Near Underriver, Sevenoaks, Kent* (*c.* 1840–43), watercolour. In the collection of Rhode Island School of Design.

63 John Everett Millais to Mrs Combe, 2 July 1851; John Guille Millais, *The Life and Letters of Sir John Everett Millais*, 2 vols (London, 1899), I, p. 119

64 *Life and Letters of Millais, p. 144*

65 P. G. Hamerton, *The Place of Landscape Painting Amongst the Fine Arts* (London, 1865), p. 202

66 *The Library Edition of the Works of John Ruskin*, ed. E. T. Cook and Alexander Wedderburn, 39 vols (London, 1903–12), XXXV, p. 311

67 *Ibid.*, III, p. 624

68 *Ibid.*, V, p. 166

69 See, for example, *Moss and Wild Strawberry*, Ashmolean Museum, WA.RS.REF.090. See Christopher Newall, *John Ruskin: Artist and*

Observer (Ottawa and London, 2014), pp. 256–7

70 John Ruskin to Dr Furnivall, 16 October 1853; *The Works of John Ruskin*, XII, p. xxiv

71 Allen Staley and Christopher Newall, *Pre-Raphaelite Vision: Truth to Nature* (London, 2004), p. 134

72 *The Works of John Ruskin*, XII, p. xxiv

73 *Ibid.*, pp. 359–60. See also Staley and Newall, pp. 145–6

74 For discussions of *Pegwell Bay*, see Marcia Pointon, 'The Representation of Time in Painting: A Study of William Dyce's *Pegwell Bay: A Recollection of October 5th, 1858*', *Art History*, 1 (1978), pp. 99–103 and Christiana Payne, 'In Focus', Tate website (November 2016) <https://www.tate.org.uk/research/publications/in-focus/pegwell-bay-kent-william-dyce> [accessed 14 May 2019]

75 Edmund Gosse, *Father and Son: A Study of Two Temperaments* (1907; London, 1970), p. 73

76 *Ibid.*, p. 76

77 John Ruskin to Henry Acland, 24 May 1851; *The Works of John Ruskin*, XXXVI, p. 115

78 Matthew Arnold, 'Dover Beach' [first published in *New Poems*, 1867], lines 22 and 24–8

VII Feeling

1 Charlotte Brontë to W. S. Williams, 22 May 1850; Margaret Smith, *Selected Letters of Charlotte Brontë* (Oxford, 2007), p. 163

2 Elizabeth Gaskell, *The Life of Charlotte Brontë* (4th edn, London, 1858), p. 111

3 Emily Brontë, *Wuthering Heights* [London, 1847], ch. 10

4 *Ibid.*, ch. 12

5 *Ibid.*, ch. 9

6 Charlotte Brontë and Emily Brontë, *The Belgian Essays: a Critical Edition*, ed. and tr. Sue Lonoff (New Haven and London, 1996), p. 176

7 Thomas Hardy, *The Return of the Native* [London, 1878], I, ch. 9

8 *Ibid.*

9 *Ibid.*, I, ch. 1

10 Claire Tomalin, *Thomas Hardy: the Time-Torn Man* (London, 2006), pp. 32–3

11 *Return of the Native*, I, ch. 9

12 *Ibid.*, I, ch. 6

13 *Ibid.*, IV, ch. 2

14 *Ibid.*, V, ch. 7

15 *Ibid.*, V, ch. 2

16 *Ibid.*, VI, ch. 4

17 Mary Shelley, Introduction, Standard Novels edition of *Frankenstein* (1831); quoted in Mary Shelley, *Frankenstein or The Modern Prometheus, the 1818 Text*, ed. Marilyn Butler (Oxford, 1993), p. 196

18 *Ibid.*, p. 136

19 Frederic George Kitton (ed.), *Charles Dickens by Pen and Pencil* (London, 1890), p. 131

20 Charles Dickens, *Great Expectations* [London, 1861], ch. 1

21 Wilkie Collins, *The Moonstone* [London, 1868], First Period, ch. 4

22 *Ibid.*

23 Theodore Watts-Dunton, *Aylwin* [London, 1898], ch. 1

24 Arthur Conan Doyle, *The Hound of the Baskervilles* [London, 1901–2], ch. 14

25 Richard Jefferies, *After London* [London, 1885], chs 1 and 5

26 *The Exhibition of the Royal Academy of Arts*, exh. cat. (London, 1890), p. 9 <https://www.royalacademy.org.uk/art-artists/exhibition-catalogue/ra-sec-vol122 -1890> [accessed 27 May 2019]

27 Oscar Wilde, 'The Decay of Lying', in *Intentions* (London, 1894), pp. 41–2

28 Richard Jefferies, *The Story of My Heart* [London, 1883], ch. 1

29 *Ibid.*, ch. 5

30 *Ibid.*, ch. 3

31 Journal entries for 12 December 1872, 10 August 1872 and 16 August 1873, *The Journals and Papers of Gerard Manley Hopkins*, ed. Humphry House, completed by Graham Storey (2nd edn, Oxford, 1959), pp. 228, 236, 223

32 Gerard Manley Hopkins to Coventry Patmore, 6 October 1886; *Further Letters of Gerard Manley Hopkins Including his Correspondence with Coventry Patmore*, ed. Claude Colleer Abbott (2nd edn, London, 1956), no. CLXXXII, p. 370

33 Norman White, 'Gerard Manley Hopkins (1844–1889)', *Oxford Dictionary of National Biography*, 2004 <https://doi.org/10.1093/odnb/9780192683120.013.37565> [accessed 28 May 2019]

34 *Poems and Prose of Gerard Manley Hopkins*, ed. W. H. Gardner (London, 1953), no. 15, lines 1–8, 9–10

35 *Ibid.*, no. 8, lines 5–8

36 *The Letters of Gerard Manley Hopkins to Robert Bridges*, ed. Claude Colleer Abbott (2nd edn, London, 1955) no. XXXIX, p. 48

37 E. M. Forster, *Howards End* [London, 1910], ch. 23

38 Max Beerbohm, 'Prangley Valley', *More* (London, 1899), pp. 129–30

39 Charlotte S. Burne, 'The Collection of English Folk-Lore', *Folklore*, 1/3 (1890), pp. 313–30 (330)

40 E. M. Forster, *The Longest Journey* [London, 1907], ch. 13

41 William Morris, 'Prologue – the Wanderers', *The Earthly Paradise* [London, 1868], lines 1–6

42 Richard Dalby (ed.), *The Virago Book of Victorian Ghost Stories* (London, 1988), p. 292

43 *The Collected Ghost Stories of M. R. James* (London, 1931), pp. 128, 135

44 John Constable to C. R. Leslie, 21 January 1829; *John Constable's Correspondence*, 6 vols, III, ed. R. B. Beckett (Ipswich, 1965), p. 19

45 The popularity of Pan in this period is explored by Richard Stromer in 'An Odd Sort of God for the British: Exploring the Appearance of Pan in Late Victorian and Edwardian Literature' <http://soulmyths. com/oddgod.pdf> [accessed 4 June 2019]

46 Burne Jones's composition was based on an episode from William Morris's poem *The Earthly Paradise*, in which Pan comforts Psyche after, distraught after her loss of Cupid, she has attempted to drown herself in a river (Harvard University, Grenville L. Winthrop Collection, 1943.187).

47 E. F. Benson, *Ghost Stories* (London, 2016), p. 49

48 *Ibid.*, p. 73

49 Quoted in Jean Moorcroft Wilson, *Edward Thomas: From Adlestrop to Arras: A Biography* (London, 2015), p. 313

50 Ivor Gurney, 'To His Love' [composed 1917, first published in *War's Embers*, 1919], lines 1–5

51 Siegfried Sassoon, *Memoirs of a Fox-Hunting Man* [London, 1928], 3, ch. 1

52 A. E. Housman, *A Shropshire Lad* [London, 1896], XL

53 Paul Nash to Margaret Nash, 16 November 1917; quoted in David Boyd Haycock, *Nash Nevinson Spencer Gertler Carrington Bomberg: A Crisis of Brilliance, 1908–1922* (London, 2013), p. 137

54 Paul Nash to Anthony Bertram, 2 March 1925; quoted in Anthony Bertram, *Paul Nash: the Portrait of an Artist* (London, 1955), p. 137

55 Graham Sutherland, Introduction to *The English Vision*, exh. cat. (London, 1973); quoted in Robert Meyrick, 'In Pursuit of Arcadia: British Printmakers in the 1920s', in Simon Martin, Martin Butlin and Robert Meyrick (eds), *Poets in the Landscape: the Romantic Spirit in British Art* (Chichester, 2007), pp. 59–64 (61)

56 *Ibid.*

57 Stella Gibbons, *Cold Comfort Farm*, [London, 1932], ch. 5

58 John Ruskin, *Dilecta*, in *The Library Edition of the Works of John Ruskin*, ed. E. T. Cook and Alexander Wedderburn, 39 vols (London, 1903–12), XXXV, p. 601

59 Lewis Melville, *The Life of William Makepeace Thackeray*, 6 vols, ed. Richard Pearson (Abingdon and New York, 1996), IV, p. 390

60 John Ruskin, *Dilecta*, pp. 598–601

61 John Ruskin, *Modern Painters*, in *The Library Edition of the Works of John Ruskin*, ed. E. T. Cook and Alexander Wedderburn, 39 vols (London, 1903–12), V, p. 370

62 See Allen Staley and Hilary Underwood, *Painting the Cosmos: Landscapes* by G. F. Watts (Compton, 2006), p. 55

63 W. G. Sebald, *The Rings of Saturn*, tr. Michael Hulse (Frankfurt, 1995; London 2002), p. 29

64 F. T. Marinetti, 'Vital English Art. Futurist Manifesto' <https://www.newspapers.com/clip/18550827/vital_english_art_futurist/> [accessed 19 June 2019]

65 Nevinson 'entered the war a visual radical and came out of it a chastened realist – of a sort.' Richard Humphreys, *The Tate Companion to British Art* (London 2001), p. 183

66 Patricia Reed, *William Nicholson: Catalogue Raisonné of the Oil Paintings* (London, 2011), p. 185 (no. 200) and p. 461 (no. 580)

67 Paul Nash, contribution to Herbert Read (ed.), *Unit One* (London, 1934), pp. 79–81 (80). See also Alexandra Harris, *Romantic Moderns: English Writers, Artists and the Imagination from Virginia Woolf to John Piper* (London, 2010), p. 26

68 Wyndham Lewis, *The Revenge for Love* [London, 1937], VII, ch. 6

VIII Presence

1 Edith Olivier, *Without Knowing Mr. Walkley: Personal Memories* (London, 1938), pp. 227–30

2 Quoted in *Black's Guide to Dorset, Salisbury, Stonehenge etc.*, ed. A. R. Hope Moncrieff (London, 1897), p. 66

3 Victorian responses to pre-historic sites are discussed by Sam Smiles in *British Art: Ancient Landscapes* (London, 2017), pp. 18–19

4 See, for example, Rosemary Hill, *Stonehenge* (London, 2008), p. 148, and Sam Smiles, 'Equivalents for the Megaliths: Prehistory and English Culture, 1920–50',

in David Peters Corbett, Ysanne Holt and Fiona Russell (eds), *The Geographies of Englishness: Landscape and the National Past 1880–1940* (New Haven and London, 2002), p. 208

5 Alfred Watkins, *The Old Straight Track: Its Mounds, Beacons, Moats, Sites and Mark Stones* (4th edn, London, 1948), p. 91. See also pp. 91–9 (on traders' tracks), pp. 84–90 (on sighting staffs) and pp. 168–74 (on folklore)

6 Quoted in Frances Spalding, *John Piper Myfanwy Piper: Lives in Art* (Oxford, 2009), p. 98

7 O. G. S. Crawford, *Archaeology in the Field* (London, 1953), p. 51

8 John Piper, 'Prehistory from the Air', *Axis*, 8 (1937), pp. 4–9 (7–8)

9 John Piper, 'Stonehenge', *Architectural Review*, 106/633 (1949), p. 177

10 Cited in Anthony Bertram, *Paul Nash: the Portrait of an Artist* (London, 1955), p. 237

11 Paul Nash, 'Picture History', November 1943; one of a collection of typescripts sent by Nash to his dealer Dudley Tooth, now in the Tate Archive (769/1/29-50). Quoted in Andrew Causey, *Paul Nash: Landscape and the Life of Objects* (London, 2013), p. 157

12 John Piper carried out a similar feat of imaginative restoration in a lithograph of 1944, *Avebury Restored*; see Smiles, *British Art: Ancient Landscapes*, pp. 84–7

13 Myfanwy Evans, 'Paul Nash, 1937', *Axis*, 8 (1937), pp. 12–15 (12).

14 Paul Nash, 'Notes on the Picture called *Farewell*', in *Writings on Art*, ed. Andrew Causey (Oxford, 2000), p. 163

15 D. H. Lawrence, *Sea and Sardinia*, ed. Mara Kalnins (1921; Cambridge, 2002), p. 57

16 Graham Sutherland to Colin Anderson, 1934; quoted in Martin Hammer, *Graham Sutherland: Landscapes, War Scenes, Portraits 1924–1950* (London, 2005), pp. 68–70

17 John Piper to John Betjeman, 23 August 1941; quoted in Susan Owens, 'Evocation or Topography: John Piper's Watercolours of Windsor Castle, 1941–44', *Burlington Magazine*, 147/1230 (2005), pp. 598–605 (603).

18 File on John Piper's views of Windsor with comparative photographs compiled by Susan Owens, November 2005; Print Room, Royal Library, Windsor Castle

19 John Betjeman and Geoffrey Taylor, 'Apology', *English Scottish & Welsh Landscape* (London, 1944), p. vi

20 Magdalen Evans, 'John Leith Craxton (1922–2009)', *Oxford Dictionary of National Biography*, 2013 <https://doi.org/10.1093/ref:odnb/101581> [accessed 5 July 2019]

21 Catalogue entry for John Craxton, *Dreamer in Landscape* (T03836), Tate website <https://www.tate.org.uk/art/artworks/craxton-dreamer-in-landscape-t03836> [accessed 6 July 2019]

22 Alice Correia, catalogue entry for Henry Moore, *Recumbent Figure* (N05387) Tate website <https://www.tate.org.uk/art/research-publications/henry-moore/henry-moore-om-ch-recumbent-figure-r1147451> [accessed 5 July 2019]

23 *Ibid.*

24 Henry Moore, 'A Sculptor Speaks', *Listener*, 18 August 1937, pp. 228–40; quoted *ibid.*

25 Henry Moore in *Sculpture in the Open Air*, British Council film, 1955; transcript reprinted in Alan Wilkinson (ed.), *Henry Moore: Writings and Conversations* (Aldershot, 2002), 258–9; quoted in Correia, *Recumbent Figure* (N05387)

26 Barbara Hepworth to John Summerson, 3 January 1940; quoted in Sally Festing, *Barbara Hepworth: A Life of Forms* (London, 2005), p. 141

27 Barbara Hepworth, *Barbara Hepworth: Carvings and Drawings* (London, 1952), n.p.

28 Quoted in E. H. Ramsden, *Sculpture: Theme and Variations: Towards a Contemporary Aesthetic* (London, 1953), p. 42

29 Quoted in Chris Stephens, catalogue entry for Barbara Hepworth, *Landscape Sculpture* (T12284), Tate website <https://www.tate.org.uk/art/artworks/hepworth-landscape-sculpture-t12284> [accessed 5 July 2019]

30 See Peter Khoroche, *Ivon Hitchens* (2007; 2nd edn, Farnham, 2014), p. 70

31 Ivon Hitchens, 'Notes on Painting', *Ark*, 1956, n. p.

32 Ralph of Coggeshall, *Chronicon Anglicanum* (1200); the autograph manuscript is lodged at Coggeshall Abbey, where Ralph was a monk and later abbot.

33 T. H. to the editor, Edward Cave (under the pseudonym Sylvanus Urban), October 4, 1749; *Gentleman's Magazine*, November 1749, p. 506

34 W. G. Sebald, *The Rings of Saturn*, tr. Michael Hulse (Frankfurt, 1995; London 2002), pp. 234–7.

35 See Robert Macfarlane, 'Walking in Unquiet Landscapes', *Tate Etc*, 26 (2019) <https://www.tate.org.uk/tate-etc/issue-36-spring-2016/walking-unquiet-landscapes> [accessed 22 July 2019]

36 Ingrid Pollard, *Pastoral Interlude* (1987), hand-coloured gelatin silver print. Victoria and Albert Museum, London, E.722-1993

37 'Clare Woods on Graham Sutherland's Black Landscape 1939–40', *Tate Etc*, 23 (2011) <http://www.clare-woods.com/wp-content/uploads/2015/11/Clare-Woods-on-Graham-Sutherland%E2%80%99s-Black-Landscape-1939-40-Tate-Etc.-issue-23-September-2011.pdf> [accessed 24 July 2019]

38 Andrew Michael Hurley, *The Loney* [London, 2014], ch. 2

39 Seamus Heaney, 'Digging', line 31, from *Death of a Naturalist* [London, 1966]

40 Seamus Heaney, 'The Grauballe Man', lines 6–7, 23–4, and 'Strange Fruit', line 3, from *North* [London, 1975]

41 Seamus Heaney, 'The Tollund Man', II, lines 9–12; III, lines 9–12, from *Wintering Out* [London, 1972]

42 Daniel Defoe, *A Tour Through the Whole Island of Great Britain*, ed. P. N. Furbank and W. R. Owens (New Haven and London, 1991), pp. 256–7

43 Ted Hughes, *Remains of Elmet* (London, 1979), n.p.

44 Roger Coulam, 'The Blast: Where the Earth Bleeds', <http://www.rogercoulam.com/galleries/34/>

45 Roger Coulam, 'Close Up: Roger Coulam – the Blast', *Shutter Hub*, 30 January 2017 <https://shutterhub.org.uk/close-up-roger-coulam-the-blast/> [accessed 23 July 2019]

46 Keith Arnatt, *Self-Burial*, originally shown on Westdeutsches Fernsehen, October 1969. Tate Report 1972–4 (London 1975), <https://www.tate.org.uk/art/artworks/arnatt-self-burial-television-interference-project-t01747> [accessed 12 July 2019]

47 Reproduced in Malcolm Andrews, *Landscape and Western Art* (Oxford, 1999), p. 216

48 Roger Deakin, *Wildwood: A Journey through Trees* (London, 2007), pp. 158–61

49 Quoted in Javier Pes, 'What's a Land Artist to do when his Living Sculpture Starts Dying?', *artnet news* <https://news.artnet.com/art-world/artist-living-sculpture-starts-dying-david-nash-stoical-life-death-ash-dome-1307201> [accessed 8 July 2019]

50 Andy Goldsworthy Digital Catalogue, 1, 1976–86 <https://www.goldsworthy.cc.gla.ac.uk/> [accessed 8 July 2019]; for example, 1980_038, 1986_115, 1985_072

51 Alice Sanger, '*Bigger Trees Near Warter* or / ou Peinture Sur le Motif Pour le Nouvel Age Post-Photographique', Tate website, 2009 <https://www.tate.org.uk/art/artworks/hockney-bigger-trees-near-warter-or-ou-peinture-sur-le-motif-pour-le-nouvel-age-post-t12887> [accessed 12 July 2019]

52 Quoted in John Haffenden,
 'Interview with Iris Murdoch',
 Literary Review, April 1983
 <https://literaryreview.co.uk/
 john-haffenden-talks-to-iris-
 murdoch> [accessed 12 July 2019]
53 Iris Murdoch, *The Nice and the
 Good* (London, 1968), ch. 35; *The
 Sea, The Sea* (London, 1978), ch. 5
54 Iris Murdoch, *Nuns and Soldiers*
 (London, 1980), ch. 7
55 Nan Shepherd, *The Living
 Mountain* (1977; London, 2014),
 pp. 16, 105
56 *Ibid.*, pp. 16, 12–13, 30
57 *Ibid.*, pp. 102–3
58 *Ibid.*, p. 108
59 Robert Macfarlane, 'Introduction'
 to *The Living Mountain* (London,
 2014), pp. x–xi
60 Roger Deakin, *Waterlog* (London,
 1999), pp. 3–4
61 Robert Macfarlane, *The Wild
 Places* (London, 2007), pp. 225, 227
62 Sebald, *Rings of Saturn*, pp. 159, 169
63 See David Matless, 'The
 Anthroposcenic: Landscape in
 the Anthroposcene', *British Art
 Studies*, 10 (2018) <https://www.
 britishartstudies.ac.uk/issues/
 issue-index/issue-10/landscape-
 anthroposcene> [accessed 24 July
 2019]
64 William Shakespeare, *A
 Midsummer Night's Dream*, II.1,
 lines 111–14
65 John Lewis-Stempel, *Meadowland:
 The Private Life of an English Field*
 (London, 2014); Mark Cocker, *Crow
 Country: A Meditation on Birds,
 Landscape and Nature* (London,
 2007); Rob Cowen, *Common
 Ground* (London, 2015); Olivia
 Laing, *To the River: A Journey
 Beneath the Surface* (London, 2011)

Epilogue

1 Quoted in Michael Shepherd,
 Barbara Hepworth (London 1963),
 p. 3
2 For a detailed account of the
 history and construction of *Deer
 Shelter Skyspace*, see Andrew
 Graham-Dixon, 'James Turrell:
 Deer Shelter Skyspace', in Andrew
 Graham-Dixon, Claire Lilley and
 Caroline Bugler, *James Turrell Deer
 Shelter: An Art Fund Commission*
 (London, 2006), pp. 7–11
3 Quoted in Calvin Tomkins, 'Flying
 into the Light', *New Yorker*, 13
 January 2000
4 John Constable to John Fisher:
 'I have done a good deal of
 skying', 23 October 1821, in *John
 Constable's Correspondence*, VI, ed.
 R. B. Beckett (London, 1968), p. 76
5 A group of Dean's cloud drawings
 on slate was shown at *Tacita
 Dean: Landscape*, Royal Academy
 of Arts, 19 May to 12 August 2018
6 William Shakespeare, *As You Like
 It*, II.7, line 28

FURTHER READING

As I was completing this book I had dinner with an art-historian friend who was visiting from the United States. 'Surely it would have been easier to have written a book about artists who *haven't* painted landscapes,' he remarked drily as we caught up on our projects. I had to admit that he had a point. Landscape has been central to British art since the eighteenth century, and, as I have argued here, it played a large part in British culture in preceding centuries. The same might be said for literature. I could see that my bibliography could easily become as unruly as one of Richard Jefferies's unpruned hedgerows, and it is for this reason that it excludes all but a few books and exhibition catalogues that focus on the work of individual artists and writers in favour of those that deal with themes, groups or periods. If I were asked, however, to narrow the bibliography down further to fit a single bookshelf with key suggestions for further reading, it would look something like this:

To establish the main contours of the subject I would begin with: Leslie Parris's *Landscape in Britain, c. 1750–1850* (1973); Margaret Drabble's *A Writer's Britain: Landscape in Literature* (1979); Michael Rosenthal's *British Landscape Painting* (1982); the multi-authored book *Towards a New Landscape* (Nicholas Alfrey, Paul Barker, Margaret Drabble *et al.*, 1993); Malcolm Andrews's *Landscape and Western Art* (1999); and Christina Hardyment's *Writing Britain: Wastelands to Wonderlands* (2012). Then space would have to be made for Martin Hardie's great three-volume *Watercolour Painting in Britain* (1966–68), which offers a panorama of the British landscape as seen throughout the eighteenth and nineteenth centuries. Next to them I would add two books of engrossing essays that offer a broad range of thinking about ways in which landscape represents identity and society: *Prospects for the Nation: Recent Essays in British Landscape, 1750–1880* (1997, ed. Michael Rosenthal, Christiana Payne and Scott Wilcox) and its successor *The Geographies of Englishness: Landscape and the National Past 1880–1940* (2002, ed. David Peters Corbett, Ysanne Holt and Fiona Russell). Simon Schama's classic and deeply reflective *Landscape and Memory* (1995) would have to be there too.

John Barrell's *The Dark Side of the Landscape: The Rural Poor in English Painting 1730–1840* (1980) is an essential presence on the bookshelf, a landmark book that shifted our focus and introduced a new way of looking at painting. It has exerted an incalculable influence, but among the most valuable and useful responses to it are Ann Bermingham's *Landscape and Ideology: The English Rural Tradition, 1740–1860* (1987) and Christiana Payne's *Toil and Plenty: Images of the Agricultural Landscape in England, 1780–1890* (1993).

Onwards to specialist studies of particular periods, and an outstanding discussion of late-eighteenth-century landscape art – which deserves its own special slip-case – is Malcolm Andrews's *The Search for the Picturesque: Landscape Aesthetics and Tourism in Britain, 1760–1800* (1989). Of books that cover the art and politics of a later period, I would find room for *Places of the Mind: British Watercolour Landscapes 1850–1950* (2017, ed. Kim Sloan) and *Landscape in Britain 1850–1950* (1983, ed. Judy Collins and Nicola Bennett). Christopher Neve's dazzling *Unquiet Landscape: Places and Ideas in Twentieth-Century English Painting* (1990; new edition 2020) is – along with Drabble's *Writer's Britain* – probably the book I find myself taking off my own bookshelf most regularly for the sheer pleasure it gives, and so I put it on this one. As for contemporary ideas about landscape, *Creating the Countryside: The Rural Idyll Past and Present* (2017; ed. Verity Elson and Rosemary Shirley) offers numerous thought-provoking excursions into current attitudes.

Finally, in the midst of this imaginative phantasmagoria that has been unfolding for centuries and shows no sign of abating, I would suggest bookending this capsule library with three absorbing books that reconnect us to the history and evolution of the actual landscape. The classic work in this respect is W. G. Hoskins's *The Making of the English Landscape*. First published in 1955, it is most rewardingly read now in the edition of 1988 which pairs Hoskins's text with an incisive commentary by Christopher Taylor. More recently the subject has been revisited by Francis Pryor in *The Making of the British Landscape: How We Have Transformed the Land, from Prehistory to Today* (2010) and Nicholas Crane in *The Making of the British Landscape: From the Ice Age to the Present* (2016).

Select Bibliography

Ackroyd, Peter, *Albion: The Origins of the English Imagination* (London, 2002)

Alfrey, Nicholas, Paul Barker, Margaret Drabble et al., *Towards a New Landscape* (London, 1993)

Andrews, Malcolm, *The Search for the Picturesque: Landscape Aesthetics and Tourism in Britain, 1760–1800* (Stanford, CA, 1989)

—, *Landscape and Western Art* (Oxford, 1999)

Ashe, Geoffrey, *The Landscape of King Arthur* (London, 1987)

Ayres, James, *Domestic Interiors: The British Tradition 1500–1850* (New Haven and London, 2003)

—, *Art, Artisans & Apprentices: Apprentice Painters and Sculptors in the Early Modern British Tradition* (Oxford, 2014)

Barber, Peter, 'John Darby's Map of the Parish of Smallburgh in Norfolk, 1582', *Imago Mundi*, 57/1 (2005), pp. 55–8

— and Harper, Tom, *Magnificent Maps: Power, Propaganda and Art* (London, 2010)

Barrell, John, *The Idea of Landscape and the Sense of Place 1730–1840: An Approach to the Poetry of John Clare* (Cambridge, 1972)

—, *The Dark Side of the Landscape: The Rural Poor in English Painting 1730–1840* (Cambridge, 1980)

Barringer, Tim, Edith Devaney, Margaret Drabble et al., *David Hockney: A Bigger Picture*, exh. cat. (London, 2012)

Bermingham, Ann, *Landscape and Ideology: The English Rustic Tradition, 1740–1860* (London, 1987)

—, 'Landscape-O-Rama: The Exhibition Landscape at Somerset House and the Rise of Popular Landscape Entertainments', in *Art on the Line: The Royal Academy Exhibitions at Somerset House 1780–1836*, ed. David H. Solkin (New Haven and London, 2001), pp. 127–43

Bindman, David, *Blake as an Artist* (Oxford, 1977)

Blair, John, *Building Anglo-Saxon England* (Princeton, NJ, 2018)

Bord, Janet and Colin, *Mysterious Britain: Ancient Secrets of the United Kingdom and Ireland* (London, 1972)

Bottema, Els and Lida Cardozo Kindersley, *The Shingle Street Shell Line* (Cambridge, 2018)

Bracewell, Michael, et al., *Clare Woods: Strange Meetings* (London, 2016)

Brownell, Morris R., *Alexander Pope & the Arts of Georgian England* (Oxford, 1978)

Burl, Aubrey, *The Stone Circles of the British Isles* (New Haven and London, 1976)

—, *Prehistoric Avebury* (London, 1979)

Carley, James P., 'John Leland's *Cygnea cantio*: a Neglected Tudor River Poem', *Humanistica Lovaniensia*, 32 (1983), pp. 225–41

Carter, George, Patrick Goode and Kedrun Laurie, *Humphry Repton Landscape Gardener 1752–1818* (Norwich, 1982)

Causey, Andrew, *Paul Nash: Landscape and the Life of Objects* (London, 2013)

Chamberlin, Russell, *The Idea of England* (London, 1986)

Chandler, John (ed.), *John Leland's Itinerary: Travels in Tudor England* (Stroud, 1993)

Goodchild, Ann, Claudia Tobin, Claudia Milburn et al., *Ivon Hitchens: Space through Colour,* exh. cat. (Chichester, 2019)

Clifford, Sue and Angela King, *England in Particular: A Celebration of the Commonplace, the Local, the Vernacular and the Distinctive* (London, 2006)

Collins, Judy and Nicola Bennett, *Landscape in Britain 1850–1950,* exh. cat. (London, 1983)

Corbett, David Peters, Ysanne Holt and Fiona Russell, *The Geographies of Englishness: Landscape and the National Past 1880–1940* (New Haven and London, 2002)

Coverley, Merlin, *Psychogeography* (Harpenden, 2006)

Cramsie, John, *British Travellers and the Encounter with Britain 1450–1700* (Woodbridge, 2015)

Crane, Nicholas, *The Making of the British Landscape from the Ice Age to the Present* (London, 2016)

Daiches, David and John Flower, *Literary Landscapes of the British Isles: A Narrative Atlas* (New York and London, 1979)

Davidson, Peter, *The Last of the Light: About Twilight* (London, 2015)

Deakin, Roger, *Wildwood: A Journey Through Trees* (London, 2007)

Dee, Tim (ed.), *Ground Work: Writing on People and Places* (London, 2018)

Dixon Hunt, John and Peter Willis (eds), *The Genius of the Place: the English Landscape Garden 1620–1820* (London, 1975)

—, *The Figure in the Landscape: Poetry, Painting and Gardening during the Eighteenth Century* (Baltimore and London, 1976)

Drabble, Margaret, *A Writer's Britain: Landscape in Literature* (London, 1979)

Einberg, Elizabeth, *The Origins of Landscape Painting in England*, exh. cat. (London, 1967)

Elson, Verity and Rosemary Shirley, *Creating the Countryside: The Rural Idyll Past and Present* (London, 2017)

Evans, Mark, *John Constable: Oil Sketches from the Victoria and Albert Museum* (London, 2011)

—, *John Constable: the Making of a Master* (London, 2014)

—, *Constable's Skies: Paintings and Sketches by John Constable* (London, 2018)

Gelling, Margaret, *Signposts to the Past: Place-Names and the History of England* (London, 1978)

—, *Place-Names in the Landscape* (London, 1984)

Gerbino, Anthony, 'The Paper Revolution: The Origin of Large-Scale Technical Drawing under Henry VIII', in Anthony Gerbino and Stephen Johnston, eds, *Compass & Rule: Architecture as Mathematical Practice in England* (New Haven and London, 2009), pp. 31–44

Gildas, *The Ruin of Britain and Other Works*, ed. and trans. Michael Winterbottom (London and Chichester, 1978)

Girouard, Mark, *Hardwick Hall, Derbyshire, A History and a Guide* (London, 1976)

Gombrich, E. H., 'The Renaissance Theory of Art and the Rise of Landscape', in *Norm and Form: Studies in the Art of the Renaissance* (2nd edn, London, 1971), pp. 107–21

Gordon, Andrew and Bernhard Klein, *Literature, Mapping and the Politics of Space in Early Modern Britain* (Cambridge, 2001)

Graham-Dixon, Andrew, Claire Lilley and Caroline Bugler, *James Turrell Deer Shelter: An Art Fund Commission* (London, 2006)

Grigson, Geoffrey, *Britain Observed: The Landscape through Artists' Eyes* (London, 1975)

—, *The Shell Country Alphabet: From Apple Trees to Stone Circles, How to Understand the British Countryside* (1966; London, 2009)

Groom, Nick, *The Seasons: A Celebration of the English Year* (London, 2013)

Hamilton, James, *Gainsborough: A Portrait* (London, 2017)

Hammer, Martin, *Graham Sutherland: Landscapes, War Scenes, Portraits 1924–1950* (London, 2005)

Hanning, Robert W., *The Vision of History in Early Britain: From Gildas to Geoffrey of Monmouth* (New York and London, 1966)

Hardie, Martin, *Watercolour Painting in Britain*, 3 vols (London, 1966–68)

Hardyment, Christina, *Literary Trails: British Writers in their Landscapes* (London, 2000)

—, *Writing Britain: Wastelands to Wonderlands* (London, 2012)

Hargreaves, Matthew, and Rachel Sloan, *A Dialogue with Nature: Romantic Landscapes from Britain and Germany*, exh. cat. (London and New York, 2014)

Harris, Alexandra, *Romantic Moderns: English Writers, Artists and the Imagination from Virginia Woolf to John Piper* (London, 2010)

—, *Weatherland: Writers & Artists under English Skies* (London, 2015)

—, Alan Hollinghurst and Ali Smith, *Tacita Dean: Landscape, Portrait, Still Life*, exh. cat. (London, 2018)

Harris, John, Stephen Orgel and Roy Strong, *The King's Arcadia: Inigo Jones and the Stuart Court: a quatercentenary exhibition held at the Banqueting House, Whitehall from July 12th to September 2nd, 1973* (London, 1973)

Harris, Oliver D., 'William Camden, Philemon Holland and the 1610 Translation of *Britannia*', *The Antiquaries Journal*, 95 (2015), pp. 279–303

Harrison, William, *The Description of England: the Classic and Contemporary Account of Tudor Social Life*, ed. George Edelen (Washington and New York, 1994)

Harvey, P. D. A., *Maps in Tudor England* (London, 1993)

Hauser, Kitty, *Shadow Sites: Photography, Archaeology, and the British Landscape 1927–1955* (Oxford, 2007)

Hawes, Louis, *Presences of Nature: British Landscape 1780–1830* (New Haven, 1982)

Heathcote, David, *A Shell Eye on England: The Shell County Guides 1934–1984* (Faringdon, 2011)

Higham, Nicholas J., *King Arthur: The Making of the Legend* (New Haven and London, 2018)

Hill, Rosemary, *Stonehenge* (London, 2007)

Holmes, Richard, *Coleridge: Early Visions* (London, 1989)

—, *Coleridge: Darker Reflections* (London, 2005)

Holt, Ysanne, *British Artists and the Modernist Landscape* (Aldershot, 2003)

Hoskins, W. G., *The Making of the English Landscape*, ed. Christopher Taylor (London, 1988)

House, Humphry (ed.), completed by Graham Storey, *The Journals and Papers of Gerard Manley Hopkins* (2nd edn, Oxford, 1959)

Humphreys, Richard, *John Constable: The Leaping Horse* (London, 2018)

Hurst, Henry, 'The Textual and Archaeological Evidence', in Martin Millett, Louise Revell and Alison Moore (eds), *The Oxford Handbook of Roman Britain* (Oxford, 2016), pp. 95–116

Knoepflmacher, U. C. and G. B. Tennyson, *Nature and the Victorian Imagination* (Los Angeles and London, 1977)

Lancaster, Charles, *Seeing England: Antiquaries, Travellers & Naturalists* (Stroud, 2008)

Lyles, Anne, and Andrew Wilton, *The Great Age of British Watercolours 1750–1880*, exh. cat. (London and Washington, D.C., 1993)

Macfarlane, Robert, *The Wild Places* (London, 2007)

—, *The Old Ways: A Journey on Foot* (London, 2012)

—, *Landmarks* (London, 2015)

—, 'The Eeriness of the English Countryside', *Guardian*, 10 April 2015

—, *Underland: A Deep Time Journey* (London, 2019)

—, 'Walking in Unquiet Landscapes', *Tate Etc*, 36, 25 June 2019

— and Stanley Donwood, *Ness* (London, 2019)

Marsh, Jan, *Back to the Land: the Pastoral Impulse in Victorian England from 1880 to 1914* (London, 1982)

Martin, Simon, Martin Butlin and Robert Meyrick, *Poets in the Landscape: The Romantic Spirit in British Art* (Chichester, 2007)

Matless, David, *Landscape and Englishness* (2nd edn, London 2016)

McCarthy, Sarah, Bernard Nurse and David Gaimster (eds), *Making History: Antiquaries in Britain, 1707–2007*, exh. cat. (London, 2007)

McRae, Andrew, *God Speed the Plough: The Representation of Agrarian England, 1500–1660* (Cambridge, 1996)

Meakin, H. L., *The Painted Closet of Lady Anne Bacon Drury* (Farnham, 2013)

Mellor, David (ed.), *A Paradise Lost: The Neo-Romantic Imagination in Britain 1935–55* (London, 1987)

Melrose, Robin, *Warriors and Wilderness in Medieval Britain: From Arthur and Beowulf to Sir Gawain and Robin Hood* (North Carolina, 2017)

Michell, John, *The New View over Atlantis* (rev. edn, London, 1983)

—, *The Traveller's Guide to Sacred England: A Guide to the Legends, Lore and Landscape of England's Sacred Places* (London, 2003)

Millar, Delia, *Queen Victoria's Life in the Scottish Highlands Depicted by her Watercolour Artists* (London, 1985)

Mitchell, W. J. T., *Landscape and Power* (2nd edn, Chicago and London, 2002)

Moir, Esther, *The Discovery of Britain: The English Tourists 1540 to 1840* (London, 1964)

Monmouth, Geoffrey of, *The History of the Kings of Britain*, trans. Lewis Thorpe (London, 1966)

Monmouth, Geoffrey of, *The History of the Kings of Britain*, ed. Michael D. Reeve and trans. Neil Wright (Woodbridge, 2007)

Moore, William H., 'Sources of Drayton's Conception of "Poly-Olbion"', *Studies in Philology*, 65/5 (1968), pp. 783–803

Morris, Christopher (ed.), *The Journeys of Celia Fiennes* (London, 1947)

Neve, Christopher, *Unquiet Landscape: Places and Ideas in Twentieth-Century English Painting* (London, 1990)

Newall, Christopher, *John Ruskin: Artist and Observer* (Ottawa and London, 2014)

Norgate, Edward, *Miniatura or the Art of Limning*, ed. Jeffrey M. Muller and Jim Murrell (New Haven and London, 1997)

O'Gorman, Francis, 'The Rural Scene: Victorian Literature and the Natural World', in Kate Flint (ed.), *The Cambridge History of Victorian Literature* (Cambridge, 2012), pp. 532–49

Orton, Jason and Ken Worpole, *The New English Landscape* (London, 2013)

Palmer, Samuel, *The Sketchbook of 1824*, ed. Martin Butlin (London, 2005)

Parnell, Edward, *Ghostland: In Search of a Haunted Country* (London, 2019)

Parris, Leslie (ed.), *Landscape in Britain c. 1750–1850*, exh. cat. (London, 1973)

— (ed.), *The Pre-Raphaelites*, exh. cat. (London, 1984)

Payne, Ann, *Views of the Past: Topographical Drawings in the British Library* (London, 1987)

Payne, Christiana, *Toil and Plenty: Images of the Agricultural Landscape in England, 1780–1890* (New Haven and London, 1993)

—, *Silent Witnesses: Trees in British Art 1760–1870* (Bristol, 2017)

Peacock, John, *The Stage Designs of Inigo Jones: The European Context* (Cambridge, 2006)

Piggott, Stuart, *Ruins in a Landscape: Essays in Antiquarianism* (Edinburgh, 1976)

Powell, Anthony, *John Aubrey and his Friends* (London, 1948)

Powers, Alan, *Eric Ravilious: Imagined Realities* (London, 2003)

Pryor, Francis, *The Making of the British Landscape: How We Have Transformed the Land, from Prehistory to Today* (London, 2010)

Readman, Paul, *Storied Ground: Landscape and the Shaping of English National Identity* (Cambridge, 2018)

Reed, Michael, *The Landscape of Britain from the Beginnings to 1914* (London, 1990)

Rosenthal, Michael, *British Landscape Painting* (Oxford, 1982)

—, *Constable: the Painter and his Landscape* (London, 1983)

—, Christiana Payne and Scott Wilcox (eds), *Prospects for the Nation: Recent Essays in British Landscape, 1750–1880* (New Haven and London, 1997)

Schama, Simon, *Landscape and Memory* (London, 1995)

Sekules, Veronica, *Cultures of the Countryside: Art, Museum, Heritage, Environment, 1970–2015* (London, 2017)

Semple, Sarah, 'A Fear of the Past: The Place of the Prehistoric Burial Mound in the Ideology of Middle and Later Anglo-Saxon England',

World Archaeology, 30 (June 1998), pp. 109–26

—, *Perceptions of the Prehistoric in Anglo-Saxon England: Religion, Ritual, and Rulership in the Landscape* (Oxford, 2013)

Shanes, Eric, *Turner's Picturesque Views in England and Wales 1825–1838* (London, 1979)

Sloan, Kim, *Alexander and John Robert Cozens: The Poetry of Landscape* (New Haven and London, 1986)

—, *'A Noble Art': Amateur Artists and Drawing Masters c. 1600–1800* (London, 2000)

— (ed.), *Places of the Mind: British Watercolour Landscapes 1850–1950* (London, 2017)

Sloman, Susan, *Gainsborough's Landscapes: Themes and Variations* (London, 2011)

Smiles, Sam, *British Art: Ancient Landscapes*, exh. cat. (London, 2016)

Smith, Alison (ed.), *Watercolour*, exh. cat. (London, 2011)

Smith, D. K., *The Cartographic Imagination in Early Modern England: Re-writing the World in Marlowe, Spenser, Raleigh and Marvell* (London, 2016)

Spalding, Frances, *John Piper Myfanwy Piper: Lives in Art* (Oxford, 2009)

Staley, Allen, *The Pre-Raphaelite Landscape* (2nd edn, New Haven and London, 2001)

— and Newall, Christopher, *Pre-Raphaelite Vision: Truth to Nature* (London, 2004)

Stafford, Fiona, *The Long, Long Life of Trees* (London, 2016)

Stainton, Lindsay, *British Landscape Watercolours 1600–1860* (London, 1985)

Stephens, Chris, *Peter Lanyon: At the Edge of Landscape* (London, 2000)

Stourton, James and Charles Sebag-Montefiore, *The British as Art Collectors: From the Tudors to the Present* (London, 2012)

Taplin, Kim, *The English Path* (Ipswich, 1979)

Thomas, Gwyn (ed. and trans.), *Dafydd ap Gwilym: His Poems* (Cardiff, 2001)

Thomas, Keith, *Man and the Natural World: Changing Attitudes in England 1500–1800* (London, 1983)

Thompson, Denys (ed.), *Change and Tradition in Rural England: An Anthology of Writings on Country Life* (Cambridge, 1980)

Tindall, Gillian, *Countries of the Mind: The Meaning of Place to Writers* (London, 2011)

Tooley, R. V., *Maps and Map-Makers* (London, 1970)

Treves, Toby and Barnaby Wright (eds), *Soaring Flight: Peter Lanyon's Gliding Paintings* (London, 2015)

Turner, James, 'Landscape and the "Art Prospective" in England, 1584–1660', in *Journal of the Warburg and Courtauld Institutes*, 42 (1979), pp. 290–93

Tyler, Richard, *Francis Place 1647–1728* (York, 1971)

Vaughan, William, *Samuel Palmer: Shadows on the Wall* (New Haven and London, 2015)

Wallace, Anne D., *Walking, Literature, and English Culture: The Origins and Uses of Peripatetic in the Nineteenth Century* (Oxford, 1993)

Walsham, Alexandra, *The Reformation of the Landscape: Religion, Identity, and Memory in Early Modern Britain and Ireland* (Oxford, 2011)

Watson, Nicola J., *The Literary Tourist* (Basingstoke, 2006)

White, Christopher, *English Landscape 1630–1850: Drawings, Prints & Books from the Paul Mellon Collection*, exh. cat. (New Haven, 1977)

Williams, Iolo, *Early English Watercolours and Some Cognate Drawings by Artists Born Not Later Than 1785* (London, 1952)

Woodell, S. J. R., *The English Landscape: Past, Present, and Future* (Oxford, 1985)

Woodward, Christopher, *In Ruins* (London, 2001)

Yorke, Malcolm, *The Spirit of Place: Nine Neo-Romantic Artists and their Times* (London, 1988)

ACKNOWLEDGMENTS

I have not only been thinking about landscape in art and literature for many years, but talking about it too. It is my pleasure now to be able to thank the following friends who have listened, been generous with their books, and offered a wealth of suggestions, ideas and insights: Juliet Blaxland, Bronwen Burgess, George Carter, Stephen Clarke, David Connearn, Penny Deben, David Evans, Mark Evans, Charles Freeman, Tony Furnival, John Gardiner, Roseline Greenwood, Alexandra Harris, Sandy Heslop, Richard Humphreys, John Huntingford, Samantha Knights, Francis Kyle, Christopher Lloyd, Charles Michell, Liza Rowell, Marcus Rowell, Veronica Sekules, Kim Sloan, Giles Stibbe, Miles Thistlethwaite, Michael Waller-Bridge, the late Giles Waterfield, Xanthe Wilde and Viktor Wynd.

Particularly heartfelt thanks are due to John Deben, who has taken a close interest in this project from the beginning and whose knowledge of literature and the Suffolk landscape has been a valuable source of inspiration; and to Benedict Gummer, who generously read the manuscript and whose erudition, wit and good sense have greatly improved this book.

At Thames and Hudson I offer the warmest of thanks to my commissioning editor, Ben Hayes. His imagination and dedication have encouraged me throughout. Sincere thanks are due to each member of the wider team, but most of all to Kate Edwards for her careful editing, Joanna McGuire for her resourceful picture research and Celia Falconer for her meticulous picture proofing.

I should like to thank Rachael Boast for kindly allowing me to quote from a poem in her collection *Pilgrim's Flower*. Rachael's talk at the 2018 Shute Festival in Devon, run by Samantha Knights and Paddy Magrane, inspired me to think about Coleridge in a new way.

I am most grateful to the staff of the British Library and to Natasha Held in the library of the Paul Mellon Centre.

Finally, my husband Stephen Calloway has been at my side for daily discussions, whether at the kitchen table or descending a cavern in the Peak District. My love and thanks.

LIST OF ILLUSTRATIONS

silver prints, each 46.7 x 46.7 cm. Tate, London (T01747). Image courtesy Sprüth Magers. © Keith Arnatt Estate. All rights reserved. DACS/Artimage 2020.

p. 251 William Stukeley, 'Silbury Hill', 1723 and aerial photograph of Silbury Hill, illustrations to John Piper, 'Prehistory from the Air', *Axis*, no. 8, 1937. Bodleian Library, University of Oxford

p. 253 Paul Nash, *Monster Field*, 1938. Black and white negative, 8.5 x 12.7 cm. Private Collection

p. 254 Graham Sutherland, *Pastoral*, 1930. Etching, 16.9 x 22.8 cm. Tate, London (P07117). © Estate of Graham Sutherland

p. 255 Graham Sutherland, *Brimham Rock, Yorkshire*, 1937. Lithograph, 76 x 114 cm. Shell Art Collection, Beaulieu. © Estate of Graham Sutherland

p. 259 John Craxton, *Dreamer in Landscape*, 1942. Ink and chalk, 54.8 x 76.2 cm. Tate, London (T03836). © Estate of John Craxton. All Rights Reserved, DACS 2020

p. 260 Henry Moore, *Recumbent Figure*, 1938. Green Hornton stone, 88.9 x 132.7 x 73.7 cm. Tate, London (N05387). Reproduced by permission of The Henry Moore Foundation

p. 262 Barbara Hepworth, *Landscape Sculpture*, 1944. Broadleaf elm and strings, 32 x 68 x 29 cm. Tate, London (T12284) Photo Tate. Barbara Hepworth © Bowness

p. 277 Andy Goldsworthy, *Leaf Horn, Penpont, Dumfriesshire*, 1986. Colour transparency, 5.7 x 5.7 cm. Courtesy Galerie Lelong & Co. © Andy Goldsworthy

p. 279 John Virtue, *Landscape no. 67*, 1987. Graphite, charcoal, shellac, ink and gouache, 173 x 154 cm. Victoria and Albert Museum, London (E.1416-1988). © John Virtue. All Rights Reserved, DACS 2020

p. 283 Bettina Furnée, *Lines of Defence*, January 2005. Digital photograph and installation. Courtesy the artist

Plates

1 Illustration to 'Pearl', in *Pearl, Cleanness, Patience and Sir Gawain and the Green Knight*, *c.* 1375–1424 (illustration added *c.* 1400–10). Watercolour on vellum, 18 x 15.5 cm. British Library, London (Cotton MS Nero A X/2, f. 41 r)

2 Illustration to 'Sir Gawain and the Green Knight', in *Pearl, Cleanness, Patience and Sir Gawain and the Green Knight*, *c.* 1375–1424 (illustration added *c.* 1400– 10). Watercolour on vellum, 18 x 15.5 cm. British Library, London (Cotton MS Nero A X/2, f. 129 v)

3 Isaac Oliver, *A Young Man Seated Under a Tree*, *c.* 1590–5. Watercolour on vellum laid on card, 12.4 x 8.9 cm. Royal Collection Trust, London (RCIN 420639)

4 Jan Siberechts, *View of Nottingham from the East*, *c.* 1695. Oil on canvas, 58.4 x 120.7 cm. Nottingham Castle Museum and Art Gallery (NCM 1977-515)

5 Richard Wilson, *View near Wynnstay, Llangollen, the Seat of Sir Watkin Williams-Wynn*, 1770–1. Oil on canvas, 180.3 x 244.8 cm. Yale Center for British Art, Paul Mellon Collection (B1976.7.84)

6 Thomas Gainsborough, *Landscape with Cattle*, *c.* 1773. Oil on canvas, 120 x 145.4 cm. Yale Center for British Art, Paul Mellon Collection (B1981.25.305)

7 Philippe Jacques de Loutherbourg, *Coalbrookdale by Night*, 1801. Oil on canvas, 68 x 107 cm. Science Museum, London (1952-452)

INDEX